THE HOUSE OF FRAGILE THINGS

THE
HOUSE OF
FRAGILE THINGS

JEWISH ART COLLECTORS
AND THE FALL OF FRANCE

JAMES McAULEY

YALE UNIVERSITY PRESS
NEW HAVEN AND LONDON

For information about this and other Yale University Press publications, please contact:

U.S. Office: sales.press@yale.edu yalebooks.com

Europe Office: sales@yaleup.co.uk yalebooks.co.uk

Set in Adobe Garamond Pro by IDSUK (DataConnection) Ltd

Printed in the United States of America

Library of Congress Control Number: 2021930169

ISBN 978-0-300-23337-7

A catalogue record for this book is available from the British Library.

10 9 8 7 6 5 4 3 2

CONTENTS

List of Illustrations		*vi*
Acknowledgements		*x*
Maps		*xiii*
Genealogies		*xv*
Introduction: A Letter		1
1	Portraits of a Milieu: A Jewish Elite in Crisis	18
2	Dreyfus and Drumont: Towards a Material Antisemitism	47
3	'Apogee of the *Israélite*': Jewish Collectors and the First World War	78
4	Moïse de Camondo: Chaos and Control	105
5	Théodore Reinach: Jewish Past, French Future	131
6	Béatrice Éphrussi de Rothschild: A Woman Collects	159
7	Museums of Memory: From Private Collections to National Bequests	185
8	To the End of the Line: Drancy and Auschwitz	214
9	'La Petite Irène': The Afterlife of a Portrait	244
Conclusion: A Death Certificate		255
Notes		*264*
Index		*295*

ILLUSTRATIONS

Plates

1 Pierre-Auguste Renoir, *Mlle Irène Cahen d'Anvers* (1880).

2 Pierre-Auguste Renoir, *Les Demoiselles Cahen d'Anvers* (1881). Photo João Musa.

3 Léon Bonnat, *Portrait de Louis Cahen d'Anvers* (1901). © Pascal Lemaître / Centre des monuments nationaux.

4 Carolus-Duran, *Portrait de Louise Cahen d'Anvers* (1874). © Pascal Lemaître / Centre des monuments nationaux.

5 The Château de Champs-sur-Marne. © Benjamin Gavaudo / Centre des monuments nationaux.

6 Interior of the Château de Champs-sur-Marne. © Patrick Cadet / Centre des monuments nationaux.

7 Abraham Salomon de Camondo, the family patriarch, Constantinople. Paris, Musée Nissim de Camondo. © MAD, Paris.

8 Isaac de Camondo and Moïse de Camondo as children, Constantinople. Paris, Musée Nissim de Camondo. © MAD, Paris.

9 Moïse de Camondo as a young man. Private Archives, Paris.

10 Nissim de Camondo and friends during the First World War, rue de Monceau, Paris. Private Archives, Paris.

11 Musée Nissim de Camondo, Paris. Hemis / Alamy Stock Photo.

12 Salon des Huets, Musée Nissim de Camondo. Photononstop / Alamy Stock Photo.

13 Théodore Reinach, self-portrait. © Benjamin Gavaudo / Centre des monuments nationaux.

14 Villa Kérylos. Clearview / Alamy Stock Photo.

15 The Reinach grandchildren at Kérylos, undated. © Reproduction Benjamin Gavaudo / CMN.

16 Fanny Reinach riding 'Pamplemousse', August 1942. Paris, Musée Nissim de Camondo. © MAD, Paris.

17 Béatrice's flowchart of duties. Archives of the Memorial de la Shoah.

18 Camondo memorial plaque, Musée Nissim de Camondo. Glenn Harper / Alamy Stock Photo.

In text

1 Béatrice de Camondo. Paris, Musée Nissim de Camondo. 1
© MAD, Paris / Christophe Dellière.

2 Letter from Béatrice de Camondo to a childhood friend, 3
5 September 1942. Private Archives, Paris.

3 Alfred Dreyfus. Bibliothèque Nationale de France. 12

4 An aerial view of the Château de Champs-sur-Marne, the home 19
of the Cahen d'Anvers family. © Reproduction Philippe
Berthé / CMN.

5 Louise Cahen d'Anvers. Bibliothèque Nationale de France. 29

6 A young Irène Cahen d'Anvers. Bibliothèque Nationale 33
de France.

7 Irène Cahen d'Anvers-Sampieri, Nissim and Béatrice de Camondo, 39
and Claude Sampieri, Paris, c. 1905. Paris, Musée Nissim
de Camondo. © MAD, Paris.

8 Béatrice de Camondo (right) at the wedding of her half-sister, 40
Claude Sampieri, Paris, 1932. Courtesy of the collection of
Catherine Bonnet.

9 Hélène Reinach-Abrami. Musée d'Art et d'Histoire du 43
Judaïsme, Paris.

10 Édouard Drumont. Bibliothèque Nationale de France. 58

11 Château de Ferrières, the estate of the Rothschild family. 63
MOSSOT / CC BY-SA 3.0.

12 Joseph Reinach by Agence Rol. Bibliothèque Nationale 66
de France.

ILLUSTRATIONS

13 Nissim de Camondo in uniform during the First World War, 82
November 1915. Paris, Musée Nissim de Camondo. © MAD, Paris.

14 Nissim de Camondo and his lover, Renée Dorville, at Deauville 89
with a friend, August 1917. Paris, Musée Nissim de Camondo.
© MAD, Paris.

15 Alice Ferrers Townshend (née Cahen d'Anvers), Lady Townshend, 93
by Bassano Ltd. National Portrait Gallery, London.

16 Nissim de Camondo, Béatrice de Camondo, Irène Sampieri, and 95
Louis and Louise Cahen d'Anvers at Champs-sur-Marne, spring
1916. Paris, Musée Nissim de Camondo. © MAD, Paris.

17 Nissim de Camondo piloting an airplane in unit MF33, 97
Hourges, France, June 1917. Paris, Musée Nissim de
Camondo. © MAD, Paris.

18 Nissim de Camondo and Béatrice de Camondo at 100
Champs-sur-Marne, spring 1916. Paris, Musée Nissim de
Camondo. © MAD, Paris.

19 Caricature of Moïse de Camondo, by Georges Goursat, known as 106
Sem, c. 1904. Paris, Musée Nissim de Camondo. © MAD, Paris.

20 Galata Bridge, Constantinople, by Agence Rol. Bibliothèque 109
Nationale de France.

21 Parc Monceau, monument Gounod, by Agence Rol. Bibliothèque 115
Nationale de France.

22 Moïse de Camondo and Nissim de Camondo in the gardens 124
of 63, rue de Monceau, Paris, August 1916. Paris, Musée Nissim
de Camondo. © MAD, Paris.

23 Théodore Reinach by Agence Meurisse. Bibliothèque Nationale 132
de France. Centre des Monuments Nationaux, Paris.

24 Pontremoli's sketch for Kérylos, the 'maison grecque'. Villa Kérylos, 150
Fondation Théodore Reinach-Institut de France.

25 Pontremoli's plans for the villa's mosaics. Villa Kérylos, Fondation 151
Théodore Reinach-Institut de France.

26 Grandchildren of Théodore Reinach playing on the peristyle at 155
Kérylos. © Reproduction Benjamin Gavaudo / CMN.

27 A granddaughter of Théodore Reinach does a cartwheel on the 158
terrace of Kérylos. © Reproduction Benjamin Gavaudo / CMN.

ILLUSTRATIONS

28 Béatrice Ephrussi de Rothschild. 159

29 Henri James de Rothschild. BIU Health Medicine Collection, 164
 University of Paris / ODC-BY, CC-BY 2.0.

30 Alphonse de Rothschild. Bibliotheque Nationale de France. 166

31 Cap Ferrat, 1912. Bibliotheque Nationale de France. 174

32 Villa Île de France. Berthold Werner / CC BY-SA 3.0. 177

33 Isaac de Camondo. Paris, Musée Nissim de Camondo. 189
 © MAD, Paris.

34 Charles Cahen d'Anvers at Château de Champs-sur-Marne. 199
 © Reproduction Philippe Berthé / CMN.

35 The library at Villa Kérylos, Visitors' Guide, 1934. Bibliothèque 205
 Nationale de France.

36 The solarium at Villa Kérylos, Visitors' Guide, 1934. Bibliothèque 207
 Nationale de France.

37 Béatrice de Camondo on horseback. Paris, Musée Nissim de 214
 Camondo. © MAD, Paris.

38 Élisabeth Cahen d'Anvers in Sablé-sur-Sarthe, 1943. Courtesy 219
 of the collection of Jean de Monbrison, Paris.

39 Julien Reinach. © Reproduction Benjamin Gavaudo / CMN. 224

40 Léon Reinach. Paris, Musée Nissim de Camondo. © MAD, Paris. 225

41 Drancy identification card of Béatrice de Camondo. 237
 Archives Nationales de France.

42 Letter from Béatrice de Camondo to Nadine Anspach, 239
 August 1942. Private Archives, Paris.

43 Bertrand Reinach. Paris, Musée Nissim de Camondo. © MAD, 242
 Paris / Christophe Dellière.

44 Jean Seberg with 'La Petite Irène' in Jean-Luc Godard's *À bout* 252
 de souffle, 1960. Walter Daran / The LIFE Images Collection via
 Getty Images / Getty Images.

45 Irène Sampieri, Paris, *c.* 1958. Courtesy of the collection of 254
 Catherine Bonnet.

46 Death certificate of Béatrice de Camondo. Office National des 255
 Anciens Combattants et Victimes de Guerre, 1946.

47 Letter from Béatrice de Camondo to a childhood friend, 262
 9 September 1917. Private Archives, Paris.

ACKNOWLEDGEMENTS

This book began as a doctoral dissertation in Oxford funded by the Marshall Scholarship, without whose support I could not have conducted this research. I am immensely grateful for the opportunity and for the friends I made along the way.

In Oxford, I had the great fortune of having two remarkable supervisors who shaped this project in its early stages. Ruth Haris, whose expertise in Dreyfus-era France is unrivaled, let me be creative and taught me how to write history. Martin Conway opened my eyes to so many new ideas and arguments and was always patient with me as I wandered between journalism and academia. I benefited so much from Oxford's unique intellectual environment, and especially from the Modern Jewish History Seminar, which gave me multiple opportunities to workshop portions of the project that later became this book. For that I thank Derek Penslar, David Rechter, and Abigail Green, who also very kindly read portions of my draft, as well as Robert Gildea, who evaluated the dissertation that grew into this book. It was also my luck to be in Oxford when Abigail and Tom Stammers launched the 'Jewish Country Houses' project, a seminar that has already opened so many new doors for the study of collecting and created a wonderful community of scholarly exchange. I must thank Tom Stammers in particular, although I know I won't be able to do so enough. Tom is the real expert on this subject, and this book would simply not exist without the incredible research he has done in this field, his generosity, and his perceptive comments on these pages.

This book would also not exist were it not for the help of archivists and research librarians who helped me at every step of the way. Ever since I was a doctoral student, Sophie Le Tarnec and Sylvie Legrand-Rossi at the Musée Nissim de Camondo in Paris have provided me with countless documents,

answered any number of bizarre questions even at the last minute, and combed through the entire manuscript to verify every single detail about the Camondo. Oliver Gabet, the director of the Musée des Arts Decoratifs, has also been an invaluable resource and friend as I wrote this book; I have greatly appreciated his support. At the Rothschild Archive in London, Melanie Aspey and Justin Cavernelis-Frost have likewise been exceedingly helpful and supportive, especially when the coronavirus pandemic made travel impossible. Finally, no one has been more helpful than my dear friend Bernadette Murphy of the Orphan Art Project in Paris, who knows the details of this story far better than I do. Years ago, Bernadette was my first boss, in the research library of the now-defunct *International Herald Tribune* in Paris; she taught me everything I know about archives. While she worked on a related project of her own, she graciously shared with me many important documents she found, including Béatrice de Camondo's elusive death certificate.

But I also relied heavily on a number of private archives for this book, and I am more grateful than I can say to the people who took the time to share their family stories with me. Years ago in New York, Felipe and Renata Propper welcomed me into their home, told me everything they knew about France in 1940, and have since become dear friends. If nothing else, this research project has been worth it just for their friendship. Elena Bonham-Carter in London likewise kindly received me on multiple occasions and helped me greatly in the early stages of my research. In Paris, I particularly appreciate the generosity and kindness of Catherine Bonnet, who shared her family albums and stories with me. Nathalie Corvée and Guy de Leusse also contributed immensely to my research.

So many conversations and exchanges with friends and fellow scholars shaped this project, more than I can list here. But I want to thank especially Alice Kaplan, who found the time to read every single chapter of this book as it was written and to give excellent comments (and encouragement) on my drafts even as she finished a book of her own. I must also thank Lisa Fine, whose generosity knows no limit and who believed in this project long before anyone else did. Alejandra Cicognani was an invaluable sounding board, and Stellene Volandes gave me the rare opportunity to sketch out a portion of this book as an article for a general reader. That piece, edited with great care by Norman Vanamee, grew into my introduction. Anne Higonnet, whose work

has been an inspiration, gave so much good advice from the very beginning and combed through these pages with a razor-sharp eye. Aron Rodrigue, Lisa Leff, Phil Nord, Maurie Samuels, Emma Rothschild, Patrick Weil, Jean-Marc Dreyfus, Nicolas Kugel, Alice Legé, David Pullins, Basile Baudez, Margaret Higonnet, and Pauline Prevost-Marcilhacy all read through the manuscript and offered terrific suggestions for how to make it stronger. Cyril Grange, whose book on the Parisian Jewish elite is an inspiration, generously shared private archival documents with me. Natasha Lehrer knows more about the Reinachs than anyone, and went with me to trace what remains of the family in Saint-Germain-en-Laye. I would also be remiss not to thank especially Alex Katz, who has been dragged to the Camondo museum way too many times on visits to Paris, Jason Farago, the best editor (and friend) there is, and Simon Kuper, who gave excellent comments on my draft even while writing his next book. Pamela Druckerman, Rachel Donadio, Benjamin Moser, Isabel Kaplan, Julian Gewirtz, Madeleine Schwartz, Sofia Groopman, Etelle Higonnet, Ruth Eglash, Judith Jacob, Adam Nossiter, Geoffrey Shaw, Will Stoeckle, Hilary Hurd, Sarah Cleveland, Patricia Sustrac, Anne Sebba, Cameron Barr, Phil Kennicott, Charlotte Smart, Susannah Jacob, and Eli Martin all gave invaluable insights as I wrote.

I could not have asked for a better editor than Julian Loose, who immediately understood this project and was incredibly patient with me as I researched it. At Yale University Press, I would also like to thank Marika Lysandrou, Katie Urquhart, and Percie Edgeler, who made this book look beautiful, and Rachael Lonsdale and Lucy Buchan for putting it all together. Heather Nathan, Chloe Foster, and Maria Zygogianni have handled the book's publicity brilliantly.

Finally, I also thank my parents, Jennifer and Jay McAuley, who I love more than I can say and who have been so incredibly supportive of me, including in providing every educational opportunity imaginable from a young age. It's in that spirit that I reflect on the origins of this project. Everyone should be so fortunate to have a professor who changes their life, as I did in Patrice Higonnet, who has taught me so much and who first suggested I visit the Camondo museum many years ago. This book is dedicated to him.

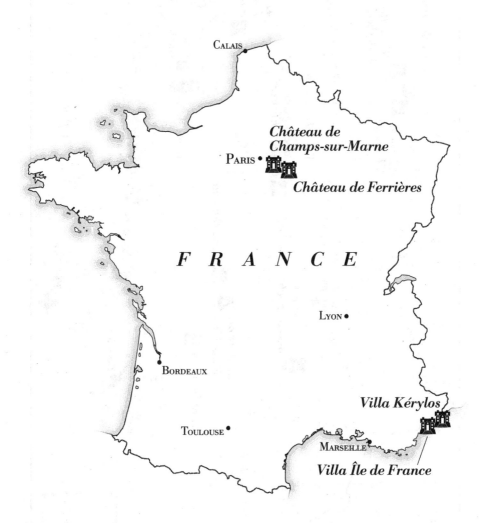

CALAIS

Château de
Champs-sur-Marne

PARIS

Château de Ferrières

F R A N C E

LYON

BORDEAUX

Villa Kérylos

TOULOUSE

MARSEILLE

Villa Île de France

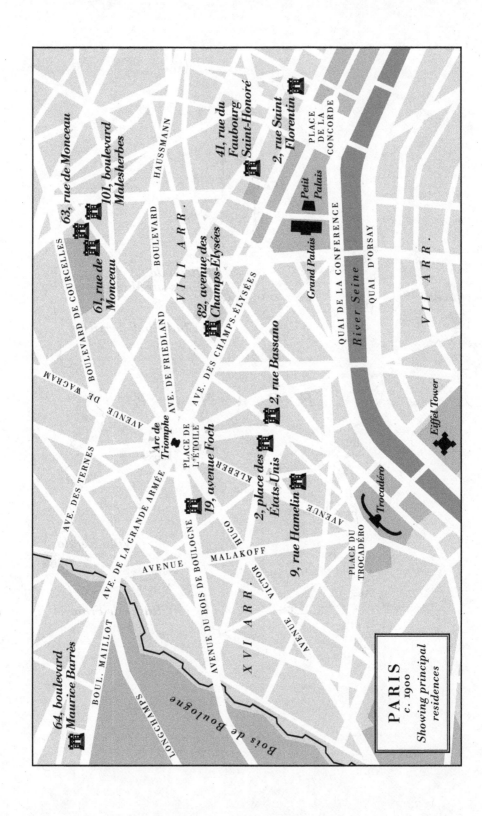

63, rue de Monceau

101, boulevard Malesherbes

41, rue du Faubourg Saint-Honoré

2, rue Saint Florentin

61, rue de Monceau

BOULEVARD HAUSSMANN

VIII ARR.

PLACE DE LA CONCORDE

Petit Palais

82, avenue des Champs-Élysées

Grand Palais

QUAI DE LA CONFERENCE

QUAI D'ORSAY

River Seine

VII ARR.

BOULEVARD

BOULEVARD DE COURCELLES

AVE. DE FRIEDLAND

AVE. DES CHAMPS-ÉLYSÉES

AVENUE DE WAGRAM

2, rue Bassano

AVE. DES TERNES

Arc de Triomphe

PLACE DE L'ÉTOILE

KLÉBER

2, place des États-Unis

Eiffel Tower

AVE. DE LA GRANDE ARMÉE

19, avenue Foch

Trocadéro

BOUL. MAILLOT

AVENUE DU BOIS DE BOULOGNE

HUGO

AVENUE VICTOR

AVENUE MALAKOFF

9, rue Hamelin

AVENUE

PLACE DU TROCADÉRO

64, boulevard Maurice Barrès

LONGCHAMPS

Bois de Boulogne

XVI ARR.

PARIS
c. 1900

Showing principal residences

Camondo

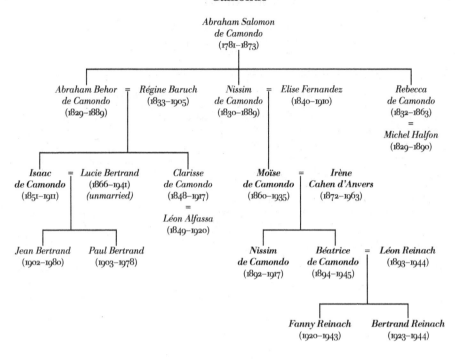

Abraham Salomon
de Camondo
(1781–1873)

Abraham Behor = Régine Baruch Nissim = Elise Fernandez Rebecca
de Camondo (1833–1905) de Camondo (1840–1910) de Camondo
(1829–1889) (1830–1889) (1832–1863)
 =
 Michel Halfon
 (1829–1890)

Isaac = Lucie Bertrand Clarisse Moïse = Irène
de Camondo (1866–1941) de Camondo de Camondo Cahen d'Anvers
(1851–1911) (unmarried) (1848–1917) (1860–1935) (1872–1963)
 =
 Léon Alfassa
 (1849–1920)

Jean Bertrand Paul Bertrand Nissim Béatrice = Léon Reinach
(1902–1980) (1903–1978) de Camondo de Camondo (1893–1944)
 (1892–1917) (1894–1945)

 Fanny Reinach Bertrand Reinach
 (1920–1943) (1923–1944)

Reinach

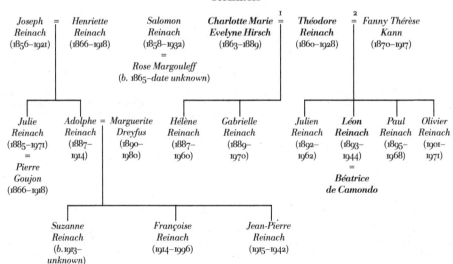

Joseph = Henriette Salomon Charlotte Marie [1] Théodore [2] = Fanny Thérèse
Reinach Reinach Reinach Evelyne Hirsch Reinach Kann
(1856–1921) (1866–1918) (1858–1932) (1863–1889) (1860–1928) (1870–1917)
 =
 Rose Margouleff
 (b. 1865–date unknown)

Julie Adolphe = Marguerite Hélène Gabrielle Julien Léon Paul Olivier
Reinach Reinach Dreyfus Reinach Reinach Reinach Reinach Reinach Reinach
(1885–1971) (1887– (1890– (1887– (1889– (1892– (1893– (1895– (1901–
= 1914) 1980) 1960) 1970) 1962) 1944) 1968) 1971)
Pierre =
Goujon Béatrice
(1866–1918) de Camondo

 Suzanne Françoise Jean-Pierre
 Reinach Reinach Reinach
 (b.1913– (1914–1996) (1915–1942)
 unknown)

Cahen d'Anvers

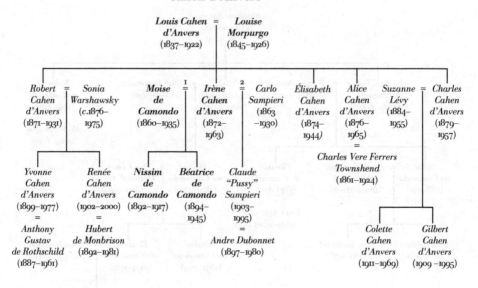

Louis Cahen d'Anvers (1837–1922) = **Louise Morpurgo** (1845–1926)

Robert Cahen d'Anvers (1871–1931) = **Sonia Warshawsky** (c.1876–1975)

Moise de Camondo (1860–1935) =[1] **Irène Cahen d'Anvers** (1872–1963) =[2] **Carlo Sampieri** (1863–1930)

Élisabeth Cahen d'Anvers (1874–1944)

Alice Cahen d'Anvers (1876–1965)

Suzanne Lévy (1884–1955) = **Charles Cahen d'Anvers** (1879–1957)

Charles Vere Ferrers Townshend (1861–1924)

Yvonne Cahen d'Anvers (1899–1977) = **Anthony Gustav de Rothschild** (1887–1961)

Renée Cahen d'Anvers (1902–2000) = **Hubert de Monbrison** (1892–1981)

Nissim de Camondo (1892–1917)

Béatrice de Camondo (1894–1945)

Claude "Pussy" Sampieri (1903–1995) = *Andre Dubonnet* (1897–1980)

Colette Cahen d'Anvers (1911–1969)

Gilbert Cahen d'Anvers (1909–1995)

Rothschild

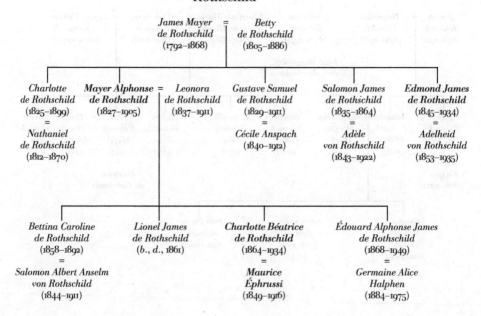

James Mayer de Rothschild (1792–1868) = **Betty de Rothschild** (1805–1886)

Charlotte de Rothschild (1825–1899) = **Nathaniel de Rothschild** (1812–1870)

Mayer Alphonse de Rothschild (1827–1905) = **Leonora de Rothschild** (1837–1911)

Gustave Samuel de Rothschild (1829–1911) = **Cécile Anspach** (1840–1912)

Salomon James de Rothschild (1835–1864) = **Adèle von Rothschild** (1843–1922)

Edmond James de Rothschild (1845–1934) = **Adelheid von Rothschild** (1853–1935)

Bettina Caroline de Rothschild (1858–1892) = **Salomon Albert Anselm von Rothschild** (1844–1911)

Lionel James de Rothschild (b., d., 1861)

Charlotte Béatrice de Rothschild (1864–1934) = **Maurice Éphrussi** (1849–1916)

Édouard Alphonse James de Rothschild (1868–1949) = **Germaine Alice Halphen** (1884–1975)

INTRODUCTION
A LETTER

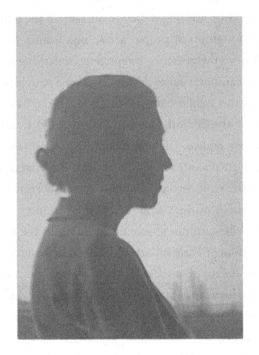

Béatrice de Camondo (1894–1945).

All that remains is the art – the Aubusson tapestries, the Sèvres tureens. When you pass into the courtyard of the Musée Nissim de Camondo, home to one of the world's most exquisite collections of eighteenth-century objets d'art, what you notice first is a pair of marble plaques. The original is grand: unveiled when the place opened in 1936, it commemorates the museum's namesake, Nissim de Camondo, a young man of 25 who died fighting for France in the First World War and whose father, Moïse, a wealthy financier, donated the

family's collection to the nation in honour of his fallen son. The second is smaller, almost an afterthought. Added decades later, it reveals that in 1943 and 1944, a few short years after the museum opened, Béatrice de Camondo, the founder's daughter, her husband, the composer Léon Reinach, and their two teenage children, Fanny and Bertrand, were deported to Auschwitz, where they were all murdered.

Since I first ambled into the museum, the lacunae in this story have bothered me in the way a dripping faucet does – a faint little trickle that becomes a deafening sound. I suppose this is a classic hazard of micro-history: you go on with your life, but while washing dishes or running in the park you find yourself thinking about a group of people whose significance is not immediately obvious but who nevertheless seem to represent something important – albeit what, exactly, you can never quite decide. You keep searching anyway. In my case, after years in the archives, on the top floor of the Musée Camondo, in the reading room of the Bibliothèque nationale de France and in a number of private homes across France, I finally made the acquaintance of a man who knew something of this family's inner life beyond the ledgers of their accounts and the deeds to their properties. His mother had been close to Béatrice in childhood, a neighbour of the Camondos at their country estate in Aumont-en-Halatte. One chilly autumn afternoon in 2019, in the living room of his apartment in the affluent Paris suburb of Neuilly, he handed me a demi-tasse of Nescafé and the dream of any historian: two letters Béatrice had written to his late mother and that he kept in a slant-top desk, one dated 1917 and the other dated September 1942 – exactly three months to the day before her arrest.

By then, I felt I knew Béatrice de Camondo. I had a letter her mother wrote to her and her brother in 1903, when Béatrice was 9, telling them she was leaving their father to marry another man.[1] I had the transcript of an unpublished interview conducted in the early 1980s with a second cousin who alleged both that Béatrice was hard of hearing and that she hated the ancien régime objects that Moïse obsessively collected.[2] I had snapshots of Béatrice taken in 1932 at the second wedding of her half-sister, in which she does not look entirely pleased, and I had listened to rare recordings of a sonata composed by her husband, Léon, in 1925.[3] Most of all, I had a string of letters Béatrice exchanged during the early years of the German

Letter from Béatrice de Camondo to a childhood friend, 5 September 1942.

Occupation with the Commisariat Général aux Questions Juives, the central body charged with imposing the anti-Jewish laws in France.[4] Her main request: to insist that her sequestered accounts still be regularly debited to continue paying the non-Jewish workers her family had employed for decades. She counted them out, one by one. 'To my knowledge, all these people are Aryans, except Madame Tedeschi, who has a blocked account, and Mme Danon,' she wrote.[5]

These traces told me that this was a woman whose story was the lived experience of state antisemitism in occupied France and the failure of French republican universalism. She mattered, I thought, because she was a Jewish victim of the Holocaust who had believed in the mythology of a national enterprise that ultimately saw her as expendable.[6] All of that I still believe. And yet nothing quite prepares you for the moment when you finally hear your elusive subject speak for herself. What you see are her actual ideas and sentiments, and how they diverge from the theories you had spun out of scant archival traces to explain who she was and what she

had represented. What you realize is perhaps something you should have already known, which is how fundamentally inscrutable any other person always is.

Before that chilly afternoon in Neuilly, I was aware that Béatrice de Camondo had converted to Catholicism in July 1942. This was not especially surprising, as a number of other Jews had done the same as a last-minute survival mechanism. There was also what seemed the obvious timing: on the night of 16 July 1942, French police forces arrested more than 13,000 Jews in Paris alone in the infamous 'Vel d'Hiv' round-up. From the traces that survive, it seems most likely that she converted at the parish church of Saint Rémy-de-Vanves and that the priest who baptized her would have been Gaston Fessard, a well-known and vocal crusader against the embrace of Nazism within the French Catholic Church. Given all of this information, I had assumed her conversion was probably a failed attempt at an insurance policy. But reading Béatrice's letter, I realized I knew next to nothing about her at all. As unlikely as it seems, she appears to have been a genuine convert, a possibility I had never considered.[7]

Yet her language leaves little room for any other interpretation. 'And then, more often, I am <u>sure</u> that I am miraculously protected,' she wrote to her friend, a devout Catholic, underscoring her own certainty.[8] She does mention the 'nightmare' of the yellow star, which all Jews over the age of 6 in the occupied zone had been required to wear since May of that year, and she does ask her friend about a mutual acquaintance, Irène de Leusse, née Manheimer, who had only one Jewish grandparent, had been baptized long before, and had married into a prominent family of Catholic diplomats only to be classified as a Jew by Vichy authorities on 13 July 1942.[9] But Béatrice does not seem to entertain the possibility that the same fate could befall her as well.[10] Philippe Pétain, the head of the Vichy government, personally intervened to save only three French Jews, one of whom happened to be a mutual friend of the Camondo: Marie-Louise de Chasseloup Laubat. In photographs that survive, Marie-Louise appears regularly on the hunts and the country weekends that Béatrice obsessively documented in her tattered albums. My sense is that she believed she could eventually arrange the same sort of special exemption for herself and her family, but whether she still thought so as late as September 1942 I do not know.[11]

In any case, imminent danger seemed far from her mind when she sat down to write to her friend. What she describes instead is her anguish over her pending divorce from her husband of twenty-three years, which became official in October 1942, a month after she wrote these lines. According to their divorce settlement, preserved to this day in the Archives de Paris, it turns out that Léon Reinach had been having an affair and that Béatrice could stand it no longer, even in the darkest days of the Occupation.[12] In her letter to her friend, she makes no mention of her frozen accounts, or of the fact that Nazi authorities had already confiscated one of her most prized possessions: Renoir's 1880 portrait of her mother, *Mlle Irène Cahen d'Anvers*, which had by then already passed into the hands of Hermann Göring. 'The divorce is in process, even without me truly knowing whether it's worth it to go to all this trouble,' she reports. 'There are moments where it seems to me that it would have been better not to fight and to take all the blows.'[13]

Her newfound faith, she writes, is what has sustained her: 'I've sensed it for years but only in this last year have I understood from where all this good fortune has come to me. Will I have the years necessary to thank God and the Virgin enough for their protection? I am so little and so low, so unworthy.'[14] She even exhibits a bit of what we might call the convert's zeal. Towards the end of the letter, she concludes that she was delighted to learn that her son, Bertrand, seems to have been convinced by his sister to join the Church as well. 'He seems such a rebel, so forcibly an atheist, that I cannot believe he wrote to me that he thinks all this would do him a lot of good,' Béatrice wrote. 'Even if his light is pale, it would be better than darkness.'[15]

In the end, how Béatrice de Camondo understood herself was entirely beside the point. Police records show that she and Fanny were arrested in their apartment overlooking the Bois de Boulogne sometime on 6 December 1942. Bertrand and his father, Léon, were arrested early in 1943, trying to escape across the Spanish border. All four were interned in Drancy, the concentration camp on the northern outskirts of Paris, where Béatrice, according to the camp's archives, was charged with nursing duties throughout her unusually long imprisonment – fifteen months in gruelling conditions. In the end, all four were deported to Auschwitz: Léon, Bertrand, and Fanny on 20 November 1943 on convoy 62, and Béatrice on 7 March 1944 on convoy

69. She was murdered in Auschwitz on 4 January 1945 – two weeks before the Soviet Army liberated the camp.

This is only how the story ends, and the ending has always overshadowed the beginning and the middle. Béatrice de Camondo and her milieu represented a complicated, nuanced, and profoundly human world almost entirely destroyed by the ruptures of the twentieth century. When we remember the people from that world today, we tend to remember them in the monolithic category of 'victims'. But they were so much more before they were ever that, and, in any case, we have no excuse to think of them only in those terms. As it happens, this particular élite left behind considerable traces of the multifaceted, contradictory people they had been. These traces come in the form of their art collections, which many of them ultimately bequeathed to the French state before the Second World War as tokens of appreciation, and which largely remain intact. These collections function as self-portraits[16] that afford a rich potential for interpreting how a milieu, to borrow from the historian Robert Darnton, 'construed the world, invested it with meaning, and infused it with emotion'.[17]

Understanding this world and the people who comprised it is key to understanding one of the central and unresolved dilemmas in modern French history: the place of minority communities in a society of 'universal' citizens (at least in theory) that emerged from the French Revolution. Most of the characters in this book came from a cosmopolitan Jewish world with relations across Europe and the Mediterranean, although they had vastly different relationships to Jewish identity, and sometimes no Jewish identity at all. But, despite their cosmopolitan origins, they all played leading roles in French public life, and they were committed French citizens – deputies in France's parliament, the heads of some of its largest banks, and the philanthropists who endowed its most beloved cultural institutions. At the same time, they were among the most important stewards of France's Jewish community, the leaders of the country's central Jewish organizations and the careful architects of an identity that sought to present Frenchness and Jewishness as symbiotic, and perhaps even as natural extensions of each other. This was the sensibility of what in France was once called the 'israélite', the Jewish citizen who embraced the French republic with a fervent passion and for whom Jewishness was merely a fact of life, no longer something for which to apologize.[18] The israélite

was a model citizen, proud of their heritage but perhaps even prouder of the nation to which they felt indebted.

During the Revolution, France became the first European state to 'emancipate' its Jews, but this was an emancipation that in the decades that followed sought to redefine the notion of Jewish particularity, although never quite as a quid pro quo. 'To the Jews as a nation, nothing; to the Jews as individuals, everything.' So reads the famous declaration of Clermont-Tonnere from 1791. But throughout the long nineteenth century, different iterations of antisemitism undermined the promise of assimilation. By the fin de siècle, a century after 'emancipation', this was the painful reality for even the most elite French Jews, for whom the Dreyfus Affair was a reminder that French society had never quite seen the *israélite* as the *israélite* saw themself. There were always impermeable barriers, dividing lines that blocked not so much what successful French Jews could achieve professionally but the kind of lived experiences they could aspire to personally. The writer Marcel Proust captures this perfectly in the first volume of *À la recherche du temps perdu*, when the narrator, Marcel, recalls how every time he invited a Jewish friend home from school, his grandfather would hum certain tunes. 'These little eccentricities on my grandfather's part implied no ill-will whatsoever towards my friends,' Marcel observes, unconvinced even by his own reassurance. Proust himself came from this milieu and was a regular guest at the homes of these families; his inimitable protagonist, the Jewish collector Charles Swann, was an amalgam of several of the real-life characters in this book.[19] All of them lived their lives to the sound of that hummed and hateful music.

The collections they left behind are testimonies to the specific people they were but also to the proud identity this milieu sought to build – Jewish and French, particular and universal. Granted, in the commoditized fin de siècle, Jews were far from the only elites who embraced collecting as a bourgeois sport and pastime, and nor were they necessarily unique in terms of the particular items they sought. But, for them, collecting bore special significance. As numerous archival materials show, in the wake of various personal tragedies and in the midst of a vocal antisemitism that reached a fever pitch during the Dreyfus Affair, the objects they arranged and the homes they designed provided a profound sense of solace and sanctuary. In the private spaces they created,

they had total control and absolute authority, a security they never enjoyed in the outside world.

In their public lives, material culture was perhaps even more important. In the age of the salon, the barrier between public and private was never a fixed one, and it was through the projection of their collections that members of this French-Jewish establishment sought to present themselves and their values to the world. The relationship of Jews to art collecting is an admittedly vast and sprawling subject, and there are several well-known French collectors whose stories I will not tell here. But this is merely because I have chosen to explore the milieu whose members left their collections to the state, as a means of shaping its cultural legacy.

They may have sought to do so in different ways – and with different politics in mind – but each of these collections was a profound statement, a love letter to France and a subtle attempt to write Jews into France's *roman national*, or national narrative. Those Jewish chapters remain today, even if the families that left them behind do not. The terrible end of the story should obscure neither the bravery nor the beauty of what they built together, even if that edifice turned out to be a house of fragile things.

To collect is to create. Collectors do not so much arrange or even possess objects as transform them. In a collection, each object becomes an artefact, something entirely different from what it was before, and an object's meaning changes when it finds a new home in a new place among other objects and in the possession of a person who desires it. Its value shifts, and so does its context. It is no longer just a 'thing': it is a metaphor, a material embodiment of something important to the collector – a childhood memory, perhaps, or, as is often the case, a particular chapter of history that the collector wishes to restore. Few understood this better than Walter Benjamin, an impassioned collector of books. 'The most profound enchantment for the collector', he wrote in a 1931 essay, 'is the locking of individual items within a magic circle in which they are fixed as the final thrill, the thrill of acquisition, passes over them.'[20] In the lines that followed, he even compared an object's acquisition to its 'rebirth'.[21] Yet what collectors create is not merely the 'magic circle' of trans-

8

formed, reborn objects that Benjamin describes. What collectors create are themselves.

Traditionally, studies of collecting have examined specific collections. It is well known, for instance, that Richard Seymour-Conway (1800–70), the Marquess of Hertford, built one of the most impressive collections of Old Masters and Dutch art in modern history and that the socialite Peggy Guggenheim (1898–1979) did much the same with abstract expressionism in the mid-twentieth century. But much is lost when we merely ask what people collect without asking why. What stories were these collectors telling about themselves and about their worlds? Collecting is not only a matter of material consumption. It is also a question of identity construction and, as such, of individual psychology.

This psychological motivation has characterized almost every memorable depiction of collectors in literature, especially in the literature of France's long nineteenth century. There, collecting appears as a veritable disorder. Proust's Swann, Balzac's Sylvain Pons, and Huysmans's Jean des Ésseintes are all presented as victims of an insatiable material affliction, the obsessive compulsion to collect.[22] This was true across the Atlantic world. Henry James, the expatriate American novelist, observed much the same in *The American*, his 1877 portrait of Christopher Newman, an American businessman in search of European grandeur. When Christopher buys his first picture, James writes, he encounters 'the germ of the mania of "the collector"' and is convinced that collecting is 'a fascinating pursuit'. The purchase is indeed a 'germ', the first sign of an inevitable addiction to come. As James continues, Christopher 'had taken the first step; why should he not go on?'[23]

In more recent years, this psychological – and perhaps even pathological – aspect of collecting has made its way into academic studies of this bizarre human tendency.[24] Susan Stewart's 1993 study, for instance, is well encapsulated by her title, *On Longing*. In her view, collecting is a deliberate, personal withdrawal into a nostalgic past: 'The collection', she wrote, 'seeks a form of self-enclosure.'[25] But if collecting is primarily a function of individual psychology, it is also profoundly social and often political. Collecting may be an act of self-fashioning, but this is ultimately a self-fashioning rendered through objects whose availability, value, and meaning are all determined by external social factors beyond individual psychology.[26] Individuals are also not the only ones who collect: institutions such as museums, universities, and

governments do as well. If collecting affords private solace, it also provides significant potential for projecting a public image, even for individuals.[27]

For historians, collections can be invaluable sources in teasing out how and why people understand themselves and their worlds as they do. Objects, after all, can sometimes surpass the insights of texts.[28] They have histories of their own, but they also attract consumers for a host of intimate, cultural, and political reasons. Yet in the writing of history, material culture has not fared particularly well. As Leora Auslander observed as recently as 2005: 'Historians are, by profession, suspicious of things.'[29] In the same essay, Auslander sounded something of a clarion call for the historical discipline, emphatically defending objects and things as source materials. Most suggestive, however, were her lines on the ways in which objects often go beyond the boundaries of language:

> people's relation to language is not the same as their relation to things; all that they express through their creation and use of material objects is, furthermore, not reducible to words. That particular relation to things means that even highly literate people in logocentric societies continue to use objects for a crucial part of their emotional, sensual, representational, and communicative expression. Artifacts, therefore, are differently informative than texts even when texts are available; texts, in fact, sometimes obscure the meanings borne by material culture.[30]

The French-Jewish establishment during the fraught years between Dreyfus and Vichy was nothing if not a highly literate society. But, in the end, the texts that these highly literate people produced reveal only so much. In some cases, members of their ranks were astonishingly prolific, writing histories, academic articles, newspaper editorials, and art criticism. Although these remain crucial sources, they were not always their most intimate attempts at self-expression. But material culture often was, and it is the objects they amassed and the collections that they created that have survived into the present. Long after the destruction of their world, collections have proved their most enduring legacy.

This book explores two generations of a Parisian elite to probe how their inner lives were expressed in language of art. This was a true 'cousinhood' of interconnected Jewish families who lived together in the same exclusive section of Paris around the Parc Monceau, whose children married each other, and who in some cases were the stewards of French-Jewish communal life during a moment of unprecedented crisis.[31] My aim is to show how central art collecting was to the social experience of this elite, in public and in private. Between the mid-1880s and 1940, a period during which antisemitism reached a fever pitch and often targeted these prominent individuals personally, each of the families I consider amassed an extensive art collection that they ultimately bequeathed to the French state in the 1920s and 1930s. It is not a coincidence that a number of the most important art collections amassed in the history of modern France emerged from precisely this same tightly knit milieu in the years between the Dreyfus Affair and the emergence of the Vichy government.

The house that the Camondos left behind on the rue de Monceau was hardly the only one of its kind. The politician and well-known academic Théodore Reinach (1860–1928) – whose son, Léon, married Béatrice de Camondo, and who had been the Camondo's neighbour in Paris for years – left his Villa Kérylos in Beaulieu-sur-Mer, a painstaking adaptation of a Greek villa at Delos, to the Institut de France. Kérylos opened to the public after the Second World War, during which it had been ransacked by Nazi forces. Directly across the bay from the Reinach house, Béatrice Éphrussi de Rothschild (1864–1934), a cousin of Théodore Reinach's by marriage, did the same with her Italianate villa at Saint-Jean-Cap-Ferrat. She followed in the footsteps of her father, Alphonse de Rothschild (1827–1905), the legendary cultural philanthropist whose numerous bequests brought contemporary art to every corner of France.[32] Louis Cahen d'Anvers (1837–1922) – a patron of Auguste Renoir and whose elder daughter, Irène, married Moïse de Camondo in a ceremony at which Alphonse de Rothschild was a witness – painstakingly restored the seventeenth-century château at Champs-sur-Marne that his son, Charles, donated to the state in 1935. Isaac de Camondo (1851–1911) – Moïse de Camondo's cousin – likewise left an extensive collection of Impressionist paintings and ancien régime objets d'art to the Musée du Louvre in 1911 in a suite of rooms that bore his name, at least for a while. Edmond de Rothschild (1845–1934), the impassioned collector and uncle of Béatrice

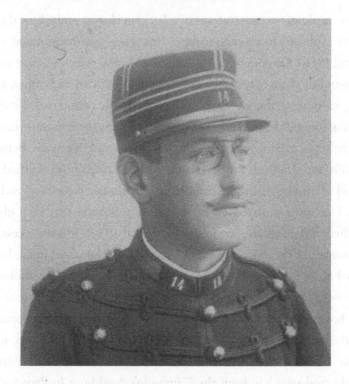

Alfred Dreyfus (1859–1935).

Éphrussi, did the same, leaving France's most important museum with his encyclopaedic collection of some 40,000 prints and drawings.

By examining these collectors as a group, my hope is to advance an already expansive body of scholarship on Jewish life in France between the Dreyfus Affair and the Second World War. Although the conclusion of the Dreyfus Affair ultimately vindicated Alfred Dreyfus (1859–1935), the Jewish military captain wrongfully accused of treason, the end of the unprecedented twelve-year social drama created a changed landscape in French public discourse, which had grown accustomed to an exacerbated nationalism, a predictable xenophobia, and a concomitant antisemitism. By the end of the Affair in 1906, French Jewry, in the most abstract sense, may have been affirmed, but the post-Dreyfus position that the community occupied was ultimately one of uncertainty if not anxiety. As Aron Rodrigue has shown in his analysis of six prominent French-Jewish intellectuals after 1906, the Affair did not necessarily lead to 'the sudden crystallization of new identities' but rather 'gave an impetus to a process of questioning and new identity formation that was to remain in

flux over the next decades'.[33] Both collecting – and, later, cultural philanthropy – played a crucial role in the experience of the French-Jewish elite after the Dreyfus Affair, negotiating an increasingly tenuous social position.

On some level, it is not at all surprising that prominent French Jews would have collected with such passion, and many of their non-Jewish counterparts did the same. They inhabited, after all, the 'capital of the nineteenth century' in the sense that Paris was the continental epicentre of bourgeois fantasy, an urban tableau of displays and department stores and a veritable 'universe of commodities'. As depicted in the literature of the period, the denizens of this city were less citizens than they were consumers,[34] and Paris's transformation in the late nineteenth century relied on radically redefined conceptions of property that knew no bounds.[35] Everything in this environment, it followed, was seemingly for sale – including the coveted watermarks of *la vieille France*, the objects and artworks that had once been the exclusive property of the nobility but that were now available for a wealthy industrial and financial class to purchase at leisure. These haute bourgeois consumers were buying the pedigree of the objects at least as much as the objects themselves: collecting was also aspiration.

Unsurprisingly, the French fin de siècle was a period marked by what the critics and diarists Edmond (1822–96) and Jules Goncourt (1830–70) would denounce as '*bricabracomania*', the desire to accumulate, collect, and possess. Quintessentially bourgeois, this 'mania' afflicted members of the wealthier strata of Parisian and French society in the period, seduced by what Benjamin would later call 'phantasmagorias of the interior'. These, he wrote, 'represented the universe for the private citizen. . . . His drawing-room was a box in the world-theatre.'[36] This willing withdrawal into an illusory alternate reality, a built environment of material things, was a characteristic of bourgeois life in the fin de siècle.

Recent studies, most notably by the historian Tom Stammers, have amply demonstrated how collecting culture flourished throughout the tumult of the French nineteenth century.[37] But for the Jewish collectors of the period, these flights of fancy often had a deeper meaning, as their private correspondence reveals. Their collections were not merely an escape into an aesthetic sanctuary: they were an escape from an increasingly hostile social climate in which antisemitism – and especially an antisemitism expressed in material terms – had become a mainstay in public discourse. Often seen as the nexus between

economic and political power, many of the prominent Jewish collectors, such as the Rothschilds and the Camondos, were attacked constantly in public, and always by name.

This book will seek to show that what I will call 'material antisemitism' was a hallmark of the French fin de siècle. It is rarely remembered that Édouard Drumont (1884–1917), France's so-called 'antisemitic pope', had been an antiquarian prior to writing *La France juive*, his 1886 invective against what he considered to be the Jewish erosion of his beloved nation. As Drumont's biographer, Grégoire Kauffmann, has noted, *La France juive* itself grew out of his earlier material interests, especially his doleful, nostalgic study *Mon vieux Paris: Hommes et choses* (1879).[38] The attacks against Jews in his best-selling and oft-quoted text – as well as in the writings of Léon Daudet, the art criticism of J.K. Huysmans, and the diaries of the Goncourts, among others – have an unmistakably material character. For Drumont, the Jewish crime was primarily the way Jews threatened French cultural patrimony. He loathed when Jews bought pieces that, in his eyes, they, as foreigners, could never understand, and he abhorred when they lived in the historic homes that belonged, for him, to a nation in which Jews could never be anything but external parasites.

Consider, for instance, his pages on Ferrières, the château owned by the Rothschilds outside Paris, which would later become an official site of France's capitulation to Chancellor Otto von Bismarck in 1871 – further evidence, for Drumont, of Jewish disloyalty to the national project. There was also the reality that the Rothschild bank brokered the 5 billion franc indemnity France was made to pay Germany after the war, which for Drumont was another sign of eternal treason. But the way he described the Rothschilds' foreignness was through his evisceration of 'their ordinary bad taste and their lack of sympathy for our French artists'.[39] Just as damaging as their invasion of France was their invasion of its material heritage. As he observed in one room of the house: 'In the middle, like a trophy, there is the incomparable harpsichord of Marie-Antoinette, which is heartbreaking to find in this house of Jews.'[40]

At the same time, French-Jewish elites in the fin de siècle relied on material culture as a means of expressing their fealty to the French national project, at least as they understood it. The aesthetics of everyday life in nineteenth-century France were fundamentally linked to politics:[41] after France's humiliating

defeat in the Franco-Prussian War, for instance, French conservatives embraced the material remnants of the ancien régime as a means of preserving French cultural patrimony in the midst of what they perceived to be a social decline. As Stammers has written, throughout the nineteenth century 'what should be collected, how it should be acquired and by whom remained intensely controversial'.[42] Certain objects became symbols of a fallen nation, their owners the guardians of a dying legacy. In that sense, in France, the ancien régime style came to be seen as a battleground for the control of a nation and its symbols, even if that same style was popular with collectors elsewhere during the same period.[43] The antisemites of the period imbued that style with an exclusive nationalistic significance, and Jewish collectors often seemed to view it as the ultimate gateway to assimilation.

When these collectors donated their collections and their homes to the French state in the 1920s and 1930s, they were some of the most comprehensive collections of eighteenth-century French art. But they were also, as was particularly evident in the Musée Nissim de Camondo, subtle arguments for the compatibility of Frenchness and Jewishness at a time when many sought to present those two identities as mutually exclusive. As Moïse de Camondo wrote in his last will and testament, the museum that would bear his name was intended as a monument to the 'glories of France during the period I have loved most among all others'.[44] At least to some extent, it was through the material lens that this rarefied milieu constructed and articulated their vision of citizenship, in public and in private.

Beginning most likely with Hannah Arendt's *Origins of Totalitarianism* (1951) but continued throughout the general rediscovery of the European Jewish experience in the 1960s,[45] a considerable amount of attention has been paid to French Jews at the time of the Dreyfus Affair. Many of these studies, however, tend to remove their subjects from the context of their times, and French Jews become the embodiments of abstractions – citizenship and assimilation, community and universality. In the aftermath of the Holocaust, the central question in the historiography was, understandably, whether France's Jewish community and especially its leaders were sufficiently forceful in

responding to the antisemitism unleashed during the Dreyfus Affair. The anti-semitism that emerged during the Dreyfus Affair, Arendt argued, amplified in the period following the First World War, took decisive form under Vichy, and culminated in the deportations of some 76,000 French and foreign-born Jews to Nazi camps.[46] Michael Marrus, in the next major study of the subject, *The Politics of Assimilation* (1971), essentially adopted Arendt's view.[47] In subse-quent generations, Arendt's and Marrus's interpretations have been convinc-ingly challenged by historians such as Pierre Birnbaum,[48] Paula Hyman,[49] Nadia Malinovich,[50] Michael Graetz,[51] Lisa Leff,[52] Maurice Samuels,[53] and others who have shown that French Jews of the fin de siècle were actually a stronger community than previously considered, successfully navigating a commitment to French republicanism and the threat of antisemitism.

These illuminating and recent studies have begun to ask crucial questions, among them that of the actual nature of the lived experiences – as Jews and as people – of those so often held accountable for the fate of their community.[54] Rather than asking, once again, what they did and did not do – or what they could and could not have known – how did these individuals understand themselves, their Frenchness and their Jewishness? In which of these categories did they feel themselves to belong most comfortably, at precisely the moment when those categories were mobilized against them? How did they experience antisemitism, not as communal leaders but as real people with inner lives and emotional subjectivities? How, in the early decades of the twentieth century, did they understand the changed nature of their world and, on a personal level, their own places within it? I attempt to answer these questions through the oft-forgotten lens of art collecting, a line of inquiry that requires a return to the specific socio-cultural context of the fin de siècle rather than a departure from it. The characters in this book were not metaphors for abstract concepts. They were individuals who inhabited a certain moment in time, and they matter because of who and what they were, not because of a catastrophe none of them could have foreseen.

This is the power of the Musée Nissim de Camondo, and of all the other collections and houses that this Jewish world left behind – the Château de Champs, the Villa Kérylos, the Villa Île de France. They are sites of memory, places that preserve both the aspiration of their founders and the darkness of what followed. It is impossible to visit any of them without having both in

mind: first the story told by the collectors themselves, and then the inescapable horror of what happened after. Countless other museums tell the story of the Holocaust, whereas these each evoke one particular family in the midst of that nightmare, even if most of them – with the exception of the Musée Camondo – barely mention the wartime experiences of the families at all. The question they inevitably pose is a haunting one, whether it is ever possible to fully grasp one's times or whether we are doomed to misread, misinterpret, and misunderstand.

Moïse de Camondo, after all, left all his worldly goods to the country he loved, the country his son, Nissim, died defending in the First World War and the country that later sentenced his daughter to death. With the benefit of hindsight, it can be tempting to dismiss Moïse as blind, to decry him for failing to read the writing that, at least during his lifetime, was never actually on the wall. It can likewise be tempting to fault Béatrice de Camondo, his daughter, for refusing to leave France or go into hiding when the writing was indeed on the wall: she had the means to escape, and she had two beautiful children who might have led long and fruitful lives. I admit that there were times in reading her correspondence when I had to stop. Up until the very end, she was convinced that what she called 'all this good fortune' would save them all.

Yet to see this milieu as victims of their own blindness is to miss the point entirely, and I have come to believe that what they failed – or refused – to see is the source of their enduring power. There is an undeniable dignity in living according to universalist principles in a time of hateful irrationality, and it was their 'blindness' that ultimately reveals the depth of their commitment to their country and the Jewish roots they planted within it. That 'blindness' is precisely what enabled the beauty of what they built – their collections, but also the multifaceted identities those collections evince, nothing short of daring interventions in a nation where the boundaries of citizenship and belonging remain so fiercely contested. What transpired after their deaths in a world they thought they knew does not in any way diminish their contribution, which was real while it lasted. This is why their collections are more than gilded footnotes in the story of a vanished past. Objects are not people, but in their inanimate bodies they suggest, and in their stillness they preserve.

1

PORTRAITS OF A MILIEU
A JEWISH ELITE IN CRISIS

In late December 1962, the old woman, then 86, welcomed Philippe Jullian into her apartment in the avenue Gabriel, not far from the Champs-Élysées. Lady Alice Townshend, as she was known by then, had written a letter to Jullian, renowned aesthete, art critic, and man-about-town, who had recently published a biography of King Edward VII. As she told him in her letter, she had known the late king during her days as a young bride in late Victorian Britain. Jullian had then asked to meet her, and ended up publishing their conversation in *Le Figaro*.

The journalist soon discovered that Lady Townshend was more than the eccentric widow of Major General Charles Townshend, the British commanding officer who had overseen the doomed Siege of Kut, in modern-day Iraq, in 1915 and 1916, among the most humiliating Allied defeats of the First World War. She was herself a relic of a lost Parisian world and, as it happened, one of two young subjects of a Renoir portrait he remembered, *Rose et bleu*, completed in 1881 but by then already in the collection of the São Paulo Museum of Art. Lady Alice Townshend was born Alice Cahen d'Anvers, the youngest daughter of a Parisian Jewish banking family that had once been at the epicentre of cultural life in the capital. Renoir had also painted her eldest sister, Irène Cahen d'Anvers, in a canvas that was exhibited in the 1880 Salon and celebrated in the prestigious *Gazette des Beaux-Arts*. This had not been enough to satisfy the girls' parents, Louis and Louise Cahen d'Anvers, who never displayed it in a position of prominence.

In any case, both paintings are now testaments to the destruction of a Jewish world at the hands of the Nazi regime and its French collaborators. The other subject depicted in *Rose et bleu* is Alice's elder sister Élisabeth Cahen d'Anvers, who was arrested in Juigné-sur-Sarthe in February 1944 before her

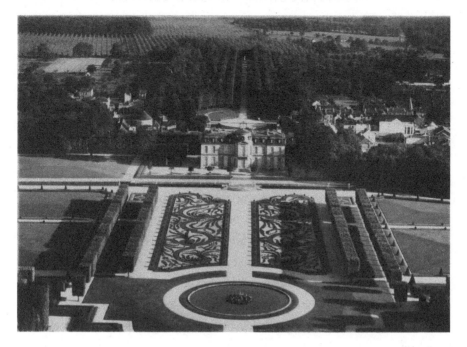

An aerial view of the Château de Champs-sur-Marne, the home of the
Cahen d'Anvers family.

murder in Auschwitz in April of that year, at the age of 69. Alice's eldest sister,
Irène, survived the war, but her niece Béatrice de Camondo, who had carried
her train at her wedding, did not. Irène's portrait, known as 'La Petite Irène',
soon became the evidence of a crime: it had hung in a place of pride in Béatrice's
apartment in Neuilly, and it was ultimately sequestered by the Nazis in 1941,
one of the millions of objects looted from Jewish homes throughout France.
But in the interview Alice gave to Jullian in 1962, all she was willing to say
was a tongue-in-cheek complaint about the bourgeois nature of her upbringing.
'It's me, the smallest one,' she said, laughing about *Rose et bleu*. 'It was
around 1880, when I was five. It annoyed me so much to have to pose, my
only consolation being that I was allowed to wear an Irish lace dress that I so
loved.'[1]

From the article he published, it was clear that Lady Townshend
had charmed Jullian, and his write-up reflects a considerable nostalgia for
what he decided she represented: a certain ideal of Edwardian grace. 'The dog
barks – it's time for a stroll,' he concluded. 'In five minutes, the passerby on
the avenue Gabriel, passing this very little lady, will have no idea that she

19

was the most beautiful model of Renoir, one of the ravishing women at the court of Edward VII, and the wife of a hero.'[2] Alice Townshend was indeed all of those things. But, like her sisters, she was a product of a Jewish elite that was already crumbling from within – decades before the Nazi Occupation and the horrors of the Holocaust. By 1962, she was a rare emblem of what others in her milieu might have become had they, too, managed to live long lives free of the identity categories that had shattered their cosmopolitan world after the rise of Nazism and the imposition of state antisemitism. With an Anglican baptism and a seat at the British court, Alice's trajectory would not have pleased the majority of her Jewish forebears and their peers, although they had certainly all been well aware of this drift away from tradition decades before. Countering that trend was among the reasons these Jewish elites embraced collecting with such a fervour in the fin de siècle and the early decades of the twentieth century: collecting was a means of taking back control in a changing world, however imagined that control may have been.

The late nineteenth century – in Europe in general but especially in France – was something of a golden age for the sale and purchase of fine art and objets d'art available for the first time in a newly created market that had emerged from the dissolution of private collections that for generations had been the exclusive province of the nobility. Facilitated by a network of Paris- and London-based dealers – including Joseph Duveen (1867–1939), Nathan Wildenstein (1851–1934), Jacques Seligmann (1858–1923), Daniel-Henry Kahnweiler (1884–1979), and Paul (1881–1951) and Léonce Rosenberg (1879–1947), among others – art collecting, especially of pieces with a noble provenance and history, became an important preoccupation and pastime for an upwardly mobile financial and industrial haute bourgeoisie.[3] In that regard, Jewish elites were hardly unique, but collecting is not merely a question of public presentation. It also corresponds to something deep and intimate in the social psychology of the collector, and a number of the prominent Jewish collectors in the Third Republic – many of whom were political conservatives, religiously observant and family patriarchs – found themselves in a world they no longer understood and in which their authority, even within the spheres of their own families, had dwindled almost to the point of insignificance.

In the France of the Dreyfus Affair and its immediate aftermath, there was the constant spectre of antisemitism whose exponents hounded many of the collectors in public and by name. But any number of devastating ruptures and humiliations marked their private lives. In the fin de siècle and in the early decades of the twentieth century, theirs was without question a world with clear boundaries and interwoven family ties. But this same elite was also a milieu that was becoming significantly less Jewish, as a result of intermarriage, conversion, and, perhaps most of all, children abandoning traditional gender roles and the social conventions of their parents' generation. On an interpersonal level, many of the collectors' lives were also uprooted by personal tragedies that included the infidelities of spouses, acrimonious divorces, and the deaths of their children. This experience of communal fracture united each of these prominent collectors at precisely the moment when they amassed their collections. For some of them, collecting was a means of withdrawal, an escape into an alternate reality where they could order objects in the way they could never quite order the chaos of their lives.

During the early decades of the twentieth century, significant changes occurred in the communal fabric of French-Jewish life. Although intricately connected, these changes were not entirely the consequence of the Dreyfus Affair or the exacerbated antisemitism that the affair had elicited. Rather, they were much larger: demographic and structural shifts that not only challenged the carefully cultivated social position of the nineteenth-century *israélite* but, on a more fundamental level, altered the composure and the identity of French Jewry itself. The waves of immigration that had begun in the 1880s – mostly of Jews from Eastern Europe – increased after the turn of the century: between 1906 and 1939, roughly 150,000 to 200,000 foreign Jews settled in France, more than doubling the nation's extant Jewish population of 110,000.[4]

This was not merely a staggering change in numbers. Although there was a small degree of diversity among this immigrant population – some of whom hailed from Ottoman territories or from North Africa – the vast majority came from Jewish communities in East Europe that were far more religiously observant than many of their French counterparts and tended to be working class.[5]

The paradigm of Jewish life that these newcomers embodied was thus the diametric opposite of that which their more elite French counterparts had so painstakingly fashioned over the course of the nineteenth century, a model that encouraged assimilation and that, to borrow Pierre Birnbaum's famous phrase, made French Jews the *fous de la République* ('crazy for the Republic'). Many of France's 'new Jews' were less enamoured with France than with Zionism or Jewish labour movements, and more enamoured with Jewish communal life than with French citizenship. This presented the French-Jewish establishment with something of a crisis, an existential threat to their 'integrationist model' for reconciling Jewishness with the universalizing logic of the French republic.[6]

But this external, structural crisis in French-Jewish communal life developed either in tandem or in conjunction with a decidedly internal, intimate crisis facing the more elite factions of French-Jewish society, especially with regard to their younger generations. Indeed, between the time of the Dreyfus Affair and the outbreak of the Second World War, the French-Jewish establishment was not merely concerned with advocating a specific image of Jewish life against an alternative image that had proved increasingly popular: it was also charged with convincing some of its own, enabled and emancipated, to continue living distinctively Jewish lives amidst an increasingly secular modernity.

This is not at all to say that Jewish elites in the late nineteenth and early twentieth centuries were crippled by the age-old anxiety that, as expressed in an old Yiddish saying, *Frankraykh frest yidn* ('France devours Jews'). Throughout the course of the Dreyfus Affair, most of these elites never abandoned their Jewish identities, even as they attempted to carve out a place for themselves in mainstream French society.[7] And these Jewish identities assumed a variety of meanings, personal and public alike.[8] But if these elites and their children still mostly married other Jews from a similar social caste, nominally belonged to synagogues (mostly to Paris's Grande Synagogue in the rue de la Victoire), and participated in Jewish communal leadership and philanthropic organizations, whether through the Consistoire central israélite de la France or the Alliance israélite universelle, their milieu suffered not so much from a diminished engagement with institutional Judaism but rather from a dwindling sense of its importance in their private lives.

In a number of elite families, Jewishness had become normalized almost to the point of irrelevance – what Hannah Arendt would later call an 'indisputable

fact' of life.[9] In many cases, there was a significant erosion not of their public affiliation with Judaism but – on a personal, intimate level – of their desire to maintain religiously observant Jewish lives. Between the French Revolution and the Second World War, hundreds of thousands of Jews across Europe 'left the Jewish fold', although mostly for pragmatic reasons instead of religious conviction, as the historian Todd Endelman has shown.[10] Granted, throughout the nineteenth century, not all that many French Jews formally renounced their Judaism, presumably because they had less to gain from it: only about a thousand converted to Catholicism between 1807 and 1914, although conversion was more common in the more elite social stratum of the collectors and their peers.[11] But conversion rates are not the only indicator of a Jewish world becoming less religiously or communally Jewish: intermarriage and the abandonment of traditional family structures were also increasingly prevalent, as was the fact that growing numbers in this elite, especially among its younger generations, gradually ceased to think of themselves as 'Jewish' in any significant way.[12]

Perhaps most importantly, there was a significantly gendered dimension to this private communal crisis. The French fin de siècle bore witness to a 'New Woman', an independent and often even professional character who was 'profoundly subversive' with regard to traditional societal mores.[13] Women in the tightly stitched network of elite Jewish families, of course, were rarely professionals, but they nevertheless began to 'act up' against the strict gender roles they perceived to be imposed on them both by bourgeois mores and, in a small number of instances, by the Jewish religion. Relying on their considerable financial resources, they began to emancipate themselves into a world where their lives would be arbitrated by no laws except those of their own creation. By contrast, many of the men in this network were shocked by their wives and daughters who began to 'act up', and their reactions were often characterized by feelings of abandonment, betrayal, and, perhaps above all, a loss of control. At least in part, the significant collections these men amassed during the same period when these intimate familial ruptures occurred can be seen as responses: objects and spaces can be ordered and controlled when people cannot.

The story of the Cahen d'Anvers women – whose various trajectories were the threads that ultimately wove their extended network together – is an almost perfect microcosm of this larger social transformation. Irène Cahen d'Anvers divorced Moïse de Camondo in 1903, converting to Catholicism to marry

Carlo Sampieri, a self-styled Franco-Italian aristocrat. Her sisters both married non-Jews: Alice only once, to Major General Sir Charles Townshend (1861–1924), but Élisabeth twice, first in 1896 to the Catholic Jean de Forceville, whom she divorced in 1901, and, second, in 1904, to the Protestant Alfred Emile Louis Denfert-Rochereau, a grandson of the celebrated 'Lion of Belfort' during the Franco-Prussian War. She ultimately divorced Denfert-Rochereau as well. In 1904, Béatrice de Rothschild separated from her husband, Maurice Éphrussi, after his gambling debts significantly diminished their fortune and his infidelities led her to contract syphilis, leaving her unable to bear children.[14]

That familial fracture continued in future generations: Irène's son, Nissim de Camondo, took for a lover a Catholic woman, Renée-Marguerite-Fernande Tétu (1891–1971), much to his father's chagrin.[15] And Irène's daughter, Béatrice de Camondo, divorced her husband, Léon Reinach, in 1942, two months before her arrest. In some families – notably the Reinachs and Rothschilds – the laws of tradition still reigned supreme, but there is significant evidence that their sons and daughters were losing interest in maintaining the communities their forebears had worked so tirelessly to defend and protect.

In theory, Joseph Reinach, the principal defender of Alfred Dreyfus, would have married a non-Jewish Englishwoman had not '*le Gouvernement*' – as he jokingly referred to his family – intervened. 'If the Gvt were intelligent, I would be married in a month to a ravishing, cultivated and intelligent English girl, a remarkable painter, from the best family, and rich . . . The young girl in question is a Protestant but would accept a civil marriage. Oh! The Jews!'[16] His niece, Hélène Reinach-Abrami, the future sister-in-law of Béatrice de Camondo, never converted but later distanced herself from Judaism, or at least her family's interpretation of it, which she saw as hostile to women.

Most importantly, some of these women came to see the compulsive collecting habits of their fathers and grandfathers as a clear means of asserting some kind of gendered control. For the aesthetes many of these men were, their collections were private spaces in which they could indulge their respective fantasies of beauty and perfection, no doubt informed by their interiorities and individual sexualities. But those fantasies were often articulated with a certain ideal of feminine perfection that sometimes spilled over into family life: collectors in this milieu often sought to transform their wives and daughters into art objects to be possessed and displayed like the other objects in their

collections. With each passing generation, women increasingly rebelled against those attempts.

This tension is well conveyed, for instance, in the privately published memoirs of Hélène Fould-Springer, the granddaughter of Léon Fould and Thérèse Éphrussi – herself a Renoir subject[17] and a cousin of Charles Éphrussi – who were major collectors of ancien régime objets d'art at the château they maintained in Royaumont outside Paris. Writing in the mid-1990s, Hélène, who had likewise abandoned Judaism entirely, having married a Catholic in 1929 and officially converted to Catholicism during the Second World War, recalled nearly seventy years later the almost sensual nature of her grandfather's relationship to the objects he collected in the 1910s and 1920s:

> Bonpapa was the living image of a grandfather of those days. He had lovely smiling blue eyes, a pink-coloured complexion and very soft white whiskers that curled round his cheeks. He was a great connoisseur of old china, porcelain and *objets d'art*. A few days before the New Year, he used to go and visit what he called '*mes petites amies*' meaning his art dealers. He would buy himself a gift – a cup and saucer or a Buddha or a vase or something. When he got home again, he would take a small step ladder, place his newly acquired treasure, still all wrapped up, on the top of the cupboard, right at the back. Then, on the first of January, he would take down a parcel from the top of the cupboard and produce this 'surprise'. The surprise was actually whatever he had bought himself the year before and of course he really had forgotten what it was. My brother and I often watched him unwrap the 'surprise'. Holding it with great care and love and a sweet smile on his face, he would say: '*Quel goût! Comme c'est joli!*' Even when he was going blind, he used to touch and feel the quality of a piece of china with the tips of his old fingers.[18]

That Fould referred to his art dealers as '*petites amies*', a French expression for mistresses, suggests the gendered – and even sexual – persona that collectors could ascribe to the art objects they pursued, objects they would then unwrap at a careful, tantalizing pace, all for the sake of preserving the 'surprise' within.[19] The object, in a sense, becomes an iteration of a body, often a female body, whose sole purpose is to provide the pleasure of possession. Most of the women

in this elite, at least through the end of the fin-de-siècle period, remained inscribed within a deliberately cultivated aesthetic that essentialized their femininity at the same time as it denied them their individual autonomy.

In a certain sense, a number of particular works of art – especially the portraits of wives and daughters that nearly that every single family in this milieu commissioned – evince the gendered mores of their community as a whole, while the consistency with which many (male) collectors saw art objects as feminine suggests the extent to which those mores were deliberately maintained. But that worldview was changing and in fact may have already been an artefact. Collecting was ultimately futile in preserving an image of the world as it once was, or rather as it might have been, although it could at least provide illusions of power. For some, that may even have been the point: in the face of numerous personal embarrassments and familial ruptures, those illusions proved sustaining. The image of a blind Léon Fould caressing his *bibelots* is a powerful one. What it reveals is the fragility of his solace.

On 14 September 1881, Lazare Isidor (1818–88), then the Grand Rabbin de France, and Zadoc Kahn (1839–1905), then the Grand Rabbin de Paris but soon to succeed Isidore on the national stage,[20] delivered orations at the funeral of Meyer Joseph Cahen d'Anvers (1804–81), the patriarch of one of France's most prominent banking families and a celebrated patron of the arts.

It was in Meyer Joseph's household that the future collector Louis Cahen d'Anvers was introduced to the ancien régime aesthetic that would later inform the collections he amassed with his wife, Louise Morpurgo, in their homes at 2, rue Bassano in Paris and in the Château de Champs-sur-Marne outside the city. In addition to what the two rabbis called his 'feeling for beautiful things, the taste for art productions',[21] Isidor praised Cahen d'Anvers for his fidelity to the Jewish people: 'He was a Jew of the heart, an enlightened Jew,' he said. '*Ah, messieurs*, it is the characteristic of great souls to remember their origin, and, far from denying it, to stay faithful to it and be proud of it!'[22] Zadoc Kahn – later to become the chief spiritual adviser of many of the collectors and other members of their extended milieu – then eulogized Cahen d'Anvers as an exemplar of traditional Jewish family life:

But what he was above all else, above all, was a worthy child of Judaism and a family man. His house was a patriarchal house, his interior a model interior. There, surrounded by his wife, his children, and these young generations who grew up around him, he felt truly happy – joy overflowed from his heart, and he thanked God for all his favours. God had given him as a companion a holy and noble woman, a model of all virtues, who was the charm of his existence and the ornament of his home.[23]

The traditional image of family life Kahn offered is as clear in its consideration of gender roles as it is predictable: the ideal home is a 'patriarchal house' in which women and children are mere extensions of men, who are both the centre and the foundation of these structures. But what is particularly significant is that Kahn ultimately articulated the woman's place in this haut bourgeois cosmology with the language of art: 'God had given him as a companion a holy and noble woman, a model of all virtues, who was the charm of his existence and the ornament of his home.' A woman who existed in the social world of the Cahen d'Anvers and their peers, it follows, was not merely a passive object but an art object, to be admired and to remain, in relation to a male spouse, merely a decorative embellishment.

Kahn's words were more than rhetorical flourish: at the time of Cahen d'Anvers's death, the women who belonged to this particular 'patriarchal house' – even those among its younger generations – quite literally adorned the foyers of their fathers and grandfathers, their images reduced and stylized into feminized portraits by leading artists of the day, such as Carolus-Duran (1837–1917), Léon Bonnat (1833–1922) and Pierre-Auguste Renoir (1841–1919). These portraits[24] – each commissioned and painted by men – as well as their placements in respective family homes, mostly in prominent public spaces, suggest the way in which the Cahen d'Anvers men and their contemporaries relied on a certain aesthetic as a means of enforcing a gendered control over the women in their family's milieu. In these portraits, mostly from the 1870s and 1880s, women were often idealized, fashioned into art objects to be possessed and displayed.[25] In the early decades of the twentieth century, then, it was precisely this aesthetic that women rejected when they abandoned the traditional strictures of haut bourgeois Jewish society for lives of their own designs.

27

By the fin de siècle, this feminized idealization – which the art historian Debora Silverman has called 'the celebration of female fecundity and decorative domestic intimacy'[26] – already had antecedents among the Jewish elite, most notably Ingres's beguiling 1848 portrait of Betty de Rothschild (1805–86), which blended the beauty of its sitter with obvious signs of material wealth – the red velvet sofa, the pink satin gown.[27] Much the same would characterize the eventual representation of Louise de Morpurgo (1845–1926), the Italian-born wife of Louis Cahen d'Anvers, with whom she had five children: Robert (1871–1931), Irène (1872–1963), Élisabeth (1874–1944), Alice (1876–1965), and Charles (1879–1957). The daughter of a wealthy Jewish merchant family from Trieste via Vienna, Louise was known for her delicate, Meissen-like beauty, which became, both for admirers and critics of the Cahen d'Anvers and their gilded, ostentatious lifestyle in the rue Bassano and at the Château de Champs-sur-Marne, the only relevant aspect of her personhood.

Perhaps the best example of this sentiment appears in the recollections of Edmond and Jules Goncourt, who seemed to have crossed paths with Louise frequently in the salons of the 1880s and 1890s. Not without a considerable degree of antisemitism, the brothers made the following observation of their hostess in an entry from February 1880:

> Jewesses keep, from their Eastern origins, a particular nonchalance. Today, I followed with a charmed eye the lazy cat movements with which Mrs. Louise Cahen fished her porcelain and lacquer-ware out from the bottom of her vitrine, to put them in my hand. When Jewesses are blonde, there is gold at the base of their blondeness, like in the painting of Titian's mistress. When the examination was finished, the Jewess collapsed into a lounge chair, her head skewed to the side, revealing at the top a mane of winding hair that resembled a snake's nest. She indolently complained, asking all kinds of amusing questions with the tip of her nose, about this demand from men and novelists that women not be fully human and that they could not experience love in the same way, with the same weariness and the same disgust, as men.[28]

The Goncourts' remarks are significant only in that they provide a sense of how Louise, as a woman and a Jew, was seen by her contemporaries – as a *lazy cat* in decadent splendour. Perhaps most importantly, the Goncourts depict her as

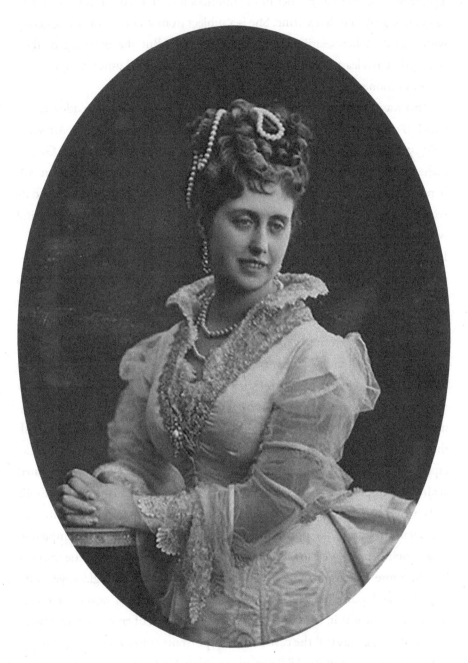

Louise Cahen d'Anvers (1845–1926).

a piece of art akin to any other of the innumerable objets d'art, porcelain, and lacquer, displayed in her vitrine. She is a subject from a Titian canvas, especially with regard to her seemingly exotic blonde hair. But the meaning of their description is clear: the Goncourts ultimately describe Louise as 'gold', the colour of money.

This was a version of the same feminine ideal enunciated by Zadoc Kahn, which is also what Louise's own family cherished most about her. In *Mémoires d'un optimiste*, a memoir he self-published in 1994, her grandson Gilbert Cahen d'Anvers recalled the nature of his grandparents' marriage. He remembered his grandfather, Louis, as having a 'very authoritarian character'. And he recalled Louise – apparently known as Florentine in the family – as 'a beautiful woman with red hair and terribly spoiled, who was adored by all the family'.[29] In another Cahen d'Anvers family memoir that was never published, another of Louise's great-granddaughters, Lorraine Dubonnet, celebrated her beauty as a source of pride, and even a family legacy. Describing her own mother, she even appeared to use the Goncourt's metaphor: 'The long Titian Venetian blond hair she got from her mother', Dubonnet wrote wistfully.[30]

As it does in Renoir's portraits of her daughters – Irène in 1880 and Alice and Élisabeth together in 1881 – this same idealization of feminine beauty manifests itself in Louise's portrait by Carolus-Duran from the 1870s, even if it was Louise herself who commissioned these portraits. Partly in keeping with the style of the times and the predominant aesthetic of the Third Republic, especially in terms of portraiture, Carolus-Duran depicted his subject seated against an imperious black background in precisely the manner that Émile Zola would later attack in his treatise on contemporary art and its potential for regeneration. In the 'old' portraiture, Zola insisted, artists merely attempted to please their sitters. 'We can even say that their great aim is to erase the traces of life,' he wrote. 'Their portraits are of shadows, pale figures with glass eyes, with satin lips and porcelain cheeks.'[31] And so Louise appears, again a piece of porcelain as she was in the Goncourts' account, devoid of emotion and vitality.

Of course, it was still the case that most portraits commissioned by elites in the 1860s, and even in the 1870s, were completed in the more academic, pedagogical template that Carolus-Duran employed in his rendition of Louise.[32] However, compared with many of the male subjects depicted both by Carolus-Duran and Léon Bonnat,[33] a close friend of the Cahen d'Anvers family who

would later paint Louise's sister-in-law, Madame Albert Cahen d'Anvers, as well as other members of the family, Louise's portrait emphasizes the opposite of austerity and gravity: it depicts instead an embellished opulence, a woman posing in a regal chair, adorned with a bejewelled tiara and swathed in a sheath of fine black lace. The same can be said of Bonnat's portrait of Louise Warshawsky, who married Albert Cahen d'Anvers (1846–1903), the composer and pianist who himself later sat for Renoir.

Similarly, Bonnat's 1891 canvas presents a full-bodied subject in a seeming void, floating in a timeless ether. As in Carolus-Duran's depiction of her sister-in-law, Louise's gender – rather than her psychology or her emotional interiority – is the portrait's primary emphasis: she is inscribed within the confines of the female body, constricted in crinoline, transformed into a mani-cured ideal of perfection. Her skin has been enhanced to reflect a flawless white pallor, and her femininity accentuated with jewels at each curve in her figure. Like her sister-in-law, she appears less a woman than a female object imagined, rendered, and ultimately consumed by the eyes of men. Portraiture was power: Louise's husband hung Carolus-Duran's portrait of his wife in the octagonal foyer of the Château de Champs-sur-Marne, where it was perhaps a reminder of the role she was meant to play.

From the only traces that survive, Louise appeared to play that role quite well.[34] As her daughter-in-law, Sonia Warshawsky, later recalled in her memoirs, Louise Cahen d'Anvers was an exemplar of feminine grace, careful to maintain the mundane rituals of haut bourgeois life. 'A custom in my day, strictly adhered to, was that a young married woman had to be introduced by her mother-in-law to all the acquaintances of her new family,' Sonia recalled. 'I inwardly prayed that some ailment would prevent them from receiving visitors and that our visiting cards would suffice. Alas, their breathing remained unimpaired, and the ordeal had to be got through.'[35] At any sign of disrespect for these customs, however, Louise would harshly discipline any who dared challenge them. Sonia wrote: 'Once in the horse-drawn brougham with coachman and footman on the box, I was severely reprimanded and asked why I sat so dolefully, never uttering a word! My reply was that I had really nothing to say to people I hardly knew.'

Despite this outward fidelity to social custom, Louise – along with many of the other women in her immediate familial and social milieu – did not maintain the same fidelity to her community, its particular image of family

life, and its vision of a woman's place within that narrative. As it was for other Jewish women across Europe in the late nineteenth century, Louise's identity as a leading *salonnière* was a subtle means of emancipation: 'through the "feminine" arts of personal friendship, conversation, and self-divulgence, these women challenged the restrictions of both mainstream and minority'.[36] It was at the frequent salons she hosted that Louise began to form her own independent relationships with writers such as Marcel Proust and Paul Bourget, with whom she exchanged numerous letters over the span of decades. It was also through those salons that she appears to have begun an extramarital affair.

Louise's affair with the critic and collector Charles Éphrussi, then the editor of the *Gazette des Beaux-Arts*, was a well-known fact in her circle, and elicited a considerable amount of interest and commentary.[37] The Goncourts, for instance, were delighted to mention the extramarital liaisons of the so-called 'lazy cat' whenever they could. As Edmond de Goncourt speculated in October 1878, the couple would often conduct their assignations at the Hôtel Sichel, 'where la Cahen d'Anvers, leaning over a lacquer box that the young Ephrussi had made her admire, whispers to her lover the day when he could come and sleep with her'.[38]

Renoir's portraits of Irène Cahen d'Anvers and her sisters were themselves products of this extramarital dalliance, artefacts of infidelity and family fracture: it was Charles Éphrussi who had counselled the Cahen d'Anvers to commission the up-and-coming artist to paint their young daughters. Largely thanks to Éphrussi, Renoir at this point in his career had begun to accept commissions from a network of predominantly Jewish and Protestant financial elites, including, perhaps most prominently, the Cahen d'Anvers. Renoir himself was an outspoken antisemite and a staunch anti-Dreyfusard. 'They come to France to make money, but the moment a fight is on, they hind behind the first tree,' he wrote of the Jews. 'There are so many in the army because the Jew likes to parade around in fancy uniforms.'[39] At the same time, he acknowledged his dependence on Jewish elites and their financial support, which he deeply resented – and the Cahen d'Anvers in particular. 'As for Cahen's 1500 francs, I have to say I find it stingy,' he wrote to his confidante, the collector Charles Deudon, in 1882.[40] That amount, paid for his portrait of Alice and Élisabeth Cahen d'Anvers, also happened to be the largest sum he ever earned for a single portrait.

But Renoir's personal animus against Jews is nowhere to be seen in the canvases he produced, among the most mesmerizing in his oeuvre. In *Rose et*

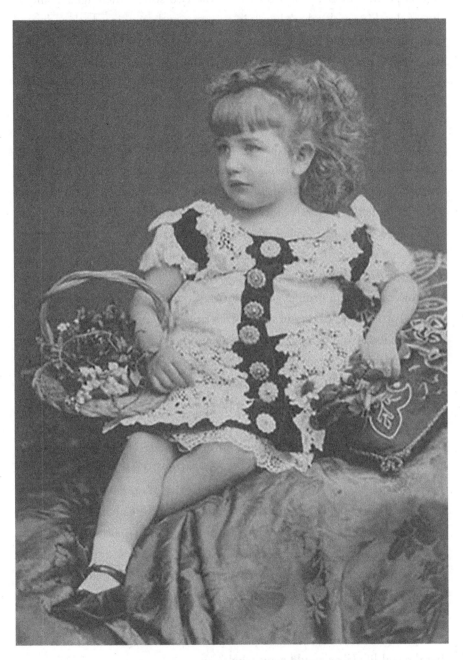

A young Irène Cahen d'Anvers (1872–1963).

bleu (1881), his portrait of Alice and Élisabeth, there are subtle echoes of Ingres's portrait of Betty de Rothschild: the two sisters, then aged 5 and 7, appear clutching each other's hands in a sumptuously appointed salon, dressed in matching pink and blue sashes, already emblems of the same feminine ideal evinced in Carolus-Duran's portrait of their mother. Alice, in pink, appears on the verge of tears, her eyes glassy orbs; Élisabeth, in blue, regards the viewer with an almost palpable anxiety, her free hand pinching the lace of her dress. 'Renoir's great achievement here', according to the art historian Ann Dumas, 'is to preserve, despite the formality of setting and dress, the little girls' freshness and their particularly childish mixture of excitement and shyness.'[41] Yet the girls can never quite transcend their affluent context – the rich red velvet behind Élisabeth, the embroidered tapestry behind Alice. And there is no escaping the portrait's psychological depth: the exquisitely rendered faces of the girls are registers of a certain unease, almost of pain.

In *Mlle Irène Cahen d'Anvers* (1880), Renoir's depiction is less emotive, and his subject appears in profile, gazing outward beyond the left boundary of the canvas. Particularly striking in the portrait of the 8-year-old Irène, however, is her hair, auburn and ochre, strewn across her body as if in a kind of veil. Her hair blends into the green foliage of the garden in which she sits, rendering the portrait's most significant contrast that between her face, pristine and seemingly lacquered, and its surroundings, raw and natural. In a certain sense, her face is framed within the existing dimensional frame of the canvas, fixed in a position that does not allow her to confront the gaze of the viewer. Charles Éphrussi included an etching of Irène's portrait in the autumn 1881 issue of the *Gazette des Beaux-Arts*, where the vast majority of its viewers encountered it.[42] The canvas remained in the private collection of the Cahen d'Anvers, who apparently hated it and allegedly hung it in the servant's quarters until Louise gave it to her granddaughter, Béatrice de Camondo, as a wedding present. In the etching, the portrait's contrast is even more pronounced, Irène's face transformed into an object viewers regarded – and perhaps even coveted – but with which they did not actively engage. What *Mlle Irène Cahen d'Anvers* depicts is less a young woman than an inescapable passivity. It was against this same ideal that the real-life Irène would soon rebel.

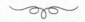

The wedding was a veritable event, on the front page of all the major Paris newspapers and society magazines. On 15 October 1891, Parisian Jewish society gathered at the Grande Synagogue in the rue de la Victoire for the wedding of Irène Cahen d'Anvers to Moïse de Camondo, the heir to a staggering banking fortune. The synagogue was the official seat of France's chief rabbi, a soaring Neoclassical sanctuary adorned with Byzantine flourishes and red velvet upholstery. This was the temple of the so-called '*israélites*', the built embodiment of Franco-Judaism and the synagogue whose members came from the predominantly Ashkenazi elite that formed France's Jewish establishment at the time. The Cahen d'Anvers were key members of that elite, but the Camondos were not – not quite: no Camondo was yet French-born since they had arrived in Paris from Constantinople less than a generation before, and they were much more religiously observant. The wedding would ensure the consolidation of two important banks, but also the social elevation of the Camondos into Parisian society.

The newspapers relished every detail of the ostentatious wealth on display, with a particular interest in what they perceived to be the exotic splendour of the Camondos. The bride, Parisians were told, wore a white satin dress with white lace 'of a fabulous price' that covered her entire train – apparently a gift from her mother, at least according to the society magazine *La Mode de style*, whose correspondent was in the synagogue that day.[43] 'Charming, the uniform dresses of the maids of honour – blue faille dresses, pompadour belts, black hats garnished with black feathers,' observed *Le Matin*.[44] 'Mlle Cahen received marvellous gifts,' read one account. 'Her uncle gave her 100,000 francs worth of silver. Her mother-in-law offered her a famous Oriental pearl necklace of an extraordinary value that the women of Constantinople would certainly remember (and God knows that in Turkey beautiful jewels abound). Finally, bronzes, furniture, silver, *bibelots* . . . the charming countess will gain millions.'[45]

Irène's uncle and one of her two witnesses that day, the composer Albert Cahen d'Anvers, prepared a special orchestral interlude for the occasion, and the couple processed out of the synagogue to the sound of Wagner's *Lohengrin*, *Le Figaro* reported.[46] But the significance of the day is captured by the crowd of guests, made up from every important family in their world. What the reports called '*le tout Paris israélite*' were there to pay their respects to the young couple: Léonora and Alphonse de Rothschild (Irène's other witness); Léon

Fould and Thérèse Éphrussi-Fould; Maurice Éphrussi and Béatrice Éphrussi de Rothschild; the list went on.[47] The wedding solidified another familial link in an already tightly knit social community. 'Among the impressive guests – elegant, amiable – were there any who thought to pray to God for the happiness of this charming couple?' asked one correspondent. 'I like to believe so.'[48]

Despite the financial relationship between Moïse and Irène's father, it remains unclear what the bride and groom knew of each other, or how well they knew each other at all. Moïse was 31, but Irène was only 19. They were both accustomed to immense wealth, yet they ultimately came from entirely different worlds. Moïse was born in Constantinople, had grown up there, worked in the family bank, and had only come to Paris as an adolescent, shortly after his new wife was born. Irène, however, was a quintessential *parisienne*: her life to date had been spent on the rue Bassano, sitting for a portrait by Renoir and at various tables with a revolving door of luminaries her parents invited to banquets – Marcel Proust, Paul Bourget, and Carolus-Duran. In the 1980s, Philippe Erlanger, a distant cousin of Moïse's gave an interview – not without a certain xenophobia – in which he offered some sympathy to his cousin's young bride: '[Moïse] was very egotistical and extremely Oriental. You know how they consider women in the East,' Erlanger said. 'The Camondo, at that time . . . had kept vis-à-vis their women attitudes that were not at all those of the Cahen d'Anvers who were much more Parisian.'[49]

By the age of 31, Moïse, sturdy and heavy set, was a man set in his ways. He was already a caricature of sorts, regularly lampooned by cartoonists in the papers for wearing an eye patch after having lost his right eye in a hunting accident in his youth. He had started his collection by the time of his marriage, and his purchases eventually earned him a reputation for stubbornness, only compounded by his apparent refusal to accept any alternative to his exacting vision. He may have lavished on his young bride diamonds from Boucheron and exquisite pearls from family heirlooms, but there is no evidence that Irène wanted any of these gifts, or the kind of life they represented. At only 19, it was unlikely she knew what she wanted, and even less likely that she had ever been asked.

The 'Contrat de Mariage' between Moïse de Camondo and Irène Cahen d'Anvers is a document that clearly revealed the transactional nature of their marriage as well as the role that Irène was intended to play within it. Most

significantly, the contract details that Louis and Louise Cahen d'Anvers paid Moïse de Camondo a dowry of 1.05 million francs, including a significant amount of stock holdings both in France and abroad.[50] What is also apparent throughout the document is the expectation of the kind of material lives the couple would lead, and the clear notion that the young woman who was entering the marriage ultimately was doing so as precisely the kind of precious object she had been depicted as in Renoir's portrait: 'The future spouse entering into marriage comes with a personally constituted dowry,' the contract reads. 'Dresses, linens, jewels, furniture for her personal use – each of a value of 10,000 francs.'[51]

Much like her own mother, Irène did not remain confined within the parameters of this fixed, feminine ideal for long. She soon began conducting an affair with Carlo Sampieri, a well-known sportsman and equestrian known to manage the stables of other Parisian elites, including the socialite Boni de Castellane.[52] But unlike her own mother, whose extramarital dalliances remained a strictly private matter, Irène seems to have seen in hers a chance to change her life, which she seized. By 1897, she had separated from her husband and, by January 1902, she had divorced Moïse, having converted to Catholicism in the process. A copy of their final divorce agreement survives in the Paris Municipal Archives, and it describes what was clearly an acrimonious separation. Irène, the settlement reads, 'directed serious accusations against her husband which she herself seems to have admitted were so ill-founded that she waived all the evidence'.[53] The nature of those retracted accusations remains unknown, and the settlement also reveals that Irène had requested a monthly stipend of 4,000 francs all throughout their separation, which was to last until their divorce was finalized. She married Carlo in March 1903, little more than a year after that settlement was signed, in the church of St Honoré d'Eylau in the 16th arrondissement – a rupture that was widely covered in the press, most likely to Moïse's utter humiliation.[54] The Countess Camondo was now the Countess Sampieri.

Nowhere in Moïse's extensive correspondence does he describe his feelings after the divorce, but he clearly sought to punish Irène in their settlement, taking custody of the children and severely restricting her access to them. In July 1903, Irène sued Moïse for custody only of Béatrice. A French judge denied her claim but granted her regular visitation rights. The reason was that the children's age, as well as Nissim's academic studies, 'no longer permit them to be sent every day' to their mother, as they had been before her marriage to

Sampieri, a second settlement read (Béatrice is mentioned nowhere in the text).[55] The children were to live with their father year-round, save for the month of September, which they would spend with their Cahen d'Anvers grandparents. Irène was permitted to see Nissim and Béatrice only on Thursdays and Sundays, between one o'clock and four o'clock in the afternoon.[56]

But the bitter dispute for the Camondo children was also a highly public affair, covered on the front page of *Le Temps*, then France's most important daily newspaper. This time, Moïse entered the fray. Through his lawyer, he attacked his ex-wife for abandoning Judaism, an unforgiveable sin that, in his eyes, made her unfit for motherhood: 'It is a great pity to place a nine-year-old child with a mother who has changed her religion, because it is feared that the mother will also want to force her daughter to change, too,' reads the statement his lawyer gave to *Le Temps*. 'And it is always regrettable to see children abandon their parents' religion.'[57]

In choosing to leave the social world of the quartier Monceau, Irène chose to leave her children behind as well. Even if this was a choice entirely forced on her by Moïse, she ultimately accepted its terms, opting for a new life of her own design over one that was already circumscribed by her family's immediate milieu. The price was high, but she was prepared to pay it. After her marriage to Sampieri, Irène wrote her children a striking letter to explain her decision and to say goodbye:

My darlings, as I told you the other day, I will be away for several weeks in Italy. I have some news that will not shock you, because you were waiting for it! I am married to Monsieur Sampieri. You know, both of you, and understand how much my life is lonely now and how I suffer from not having anyone next to me to help me through life and to keep me company, especially much later when I will be old, when Béatrice will marry and Nini will be a big boy who will run around on his own. In the end, my darlings, you know how much I love you! That if I scold you sometimes, it's for your own good, because I want you to be wiser and better children than the others! You know that you are and that you will always be my darling children and that M. Sampieri is only asking to be a true and good friend to you. . . . Be wise and docile and obedient, and above all respectful and kind to your father, who loves you so much – even too much.[58]

If Irène sought to free herself from her family's world, she did not challenge its nature or customs upon her departure. In fact, she concluded her letter with orders that her children continue to obey its laws, even in her absence:

If on Sunday you have a few minutes invite Audrey[59] to have tea; she's alone in the rue Bassano; all you have to do is telephone her. Uncle Charlie[60] sent Nini a coat that is far too nice for a child. I suggest, Nini, that you write as soon as possible a note to rue Bassano to thank your uncle – your aunt Alice is leaving for London tonight and she will bring him the letter.

Irène Cahen d'Anvers-Sampieri, Nissim and Béatrice de Camondo, and Claude Sampieri, Paris, *c*. 1905.

Eventually, she returned from Italy, and she started a new family with Carlo, giving birth to another daughter, Claude Sampieri, known as 'Pussy', in 1903. By all accounts, Irène doted on her new daughter and indulged her every whim. 'She wanted the best for Pussy, nothing was good enough for her,' recalled Pussy's own daughter, Lorraine Dubonnet, in a memoir she wrote in English after the Second World War, but never published.[61] Pussy was everything the quiet and plain Béatrice was not: dazzling, social, and, perhaps most of all, beautiful. 'Her beauty

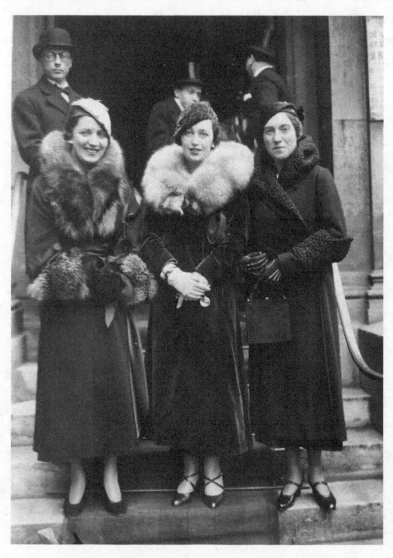

Béatrice de Camondo (right) at the wedding of her half-sister,
Claude Sampieri, Paris, 1932.

helped,' Pussy's daughter later recalled, explaining Irène's adoration for her. What is more, Irène seems to have cherished in Pussy the same enviable features that defined generations of Cahen d'Anvers women – Irène herself, and her mother Louise: 'The long Titian Venetian blonde hair she got from her mother.'

Despite the initial public scandal, Irène's divorce from Moïse did not amount to a total excommunication for long, and she was slowly welcomed back into French-Jewish society. As her granddaughter later recalled, 'the few who had turned their back on her had forgiven her', and she chose to raise her new daughter in the same predominantly Jewish milieu she had earlier sought to escape, although the Sampieris always remained Catholic.[62] Exactly how Nissim and Béatrice would have understood their mother's choice to leave their father – and whom they would have blamed for it, if anyone at all – remains unclear. It also remains unclear what they thought of their half-sister, and whether they would have seen her as a replacement. For Nissim and Béatrice, Irène seems to have been an absent mother, although not one who had abandoned them altogether. There are photographs that show her with Béatrice and Nissim along with their Cahen d'Anvers grandparents at Champs-sur-Marne, and during the First World War Nissim would note in a letter home to Moïse that Irène had visited him after he fell ill with appendicitis.

The Sampieri branch of the Cahen d'Anvers family continued the trend away from Jewish tradition and bourgeois social convention: Pussy married three times, each outside of Irène's milieu. A family album survives that contains a series of photographs from her second wedding in 1932.[63] Béatrice – a bit stout like her father, more Camondo than Cahen d'Anvers – was present that day, but she does not appear to have posed with either her mother or her half-sister, the bride.

Conversion and divorce were not the only threats to this Jewish world, and after the fin de siècle some of its members ultimately left Judaism without any particular destination in mind. As various family memoirs from the period attest, Judaism itself had begun to lose its relevance in the private lives of many in this milieu: it was losing its place as the orienting strand that ordered their lives and dictated their structure. This was not so much a question of assimilation: with

the exception of the Cahen d'Anvers women, almost all members of this elite still married other Jews, but most had nevertheless withdrawn from the kind of Jewish religious affiliations and communal engagements that had so defined their parents' generation, which was a source of great consternation for its patriarchs – Moïse de Camondo, Théodore Reinach, Louis Cahen d'Anvers. Although the abandonment of Judaism was largely generational, it was especially true for the young women in this milieu, struggling to reconcile their autonomy with the subordinate roles they were assigned in their respective families. Some of these women saw in Judaism both the source and the essence of the gendered power structures that governed every aspect of their lives. Leaving the faith was a quiet rebellion, an attempt at taking back whatever control they could grasp.

Hélène Reinach-Abrami (1887–1960), the eldest daughter of Théodore Reinach by his first wife, Charlotte Hirsch (d. 1889), appears to have considered Judaism an institution that advanced the extant gender disparities she saw elsewhere in bourgeois society. That these attitudes would emerge within the specific family culture of the Reinachs is especially significant. After all, of all the families in their milieu, the Reinachs were perhaps the most invested in formulating a durable vision of Franco-Judaism that emphasized the fundamental affinity between the French republic and the Jewish past. With the possible exception of Émile Zola, her uncle Joseph Reinach was perhaps the most outspoken defender of Alfred Dreyfus during the affair; her other uncle Salomon Reinach was a well-known scholar and antiquarian deeply involved in Jewish philanthropy and communal life. Her father, Théodore Reinach, was a polymath and a great theoretician of the Franco-Jewish encounter, a subject he explored all his life.

As Théodore argued emphatically in his *Histoire des israélites depuis la ruine de leur indépendance nationale jusqu'à nos jours* (1884), to be French was to endorse, on some level, a fundamentally 'Jewish' ethic, and to be Jewish was to recognize that secular France – and, more importantly, the type of emancipated (male) citizenship it offered – was a place that embodied more faithfully than anywhere else in continental Europe the exalted ideals of the Hebrew past. For Théodore Reinach, to identify as both Jewish *and* French was to adopt a secular universality accessed only through the embrace of a prior particularity: Jewishness, in his mind, was a kind of portal to the universal and

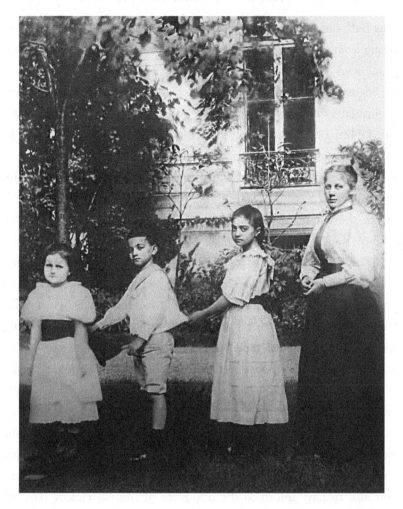

Hélène Reinach-Abrami (1887–1960), second from right.

even the global aspirations that undergirded the identity of the French citizen after 1789.[64] That his own daughter would challenge and even abandon this worldview suggests a considerable degree of internal strife within one of France's most important Jewish families.

Hélène Reinach-Abrami completed her book-length memoir, entitled *Le Bien-aimée*, in 1934 and 1935, after her father's death in 1928. Written before the Holocaust, which would claim the lives of her brother, Léon, her sister-in-law, Béatrice de Camondo, and others in their milieu, her recollections offer an image of Jewish life well in advance of its unforeseen near-destruction between 1942 and 1944. They are purely personal, the perceptive reflections of a woman

recalling both her spiritual disillusionment at the young age of 11 as well as an increasing awareness of a social reality that separated her from her male relations and peers.

She begins a lengthy chapter entitled 'Religion' with her memories of a childhood spiritual awakening, an experience in which she regarded the sky as the majestic tableau of an omnipotent god: 'I looked at it so intensely, for so long, with so much love, that a sort of intoxication took hold of me,' she wrote. 'My body became light, so light, and I no longer felt the hard touch of the metal rooftop. I floated, an ecstatic soul, in the bliss of a divine communion.'[65] This experience she sought to explore by asking her 'mother' – her father's second wife, Fanny Kann – for '*leçons de religion*', which amounted to private lessons, mostly in reading Hebrew, with a young tutor from the Grande Synagogue.

Although Théodore consented to his daughter receiving these lessons, and although he was such a passionate student of Jewish history, the Jewish religion itself was rarely a subject that featured in family discussions. According to Hélène's recollections, it was merely a fact of life that never warranted the intellectual scrutiny that Théodore Reinach and his brothers applied to nearly everything else. 'Papa and Maman and the others only went to temple to attend weddings,' she wrote. 'Religion was a subject they never broached, no doubt because it was too sacred a subject. I assumed they, too, had come to terms with God without intermediaries. It's necessary when one is a Jew.'[66] This particular relationship to Judaism – private but automatically maintained – seems also to have informed the one piece of counsel Hélène remembers having received from her father on the question of faith: 'Nothing is simpler,' Théodore told her. 'Duty is always the most unpleasant thing.'[67]

For Hélène, maintaining a Jewish faith was hardly simple. In her experience, Judaism seems to have fostered a sense of otherness, both in an ethno-religious and a gendered sense. She had been eager to be confirmed in her synagogue, and had studied with her tutor for a year before the ceremony at the Grande Synagogue. In *La Bien-aimée*, she recalled her excitement at going with her mother to the Magasin du Louvre to buy a dress for the occasion. But this same dress, she wrote, only served to represent her separation from the male peers in her cohort who were seated in a different part of the synagogue. She appeared with the same decorated finery that characterized the portraits of the Cahen d'Anvers women and daughters a generation before, and she deeply

resented the fact that all anyone seemed to notice about her was her appearance, not the learning she had done. 'You are taller than ever with this long blue dress,' she remembers being told by a friend when she entered the synagogue. 'You have the air of a bride!'[68] This equation of her official entry into the faith with a future wedding only further served to gender the experience, which Hélène noticed when the service began and she, along with all the other young women, was separated from the young men.

Incidentally, the episode in which Hélène and her mother bought this dress was the first time in *La Bien-aimée* that she discusses the question of antisemitism. The shopkeeper, she recalled, asked Hélène whether she was purchasing the dress for communion at St Philippe-du-Roule, a nearby church in Paris's 8th arrondissement. Before she could reply, her mother cut her off and quickly paid. In a low voice outside the shop, Fanny quietly informed her that the shopkeeper did not recognize their religion. As Hélène wrote: 'I began to feel more and more foreign!'[69]

This rising sense of foreignness, even of alienation, was exacerbated by her experience of the actual confirmation ceremony, performed by Zadoc Kahn, then chief rabbi of France. During the proceedings, Hélène recalled a feeling of incarceration within a sphere of women, removed from actual engagement with the sacred texts and confined to a lesser realm on the literal and figurative periphery of the synagogue:

> They made us sit, we girls, on the benches in the left bay. The others having opened their prayer books, I did the same as them, in appearance, but I was not reading, I was waiting my turn to go up to the altar, my heart was failing. But this turn did not come, neither for me nor for my companions. We were there, disguised as communicants, allowed only to watch our brothers being received as men in the community of Israel.[70]

The female students were essentially spectators, accessories there to observe their male counterparts join 'the community of Israel', a community the very essence of which, Hélène came to believe, would never welcome her. The palpable anger she experienced at the age of 11 still clearly informed her prose when she wrote *La Bien-aimée* in the mid-1930s. Her bold declaration that 'only men play a role in the house of God' gave way to a shift in her language,

whereby Hélène situates herself, for the first time in her memoir, in a collective structure different from the collective structure of her family. In a certain sense, her confirmation was where she began to think of herself as a woman:

> The last boy had returned to his seat, and now the Chief Rabbi, alone on the platform, was addressing us. Out of politeness, he turned to our white troop, called us his dear daughters, and recommended to us all kinds of virtues, with a very marked Alsatian accent. He was obviously doing his best not to treat us as intruders in this ceremony, but I felt that we were there in excess. Only men played a role in this house of God; we did not count in His Eyes. We were only intended for the home, good as the women of the Bible, to be numbered with camels, donkeys and cows . . .[71]

It is entirely coincidental, of course, that Hélène decried the fact that women were destined for the '*foyer*' – the same term that Rabbi Zadoc Kahn, who had presided over her confirmation, had also used to describe the ideal place for Jewish women during the funeral of Meyer Joseph Cahen d'Anvers in 1881. But a collective rejection of this marginal experience seems to have defined the lives of many women in the elite strata of Paris's Jewish community. Others, such as Louise Cahen d'Anvers and Irène Cahen d'Anvers, subverted this feminized ideal by abandoning the bourgeois sensibilities that governed the lives of women in their social class; others, such as Hélène, saw the culprit as Judaism, as *La Bien-aimée* suggests. Despite her family's strong position within the Jewish community, Hélène gave up her faith entirely shortly after her confirmation: 'The God of Israel disappointed me so much that I tore myself away from it every day,' she wrote.[72]

In the time of the Dreyfus Affair and the heightened antisemitism that followed it, the world of these Jewish families – the Reinachs and the Rothschilds, the Cahen d'Anvers and the Camondos, the Foulds and the Éphrussis – no longer faced only external hostilities. The battles they faced on the inside of their carefully constructed social universe were often just as intense.

2

DREYFUS AND DRUMONT
TOWARDS A MATERIAL ANTISEMITISM

On 4 June 1889, Edmond de Rothschild and his wife, Adelheid, gave a lavish banquet at their Paris home, the sprawling Hôtel de Pontalba. Held in honour of Mathilde Bonaparte – the only member of the Bonaparte family to have remained in France after the Third Republic expelled all descendants of France's former ruling dynasty three years before – the guest list that night was a microcosm of the Parisian fin-de-siècle elite. Bankers and barons, impoverished aristocrats, and society doyennes were all assembled in the gilded salons of 41, rue du Faubourg Saint-Honoré, a Parisian landmark designed by the famed Italian-born French architect Louis Visconti and completed in 1855. The Hôtel de Pontalba was a prime example of the rediscovered ancien régime style much in vogue among French elites in the late nineteenth century, and the Rothschilds were thus the custodians of a prized piece of French history.[1]

Also present that night was the art critic and consummate man-about-town Edmond de Goncourt, who recorded in unsparing detail everything he saw in the diary that remains one of the most evocative chronicles of social life in the fin de siècle. Goncourt, a self-appointed arbiter of taste, was hardly impressed by the Rothschilds' home and its carefully restored eighteenth-century furnishings. Never mind that this was the predominant style favoured by the French elite in the late nineteenth century, a style whose rehabilitation and popularity Goncourt himself had personally facilitated.[2] In his eyes, the opulence he saw at the Hôtel de Pontalba was inescapably ersatz: even with a dazzling fortune, a Jew could never quite achieve authentic beauty.

'I was persecuted by a thought, which never arrives at the homes of the poorest collectors,' Goncourt wrote in his diary from that night. 'I was haunted by the idea of the falsehood of the objets d'art that surrounded me, by the falsehood of the paintings, by the falsehood of the sculptures and especially by

the falsehood of the gilded bronzes, the item of artistic creation that is the richest prize of all and for which they pay the most and which seems to me, most of the time, to come from the studio of a forger.'[3] For Goncourt, Jews were fundamentally counterfeit, doomed to a mimetic parroting of a national identity that could never be theirs.

The right-wing journalist and writer Léon Daudet emphatically agreed. In much the same way, he described a visit to the salon of the acclaimed collector Gustave Dreyfus in the late 1890s. By then, Dreyfus had amassed one of the most extensive collections of Renaissance Italian medals, paintings, and sculptures, including *Madonna and Child with a Pomegranate*, a landmark fifteenth-century canvas currently attributed to Lorenzo di Credi but believed at the time to have been none other than the work of Leonardo da Vinci himself.[4] But none of these treasures delighted Daudet – quite the opposite. 'These beautiful objects were grouped and disseminated throughout the rooms with a remarkable lack of taste,' he wrote.[5] For Daudet, the rest of Dreyfus's apartment – at 101, boulevard Malesherbes, two blocks from the Camondo mansion – was a pastiche of mismatched styles, befitting a collector whose foreignness could never be overcome. He observed 'a bizarre, oriental piece of furniture, resembling a fence screen from a mosque, reserved as smoking room', where the guests were all prominent Jews – Weisweiller, Fould, Éphrussi, and Seligmann, among others. For Daudet they were all facsimiles of Frenchmen, each of them 'truncated, hybrid beings . . . in search of an impossible nationality'.[6]

This was a painful reality of life for Jewish elites in fin-de-siècle France: an antisemitism that attacked the people they were through the objects they bought and the houses they owned. It was a viciousness that transcended the typical snobbery of aristocrats and tastemakers. Both the collectors and their critics saw in certain objects – typically with surviving traces of the ancien régime – pieces of a vanished past that carried a powerful potential for projecting an image of national belonging in the present. This was especially true in a moment when the very notion of Frenchness was more fiercely contested than ever before, when the Dreyfus Affair and the antisemitism it unleashed became existential questions for the future of France. At the end of the long nineteenth century, during which France had repeatedly swung between revolution and reaction, republic and restoration, the fight for the objects from a nation's storied past became a battle for the soul of the nation – to whom it belonged, but also who belonged to it.

France, the storied republic of human rights, occupies a crucial position in the history and evolution of antisemitism. The French republic, after all, was the first modern European state to 'emancipate' its Jews, in 1790 and 1791. But the unique significance of Jewish history in France has never been a simple matter of chronology. As Maurice Samuels has convincingly argued, what is most important is that the famous universalism inspired by the French Revolution – towards a community of equal citizens before the law, irrespective of their particular identities – was predominantly conceived as a discourse about Jews, the principal minority group in France in the late eighteenth century.[7] French antisemites came to see Jews as the victors of the Revolution, the ennobled faces of a corrupt and decadent republic.

In that sense, the history of French antisemitism has long been seen as figurative as well, as French antisemitism was an indictment not only of the Jews of France but also of the political regimes and value systems that defended them. Especially in the aftermath of the Holocaust, the fact that French antisemitism was so constant and so comparatively aggressive throughout the nineteenth century led many post-war historians, most notably Hannah Arendt, to wonder whether the horrors of the twentieth century had essentially been foretold in the nineteenth. In the words of the historian and rabbi Arthur Hertzberg, writing in 1967: 'It is in the land in which the emancipation of the Jews began that we must search for some clues with which to explain not only its successes but also its failure.'[8]

At first glance, that 'failure' seems to have plenty of evidence. The French intellectual tradition produced Voltaire, arguably the Enlightenment's most venomous opponent of Judaism, and it was in France – not in Germany or even in Eastern Europe – that the Dreyfus Affair, perhaps the most politically significant antisemitic scandal in nineteenth-century Europe, erupted. From the French socialists of the 1840s – such as Pierre-Joseph Proudhon and Charles Fourier – to the nationalist reactionaries of the 1880s – Maurice Barrès, Charles Maurras, and, most of all, Édouard Drumont – French antisemitism was an especially robust and hostile tradition. It can be tempting to elide each of these very different chapters into a narrative whose natural and inevitable end was the Holocaust, which in France assumed the form of the

Vichy government's open collaboration with Nazi Germany and its willing deportation of some 76,000 French and foreign-born Jews by the end of 1944.

But each of these chapters nevertheless illustrates a different hatred that targeted Jews for different reasons in different historical contexts. Voltaire, for instance, attacked Jews for their refusal to abandon religious particularity altogether. Fourier and Proudhon hated Jews for their perceived capitalistic tendencies. Barrès targeted Jews for their 'cosmopolitan' subversion of his organic, rooted vision of *la France profonde*. Drumont, writing in the fin de siècle, condemned Jews for the 'race' he believed them to represent. None of these hatreds was quite the same. Attempting to weave them together into one single teleology of tragedy ultimately obscures the lived experiences of the actual Jewish individuals who faced significantly different prejudices in different times.

This is an especially important consideration in understanding the fin de siècle, the France of Dreyfus, the France of Drumont, and the France of multiple devastating financial scandals in which these collectors and their families were implicated – the Panama scandal for the Reinachs, the Alfassa Affair for the Camondo, and the 1882 crash of the Union Générale for the Rothschilds. The rationale behind the public identities these families assumed – and, most importantly, their embrace of collecting as a means of self-expression – becomes clear only in the specific context of the fin-de-siècle antisemitism they experienced in the 1880s and 1890s. This was indeed a language of its own.

The fin de siècle was a predominantly material world. French literature from the period – Émile Zola's *Au bonheur des dames* (1883), Joris-Karl Huysman's *À rebours* (1884), and even Marcel Proust's *À la recherche du temps perdu* (1913–27) – depicts an environment in which daily life becomes increasingly commoditized at the same time as the bourgeois desire to possess becomes an almost existential endeavour.[9] As in Zola's novel, the department store was a veritable temple for this secular, material age, and the arcade, as Walter Benjamin would later note, a fount of self-realization: commodity fetishism somehow blended into self-discovery. The Goncourts would later dub this mentality '*bricobracomania*', by which the bourgeois could escape the ennui and the alienation of modern society through the mystical world of

objects.[10] But this state of mind went much further than the sphere of the individual.

At least by the mid-nineteenth century, there was a growing sense that something essential about the French nation was preserved in the material traces of its history. In the aftermath of the French Revolution, much of the artistic patrimony of the Church and of the aristocracy – the items and the artefacts that represented an aesthetic heritage seen as truly 'French' – had made its way onto a new market, for new classes of consumers and dealers to buy and sell. Newly minted fortunes, mostly made in securities, real estate, and, of course, the '*haute banque*', were quick to acquire these pieces.[11] Collectors could acquire patrimony and, with it, prestige. To purchase what was obviously French was a means of purchasing a certain image of Frenchness for themselves and for their families. Objects and things became imbued with national significance: they furnished a plane of identity construction that was both personal and political.

The nineteenth century in France was rife with political turmoil, and each disruption inspired new disputes about who truly owned the past. As the historian Tom Stammers has written, each regime change – 1814–15, 1830, 1848, and 1870–71 – inspired a 'fresh assault on cultural property' as well as 'a new bid for legitimate ownership'.[12] This was perhaps especially true in 1871, the end of the Franco-Prussian War, when what remained of the Paris Commune destroyed numerous iconic sites of cultural heritage in the capital, among them the archives of the Hôtel de Ville and the palais des Tuileries. A generation of collectors felt impelled to respond, and they saw themselves as conservators above all else. Their collective rejoinder, Stammers has written, was to reignite 'a political debate about who could – and who could not – be entrusted with care of the French past'.[13] This debate was fundamentally reactionary and anti-revolutionary, but it was also a debate imbued with considerable xenophobia and, perhaps most of all, antisemitism.

The Third Republic, the system of government adopted at the end of the Franco-Prussian War, was born in a moment of utter trauma and chaos. France had capitulated to Germany, lost Alsace-Lorraine on its eastern border, and, as per the peace treaty, endured a German military occupation until the government could pay the hefty 5 billion franc war indemnity – a settlement brokered by none other than the banker and collector Alphonse de Rothschild (1827–1905), whose family home, the Château de Ferrières, saw France humiliated

by Otto von Bismarck, a memory that would linger in the public imagination. In any case, no one – including its first president, Adolphe Thiers – expected the Third Republic to last. But it did, and for seventy years, longer than any other post-revolutionary French regime to date. Those seventy years were marked by constant political tumult, but also by remarkable prosperity, financial stability, and unprecedented material advancements in the lives of ordinary citizens – not to mention a politics of ruthless imperial expansion.

But elites were nevertheless deeply distrustful of the Third Republic and the changes it was inspiring. In an increasingly secular society, there was a palpable sense for many of them that a way of life was hurtling towards an inevitable end. The anxiety of the age was the perceived disease of 'decadence'. This was an affliction all to easy to diagnose: the symptoms were decline and decay, however defined, and the cause was whichever internal agent, in the eye of the beholder, posed the most critical threat to the health of the body politic. Then as now, 'decadence' had no clear meaning, and it appealed to critics on the right of the political spectrum as much as it did those on the left: the former decried what they saw as moral degeneration, while the latter tended to attack the excesses of consumer capitalism. All too often, they agreed on a culprit – the Jews.

Jews enjoyed a greater level of civic advancement and public visibility in the Third Republic than at any other point in modern French history. The Crémieux Decree of October 1870 had guaranteed the French citizenship of Algerian Jews and, in metropolitan France, Jewish citizens reached unparalleled heights in the institutions of the republic. In the period between 1870 and 1940, the sociologist Pierre Birnbaum counted 171 'juifs d'état' – 'state Jews' – in the French parliament, local administration, the justice system, and the upper ranks of the military. In the same period, there were 25 Jewish generals, 34 Jewish judges, and 42 Jewish prefects.[14]

But, in an age of finance capitalism and rapid industrial transformation, there was also an increasing number of Jewish-owned banks with high public profiles, and a wealthy class of Jewish elites with a rising presence in public life and aristocratic salons alike, a changed social landscape captured in intimate detail throughout Proust's À la recherche.[15] The changing face of France – and the changing faces among the leadership of the republic's institutions – led the antisemites of the day to decry what they saw as La France juive, or 'Jewish France', the title of Édouard Drumont's 1886 bestselling screed, one of the

most vindictive mainstream antisemitic texts ever published. Drumont and his allies began to see the republic itself as a Jewish fantasy that subverted the authentic French nation. Léon Daudet said it most clearly. In his mind, the republic and its leaders had 'too often made a pact with Israel' to repair the devastation of the Franco-Prussian War. 'Never before had a regime been so open to it as the republic was between 1875 and 1899.'[16]

Historians such as Pierre-André Taguieff have long emphasized the 'cultural' nature of French antisemitism in the late nineteenth century.[17] But a close reading of the actual language employed by the leading antisemites of the fin de siècle, such as Drumont and the Goncourt brothers, reveals something more: a material antisemitism for a material age, an 'aesthetic of hate' expressed in the language of objects and things.[18] In no small fashion, these critics ultimately articulated Jewish difference and foreignness in terms of what they perceived to be a Jewish aesthetic inadequacy, terminal bad taste and fundamental falsity that could never be overcome. For them, Jews invaded the French nation first and foremost by capturing its cultural patrimony, the exclusive province of Catholic elites such as themselves. On a deeper level, however, these self-appointed arbiters of fin-de-siècle culture levied a more fundamental critique: no matter how many pieces of France's cultural heritage they bought and collected, Jews could never be aesthetically authentic. The objects in question – imbued with the imagined glory of the French past – became a battle-ground for the control of the nation.

A uniquely material antisemitism was an inescapable component of social and cultural life in the French fin de siècle, and it was thus a significant external stimulus that impelled this milieu of wealthy, assimilated French Jews not only to collect but to amass collections that would eventually assume highly public afterlives. If the Goncourts and Drumont had declared that Jews were invaders of French cultural patrimony, these collectors were determined to prove them wrong. This can explain some of the points of intersection among many of their respective collections, some of which emphasized the art of the ancién régime, specifically the Louis XV or Louis XVI styles that were imbued with a certain patriotic significance in their times. It also explains the public museums many of these collectors established at their deaths in the 1920s and 1930s: each, in its own way, was a subtle argument for Jewish aesthetic authenticity and the durability of the Franco-Jewish encounter.

Long before the Dreyfus Affair, the Jewish families in this milieu were the express targets of antisemitic attacks, the human faces at whom a hateful discourse that reached an unprecedented fever pitch in the 1880s was aimed. Many of them became the unwanted focal points of public censure during a number of financial scandals that embarrassed the reputations of their families and exacerbated their sense of vulnerability. Most of these scandals were incidents for which they were wrongly blamed, but others were episodes in which certain of their family members were indeed culpable, presenting impossible challenges for the innocent among their relations. But guilty or not, the verdict was always the same, largely thanks to a media landscape that revelled in antisemitic conspiracy theories. In the years leading up to the Dreyfus Affair, the French public increasingly came to see a connection between Jews and finance capitalism, and also between Jews and betrayals of the republic. In 1894, when the French Army first discovered evidence of a German spy in its ranks, it was little wonder that its leaders immediately suspected a Jewish military captain. Any average reader of the French press at the time would most likely have done the same.

Arguably the most important event that established this current of antisemitism in the 1880s was the 1882 crash of the Paris Bourse, which followed the collapse of the Union Générale, a bank that ultimately fell because of its leveraged position and considerable accounting fraud – a saga that inspired Zola's *L'argent* (1891).[19] What happened was not entirely different from the American stock market crash of 1929, albeit on a smaller scale: as the Bourse's market soared, interest rates rose to such a degree that lenders began demanding premiums. Investors began repaying their loans to avoid those premiums and also to avoid taking out loans at the higher interest rates. Union Générale, expressly founded in 1878 by royalist conservatives as a Catholic bank that would counter the great Protestant and especially the great Jewish houses of the day, particularly the Rothschilds, quickly began to fail. It could no longer repay frantic investors, and, worse, the bank began falsifying public reports about cash reserves to avoid a total price collapse. But it was too late – over the course of one week in January 1882, the cash price of Union Générale shares plummeted. Nearly 4 billion francs vanished into thin air. The head of the bank, Paul Eugène Bontoux, who had started his career working for Rothschild-

owned rail companies and who ultimately fled to Spain to avoid a prison sentence, wasted no time in blaming the Jews.[20]

There was no Jewish conspiracy against the Union Générale, and the reality was that it was only an emergency loan from the Banque de France, brokered by major Jewish-owned banks, that prevented the closure of the Paris Bourse altogether. The particular identities of the Jewish bankers who facilitated that emergency loan are significant. They were the none other than the major collectors in this milieu: Moïse de Camondo, Louis Cahen d'Anvers, and the Rothschild Bank.[21] But the damage was already done. Antisemitic conspiracy theories ricocheted throughout the French press, and Bontoux's interpretation found a captive audience among those who had always resented the Revolution and the republic it had established. This audience turned out to be larger than the collectors may have realized. As early as 1892, a mere ten years after the crash and two years before the Dreyfus Affair, the French journalist Mermeix observed that the fall of the Union Générale 'was really the antisemitic revolt in France'.[22] Bontoux's accusations were repeated in virtually every newspaper, Mermeix noted, and 'accepted as gospel by the victims of the crash in the distinguished bourgeoisie and in the ecclesiastical world'.[23] The seeds were planted.

But sometimes Jewish financiers were guilty, and sometimes the culprits even came from within the rarefied world of the collectors. In 1885, three years after the fall of the Union Générale, there was the so-called Alfassa Affair, a crippling blow for the Camondo family and the reputation of their bank, I. Camondo & Cie. Léon Alfassa was the scion of another prominent Sephardic family, and he had married Clarisse de Camondo, the daughter of Abraham Behor de Camondo and the sister of Isaac de Camondo, in 1867. Shortly after their marriage, his father-in-law and uncle-in-law appointed him as a senior executive of the bank. This role that saw him shouldering more and more of the bank's leadership while the elder Camondo brothers embraced philanthropy in their retirement and their sons, Isaac and Moïse, increasingly withdrew into their cultural endeavours. But that decision proved disastrous: Léon Alfassa gambled and lost millions of francs of investor capital on Egyptian securities related to the Suez Canal company. In a front-page article entitled 'A sinister financier', *Le Figaro* reported that his losses were 6 million francs in Paris and 4 million francs in London, with a total of between 16 and 17 million worldwide.[24]

He fled Paris in shame on the night of 14 April 1885, leaving his wife, Clarisse, and their six children behind. A remarkable letter he wrote to his father-in-law and boss before his departure survives in the Camondo archive. Léon begged Abraham for help in paying his debts, which the old man eventually did: 'I don't even ask you to pardon my memory, I implore your generosity for your daughter, for my children.'[25] As for an excuse, this was all he had to say: 'I was brought in little by little by events and circumstances that would be too long to enumerate here.'[26] But the scandal had already revealed too much about the family, its lavish wealth and its private dynamics. *Le Figaro* soon ran headlines that described 'The Alfassa–Camondo Affair', and the publicity shook the foundations of the secluded enclave the Camondo had established on the rue de Monceau.[27] *Le Matin* reported that Clarisse 'fell to her knees before the head of the Camondo house', begging her father for help. But the article was flippant in its conclusion: 'Without doubt, the family will pay.'[28]

In any case, the outrage from angry customers caused them to distrust the Camondos, not necessarily as bankers but as Jews, who, in their eyes, had merely confirmed the age-old stereotype of avaricious moneylending. Both Abraham Behor and Nissim de Camondo died in 1889, the Alfassa Affair having darkened the reputation of their familial Parisian fantasy. But Édouard Drumont had already made mention of the scandal in *La France juive*, mocking the notion of Jewish nobility. Abraham Behor de Camondo, Drumont sneered, naturally paid 'anything that could be given not to let the spotless coat of arms of such a noble family be tarnished'.[29] His implication was that the Camondo coat of arms was a fiction to begin with.

But the Alfassa Affair paled in comparison to the Panama scandal, which made international headlines and threatened the stability of the Third Republic. This time the Reinach family was implicated. Nearly 2 billion francs were lost when the French government, in 1888 and 1889, covered up the dire financial situation of Compagnie Universelle du Canal Interocéanique, which managed the Panama Canal in Central America. The company, under the leadership of Ferdinand de Lesseps (1805–94), was charged with developing and operating the canal. Due to the harsh nature of Panama's climate, however, the company sustained high losses and never turned a profit. To avoid liquidation, the struggling company needed a lottery loan to raise money, which the French government authorized in 1888, allegedly after hundreds of deputies and other

members of the French government were bribed. But the company collapsed the following year, robbing some 800,000 French citizens of the funds they had invested and triggering a judicial inquiry.[30]

As it happened, the company's primary liaison with the government was its financial adviser, Baron Jacques de Reinach (1840–92), the uncle of Théodore, Salomon, and Joseph Reinach, and also the father-in-law of Joseph, who had been forced to marry his daughter, Henriette. After the extent of the alleged briberies he had facilitated was made public, Jacques de Reinach died in Paris in November 1892 – allegedly by suicide, although there were rumours that he had been poisoned. In any case, Joseph Reinach had seen his father-in-law the night before his death and had burned his papers, although in later years the French justice system did not conclude that the transactions Reinach had brokered on behalf of the company were all illegal bribes. For the public, the lurid details of the story were enough: they confirmed in the eyes of many the existence of a Jewish cabal that controlled the French economy and had long ago corrupted the republic. To the lay observer, the Panama scandal had exposed how easily parliamentarians and functionaries could be bribed, and how, in a number of cases, the middlemen who operated between private enterprise and the government were Jews.

The scandal had devastating consequences for the Jewish elite, especially given the final act of Jacques de Reinach. Less than a week before his death, he had approached Édouard Drumont, France's leading public antisemite, who had only recently founded his openly antisemitic newspaper La Libre Parole, to cover the fallout of the Panama scandal. Reinach no longer wanted to see his family's name tied up with sordid reports of political corruption and financial malfeasance, so he made Drumont a bargain: stop printing stories about the Reinachs and in exchange receive a full list of the parliamentarians connected to the scandal.[31] Drumont agreed and almost overnight La Libre Parole was transformed from a fringe publication into an absolute must-read. Because of the deal with Jacques de Reinach, Drumont's paper quickly became one of the most significant political news outlets in the country, soon achieving a staggering readership of 300,000.[32] His antisemitism now had a regular, mainstream public platform and he had Jacques de Reinach to thank for it. From then on, it was a platform he would use to decry the very milieu – and the family – that had given it to him.

Édouard Drumont (1844–1917) requires little introduction. He was among the most virulent – not to mention prolific – antisemites in modern European history. His name was a fixture during the Dreyfus Affair – especially among the French-Jewish elite, against whom he railed frequently and mercilessly. The Reinachs, in his eyes, were responsible not only for the Panama scandal itself but also for all the financial corruption that followed it.[33] Likewise, the Rothschilds, in his assessment, were the principal agents of France's inner erosion and, during Drumont's tenure as a representative in the French parliament, representing Algiers, he famously – and very publicly – accused a colleague of having accepted a bribe from the banker Alphonse de Rothschild (1827–1905) to pass legislation that would have helped the family bank. Antisemitism was his passion and his vocation.

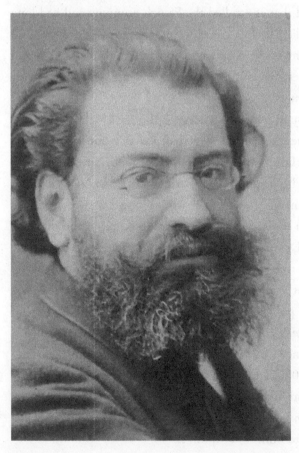

Édouard Drumont
(1844–1917).

In the aftermath of the Holocaust, Drumont's reputation has largely been transformed from that of local menace to an historical harbinger. Especially outside France, historians have often considered him as an intellectual precursor to Hitler and as a bigot whose antisemitism was possibly just as extreme.[34] The American historian Thomas P. Anderson, for instance, saw Drumont's rhetoric as something of an antecedent to Auschwitz: 'With the antisemitism of Hitler's Germany still so fresh in our minds,' he wrote in 1967, 'it is perhaps only natural that the study of the development of antisemitic doctrines has focused on Germany. However, the campaign against the Jews conducted in France during the last fifteen years of the nineteenth century rivaled anything in Austria or Germany during that period.'[35] In no small fashion, Drumont became more than a French antisemite: he became the so-called 'pope' of all antisemitism.[36]

As captivating as these interpretations can be, they often obscure the actual nature of Drumont's critique in the fin de siècle. His was a fundamentally material antisemitism, an antisemitism expressed in aesthetic terms. In fact, the particular details of his biography are often ignored in discussions of his work, as if his posthumous status as a Holocaust harbinger somehow removes him from the context in which he thought and wrote. But those details are of fundamental importance: they reveal the substance of the attacks that French-Jewish elites endured throughout the Dreyfus Affair and well into the early decades of the twentieth century. To that end, it bears revisiting the actual text of *La France juive* (1886). Essentially a modern French adaptation of the *Protocols of the Elders of Zion*, its arguments are well known. But the terms in which Drumont made those arguments are rarely remembered. Those were material terms, and it was ultimately through his conception of French material culture and cultural heritage that he articulated his vision of Jewish alterity and foreignness. In a sense, the material realm was the point from which the rest of his argument flowed, the source of his hatred and the crux of his antisemitism.

The acclaimed author of *La France juive* was first and foremost an antiquarian.[37] Drumont's first book was *Mon vieux Paris* (1878), a nostalgic reverie for a lost city. As he wrote in the early pages of that book: 'our traditions, our faith, our heritage of beliefs and ideas – all that constitutes the very soul of the Fatherland, I have defended'.[38] And these values Drumont defended by studying the 'sites' he identified with '*la Patrie*', an idea that, in fact, became

real only in association with certain buildings and objects on his wistful tour of the ancient French capital. He longed for the city he had known as a boy, a city yet to be transformed by the *grands boulevards* of Baron Haussmann and, in his eyes, the scourge of the railway and the department store. Contemporary Paris, it followed, was in the throes of an immeasurable decay: 'Without having reached the age of Methuselah, we have seen ourselves that talk, elegance, and pleasure have lost, little by little, the physiognomy they had when we were young.'[39]

It was probably his foray into nostalgia with *Mon vieux Paris* that ultimately inspired Drumont to write *La France juive*. There was an apparent affinity, in his mind, between the physical devastation of his beloved capital and the most notable minority group within it, several of whose members were at the heart of the transformations he hated the most. The financier James de Rothschild (1792–1868), for instance, the patriarch of the family's French branch, was a key financer of the expansion of French railways in the mid-nineteenth century; the Alsatian Jews Théophile Bader (1864–1942) and Alphonse Kahn (1864–1927) had opened the Galeries Lafayette department store around the same time. Grégoire Kauffmann, Drumont's biographer, cites an 1892 essay by Drumont in *La Libre Parole* entitled 'Notre oeuvre et la calomnie'. In that article, Drumont wrote that, in the midst of researching *Mon vieux Paris*, 'a light went on in my mind. I was struck by the terrible power of this race that, in a few years, had trampled on the race of the ancient French'.[40] There it was, the root of his antisemitism: the Jewish menace was a material menace.

The language of *La France juive* confirms the primacy of the material in Drumont's particular brand of antisemitism. In fact, his argument about the Jewish domination of contemporary France stems, in large part, from the 'evidence' he cites of a Jewish invasion of France's cultural patrimony. As he had suggested throughout *Mon vieux Paris*, French material heritage evoked the French nation itself and so Jewish ownership or 'occupation' of historic objects and places was ultimately an act of aggression. This is clearest in the considerable number of pages he devotes to eviscerating the Rothschild château at Ferrières, leading his readers through the house room by room, object by object.

His analysis reads like a declamatory catalogue, an itemized list of the family's attacks on his imagining of a pure, native France. The intensity of his responses to the house – not to mention the detail of his interpretations –

lends a sense of simulated, artificial credibility to the pages that then follow the passage on Ferrières in which he decries the Rothschilds, predictably, for their financial manipulation of French and world politics. But what becomes clear in *La France juive* is that Drumont could not make those latter arguments without having first established the material element of the equation: Jewish material domination, in his view, enabled Jewish financial and political domination. As he wrote at the end of his discussion of Ferrières, Jewish collecting had sinister implications:

> The love of the *bibelot*, or rather the Jewish sense of acquisition, of possessiveness, is carried out to the point of childishness. A small pot of Flanders stoneware, worth six francs, serves as an opposite side for an Orion plate or a soft pastel figurine. The good Semites of the auction house could not resist the temptation to abuse even those they so reverently call 'the barons'.[41]

In Drumont's eyes, collecting was an act of Jewish violence: it was by conquering French objects that Jews such as the Rothschilds inserted themselves into a national narrative that they then undermined from within. Ferrières was also where the Franco-German Armistice was signed – further evidence, for Drumont, of the Rothschilds' treachery. Objects and artefacts from the French past allowed them to construct a shield of false nobility. As it had been for the Goncourts, this sense of a Jewish aesthetic 'falsehood' was a seminal element of Drumont's critique as well. In the end, Ferrières, as he would write, was exhausting to visit. The château was essentially a large consignment store, with innumerable objects displayed in a decidedly indecorous ostentation:

> The impression left by this house is one of fatigue rather than admiration. It's a mess, a trainwreck, an incredible junk store. All these objects, brought back from all corners of the earth, swear among themselves; these oppressive spoils of the universe do not harmonize, these manifestations of so many different civilizations clash in this coming-together.[42]

Drumont depicts Ferrières as an essentially foreign construction, noting that the French Rothschilds had hired the British architect Joseph Paxton

(1803–65) to design a home that mirrored the British family's mansion at Mentmore in Buckinghamshire. 'Paxton built one of these bizarre châteaux we see in England and that, with their four façades in their dissimilar style, seem totally out of place in the middle of our northern territories.'[43] The eclectism of the house was intended to display a larger interpretation of the various achievements of the European Renaissance, as the art historian Pauline Prevost-Marcilhacy has amply demonstrated.[44] But precisely because of its foreign inspiration, the style of Ferrières was discordant to Drumont. Anatopism was the essence of Drumont's critique: he wrote that the house was 'out of place', a loaded term that evokes a certain distance from the native land and the people who had emerged from its soil.

The tour of the house's interior commences with an attack on the famous *style Rothschild*, a mixture of periods, styles, and schools that came together in a gilded, ornate whole. 'After having crossed a large hall decorated with a ceiling by Tiepolo,' he wrote, 'we enter a small dining room that contains some joyful paintings by Philippe Rousseau.'[45] Echoing the pronunciations of his friends the Goncourts, Drumont appeals to the reader's common knowledge in pointing out the apparent absurdity of Tiepolo juxtaposed with Philippe Rousseau, a nineteenth-century still-life painter: Jews, no matter how wealthy, could not be expected to know the difference. The Rothschilds, in his assessment, could do nothing correctly. Even the library at Ferrières was an affront to decency, filled as it was with 'the most horrible editions'.[46]

The closest 'reading' Drumont offers in his interpretation of the château is of the 'salon Louis XVI'. Clearly having adopted the standard Goncourt interpretation of Louis XVI style as the apogee of French cultural production, he depicts the room as a site of invasion:

> From the Louis XVI salon, the surprises begin. We see successively pass before our eyes all the wonders of the genius of the centuries that unite behind the gold, the universal relations, the freemasonry, the second-hand dealers on the lookout throughout Europe, reserving the flower of their findings for the sovereigns of Israel. The masterpieces of 18th-century art, the tables by Gouthière, the inlaid furniture by Riesener and Boule, the bronzes by Caffieri adorn this charming room in its clear, springtime tone surmounted by a ceiling by Henri Lévy. In the middle, like a trophy, there

is the incomparable harpsichord of Marie-Antoinette, which is heart-breaking to find in this house of Jews.[47]

There is a sense in which this room held in captivity the objects that, for Drumont, the Goncourts, and others, most evoked the French cultural genius. He speaks of the harpsichord as if it were a casualty, a symbol of defeat.

That sense of defeat characterized the rest of his interpretation of Ferrières. This is largely because the château itself was the literal site of the negotiations between the German Chancellor Otto von Bismarck and the French foreign minister Jules Favre, the famous negotiations that enshrined France's defeat in the Franco-Prussian War in 1871. In Drumont's view, not only had Jews contributed to the making of an impotent, decadent society incapable of defending itself from foreign attack, they had gone so far as to host – and even celebrate – the humiliation of France in their own home. In fact, the opposite was true: Bismarck had seized Ferrières from the Rothschilds, who were terri-fied what would become of the house during his occupation.[48] The Rothschilds had raised the loan to pay for the reparations imposed by the Treaty of Frankfurt, which Drumont would have known.

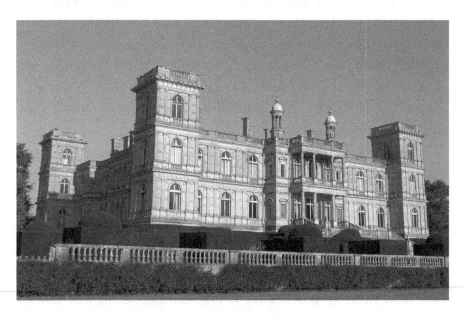

Château de Ferrières, the estate of the Rothschild family.

But in Drumont's eyes, the house was complicit in a betrayal of the French nation whose objects it had imprisoned and whose heritage it had stolen. 'Let's return to the apartments,' he exhorted his readers. 'We will encounter, for the first time, the history that has visited this château that has no history. In 1815, the Rothschilds arrived poor with the invasion, but in 1870 the invasion found them billionaires and pays them compliments.'[49] Again, Drumont's crucial theme is 'invasion'. The German-born Rothschilds, after all, had 'invaded' France in 1815, (apparently) made millions on the invasion of 1870, and continued to invade France with every day they spent in Ferrières. In the end, he considered the château an offence to those who had sacrificed their lives for France, victims of German violence but also, importantly, of this 'Jewish house': 'The heart that beats in a strong chest nevertheless felt perhaps some pity at the thought of so many men, whose mothers gave birth to them in great pain, who were about to die on the battlefields so that a few more millions could enter this house of Jews.'[50]

The Dreyfus Affair was the culmination of the antisemitism that had exacerbated, throughout the 1880s, a discourse that saw Jews as harbingers of financial corruption and the agents of international conspiracies designed to subvert the power of the sovereign French nation. At least in part, this was a discourse that had evolved largely in response to the public personas – and occasional misdeeds – of the collectors and their extended families. But nothing quite compared to the Dreyfus Affair in terms of jeopardizing their carefully cultivated social positions.

The affair was nothing less than an existential affront because it challenged, at least for a moment, the assumptions that had grounded the Jewish, French, and ultimately cosmopolitan identities that these families had cultivated in recent years. Before the 1880s, their multifaceted identities had been the subject of scorn and fascination among others, but their being perceived as exotic seems not to have troubled their respective senses of self.[51] The fact that the Camondos had arrived from Constantinople and that the Reinachs had come from Germany and that the Rothschilds had cousins with banking empires in capitals from London to Vienna never seemed to undermine the

Frenchness of those who had settled in France. But the affair was a bitter reminder that the world as they understood it was not the world as it was, and that in fact it never had been.

Above all, the Dreyfus Affair was an emotional shock for this milieu: even though Dreyfus himself was ultimately exonerated, the unprecedented twelve-year social drama only served to underscore the fragility of their illusions. Granted, this was a network of families with differing politics extending across the spectrum. Some, such as the younger generation of Reinach brothers, Joseph, Salomon, and Théodore, were staunch defenders of the republic and members of virtually all of its institutions; others, such as the Rothschilds, were no great believers in the republic and had essentially become fixtures in the antisemitic salons of the aristocracy.[52]

But the Dreyfus Affair was a moment that showed how futile these politics turned out to be: in the eyes of the French elite, Jews were Jews, loyal only to themselves. For the Jewish members of this caste, this was the real trauma of the affair: being forced, at last, to see themselves as others had seen them from the beginning, imprisoned in the confines of an identity category that may or may not have corresponded to the people they knew themselves to be. There is a line in Proust's *À la recherche* when the narrator describes the effects of the Dreyfus Affair on Charles Swann, his protagonist, who is also a collector. Along with mortal illness and age, the absurdity of the affair and the pain of the antisemitism it elicited bring about a visible change in Swann. He becomes more manifestly Jewish, almost against his will. 'There are certain Israelites, very shrewd and refined men of the world though they may be, in whom a boor and a prophet remain in reserve, or in the wings, so as to make their entry at a certain hour of life, as in a play,' Proust writes. 'Swann had arrived at the age of the prophet.'[53] For Swann – as it was for the real-life collectors on whom he was based – this was more than a transformation: it was also a form of exile, an exile from which none of them ever quite returned.

In public, many of them fearlessly defended Dreyfus, none more than the Reinach brothers. The three brothers – were all veritable institutions in the fin de siècle to the extent that it would be impossible to write any cultural history of the period without mention of their innumerable contributions.[54] They were politicians, scholars, journalists, and aesthetes whose various

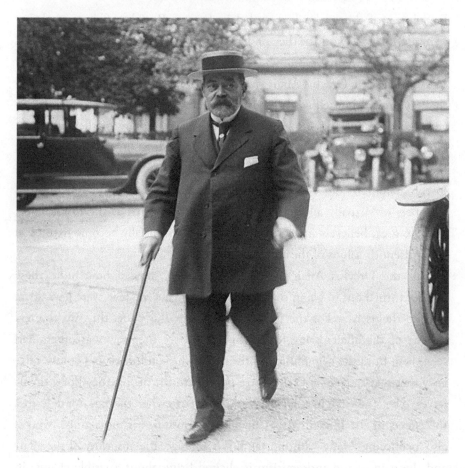

Joseph Reinach (1856–1921).

engagements had brought them to the centre of public life. During the Dreyfus Affair, they wasted no time in championing the cause of the wrongfully accused Jewish military captain in every outlet they could.

Joseph Reinach was among Dreyfus's lead defenders, and Proust mentioned him by name in the epic novel that chronicled the era. 'For him the Dreyfus Affair posed itself only to his reason, as an irrefutable theorem that "demonstrated" with the most astonishing success – success against France, some said – that we have ever seen.'[55] But even in light of his formidable intellect and his dazzling 'reason', Joseph could never quite dissociate himself from the shadows of his uncle and the Panama scandal. This was an association that dogged him – and the family – throughout the affair, a stain they could

never truly escape. After Joseph began publicly defending Dreyfus, Drumont, in a scathing article for *La Libre Parole*, had this to say: 'I declare that Captain Dreyfus's abominable action shocks me barely more than the presence of the nephew and the son-in-law of von Reinach in the French parliament.'[56] Comments like these devastated the brothers, precisely because they could not challenge Drumont on the basis of his attack – their uncle's implication was a fact. But they could challenge his attack on their Frenchness, his sneering use of the 'von' to underscore their German origins. That they could not abide.

It was Joseph who would eventually write an eleven-volume history of the entire Dreyfus Affair, a sprawling saga that remains one of the most authoritative accounts of the episode. But it was his youngest brother, Théodore, a future collector, who wrote some of the most powerful lines about what the wrongful conviction of Dreyfus meant to French Jews as people. It was clear that he identified with Dreyfus and, when he wrote about his case, it was fairly clear that Théodore was writing about himself.

'The supposed criminal was a Jew, a Jewish officer. Or, for one part of public opinion, especially for officers formed by mediocre education and rewarded little by little by an atmosphere where students of the Jesuits set the tone, a French Jew was never a true Frenchman,' he wrote. 'He could belong to a rooted family settled here since long ago; he could be a perfect Alsatian immigrant, having received a completely French education; he could have chosen a profession marked by devotion and sacrifice to the country.' If Théodore's anger was palpable, his words also betrayed a feeling of hopelessness. 'For the men of irreducible biases, [the Jew] remains a man without country, the representative of a race that is everywhere a foreigner and everywhere a parasite, destined by his origins and even divine curse to traffic and treason.'[57]

But, beyond these bold public defences, there are relatively few traces that survive in this milieu's correspondence that reveal how the unfolding of this seemingly endless saga affected their private, emotional lives. Perhaps out of pride, perhaps out of shame, there was relative silence on the subject within the closed confines of this elite, especially in comparison with other elements of the French-Jewish community at the time. But the collective wound would always remain. One document that does evoke this sense of pain is

the memoir of Hélène Fould-Springer, the granddaughter of the collector Léon Fould and the daughter of his son, Eugène Fould, another collector and a close acquaintance of Marcel Proust's. Born in 1906, Hélène had no recollections of the event itself, but she was raised with the memory of the Dreyfus Affair as a lingering shadow over her family's affairs in the 1920s and 1930s.

'My parents had lots of friends who were members of the best social circles in Paris at the time, including members of the aristocracy,' Hélène wrote. 'My father was undoubtedly very snobbish and valued these important friends and connections. Perhaps it was for this reason above all that the social behaviour . . . brought about by "*l'Affaire Dreyfus*" was such a painful shock to my father – a wound which never healed. At that time, even some of his best friends cut him dead in the street, so no wonder.'[58]

For a man such as Eugène Fould, to be 'cut dead in the street' in that way was to be identified as something other himself, assigned an unelected, unwanted role. For the first time, the collectors had become foreigners. It was time to prove their Frenchness.

After 1789, there were essentially two Frances – the France of the Revolution and the France of reaction. The France of the Revolution was devoted to the republic and aspired to transform society in keeping with its universal aims. This was the vaunted province of reason, rationality, and human emancipation – as much an idea as it was an actual place. But the France of reaction was its sworn enemy: this vision was openly hostile to that cosmopolitanism and nostalgic for a past that its partisans never stopped attempting to restore. This was the France that insisted on 'nation' – a rooted, organic community with a decidedly Catholic, monarchical heritage tied to the land and the exclusive tribe to whom it belonged. At least in part, the long nineteenth century in France can be read as an ongoing battle between these two respective visions. Between the Revolution and the Franco-German War, for instance, there were no fewer than three revolutions, five separate *coups d'état*, and two regime changes triggered by military insurrections. What was at stake was the contested identity of a nation and one of the most important theatres of this bitter war

was the realm of objects and things. To control the material traces of the nation's past was a means of controlling its present.

By the fin de siècle, the decorative style of the eighteenth century had come to represent a nostalgic vision of a lost France, a France that embodied the royalist ideals of the ancien régime and that was fundamentally disillusioned with the Revolution and its aftermath. If in its day the style of the ancien régime had connoted wealth and even a certain nonchalance, its nineteenth-century return was accompanied by an unmistakable ideology.[59] This was a point first made by the art historian Francis Haskell in his oft-cited 1976 study *Rediscoveries in Art*, which emphasized the fundamental relationship between aesthetic taste and politics. Political motives, in his view, were the rationale behind a 'rediscovery'. Haskell considered eighteenth-century French painting as a case study, considering its re-emergence in the context of a steady stream of reactionary royalism that only amplified as the nineteenth century progressed. And the same was true across partisan divides: as Haskell showed, the Rococo Revival of the 1840s was linked to the political left.[60] By the fin de siècle, then, the art of the ancien régime was more than art: it had had become an aesthetic signifier for a quiet conservatism, a material embodiment of a value system jeopardized by all facets of modern life – democracy, universal suffrage, and citizenship. To collect in this period was thus to collect the remnants of better days, when France was truly France.

There was also an element of defiance in embracing this particular style. In the aftermath of the Revolution, the outlandish ormolu of the ancien régime aesthetic was considered prime evidence of corruption and, most of all, decadence. Under the Directoire and, later, the Empire, the style of Jacques Louis-David (1748–1825) – Neoclassical and historical – was imposed by the Académie and heralded as the future of French art. At the same time, pre-revolutionary French art of the eighteenth century was vilified not only as aesthetically inferior but also as morally deficient.[61] Between 1801 and 1824, for instance, Charles Paul Landon (1760–1826), a painter and a curator at the newly established Musée du Louvre, published several editions of the *Annales du musée et de l'école moderne des Beaux-Arts*, a series of volumes that featured engravings of the important pieces in the museum's collection. The six volumes devoted to the French school divided the subject into two distinct periods. First came a section that featured the old school, from Jean Cousin the Elder (1500–c. 1593)

to Nicolas Poussin (1594–1665), Laurent de la Hyre (1606–56), and Charles Le Brun (1619–90). After these painters, Landon wrote, 'there was a long interval, a long period of decadence, between the time when art shone in France in all its splendour, and the time when certain painters, some of whom are still alive, gradually brought it back to the noble and true imitation of nature'.[62] For Landon, the painters who returned French art to 'the noble and true imitation of nature' were the likes of Joseph-Marie Vien (1716–1809); those responsible for the 'long period of decadence' were, unsurprisingly, François Boucher (1703–70), Jean-Honoré Fragonard (1732–1806), and, most of all, Antoine Watteau (1684–1721), the master of the so-called *fête galante*. Similarly, Boucher was attacked in the *Encyclopédie méthodique*[63] and also in the Académie de Peinture[64] for perceived frivolity and hedonism.

But, despite these public and even official denunciations, a taste for eighteenth-century art never completely evaporated after the Revolution. As Seymour O. Simches notably observed in his landmark 1964 study of the period, academies and their doctrines could not eradicate the diversity of private individual tastes, even when stigma was applied.[65] Consider, for instance, the case of Dominique Vivant Denon (1747–1825), the director of the newly renamed 'Musée Napoléon', who all but banished eighteenth-century French art from his museum at the same time as he pursued it passionately for his own private collections. The published four-volume catalogue of Denon's collection, the *Monuments des Arts du dessin*, even featured an extensive commentary on the Watteau canvases he owned: *L'Enchanteur*, *L'Aventurière*, and two smaller canvases that now hang in Scotland's Brodick Castle.

Watteau, whose paintings often depicted aristocrats at play in leafy glades, was the epitome of the ancien régime aesthetic that Denon and his contemporaries sought to eradicate. Yet Denon, an arbiter of French national taste, saw much to praise in Watteau's idyllic fantasies of noble life. As he wrote of *L'Embarquement pour Cythère* (*c.* 1718–19) – the only Watteau at the time to hang in Musée Napoléon – its style demonstrated 'a plenitude of ideas that gives it the depth and philosophy of a Poussin composition'.[66] Critical assessment by the likes of Denon had warmed to Watteau, Boucher, and Fragonard, and these artists remained commercially popular throughout the early nineteenth century. As Carole Blumenfeld has written in her study of the Regency style's nineteenth-century 'rediscovery', the Paris dealer Jean-Baptiste Pierre Le Brun (1748–1813)

continued to sell these painters after the Revolution,[67] and prominent French collectors, such as the illustrious Baron de Vèze (1788–1855),[68] continued to buy their canvases.

This gradually resurgent popularity – as well as the association of the ancien régime aesthetic with lost monarchic ideals – only grew in subsequent decades, and it was the Goncourts themselves who enshrined the style as a metaphor for the French nation at the height of its majesty. Eventually, Watteau, Boucher, Fragonard, Vigée Le Brun, and other painters reached a more mainstream audience outside of their initial post-revolutionary supporters, who were mostly confined to the Académie and the upper echelons of French society. But by the mid-nineteenth century, there was, in the words of the art historian Monica Preti, a 'critical turn' in the assessment of eighteenth-century art, in which the previously pejorative term 'decadence' did not disappear but rather changed its meaning, this time to a whimsical wisdom.[69] In the midst of this shift, writers, poets, and historians all began to see value in the art of the ancien régime, especially in the much-maligned *fête galante*. There was a feeling, in this later moment, that the canvases of the ancien régime were deceptively frivolous and yet somehow secretly deep. In the darkness of the clouds over-head and of the forests that surrounded their glades, these canvases evoked a deliberate refusal, on the part of their subjects, to wallow in the inevitable suffering to come.

Without question, it was Edmond and Jules Goncourt who suffused this nostalgia for the 'decadence' of the ancien régime with the sense of a lost French past. It was the Goncourts who transposed the resurgent popularity of this style into the language of an exclusive nationalism. In their time, they were best known for the series of monographs they wrote on eighteenth-century French painters and artists, *L'Art du XVIIIème siècle,* published between 1859 and 1875. These were nothing less than an effort at defining a canon, arbitrating, in a sense, the contours of a national heritage. This subtle project was perhaps most apparent in their study of Jean-François Boucher, the famous lines in which they coined the term 'delicious decadence':

When the century of Louis XV followed the century of Louis XIV, when gallant France emerged from sumptuous France and around the more human royals things and men became smaller, the ideal of art remained an

artificial and conventional ideal; but from majesty this ideal descended to pleasure. Everywhere a refinement of elegance spread, a delicacy of voluptuousness, what was called 'the quintessence of the lovable, the colour of charms and graces; the embellishment of parties, and of love'. The theatre, literature, painting, sculpture, architecture, nothing escapes the adornment, the coquetry, and the kindness of a delicious decadence. That which is pretty – in these hours of light and breezy history – is the sign and the seduction of France. The pretty is the essence and the formula of its genius. The pretty is the tone of its values. The pretty is the school of its fashions. The pretty is the soul of the times, and that is the genius of Boucher.[70]

But the Goncourts' vision of the French eighteenth century was an exclusive vision indeed. Whenever Jews attempted to collect artworks and objets d'art from that period, the storied province of Goncourt's imagination, their collections, in Edmond's view, were inherently and inescapably inauthentic. For Goncourt, this sense of spectacle was even more pronounced in his rather caustic opinions on Rothschild homes and collections. It is perhaps Goncourt's remarks on Edmond de Rothschild – the early Zionist benefactor and a passionate collector of drawings from the Italian Renaissance to the *fête galante* – that betray the essence of his antisemitism as fundamentally material. Even with every imaginable resource available, Edmond de Rothschild could never hope to escape what Goncourt seems to have considered terminal artifice.

Edmond de Rothschild appears in the *Journal* on three separate occasions, in 1874, in 1887, and in 1889: he was an acquaintance, nothing more. Yet Edmond Goncourt considered Edmond de Rothschild – despite the impressive extent of his collections – as the very embodiment of Jewish aesthetic inauthenticity. For Goncourt, Rothschild's home was a veritable theatre and its denizens the performers of a national identity that could never quite be theirs. This impossibility was entirely a function of the material things Edmond de Rothschild may have owned but could never understand. Consider, for instance, the following entry in the *Journal*, from June 1874:

Chez Edmond Rothschild. Truly, it is in these lairs of wealth that one understands the nothingness to which capital leads, even with the help of the advisers that money brings. This is where it comes to poor devils like

me, the pride of what we have done with taste, time, hardship. I was having these thoughts while the young baron, with a conquering air, scrolled before our eyes a score of gouaches, not one of which was honest, several of which – forgive him, spiritual masters of French gouache! – were smears coated with a beastly layer of screen papers. There is, among other things, a *COUCHER DE LA MARIÉE*,[71] which he defended to me . . . no! Basically, these people can only conquer the beautiful in things of industrial art. In pure art, they have to be content with engravings, the white margins of which shout out to them that they are before their times![72]

The language he uses, almost military in its emphasis, ultimately depicts the young baron as an invader of 'pure art': Edmond de Rothschild, we read, has 'a conquering air' and requires his guests to view his drawings in a forced march. The verb Goncourt uses, after all, is not '*exposer*' or even '*exhiber*': it is '*défiler*', a term that suggests a military parade or a march in rank and file. Of the gouaches themselves, he writes that none of them were 'honest' but that many were merely done with haphazard daubs. For Goncourt, Edmond did not and could not know the difference. Thirteen years later, recounting a conversation with Edmond de Rothschild, who by then possessed one of the most extensive collections of French art, Goncourt would formulate the following maxim: 'Rich people can become amateurs, but they will always be poor amateurs.'[73] No Jew, in his estimation, could ever rise any higher.

The nineteenth-century art market was also filled with forgeries, which were often seen as Jewish mockeries of true beauty, peddled by a network of Jewish dealers and Jewish-controlled auction houses across Europe.[74] But on occasion the discerning eyes of the collectors failed to spot these fakes and their failures became public humiliations that only further served to advance the material antisemitism of the moment. Their critics could be especially cruel: a Jew failing to spot a forgery was somehow evidence that Jews themselves were forgeries, pitiful copies of the citizens they aspired to be.

Despite their erudition, despite their prestige, and despite their authority, the Reinachs were not omniscient in the way they were often portrayed and

even at times believed themselves to be. Their public lives were marked by failure and embarrassment as least as much as by success and vindication. Four years after the Panama scandal that had associated their family fame with state corruption, they were implicated in another scandal in the world of the arts, this time over the golden tiara of Saitaphernes, which the Louvre acquired in 1896 for the massive sum of 200,000 francs – partially at their insistence. The problem was that this tiara was ultimately exposed as a forgery, a reality that the Reinachs had failed to see.

Drumont had already attacked the Reinachs' credibility at the Louvre before, accusing Joseph Reinach of convincing the museum to buy three grossly over-priced portraits by Frans Hals. 'The auctioneers depend on the experts, and since most of the experts are Jews, they gather at the Hôtel Drouot to create entirely fictional prices,' Drumont had written in *La France juive*, describing the affairs of France's most famous auction house.[75] But nothing would undermine the Reinach's credibility quite like this counterfeit piece of glittering gold.

Failing to see the tiara as a forgery was a purely human and even under-standable error, albeit one that would have been terminally embarrassing for any scholar or antiquarian. But the stakes were so much higher for the Reinachs, already under fire in the public eye for their uncle's dealings in the Panama scandal and their unapologetic public championing of Alfred Dreyfus, which they began in earnest two years before the tiara had entered the Louvre. There was simply no room for mistakes of any kind, and the brothers initially strug-gled to admit that they were wrong. Entering the Louvre, France's most renowned museum, two years into the Dreyfus Affair, the tiara was ultimately proven to be the work an obscure Jewish goldsmith from Odessa called Israel Rouchomovsky, who later presented himself in Paris and proved beyond any reasonable doubt that the item in question was his work. The fallout quickly became what is arguably the most embarrassing episode in the history of the museum – worse even than the theft of the *Mona Lisa* in 1911.

The scandal began in the spring of 1896, when a pair of obscure art dealers known as Anton Vogel and Schapschelle Hochmann approached the Louvre's curator of Greek and Roman antiquities with a stunning piece of golden jewel-lery that he claimed belonged to a Scythian king in either the late second or early third century BCE. It turned out that the Imperial Museum in Vienna and the British Museum in London had already turned down the tiara on the

grounds that it could not be real, but somehow the Louvre was convinced – although exactly how remains unclear.

Decades later, Salomon Reinach, who at the time was the president of the Louvre's *conseil scientifique*, the body that approved the museum's acquisitions, claimed that in fact he had been the only one on the committee to vote against the tiara. But this was demonstrably false: he had merely been absent that day, deep into a Mediterranean cruise with colleagues from the École Française d'Athènes.[76] In any case, his alleged opposition to the tiara is highly suspect: it was Théodore who secured the necessary funds for the museum to complete the purchase, including 100,000 francs of his own money. In a sense, the tiara was as much a Reinach acquisition as it was a Louvre acquisition.

The trouble began in the autumn of that same year, when the renowned German archaeologist Adolf Furtwängler wrote an article in *Cosmopolis*, a leading journal in the discipline, disputing the tiara's authenticity. Chief among his concerns were that its Greek inscriptions were done in epigraphic characters, which was not common in the time period in which the Louvre had claimed the tiara was produced.[77] The Reinachs refused to listen, seeing Furtwängler's article as a personal attack, and possibly even as revenge. Ten years earlier, Furtwängler himself had been fooled by a forger who had sold him fake terracotta pottery allegedly from Asia Minor for the Berlin Museum. At the time, it was Salomon Reinach who had uncovered those pieces as fakes.

Théodore Reinach immediately defended the tiara – and his brother – in a long article for the *Gazette des Beaux-Arts*, a rambling screed remarkable for its condescension and its lack of charity to a fellow scholar. It was essentially an ad hominem attack on Furtwängler. 'I wonder if we weren't a bit naïve in taking so seriously an article not really worthy of Mr Furtwängler's reputation, both in terms of the lightness of its substance and the heaviness of its form,' Théodore wrote. 'He already had among his liabilities recurring errors, which have made us suspicious in the past.' His conclusion was even more arrogant: 'Do not despair of seeing the fiery adversary of the tiara d'Olbia one day position himself among its warmest defenders,' he wrote, in a jab at what he considered Furtwängler's chameleon nature. 'Let's even hope – for him and for us – that this conversion will not be too long in coming. Because, frankly, another campaign of this kind would turn Mr Furtwängler's opinion on authenticity into a trifling thing.'[78]

In March 1903, a Montmartre jokester declared that he was the creator of the Louvre's new showpiece – a fanciful claim the French press repeated in reports that somehow reached Odessa, where Israel Rouchomovsky still lived and worked. The well-established forger presented himself to authorities in Ukraine as the creator of the tiara, and he was ultimately summoned to Paris for a full interrogation. The Reinachs were still reluctant to admit that they might have made a mistake, although as respected scholars they of course agreed to a full investigation. But as the evidence mounted against the golden crown, Salomon's defences grew more and more desperate: 'articles in gold, manufactured in Russia, have to bear the government stamp', he wrote in *L'Anthropologie* in 1899, in response to one critic. 'The tiara bears no stamp.'[79]

Both the Louvre and the French government were determined to get to the bottom of the affair as quickly as possible and they appointed the archaeologist Charles Clermont-Ganneau to interview Rouchomovsky. The forger then identified every character in the complex web that had brought the tiara from Odessa all the way to the rue de Rivoli, the storied address of the Louvre. As these details began to emerge in the press, Salomon still refused to be wrong – or even to remain silent and out of public view. He sat for an interview with *Le Temps* after the first reports of Rouchomovsky's interrogation appeared, and he allowed the newspaper to identify him as 'one of the promoters of the tiara's purchase'. Salomon used the conversation as a means of advancing his theory that Rouchomovsky had indeed worked on parts of the tiara, but merely for repairs. 'I've always thought that a significant part of the tiara was authentic,' he declared at the end of the article. Its alleged falsehood could only be proven the day Rouchomovsky could convince the government 'not merely that he had it in his hands and that he worked on it, which was already known in 1896, but that he built it following a model and can reproduce that model'.[80] That day came almost immediately thereafter: Rouchomovsky rebuilt portions of the tiara from memory, including with intricate patterns that Clermont-Ganneau had not even noticed the first time but that were indeed visible on closer inspection. The tiara was officially a fake, and it was promptly withdrawn from public view.

In the midst of the Dreyfus Affair, the tiara scandal was a perfect storm for the further proliferation of the antisemitism already so entrenched in public discourse at the time, and which the Reinach brothers had devoted so much energy to refuting. Everyone in the story was Jewish: Israel Rouchomovsky,

who had made the tiara; Anton Vogel and Schapschelle Hochmann, who had sold it to the Louvre; and Salomon and Théodore Reinach, who had defended it against its critiques long after that position had become indefensible. The Reinachs ultimately admitted their mistake, but it was too late for the court of public opinion. Joseph Reinach was well aware of the stakes at play and he was furious with his brothers for risking so much on a piece of fake royal insignia. 'You and Théodore are ending up on the billboards of the antisemites,' he wrote to Salomon in 1903, after his interview with *Le Temps*.[81]

Joseph was right. The antisemitic press – and Drumont's newspaper in particular – revelled in the failure of the Reinachs, 'men so sure of themselves and so well placed to be informed'.[82] *La Libre Parole* wasted no time in weaving Salomon into what it presented as a conspiracy of 'cosmopolitan Jewry' to embarrass France, hatched in Odessa but with operatives all over Europe. The key, the newspaper wrote, was Salomon's wife, Rose Margouleff, who was born in Odessa and whose family remained there. But beyond the baseless slander, there were criticisms in the article that were harder to refute. 'Ever since the appearance in Paris of this allegedly famous object, the Reinach brothers cried out what a wonder it was and demanded its immediate acquisition by the Louvre.'[83] The Reinachs, *La Libre Parole* concluded, 'were the principal protagonists' of the affair. That much, at least, was almost impossible to deny.

The brothers' obstinacy had left them vulnerable to attack, and they were ultimately ridiculed as the Jews of Drumont's description: incapable of perceiving aesthetic authenticity and embroiled in an international Jewish plot to destroy France's national institutions from within. Postcards and cartoons quickly began circulating shortly after the tiara was exposed as a fake that clearly presented the Reinachs as peddlers of falsehoods. One of them depicted a hunchbacked Jewish merchant with a caricatured nose staggering through the Louvre. 'To replace the fake Saitapharnes crown, I'm offering the crown worn by His Majesty Panama I,' the caption read. 'And I guarantee you it's authentic!' Panama was an obvious allusion to Jacques de Reinach. But perhaps even more telling was the painting in the peddler's hand: a portrait by Frans Hals, the same one Joseph had been accused of profiting from more than a decade before. In the years to come, the Reinachs and the others in their milieu would respond to their critics, a rejoinder crafted out of the art and the objects they were told they could never understand. This was a fight they refused to surrender.

'APOGEE OF THE *ISRAÉLITE*'
JEWISH COLLECTORS AND THE FIRST WORLD WAR

The writing – quite literally – was on the wall. By the late afternoon of 1 August 1914, Germany and Russia had declared war on each other, and President Raymond Poincaré signed a general mobilization order that police officials immediately posted on street corners and windows all throughout France. In the cities, the news spread instantly, by word of mouth, running like fire through the cafes and *grands boulevards*. But in the unknown villages of the soon-to-be destroyed rural France, the word came slowly. Local mayors suspected what was coming, and many of them spent the entire afternoon by the telephone waiting for the call, which came in the late afternoon. They, too, put up the mobilization orders, soon attached to nearly every town hall, school, and post office throughout the country.[1]

These posters – thin pieces of paper, no more than three feet by two-and-a-half feet – were a shock, a call to arms that the French public had not been expecting to hear, and certainly not so soon. Every day since 28 June, when Archduke Franz Ferdinand of Austria had been assassinated on the streets of Sarajevo, the Paris papers had followed each detail of what they interpreted as a grave threat to Europe's political order. But at no point in France had war seemed inevitable.[2] If images survive of patriotic jubilation – celebratory crowds flying *le tricolore* at the Gare de l'Est; drunken renditions of 'La Marseillaise' and 'Le chant du départ' late into the night – these were hardly expressions of a widespread sentiment.

Marc Bloch, the great medieval historian who was 28 in August 1914, and was himself called to serve, described the atmosphere in Paris on that langourous afternoon as already funereal. 'The city was peaceful and a bit solemn,' he would later recall. 'With traffic reduced to a halt, the absence of buses and the scarcity of taxis made the streets almost silent.'[3] Shop owners immediately

began pampering the soon-to-be soldiers due to be deployed, but nowhere was there joy. 'The men for the most part were not cheerful,' recalled the historian. 'They were resolute, which is better.' For Bloch – whose diary entry from that day recorded only the contents of his pockets[4] – the point was this: 'The sadness at the bottom of all hearts did not show.' The writing on the wall left no time for sadness: beginning the following day, all able-bodied men in the nation's extensive military reserves were to report for active duty. War had come to France after all.

For many French Jews, the military had long held a special significance. In the face of a constant antisemitism, it was there that one could most emphatically prove one's patriotism. And the military provided an ideal means of demonstrating one's gratitude to the republic. There was much to be grateful for, or so it seemed. During the Revolution, France became the first nation in Western Europe to have legally emancipated its Jews, and the Napoleonic conquests that soon followed spread that egalitarian sentiment throughout much of the continent. Although antisemitism persisted throughout France's long nineteenth century, and often at a fever pitch, the state itself – in theory if not actually in practice – was nominally indifferent to the ethnic and religious origins of its Jewish citizens. As a result, by the time of the Third Republic (1870–1940), there was the distinctly French phenomenon of what the sociologist Pierre Birnbaum has called the '*juif d'état*', the thousands of 'state Jews' who entered the civil service as judges, parliamentarians, and cabinet ministers. With the election of Léon Blum in 1936, there was even a Jewish prime minister, which made France the first country in modern European history to be led by a Jew who was not required to convert in order to hold power.[5]

Granted, the Dreyfus Affair had shaken the foundations of this egalitarian mythology, and the French military was central in what soon became the most significant episode of political antisemitism in modern Europe before the Holocaust. Alfred Dreyfus, after all, was an artillery officer and a member of the military's General Staff, and it was the army's counter-intelligence service that launched the affair by wrongly accusing him of treason in 1894. Two years later, central command then covered up new evidence exonerating the Jewish captain, who served more than four years in abject conditions on Devil's Island, a penal colony off the coast of French Guiana. Fully exonerated in 1906, Dreyfus – against all odds – continued to serve, although the military refused

to count his time in prison toward his seniority and status. As he wrote to his wife, Lucie, from Devil's Island in 1896: 'I have accepted all, borne all, without a word. I am not boasting; I merely did my duty, and only my duty.' Well into his mid-fifties, Dreyfus saw front-line combat at Chemin des Dames and at Verdun, the largest and longest battle of the war.

Antisemitism continued in the military, especially against Jews of German origin. Léon Daudet, who had hounded many of the collectors before the war, wrote in 1913 that the effect of the Dreyfus Affair had merely been to launch 'a veritable invasion, the creation of an anti-France at home'.[6] But a number of French Jews at the time appear to have seen the conclusion of the Dreyfus Affair as evidence of vindication – and even, perhaps, of progress, rather than of endemic bigotry in the upper echelons of the military. Although the republic had humiliated and unjustly convicted a French citizen merely because he was Jewish, what mattered most in the eyes of many Jews was that the French state had come to its senses and taken the side of the Jewish officer, who died in 1935 having won the Légion d'Honneur, the highest order for military merit. For many, this was evidence of an inexorable bend towards justice, however imperfect.

The First World War, coming as it did on the heels of the affair, provided the ideal opportunity to continue the reaffirmation of Dreyfus's stolen dignity, as well as to honour the government that had ultimately given it back. If service was mandatory, for the *juif d'état* there was almost a sense of romance in conscription, and the military remained a prestigious career path for French Jews well into the interwar period.[7] Georges Wormser, who later led Clemenceau's cabinet and became the official head of France's Jewish community in the late 1940s, put it this way in a letter to his parents in 1914: 'I am fulfilling my duty as a Frenchman and as a Jew who cannot forget what France has done for his race.'[8] Georges Lévy, a parliamentary deputy and prominent member of the French Communist Party, invoked Jewish 'duty' in precisely the same way in a memoir he published after the war: 'I have done my duty, and for an Israelite, it's twice as good.'[9]

For the elite milieu of the collectors, the First World War was the moment when they definitively proved their Frenchness – at least in their own eyes. As the historian Philippe Landau has written, the experience of the Great War 'constituted the apogee of the *israélite*, when Jews considered themselves defin-

itively emancipated and integrated into the nation'.[10] In this network of families that had maintained cosmopolitan ties across Europe, each family joined the French war effort: Adolphe, Julien, Léon, and Théodore Reinach; Charles and Robert Cahen d'Anvers; James de Rothschild; and Nissim de Camondo. They converted some of their homes, most notably the Cahen d'Anvers estate at Champs-sur-Marne, into makeshift military hospitals, and their wives and daughters worked as nurses throughout the long and brutal conflict. They belonged to France, and they were willing to sacrifice their most precious possessions for its future.

Despite the public prominence of these families, the war was also the moment when they were forced to confront the extent of their own powerlessness, not to mention the further unravelling of a Jewish world already disappearing from within. Some of the families would pay the ultimate price. Adolphe Reinach was killed in combat in the Ardennes in August 1914; Nissim de Camondo was shot down in aerial combat somewhere over Lorraine in September 1917. As they were for every grieving family, these deaths became lingering traumas, a reminder of life's cruelty and unpredictability even for those with great wealth. For a number of the collectors, the war was the moment when they withdrew from public life, seeking solace in the immutable harmony of objects and things.

On the day the mobilization order was posted, Nissim de Camondo, at the age of 23, had recently completed his three years of compulsory military service and had just entered the civilian reserves.

In a sense, he had no choice over what soon followed: perhaps inevitably, his father had pushed him into banking, in the hopes that the young man would one day take over the family business, I. Camondo & Cie. To that end, Moïse had secured for his son a job in securities at the Banque de Paris et des Pays-Bas, later known as Paribas, the bank controlled by his Cahen d'Anvers grandfather. This was in many ways a natural, and even predictable, place for Nissim to learn the industry: his great uncle Abraham Behor de Camondo, as well as his uncle the famed collector Isaac de Camondo, had both previously sat on the bank's board. Besides, this was generally how finance was taught

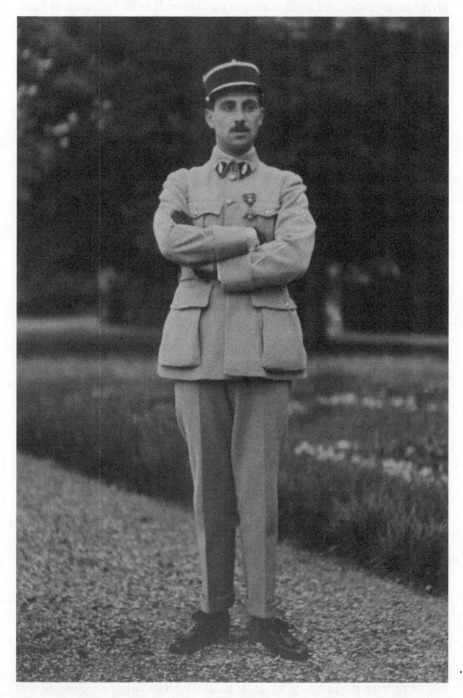

Nissim de Camondo in uniform during the First World War, November 1915.

at the time. There was no formal university education; one learned through apprenticeship, and typically through apprenticeship within a tight network of already deeply entwined banking families. If Nissim was working for Jacques Kulp, the director of Paribas, Kulp himself had done the same in Frankfurt a generation before, working for his uncle Isaac Low Koenigswarter.[11]

Little survives to describe Nissim's interest in – or indeed his aptitude for – the world of high finance. But what can be said is that the heir to the Camondo fortune had never asserted himself as a particularly engaged or motivated student. When he was of age, Moïse had sent Nissim to the Lycée Janson de Sailly, the famed republican institution in the 16th arrondissement of Paris, not too far from the rue de Monceau. Again, this was something of a predictable choice: not only had the school's administration been forceful in condemning antisemitic prejudice in the wake of the Dreyfus Affair, but it was also a pillar of the elite, a place that transformed the sons of the haute bourgeoisie into men of consequence. And indeed the school produced many of the most notable men of the French twentieth century – ministers, presidents, writers. But, from his records there, it was never clear that Nissim was destined to join their ranks, even if he did show some talent in German and the natural sciences. As his report card read, with the classic honesty of a French instructor: 'Intelligent student, but frivolous and idle. Could have done better.'[12]

From the letters Nissim wrote to his father from the front, there is the sense that the war was a relief, an escape from a listless existence. This was clear in the first letter he wrote home to Moïse, on 3 August, three days after the mobilization of the troops. 'Everyone is enchanted, the morale is fantastic and the men only fear one thing – inaction. The regiment has only been here for three days, and already we are getting annoyed.'[13] What emerges most of all from Nissim's correspondence is a hunger for adventure and even for consequences of any kind. He had the typically cavalier bravado of a young man of his age. The worst fate he could imagine was not death but dying without glory. 'To die is nothing, I wait for it every day,' Nissim wrote to his girlfriend in November 1915. 'Those who return intact are rare, but I want to die in beauty with the halo of happiness on my forehead and confidence in my heart.'[14] His wish would soon be granted.

Years later, long after his son's death, Moïse confessed that, from the very beginning of the war, he had been wracked with a crippling sense of foreboding. As he wrote to a friend: 'a sombre presentiment, almost a certitude,

was anchored in my mind, but, with time passing, the years unfolding gave me a certain hope – unfortunately, that was false'.[15] Knowing his father well, Nissim would most likely have sensed that Moïse, who had carefully chosen not only every single object in his collection but also its specific place in their home, was struggling to endure a catastrophe far beyond his control. So in his letters home he appears to have given his father a sense of illusion, a reassurance that all was not lost and that their tightly knit world would survive even despite an epic disruption.

In his letters to Moïse and Béatrice, Nissim narrated the war almost exclusively through the lens of its impact on their milieu. As he wrote to Beatrice in November 1914: 'The death of Robert Aboucaya[16] is heartbreaking, but I already knew it, unfortunately, from Julien Reinach[17] who, being on duty at Division Headquarters, was fortunate the other night to be able to telephone home to Paris for a long time. He was able to speak with Hélène,[18] Gabi, Hélène Kann, Louis Raynal, etc. He's a lucky guy.'[19] The letter is a testament to the way that members of this milieu remained in constant contact during the war, and knowing that Nissim had already been in touch with other members of their community would probably have calmed an already anxious household. 'I met Charles Cahen d'Anvers,' Nissim wrote to his father in September 1915, referring to his uncle, who served as an elite reconnaissance pilot, a rank Nissim envied and aspired to achieve. 'His squadron is very close to here and I even went to lunch with the airmen; they do very useful work, especially through photography.'[20] The subtext is clear: the young man was being looked after.

When tragedy did ultimately strike the community – and it struck very early – its social bonds were seemingly drawn even tighter. The first family to be touched was the Reinachs, a quintessentially republican family that had embraced the war effort with aplomb. Théodore, the youngest of the brothers *Je Sais Tout*, was the only one of that generation young enough to serve, although he completed his assignment – as an engineer – in the United States. His sons Léon and Julien served in the French Army – Léon in Thessaloniki and Julien in France, winning a Croix de Guerre in 1914. But their cousin

Adolphe, who was known as 'Ado' in the family, died in the Ardennes almost immediately after the outbreak of the war. The French state remembered him as a sous-lieutenant in the 46th infantry regiment, but by the time of his death, at age 27, Ado was already a typical Reinach, well on his way to a distinguished academic career. He was also already a respectable *père de famille*, a pillar of French-Jewish society in the making. He had married Marguerite Dreyfus, the niece of Alfred Dreyfus, whom his father, Joseph, had defended all throughout the Dreyfus Affair, and they had one son, Jean-Pierre Reinach, born in 1915. Like his father, Jean-Pierre would also die at war, aged 27, fighting for the French Resistance in 1942.

By 1914, Ado was already an accomplished archaeologist and Egyptologist, when he died, having published several monographs and participated in several successful digs in Egypt. Ado is credited with having discovered the Coptos Decrees in 1910–11, which ultimately entered the collection of the Metropolitan Museum of Art in New York.[21] But, before he went off to war, the young man was working on what was to be his major debut in the world of letters: an edition of all known Greek and Latin texts pertaining to ancient paintings. The project – *Textes grecs et latins relatifs à l'histoire de la peinture ancienne* – was originally the initiative of the French academic painter Paul Milliet, who wanted an accessible edition for the lay reader. When its initial editor could not complete the project, Ado, then 24, jumped at the opportunity. At the start of the war he had not yet finished, and he seemed to sense that he might never be able to, leaving behind detailed instructions on where to take the manuscript from there. 'In this way, even if I die, the first volume of our *Recueil* could still appear,' he wrote to his editor.[22]

Ado's death, less than a month after the start of the war, was a shock for the tightly knit Reinach clan, some of whom never quite recovered. Hélène Reinach-Abrami, Ado's cousin, who had been raised with him in the family compound in Saint-Germain-en-Laye, wrote in a letter shortly after he died that his disappearance was an experience of 'despondency, despair, and the cruellest time I have known in my life'.[23]

Through his grief, Salomon Reinach, himself a celebrated archaeologist, refused to allow his nephew's oeuvre to remain unfinished. He took over Ado's project, picking up where he had left off. Ado had long sought his uncle's approval and in Salomon's introduction to the final edition of the book, which

he finally published in 1921, the old man confessed he had initially doubted his young nephew's abilities. 'He did not seem to me to possess the maturity of spirit necessary to take in hand the heavy work necessary,' Salomon wrote.[24] But the famously exacting Salomon admitted that he was impressed by Ado's work, albeit in his own way. 'I have confidence, in any case, that the world of letters will not judge useless, reading the present volume, that which Adolphe Reinach justly called his "enormous labour" – there is something in it.'[25]

Salomon's ultimate tribute to his nephew was to treat his death as an event in history and to examine it with all the available traces, however scarce they were. 'Of the final moments of his brave boy, we will probably never know anything. At that time of the war, the German brutes assassinated the injured, stripping them of all, and taking care to collect all their medals.'[26] All that could be done was to imagine Ado's demise, as his body would never be recovered. Salomon concluded his introduction to his nephew's volume with a line from Pericles, in the original Greek: 'But what does a tomb matter when something of the oeuvre survives?' Salomon asked. 'πᾶσα γῆ τάφος'.[27] (The whole earth is a tomb.) The rest of that line from Pericles goes as follows: 'The whole earth is the tomb of heroic men, and their story is not given only on stone over clay but abides everywhere without visible symbol, woven into the stuff of other men's lives.' This was Salomon's way of saying that Ado would always be with them.

Nissim de Camondo went to great lengths to reassure his father and sister that he would never meet a similar fate. He entertained them with amusing stories and gossip about their milieu, which seems to have been a deliberate attempt to convince Moïse that he still considered himself a part of that world, however fractured it may have been. Consider, for instance, his letter to his father after he learned of Julien Reinach's injury, a note that expresses sympathy with his friend as well as his continued allegiance to the collective structure in which both of them remained inscribed:

I will write to you in more detail when I have details and when I am there. I already knew from the newspapers about the death of Monsieur Decori

and Madame Éphrussi, and I will write as soon as I have a minute. As for Julien Reinach, I did not know he was injured, and I hope that he will recover completely. As for Father Joseph, he was not at all mistaken; I asked him for the complete phonograph and I am not at all angry; but I understand your astonishment, however, because there is something to surprise the people inside.[28]

'Father Joseph' is Joseph Reinach, a long-time friend of the Camondo family. The exchange Nissim describes is unclear, but its triviality was its own kind of reassurance. He may have been at war, but there was still time for internecine squabbling.

Perhaps even more striking in Nissim's letters home is the lengths he clearly went to in order to show that the sensibilities of their rarefied world also remained intact, even in the trenches. This was most frequently conveyed in his numerous messages to Béatrice about horses, her great passion. Commenting at random on the specimens he saw in action seems to have been Nissim's preferred method of suggesting that at least some degree of normalcy would survive. 'My dear dear little Bella,' he wrote to his sister in October 1914. 'This morning there was a review of horses by the Colonel. Of the 32 horses we had when we left, 11 remain and the other 21 are horses that we have received since; needless to say, they are the disparate role models.'[29] This, it would follow, was the only news of the day: 'The pretty grey horse of Baudrier is the joy of the non-commissioned officer and the large Valon mare is ridden by an officer. . . . Well, my old Bamboula, lots of news for today . . .'[30]

The young soldier also cabled home a number of comments that evinced the snobbery of his world, especially in mocking other Jews he encountered who were not quite of his station. In July 1917, for instance, Nissim wrote to his father from Vichy, where he was recovering from appendicitis. Still on medical leave, he recounts meeting Jacques Seligmann (1858–1923), his father's great friend and principal antique dealer, presumably at the Grand Hôtel du Parc, and being introduced to Seligmann's innumerable acquaintances:

My dear Papa, J. Seligmann, the dealer, accosted me this morning and, with a determination and remarkable wit, succeeded, despite all my resistance, in introducing me to all the people he knows in the hôtel; and God

knows if he really knows any of them! These are all fourth-class Jews with German accents or, by contrast, exotic princes with ridiculous names. Their age varies between 65 and 75 and as for their wives, it's almost best not to mention them because, despite their respectable age, they are all dressed in sky blue or pale pink.[31]

Moïse would doubtless have appreciated the dismissive asides: he had no time for the 'fourth-class Jews' who had recently begun to arrive in Paris in growing numbers.

But all through his years at the front, Nissim did not tell his father the full truth. Moïse's illusions of control over his family would later be shattered even further: just as Irène had done a generation before, by marrying Carlo Sampieri and leaving their Jewish world behind, his beloved son and heir had been planning on leaving their community all along. Nissim intended to marry a woman who was neither Jewish nor of their class: yet another blow to the way of life his father had so painstakingly tried to curate and the traditions he had tried to protect.

On New Year's Day 1915, the young Count de Camondo fell ill. He had suffered from appendicitis in the past, a malaise that had seemingly subsided, but the pain returned in a crippling wave. In a routine letter, Nissim reported to his father that he was not feeling well, but hid the severity of the situation. 'Since your visit I've been a bit under the weather,' he wrote, discussing instead the general morale of the men. 'Life is monotonous,' he noted. In reality it was not.

On 6 January, Nissim was sent from the front for an emergency consultation with military doctors at Saumur, a medieval town in western France perched on the banks of the Loire. Once he was diagnosed with acute appendicitis, and the doctor had recommended an operation, Nissim struggled to convince the military medical staff to authorize a return to Paris. 'Let Papa know without throwing him into a panic,' he wrote to Léonce Tedeschi, Moïse's trusted secretary. 'You have no idea how difficult all of this is.'[32] His wish was ultimately granted: Nissim was evacuated on 15 January and sent to the capital, where he was committed to

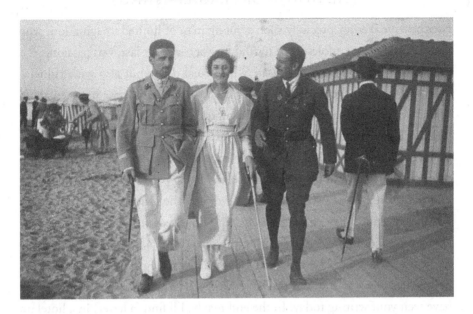

Nissim de Camondo and his lover, Renée Dorville, at Deauville with a friend, August 1917.

the auxiliary hospital at 28, rue Georges-Bizet, not far from the rue de Monceau. Doctor Antonin Gosset, the head of the military's surgical division, performed the operation ten days later. Nissim was lucky to survive.

It remains unclear at which point during his convalescence Nissim de Camondo met Renée Dorville, by all accounts his first love. She was a nurse with the Red Cross, and in the few photographs that survive of her she appears almost as the cliché of a young man's idea of beauty: tousled, unkempt hair, piercing eyes, and a figure almost perfectly Greek in its proportions. The two met at some point during Nissim's recovery in the early spring of 1915, spent between Paris and the thermal baths at Vichy, and shortly thereafter they became lovers.

The tone of his letters to Renée presents a striking departure from all of the other correspondence that Nissim left behind. With her, he almost never recounted the facts of his wartime experience, as he did to both his father and his sister. With her, he was raw, as consumed by emotional insecurity as he was comforted by the prospect of unadulterated intimacy. 'Let us leave pretty women to men with no imagination,' Marcel Proust – a frequent guest of Nissim's grandmother and a passing acquaintance of his father – would

later observe. Yet for precisely such a young man of limited imagination, who had struggled since adolescence to find his way, here, at last, was passion.

Nissim's letters to Renée pulsate with sexual desire but also with vulnerability. As he wrote to her on 4 April 1915, in the first letter between them that survives, he fantasized about the nights they had spent together in the small apartment she kept in the Square Thiers in Paris. 'What I wouldn't give to have you in my arms, to make you vibrate all over under my caresses and to take you all panting on the edge of the bed, kissing you just the way you like.'[33] Four days later, he assured her of his devotion: 'the touch of another woman horrifies me, and I beg you rest assured and don't fear other women here; they are non-existent to me'.[34] A week after that, on 15 April, writing from the Café de l'Univers in Tours, he chastised Renée for ignoring him for so long, and begged her to write to him soon: 'if you knew how much sadness I feel not to have seen your writing today! In the end maybe I'll find [a letter] in a hotel on the way back?'

By November of that year, back at the front, he was consumed by an almost theatrical insecurity. 'It's terrible on your part to make me suffer like this, and I want you so badly. Today is Friday, and you haven't written to me any more after Wednesday and Tuesday night,' he wrote, telling her that the captain of his regiment had told him that he was lucky to receive as many letters from a woman as he did, after nearly a year at war. 'In my blindness I was putting you on a pedestal above all women and venerating you like a goddess,' Nissim wrote. 'And *voilà*, for a month I've been receiving fewer and fewer letters and for four days I've received nothing. What to think? What to say? What to do?'

For someone with a family background that included a spiteful divorce and the abandonment of a mother, Nissim seems to have struggled to accept that Renée may have expressed her affection differently. Even during a war, he interpreted any silence as dismissal. 'Love is blind,' he wrote:

I love you and I can't pay attention to my suffering. I've just reread your letters and I cannot admit that such tender, scorching phrases of love are not sincere; that would be too horrible; I can't believe it. But how to explain your silence? Work? I'd like to think so, but you would never have me believe that in going out to dinner in a restaurant or in even dining at your

place, you can't find a few seconds to tell me: 'My dear Nini, I love you, I think of you, I promise myself to you.'[35]

By September 1917, he proposed marriage to Renée, but he seems to have had his doubts that summer. 'If peace came, our life would be hell, because you would probably stop being obedient – something I would never tolerate,' he wrote to her.[36] After his death, she came to the rue de Monceau and introduced herself to Moïse. He paid her a share of Nissim's inheritance with the understanding that she never contact the family again.

For French Jews as a whole, the First World War was the moment that crystallized their sense of belonging to France. In the memorable words of the historian Philippe Landau, the war was 'the apogee of *israélite* sensibility', the moment when Jews definitively considered themselves emancipated in the spirit of 1789 and fully integrated into the nation.[37] But for Jewish elites – many of whom had extensive family ties across Europe – the war was also an experience that tested and in some cases even advanced their decidedly cosmopolitan and fluidly European identities as much as it reaffirmed their commitments to France.

This was most clearly the case for the Rothschilds, whose sons fought on different sides of the conflict – and sometimes for different armies in quick succession. Edmond de Rothschild's son James, for instance, who would later continue his father's philanthropy in Israel after its establishment, first fought for France before managing to enlist in the Canadian Army and the British Army, respectively. James was naturalized as a British subject in 1920, and he ultimately served as a Liberal Member of Parliament for the Isle of Ely constituency between 1929 and 1945. But there were other Rothschilds on the opposing side of the war. James's cousin Eugene Daniel von Rothschild, of the family's Austrian branch, served for Austria, shattering his leg on the Russian front. But, after the war, Eugene moved to Paris with his American-born wife, and ultimately to New York and Monte Carlo.

The family judged that the best course of action was for each of its branches to serve their respective home countries. A remarkable letter has survived, sent

by Nathaniel, Lord Rothschild of the family's London branch, to his French cousins on 4 August 1914, shortly after Britain had declared war. 'Leo's three boys who are in the Yeomanry have been called upon to form their regiment, so you see my dear Cousins, with us as with you, everyone is called upon to do his duty,' he wrote. 'And in this very painful episode it is at all costs satisfactory to know that you and ourselves are standing shoulder to shoulder. Always yours with affection, R.'[38] The 'three boys' he mentioned were Lionel Nathan de Rothschild, Anthony Gustav de Rothshild, and Evelyn Achille de Rothschild, all of whom served as officers in the Bucks Yeomanry. Anthony was wounded at Gallipoli and was rewarded with a distinction at the end of the war; Evelyn was killed in a cavalry charge at El Mughar in Palestine in November 1917.

For other families in this milieu, relations abroad were called on to facilitate temporary escapes from war-torn France, especially for the women and children who were often sent to stay with family in Britain or in neutral locations elsewhere in Europe. Charles Cahen d'Anvers – the uncle of Nissim de Camondo and the eldest son of the collectors Louis and Louise Cahen d'Anvers – ended up a decorated war hero in 1918, having served six months in the 22nd artillery regiment and then, like his nephew, several years in the elite airborne reconnaissance division. He served in Artois, the Somme, and Verdun, and he was eventually awarded the prestigious Légion d'Honneur, France's highest military honour. But he sent his children, Gilbert and Colette, to the British countryside to stay with his sister Lady Alice Townshend, the wife of Charles Townshend, at their estate in Norfolk.

In the unpublished memoirs he wrote in old age, Gilbert recalled that the four years he and his sister spent with their aunt in England ultimately made him feel British. 'We each had a Shetland pony and a tricycle,' he wrote. 'Nanny gave us a good and true "Victorian" education – cooked and copious breakfasts, long walks, and, from time to time, a smack on the bottom to maintain discipline. We loved Nanny tenderly, and she stayed with us until my sister and I married.'[39]

In some families, immense wealth created the manifest impression belief that their fates were insulated from the vicissitudes and the vagaries of history. This seemed to be the case for the Foulds – by then the Fould-Springers, following the marriage of Léon Fould's son, Eugène, to Marie-Cécile Springer,

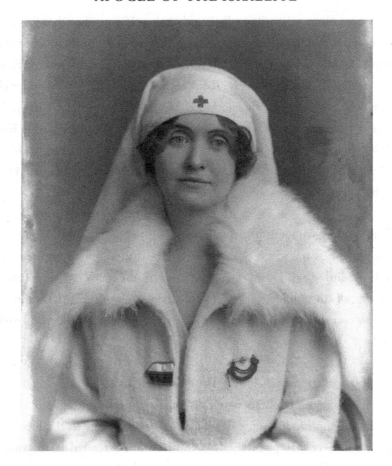

Alice Ferrers Townshend (née Cahen d'Anvers), Lady Townshend.

at the time of her birth the wealthiest woman in central Europe and heir to a colossal Viennese grain fortune. Cosmopolitanism was the essence of their lives. In one household, there were two distinct nationalities, five languages, and multiple landholdings, primarily in the eastern Habsburg territories that straddled the borders of different regions and that therefore could not be identified in terms of a single national polity. As their daughter Hélène Fould-Springer later recalled in her English-language memoirs: 'My mother considered the Orient Express and the Gare de l'Est like her own possessions.'[40] In a sense, they were: the life of Marie-Cécile's family depended on constant motion and mobility.

For them, the Great War of 1914–18 was experienced primarily as an inconvenience, an external circumstance that had required them to concentrate their

business operations primarily in Paris rather than Vienna, but that was other-
wise the opposite of an existential threat to themselves or to their own rarefied
existence. As Hélène would recall in a separate memoir she wrote in French,
Absents de nous-mêmes (1961), she spent a great deal of the war with her elder
brother, Max, at the Baur au Lac Hotel in Zurich, a neutral territory. As it
happened, the transience of a hotel was an especially appropriate setting for the
family's experience in the war, which was essentially a holiday from history,
during which the children could run free outside and the adults could while
away the hours at cards:

> Years went by without our being aware of all the horror surrounding us.
> The war for us was Papa's postcards, Mama's worries, the leaves, the map
> with the little flags. During the great event of the 'raids', so appreciated
> by us, all the children then found themselves on mattresses in a
> narrow corridor on the ground floor. The parents and grandparents played
> bridge.[41]

But in most other French-Jewish families, even those of great wealth who
relied on their cosmopolitan networks across Europe throughout the war,
there was still a profound sense of obligation to contribute to the French war
effort in whatever way possible. This contribution extended far beyond the
participation of their men at the front, although their involvement was of
course the greatest sacrifice and their deaths would remain traumas that
lingered for decades. But in a few instances, their homes and their collections
became part of their respective contributions, as they offered some of them to
the government as temporary military hospitals. These were the same private
spaces they had designed precisely in order to withdraw from the scrutiny
and the hostility of the outside world, but during the First World War these
refuges became inextricable parts of the French campaign. So, too, did their
custodians.

One example was the Château de Champs, the Cahen d'Anvers home at
Champs-sur-Marne. This had once been the storied residence of Madame de
Pompadour, which Louis Cahen d'Anvers had painstakingly renovated in all
its eighteenth-century grandeur after he bought the house in 1895. 'It was only
after I reached the age of twenty that I began to appreciate the beauty of this

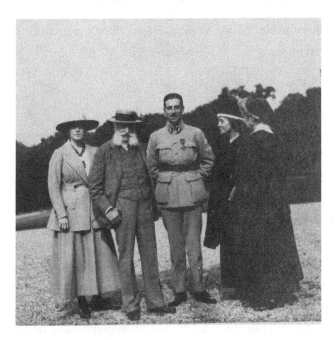

Nissim de Camondo, Béatrice de Camondo, Irène Sampieri, and Louis and Louise Cahen d'Anvers at Champs-sur-Marne, spring 1916.

house,' Gilbert Cahen d'Anvers later recalled in his memoirs. 'The Chinese salon painted by Huet, the office in shades of blue, also painted by Huet, the beautiful boiseries made by order of Madame de Pompadour when she rented the château between 1750 and 1757, the Boule commodes garnished with mother-of-pearl, ivory, and petrified wood, the Louis XIV and Louis XV fauteuils that were so beautiful . . .'[42] But in 1916 Champs-sur-Marne was converted into a military hospital, at the request of Louise Cahen d'Anvers herself. The makeshift hospital she created was equipped with twenty beds and space for a large medical staff.

The Cahen d'Anvers women worked as nurses in their own hospital, wearing the uniform of the Red Cross as they attended to the soldiers who convalesced in the geometric gardens designed by Duchêne. It was here, in the gardens at Champs-sur-Marne, that Nissim de Camondo enjoyed some of his last visits with his family. In one snapshot that remains from 1916, he towers over his Cahen d'Anvers grandparents and his mother, Irène. Louise and Irène, wearing their nurse's uniforms, gaze at him adoringly. His grandfather and Béatrice, hidden beneath a giant hat, both smile at the camera, their

pride almost palpable. Nissim is all swagger, already a decorated officer, his award pinned on his chest.

In January 1916, Nissim succeeded in securing a transfer to the French Army's more elite airborne reconnaissance squadron, the MF33. The air force was a highly coveted rank, staffed largely by other men from similarly haut bourgeois backgrounds: Nissim's uncle Charles Cahen d'Anvers and his cousin Philippe de Forceville were both in similar divisions. For the young man, still convalescing from his bout of appendicitis, the transfer was a welcome reprieve. As he wrote to Moïse shortly after taking up his new post, the change meant a vast improvement in the quality of daily life: 'We get up late, we play a little soccer, we write or we read, we play cards.'[43]

Initially, Nissim's job was to take aerial photographs, and he seems to have loved the feeling of withdrawing into the skies, high above the agony of the trenches. In one letter to Moïse, he described the battlefields below as 'children's play', a cruel spectacle he had the great to fortune to transcend, if only for a little while.[44] But the young Camondo, then 24, seems to have had a bit of an Icarus complex as well. During the Battle of Verdun, which began in February 1916, shortly after his transfer to the division, he and his comrades dared themselves to fly a bit too low and took a series of photographs that then enabled the French Army to have a better sense of German whereabouts on the other side of the line – a feat for which he received an official citation. Nissim was proud of the recognition, which seems to have been one of things that motivated him most. 'My commander said that I have an extraordinary disposition,' he wrote to his father. 'Even better.'[45]

But Nissim yearned for more action than photography: he wanted to be a pilot, a certification he was granted by August 1916. He seems to have found the work to be more gruelling – and less glorious – than he had initially anticipated, a common reaction among war pilots at the time, who found the altitude, the cold, and the constant tension in the cockpit to be exhausting. The pace of his days had become more demanding, too. 'I did a lot of work,' he wrote home to Moïse shortly after he became a pilot. 'I didn't have a minute of

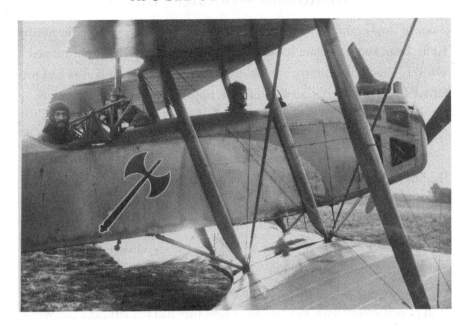

Nissim de Camondo (right) piloting an airplane in unit MF33, Hourges, France, June 1917 – three months before his death.

my own, sleeping in the tent in various different places successively and not even finding a way to change my linen.'[46]

After the end of the bloody battle of the Somme in November 1916, when French and British forces managed to pierce the German lines and advance 10 km into enemy territory, Nissim was sent deeper into eastern France, where he was to conduct reconnaissance missions further into enemy territory. He was still there in the autumn of the following year, flying over the lines every day and returning with whatever photographs his co-pilot had been able to take.

On the morning of 5 September, Nissim took off from the French military base at Villers-lès-Nancy in Lorraine as usual, with the observer Lucien Desessard on board. The two had flown together frequently; this was a routine journey. But, at an altitude of 3,000 feet, the plane was sprayed with bullets by a German Fokker tri-plane, a new model that had been introduced only in July of that year. According to a French military report, Desessard was killed immediately in the gunfire, but Nissim was only injured and left struggling to control a badly damaged aircraft. The men on the ground could see a black

plume of smoke, and they saw Nissim's two-seater reach tree-level in the nearby 'Knife Edge Forest', before it disappeared from view.[47] Given what seemed a relatively steady descent, their initial hope was that Nissim was alive and had been able to land. In fact he was killed on impact, behind enemy lines.

The first notice arrived on the rue de Monceau shortly thereafter.

Sir,

This morning your son left for a photographic reconnaissance. He took Lieutenant Desessard with him, with whom he flies often and who is also an excellent gunman. We saw the aircraft reach its altitude and then approach enemy lines. But two hours later they had not returned. . . . We therefore suppose that at the present moment they are with the enemy. Your son is considered here as one of the best pilots; with his typical bravery and sang-froid he certainly made the most of a difficult situation. It seems possible that an engine failure caused them to land behind enemy lines. . . .
It is with an anguished heart that I write these lines to you and given my own pressing anxiety I feel how serious yours must be.

Please accept, sir, my respectful compliments,

Lieutenant Rotival, interim commander of squadron F33

When that letter arrived, Moïse refused to accept that he might have already lost his beloved son and heir. He withdrew into his mansion and into a realm of magical thinking, holding on to the slightest hope that Nissim would soon be discovered alive. He stopped eating and sleeping, and two weeks later he confided in a friend that he was plagued with 'extreme trances'. He waited for further news from the military, but none had yet come. As he wrote to his friend, he began to doubt his earlier certainty: 'The hopes we had, as great as they were, are not enough.'[48]

Word quickly spread that Nissim had disappeared and Moïse received messages from any number of Parisian luminaries. But perhaps the most touching letter Moïse received is from a passing acquaintance, a man he knew

only vaguely, a dinner companion years before at the home of his former mother-in-law:

> I learned with profound sadness that you are tormented by the news of your son's passing. I don't know if my name will mean anything to you – once upon a time, we dined together chez Mme Cahen, and more recently you had me to dinner with Charles Ephrussi, who I loved deeply. All these memories are now more than ancient. Yet they suffice because my heart is broken in anguish to learn that you have news of your son. I did not know your son, but I often heard about him from my young friend Jacques Truelle[49] for whom your son was exquisite when he himself was injured. And Truelle often told me of the heroism and simplicity of this young man. My eyes are too tired to write more – otherwise I would also write to his mother who must be so anxious and so devastated – so it is to you, knowing the incomparably tender father that you are, that I send my profound sympathy. MARCEL PROUST.[50]

Béatrice was more sanguine in her sadness than her father. By 9 September, a mere four days after the army's notice had arrived, she seemed to accept that Nissim was never coming back. She was 23 in the autumn of 1917, and she had spent the war living with her father and working as a nurse at Champs-sur-Marne with the rest of the Cahen d'Anvers women. She was devastated by Nissim's loss, albeit in her own quiet way. For a woman of whom very few traces survive, and even fewer that preserve her voice, a remarkable letter survives in which Béatrice describes her anguish. Written to a childhood friend – the same friend to whom she later described her conversion in the summer of 1942 – the letter, held in a private archive and drafted in mesmerizing penmanship, reveals the intimacy between brother and sister. 'More time passes and more the void left by the Boy makes me feel that for me he was more than a brother,' she wrote to her friend, from La Motte-Servolex in Savoie, a house owned by the Reinachs. 'He was a friend, the element of happiness in the house. Fortunately, we have the memories, and that is something we will not forget.'[51]

Moïse may have lost his heir, the sole bearer of the Camondo name that had withstood the ravages of history: the Spanish Inquisition, the challenges of

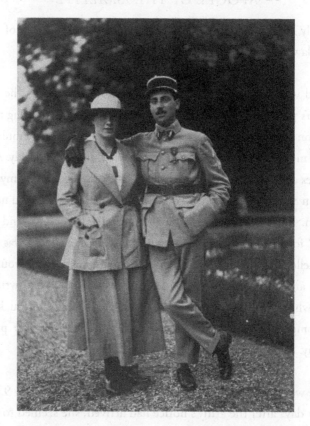

Nissim de Camondo and Béatrice de Camondo at
Champs-sur-Marne, spring 1916.

the Ottoman court, the chaos of Italian reunification, and the constant anti-
semitism of the French fin de siècle. But Béatrice had lost the only companion
she had ever known – the dashing brother who had stood by his slightly deaf
and homely sister through the innumerable family catastrophes they had
endured. It had always been the two of them, left on their own to navigate the
acrimony of their parents' divorce, the new family their mother started without
them, and even the Hebrew lessons that Moïse had forced them to take, which
neither of them seemed to absorb. To Béatrice – largely ignored by her father
and somewhat overlooked by the other women in their glittering world –
Nissim was apparently the source of whatever happiness she had known. Now
he was gone.

The truth was that Nissim had died on impact, and that the German Army
buried him in the small cemetery at Avricourt in Lorraine, then under its

control. The French Army confirmed Nissim's death on 24 September, and Moïse was now faced with another painful reality: without the body, he would not be able to give his son a proper Jewish burial. The youngest Camondo heir would also be absent from the family mausoleum in the Cimetière de Montmartre in Paris, where generations of the family before him had been laid to rest since they left Constantinople for France. So Moïse set out to reclaim the body, despite the war that continued to rage and the borders that remained closed. He was a consummate collector and he pursued his son's remains with more vigour than any other object he ever sought. It took him years, but he eventually succeeded.

By early December 1917, he already had thrown himself into researching the specific whereabouts of his son's grave. He seemed to approach this mission with the exacting precision he used to investigate all his acquisitions. 'The first versions told to me indicated, as did your letter, that my poor son was interred at Kanalkapelle, near Rémoncourt,' he wrote to a French military contact. 'Then I was told that the place he was interred was at the "Elfringhen (Lothringen)" cemetery, which is to say in "Avricourt (Lorraine)". To be precise, we believe "row 8, place 5". Which of these two versions can I hold to be the correct one?'[52] The latter was correct, but the issue was that the town of Avricourt had fallen under German control in 1915. He would have to wait until the end of the war, but even after the Armistice in 1918 the French government had not authorized the exhumation and repatriation of fallen soldiers.[53]

True to form, Moïse had no patience for rules and regulations. Mobilizing his contacts, he essentially arranged to steal Nissim's body and to bring it back to Paris. In the meantime, he had one of his business associates in Germany visit Nissim's grave and remove the cross that marked his plot. As the associate reported back from the cemetery in November 1918, a few days after the Armistice: 'Here is what I wrote instead: N. de Camondo – Lieutenant aviateur – Mort pour la France – 5 September 1917.'[54] Moïse was also in touch with a man named Auguste Bastien, a teacher who lived nearby who was willing to help with the illicit exhumation, which he successfully arranged in January 1919 for an unspecified fee. Bastien delighted in reporting the details of the mission back to Moïse: the men he hired to steal the coffin 'had to stay hidden in my house, the closest to the cemetery, where your son is buried – no – was buried,' he wrote. 'He is no longer there, the brave child, the great hero. His

tomb is still there, with flowers and plants that my daughter Jeanne has replaced. But his body is no longer here and you will receive it – you will possess it.'[55] Possession was the dream of any collector, which Bastien may well have known.

Moïse's feud with his son's mother continued to rage even after Nissim's death. According to the detailed account of the funeral in *Le Figaro*, the fallen pilot was represented by 'the Count de Camondo and Mademoiselle de Camondo, the father and sister of the deceased; the Count and Countess Cahen d'Anvers, his grandfather and grandmother, as well as other members of the family'.[56] Irène's name is conspicuously absent from this or any other report from the service. She was essentially written out of the narrative of her son's death, exactly as Moïse had tried to write her out of Nissim's life. Béatrice was once again left in the middle of a battle that knew no end, this time without the elder brother to protect her or at least enjoy the show. She was left alone with a father consumed by his grief and his fury.

But Nissim's funeral was about more than family politics. From the records that survive, the ceremony – on 12 October 1917 – was a moment of collective mourning for the entire Jewish elite. It was held in the Grande Synagogue in the rue de la Victoire, and the officiant was Rabbi Israel Lévi, the chief rabbi of France, who eulogized the young man and what his sacrifice meant to *la Patrie*. The crowd was immense, and every prominent Jewish family had at least one representative present: Théodore and Joseph Reinach; Léon Fould; Édouard de Rothschild and his wife, Germaine Halphen; Robert de Rothschild and his wife, Gabrielle Beer; Pierre de Gunzburg and his wife, Yvonne Deutsch de la Meurthe; Jacques Halphen and his wife, Marie Durkheim; Edgar Stern and his wife, Marguerite Fould; Gabriel Anspach and his wife, Alix Dalselme. The banker Ernest May, the journalist and theatre producer Gabriel Astruc, who had been a former colleague of Isaac de Camondo's, and Jacques Seligmann, Moïse's beloved dealer, whose friends Nissim had earlier mocked as 'fourth-class Jews', were all also in attendance that day.[57] They were all the individual threads that wove together a world that was continuing to unravel, this time because of the Great War. The loss of Nissim was a blow to them all. They came to mourn a young man but also a vanishing way of life.

In the months and years that followed, the families in this elite tried to stop their world from crumbling any further. Their elders banded together, closed their ranks, and did anything they could to stop the tides that were destroying their community – the siren song of assimilation, the lure of inter-marriage, and, now, the shock of premature death. In November 1918, not long after the Armistice, Moïse announced that Béatrice was engaged to be married – to Léon Reinach, the son of their close family friend Théodore Reinach, and their former neighbour from the rue Hamelin. The Camondos and the Reinachs had both been shattered by the deaths of their sons in the war. The marriage of Béatrice and Léon was thus a means of joining forces, and perhaps even of rebuilding part of what had been lost. Moïse was delighted to have his daughter married off. As he wrote to a friend, it was 'one less big problem'.[58] As for Léon, his future son-in-law, Moïse was not entirely convinced, but ultimately he was glad to have the situation under control. The young man – a 25-year-old composer, from a famous family of academics and writers – was 'an absolute stranger to business and negotiation', Moïse wrote in the same letter. But Léon had 'three army tours in Thessaloniki that's given him a light perception of the Orient'.[59] For the Constantinople-born custodian of the Camondo legacy, that would have to do.

The wedding took place on 10 March 1919 – this time at the Sephardic synagogue in the rue Buffault, the same synagogue the Camondos had helped finance and where Moïse and Isaac had bequeathed the collection of family Judaica they no longer saw the point in keeping.[60] In keeping with the times, it was a smaller affair – less glamorous, less public than it might have been. Like Nissim's funeral, Béatrice's wedding was another moment when the community sought to strengthen the ties that stitched it together. Léon's witnesses that day were his father, Joseph Reinach, and Jean Fould. Béatrice's were her grandfather, Louis Cahen d'Anvers, and her cousin Salomon Halfon.[61] With the exchange of vows, all of these clans were more than peers. Now they were essentially one extended family, bound by blood and history.

Save for their shared background, what – if anything – Léon and Béatrice had in common remains entirely unclear, but then again that was never the point. After the wedding, they moved into Moïse's mansion at 63, rue de Monceau. Moïse himself withdrew into the house, the alternate universe he

created to escape what he called 'the catastrophe that shattered my life and changed all my plans'.[62] As he wrote to a friend in April 1919, he no longer had any desire to work after Nissim's death, and he decided to liquidate his shares in the Camondo bank, its interests in foreign countries, and the family's real estate holdings abroad. From then on, Moïse would only collect.

4

MOÏSE DE CAMONDO
CHAOS AND CONTROL

Since 1899, Moïse de Camondo had lived – at the suggestion of his mentor and confidant, the critic and collector Charles Éphrussi[1] – in a Neoclassical mansion at 19, rue Hamelin, a typical Haussmannian street that runs from the Place d'Iéna to the avenue Kléber in Paris's 16th arrondissement. Although he knew he would one day inherit his father's house in the rue de Monceau, it was on the rue Hamelin that Moïse had tried to build his own family, living there (briefly) with his wife, Irène Cahen d'Anvers, and their two children, Nissim and Béatrice, in proximity with the other families who comprised their social world. The Paris residence of Théodore Reinach, for instance, whose son Léon would later marry Béatrice, was at no. 9, rue Hamelin; Moïse's own in-laws, the Cahen d'Anvers, maintained their Paris townhouse at no. 2, rue Bassano just across the Place des États-Unis. It was in this milieu that Moïse began to mature as a collector, refining his tastes and acquiring several prominent pieces that would become the hallmarks of his collection, chief among them the series of seven pastoral panels by Jean-Baptiste Huet which he had set into the panelling of the mansion's smaller drawing room.[2]

In material terms, his vision was neither as precise nor as totalizing as it would later become. In the pieces he acquired for the rue Hamelin, for instance, the Neoclassical, and, specifically, the Louis XVI aesthetic, was hardly a require-ment for purchase; in fact, during those years, Moïse bought a considerable number of objects in the rococo style, perhaps most prominently the ornate candelabrum adorned with Meissen figurines.[3] He seems to have viewed this house as an ideal place to bring up his young family. His children had just been born – Nissim in 1892 and Béatrice in 1894 – and his excitement at the pros-pect of life in a new home is nearly palpable in the early letters he sent to his architect, whom he emphatically urged not to rush: 'You told me many times

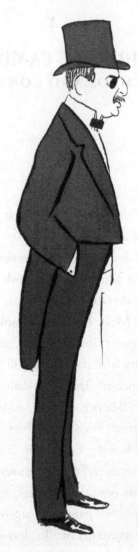

SEM

Caricature of Moïse de Camondo, by Georges Goursat, known as Sem, *c.* 1904.

before that the hotel will be finished for me on 1 March, which seems impossible to me. I repeat, as I have already told you, I am in no rush.'[4] The point was excellence, not expediency: the perfect house for the perfect life, secure in the comfort of their community.

But the ideal family life he had imagined quickly became a disaster, imploding first in private and, worse, in public: his wife, Irène, abandoned him for another man, and their divorce – a scandal among precisely the same neighbours in whose proximity he had consciously chosen to settle his family – was

a subject of public debate and comment in the newspapers in 1903. When he inherited the family house at 63, rue de Monceau on his mother's death in June 1910, it was thus an opportunity to abandon the site of his humiliation and to begin anew. The Monceau house provided Moïse a place to build a sanctuary, a withdrawal that offered the potential for order, harmony and, perhaps most importantly, tranquillity.[5]

Of course, the house as Moïse inherited it was marked by the history of the Camondo family and its particular attachment to both Levantine culture and Jewish religious tradition; there was even a private oratory at no. 61, rue de Monceau, Moïse's uncle's adjacent house. But building a new structure on that same site allowed Moïse a proverbial blank slate[6] to build a new life entirely of his own design. Moïse's innumerable letters to his art dealers and his architect, René Sergent (1865–1927) – all preserved today on the top floor of the house he built – suggest that transforming the family mansion was also a fundamentally psychological enterprise, a means of creating, in the midst of personal and political chaos, a private refuge and an interior kingdom of which he was the indomitable – and sometimes even the tyrannical – absolute monarch.

In that sense, the late eighteenth-century style in which he chose to decorate a house expressly modelled after Versailles's Petit Trianon, itself something of a monument to the era, was especially meaningful. In the same will and testament in which he later bequeathed his collection to the French state, Moïse would describe this style as a 'a decorative art that was one of the glories of France',[7] and indeed, as a Turkish-Jewish émigré, he certainly sought to project a patriotic image that would efface the foreignness of the family's name and combat the antisemitism they continually faced. But this alone is too simple a reading of the material self-portrait Moïse left behind. In the Paris of the fin de siècle, Louis XV and Louis XVI represented more than affluence and, after the Goncourt brothers' endorsement, good taste. These styles carried with them a clear nostalgia for an imagined social world in which elites, as they had been before the French Revolution, were free to pursue lives of dalliance and refinement at the same time as they controlled the natural order that afforded them such pleasure.[8] The Neoclassicism of these respective styles celebrated restraint, harmony, and order, but they were also aesthetics of the ancien régime, gilded symbols of total control and, to some degree, of a stifling autocracy.

In the narrow confines of the Monceau mansion, Moïse de Camondo can be thought of as a material monarch. The style he chose, as well as the sheer vigilance of his attention to detail in enacting his vision for the space, evokes a desire beyond the achievement of balance, symmetry, or even a particular national affiliation. Within the context of his own private sanctuary, the ancien régime aesthetic provided the illusion of power, a simulation of control for a man who had gradually been forced to accept that he had no such authority beyond the rue de Monceau.[9]

The exact origins of the Camondo family remain elusive, obscured by myth and memory. As the use of Ladino among generations of family members would suggest, their ancestors were presumably among the masses of Sephardim who had refused conversion and were thus expelled from Catholic Spain in 1492, only to settle in the Mediterranean ports of the Levant and the Italian peninsula, especially in Venice. Trade, as it was for so many other exiled Sephardim, was initially the family business, and the Camondos, not unlike the Ergas or Silvera families, were the archetypal 'insider-outsiders in early modern European commercial society', at home everywhere equally but nowhere exactly.[10]

For the critic and amateur historian Philippe Erlanger, a distant relation of the family, whose mother, Irène Hillel-Manoach, was a niece of Moïse de Camondo's mother, Elise Fernandez, the family had derived its name from the mansion it had apparently occupied in eighteenth-century Venice, Ca' Mondo, 'house of the world'. This hypothesis, as Edouard Roditi, a friend of Moïse de Camondo and himself a distant relation of the family on his father's side, has written, was probably untrue, a flight of imaginative fancy and either a selective interpretation or an outright fabrication of the facts. Venetian Jews in the eighteenth century, after all, were still confined to the city's storied ghetto,[11] and it was far more likely, for Roditi, that the family – not unlike Lorenzo da Ponte, the librettist of Mozart's major operas – had emerged from a small Jewish community on the periphery of the Veneto that had merely been called 'Camondo'.[12]

In any case, the historian Nora Seni, whose examination of the family's roots remains the most authoritative, has written that the only point that can

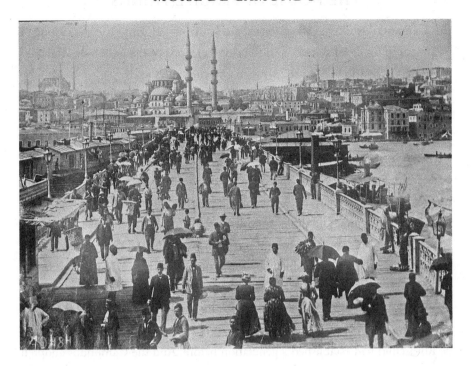

Galata Bridge, Constantinople.

be established with any certainty about the Camondos' early history is that, in 1782, having left Venice for the Ottoman capital approximately a century before, they hired a vessel, *La Madonna del Rosario*, to bring them to Habsburg Trieste from Constantinople, from which they had been temporarily expelled but would return a few years later, to become the so-called 'Rothschilds of the East'.[13]

In hindsight, of course, the Ca' Mondo myth fits the Camondos quite well. As a prominent Sephardic merchant family, even in the eighteenth century, records survive that locate members of the family trading across the Mediterranean and European worlds, in Trieste, Venice, Vienna, and elsewhere.[14] In the mid-nineteenth century, when the family had established itself in Paris, they were certainly 'of the world' in the literal and figurative sense of the term: the history and the evolution of the Camondo family was truly cosmopolitan, their social world decidedly *mondain*. Their principal home always remained Constantinople, where, in the early decades of the nineteenth century, they became the most prominent Jewish banking family in the Levant after the rapid rise of the family bank, I. Camondo & Cie, at the Ottoman court. After 1839,[15]

the Camondo bank benefited from modernizing reforms, the development of a modern financial system, and the close relations of the patriarch, Abraham Salomon Camondo (1781–1873), with government elites.[16]

Despite this affiliation, however, their citizenship was never Turkish. As was the case for many Jewish families who had ultimately settled in Ottoman trading centres, the Camondos' original citizenship was Austro-Hungarian and then, after 1865, from the Grand Duchy of Tuscany,[17] which reflected the desire of both entities to develop their Mediterranean port cities of Trieste and Livorno into major commercial hubs, by encouraging the settlement of foreign merchants such as the Camondo and other prominent Sephardim.[18] Their title was likewise Italian, granted to Abraham Salomon, Abraham Behor (1829–89) and Nissim Camondo (1830–89) individually by the King of Italy in return for their financial support of the House of Savoy's war effort, which had contributed to the reunification of Italy.[19] Arriving in France in 1869, they installed their bank's main branch in the rue Lafayette in Paris, not far from the bank that James de Rothschild had established a generation before. And the Camondos adopted the appropriate *mondainité* to accompany the intrinsic cosmopolitanism that was the life-blood of their family's experience. The brothers Abraham Behor and Nissim – each of whom had only one son, Isaac de Camondo (1851–1911) and Moïse de Camondo (1860–1935), respectively – became fixtures in the society attached to the Parisian *haute banque* of the Third Republic, flaunting, as Roditi would later recall, 'their flamboyant Italian title that sounded like that of a character in an Offenbach operetta'.[20] Despite their public pretensions, however, the two Camondo brothers maintained and developed in France a specific family culture that was a composite of Levantine, Jewish, and philanthropic identities, a hybrid sensibility that their sons, Isaac and Moïse, would later translate into the realm of public cultural life.

The initial template for this sensibility was undeniably their grandfather, Abraham Salomon Camondo, the family's patriarch. As a devoutly religious man, Abraham Salomon obeyed the traditional Jewish practice of *tzedekah*, the Hebrew Bible's injunction to help those in need through simple acts of (anonymous) charity. As such, his faith was the essence of his charity: he financed, for instance, the reprinting of certain volumes of the *Me'an Lo'ez*, the anthology of Torah commentaries composed for a secular reading public, and he established synagogues and shelters for the poorest among Constantinople's Jewish population.[21]

By the mid-nineteenth century, however, that population was in a state of considerable economic malaise and social atrophy, not to mention intellectual decline. The Greek and Armenian populations had replaced the Jewish population as the key middlemen in the Ottoman Empire's trade with Western Europe, which meant that the majority of the nearly 40,000 Jews residing in Istanbul in the 1850s lived in considerable and often even extreme poverty.[22]

Furthermore, the aftershocks, even some two centuries later, of the Sabbetai Zevi scandal, in which a Sephardic rabbi had claimed to be the Messiah, had created an environment in which Constantinople's Jewish leadership frowned on any new intellectual pursuits that questioned or challenged Jewish tradition or religious doctrine in any way. If circumstance had mired the Ottoman capital's Jews in poverty and depression, suspicion ensured that they had no means of altering their personal or collective fates. *Tzedekah* might have temporarily alleviated their suffering, but it would never end it altogether. As the most publicly prominent and certainly the richest Jew in the entirety of the Ottoman Empire, Abraham Salomon Camondo thus assumed the role not merely of the Jewish community's chief benefactor but also of its guardian, a figure with a considerable paternalistic power to redesign the community he charged himself with saving.

The patriarch, in other words, had become the iconic nineteenth-century philanthropist, the personification of the general shift, in Jewish and non-Jewish public works after the mid-1850s, from simple charity to an ideological embrace of reform and regeneration. For the historian Aron Rodrigue, Abraham Salomon Camondo was a 'perfect illustration of an important development in the wider Jewish world: the transition from the old philanthropy of *tzedekah* (charity) to the new philanthropy of reform'.[23] But, as others have argued, this newfound practice in Jewish philanthropy was influenced by a larger ferment among European elites more interested in recasting the objects of their assistance into dutiful subjects who would accept without question their own cultural value systems and their own positions of authority.[24]

Abraham Salomon Camondo was both: his business dealings with many of the most prominent European Jewish banking families certainly attuned him to the ways in which his continental peers observed and interpreted ties to fellow Jews, and his association with the pro-Western, modernizing factions at the Ottoman court responsible for the rise of his bank also most likely convinced

him of the need for decidedly Western-style reforms in his own community. This accounts, for instance, for the clearly secular character of the school he created in Istanbul in 1854 with Albert Cohn, the emissary of the Paris Rothschilds and of the Consistoire, an educational facility that taught young Jewish boys traditional Jewish subjects but emphasized modern languages such as French and Turkish rather than Hebrew. Despite initial resistance among Jewish leaders,[25] the school flourished, transforming generations of Turkish-Jewish youths into the ideal citizens whom Camondo had imagined.

The Alliance israélite universelle was established in Paris in 1860, an organization whose motto was the age-old maxim that '*kol yisrael arevim*' ('All of Israel in solidarity'), and whose mission was the observance of Jewish solidarity with communities across the globe. The historian Lisa Leff has argued that the particular type of 'solidarity' at the heart of Alliance was separate and distinct from the corporate solidarity that French Jews themselves had so desperately sought to abolish in the early decades of the nineteenth century, in the pursuit of their assimilation and emancipation. With the Alliance in the 1860s, French-Jewish elites were actually affirming 'their commitment to state secularism and of their belief that "civilized" nations should advance the cause of religious equality in their political and economic negotiations with other countries'.[26] In the view of the Alliance, solidarity was thus a particular application of a universal project, which is why its leaders linked the defence and protection of Jews abroad to the French republican ideals of 1789 and 1848.

The Alliance championed, after all, the universalist achievements of those revolutions: the separation of religion and the state, the right to work, and the expansion of suffrage, all factors that were pillars of secular modernity.[27] For the Alliance, the Jewish community was merely one particular portal through which that universality could be accessed. In the spirit of the French Revolution, reforms intended to 'emancipate' Jewish people often meant distancing them from the traditional observance of their faith. After the establishment of the Alliance in 1860, Abraham Salomon Camondo – as was the case with many other prominent nineteenth-century Jewish philanthropists, such as Moses Montefiore in Britain and Maurice de Hirsch with the Jewish Colonization Association in Palestine – continued his philanthropic activities through the infrastructure of a larger organization,[28] relying on the Alliance as a means of projecting values he shared throughout the Ottoman Empire and beyond.

In a sense, the Alliance was the perfect expression of Camondo's value system, its embrace of Jewishness at the expense of Judaism, its application of France's colonial *mission civilisatrice* (or 'civilizing mission') to his fellow co-religionists as a means of exerting some form of social control, and its imposition of Western ideals onto 'backward' Eastern subjects. As Camondo wrote to the president of the Alliance in 1864, special attention needed to be paid to 'the Jews of the East, who are so backward in civilization and for whom only *education* can open the path to progress'.[29]

The Alliance and its worldview was the cornerstone of the sensibility that Abraham Salomon Camondo later transferred to his grandsons, who would make their lives in the organization's capital city; it was the embodiment of the Camondo family's relationship to Jewish identity and to France and its republican values. Perhaps most importantly, the Alliance also encapsulated the family's view of its role in public life by the late nineteenth century. Part *noblesse oblige*, part Jewish solidarity, and part a very nineteenth-century desire to 'regenerate' a community into 'emancipated' French citizens, the Camondo version of Jewish public engagement was as much about fostering cultural edification as it was a celebration of French lofty universalist ideals. This was precisely the interpretation that Abraham Salomon's grandson Nissim de Camondo – the father of Moïse de Camondo – articulated in the same speech in which he introduced the Alliance to the community of Turkish Jews it would be supporting:

> At its core, the Alliance essentially has no other goal than to protect the Israelite who suffers for the sole reason that he is a descendant of Abraham, to eradicate the prejudices that still exist among us. ... To carry our brothers, by way of education, on the road to becoming the equals of other peoples among whom they were dispersed by a terrible and mysterious hand. It was in Paris, the centre of civilization, that many generous men conceived the design of a universal Jewish alliance.[30]

Paris hardly regarded the Camondo family with the same admiration. In the same city that Nissim de Camondo termed the *'centre de civilisation'*,

the Camondos were often regarded as Eastern, as exotic, and, to some extent, as 'backward' as the poorer Jews of the Ottoman Empire that they themselves had stigmatized. Consider, for instance, the recollections of Ludwig August Frankl, who stayed with the Camondos for Passover in 1856 and who recorded the experience, among many others, in a book entitled *The Jews in the East*. Frankl described the Camondos through a clear Orientalist perspective that presented them as strange specimens on the periphery of reality. Frankl recounted the Camondo mansion in terms of the unbridled opulence it contained:

> Four generations were seated at the table; the patriarch of the house, clothed in silks of different colours, occupied a throne furnished with cushions of purple and gold. . . . In one corner of the large room . . . was seated the mother of these children, grandchildren, and great-grandchildren, apart from the rest, on a splendid divan. She wore wide trousers of red satin, and a short white silk petticoat over them; on her feet were yellow slippers; round her waist was a shaded silk girdle . . . But her head-dress was the most valuable part of her costume; a white silk shawl was gracefully wound round a red fez, and adorned with pearls and precious stones of different colours.[31]

The Camondos, in Frankl's account, are many things, but most of all they are foreign, swathed in silks, seated on 'cushions of purple and gold', and adorned with 'precious stones' in a gaudy rainbow of wealth.

After Abraham Behor and Nissim de Camondo established themselves in Paris in 1869 – bringing along their grandfather, the patriarch Abraham Salomon – they were perhaps attempting to shed this exotic association with their 1870 purchase of two adjacent plots of land in the Plaine Monceau, which had been developed and redesigned by fellow Sephardic banker Émile Pereire in 1861, and that had become a desirable address for financial and industrial elites, especially wealthy Jews. Abraham hired Denis-Louis Destors to design something of a family compound in the space, a safe – if public and prominent – enclosure in which the family culture of the Camondos could continue to exist unchallenged. Abraham Behor, his mother, his wife, Regina, their daughter Clarisse, and her husband, Léon Alfassa, lived in the newly

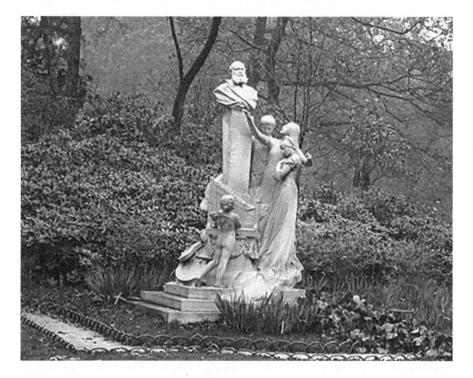

Parc Monceau, monument Gounod.

constructed townhouse mansion at no. 61, where his son, Isaac, occupied a wing they dubbed the 'Petit Hôtel'. At no. 63, Nissim likewise lived with his family, including his son Moïse, who would later transform this childhood home into a Parisian Petit Trianon, the site of his future collection.

In keeping with their grandfather's philanthropic activities vis-à-vis Jewish schools in Turkey and abroad – activities which both Abraham Behor and Nissim maintained throughout their lives, albeit by proxy – they also began supporting public works related to Jewish communal life in their new country. The most prominent among these endeavours was their support of the Sephardic synagogue on the rue Buffault, inaugurated in 1877, which remains the largest Sephardic house of worship in the French capital. Judaism mattered deeply to Abraham Behor and Nissim, who arrived in Paris with few objects from their lives in Constantinople save for a small personal collection of Judaica. The two brothers likewise had insisted on a small, private family oratory in the rue de Monceau, and it was there that they kept the collection of Jewish objects their family had begun generations before and that reflected

the various chapters in their own history: an exquisitely illuminated *megillat Esther* from eighteenth-century Italy, an imposing *parochet*, or Torah curtain, in silver and silk from nineteenth-century Constantinople. But this collection – and the past it contained – was always strictly private.

Without question, the brothers Camondo attempted to abandon the aesthetic that had labelled them, in the eyes of their French contemporaries, as exotic Orientals, and they sought to cultivate a publicly French image. And it is significant that the means by which they sought to construct that image was primarily through the display of art, the arrangement of material objects, and the creation of built environments, a vocabulary that Moïse de Camondo – and, to some extent, his cousin Isaac de Camondo – would advance even further in their own collecting activities. Consequently, the Camondos were frequent visitors to the gallery of the legendary dealer Auguste Sichel, attended exclusive auctions at Hôtel Drouot, and were proponents of Japonisme, then *de rigueur*, as much as they were of the popular contemporary style of mixing periods in French style. Émile Zola later would later satirize no. 63, rue de Monceau in *La Curée* (1872): 'It was a window display, a profusion, an embarrassment of riches.'[32]

The newcomers may have tried to shed their forebears' exotic Levantine appearances and customs, but they never made any attempt to alter the family's reputation for excess. As Arthur Meyer, an acquaintance of the family and himself a testament to the fluidity of identity in the Third Republic, would later observe in his memoirs: 'Coming straight from the land of legends, they deposited as a starting point about 40 million in the Bank of France.'[33] The Camondos emblazoned the gates of their new homes with the family crest – or, rather, the crest that they had acquired from the Italian king a mere five years before installing themselves on the rue Monceau. They entertained with a panache that shocked even the most seasoned social observers and sought to adopt the aristocratic way of life. A classic hazard of the parvenu is to embrace these careful social rites with a bit too much enthusiasm, and the Camondos were no exception. 'At the ball of Countess Camondo last year, there was even a hand-out of jewels,' one society periodical observed in 1881.[34]

But after years in Paris, the Camondos had mimicked the customs of the French elite to the point where they became the kind of elites who could tell who was merely performing and who truly belonged. They took the waters at

Vichy, watched the races at Deauville, and spent the winters at Biarritz. Count Nissim de Camondo became a passionate equestrian – as would his son, Moïse, and, eventually, his granddaughter Béatrice de Camondo – a fixture in the Bois de Boulogne social set. 'Now the beautiful days of the Bois are fortunately back,' a society magazine observed of the season's opening in 1881. 'The rendezvous at the barrier by Place de l'Étoile was very lively. Among the most elegant was the Count de Camondo with two bay coachbuilders. A bit sombre, but so beautiful!'[35] Moïse's daughter, Béatrice, shared her father's passion and later became an impassioned equestrienne, continuing her riding in the Bois de Boulogne even well after the German Occupation of Paris.

As it was for the other families in this tightly knit Parisian Jewish milieu, the public perception of their ostentation was not always as adulatory. In the increasingly pronounced antisemitic discourse of the Third Republic, the name 'Camondo' itself became a synonym for the confused set of social ills that antisemites projected onto prominent Jews in French public life. Drumont's *La France juive* appeared initially in 1886 and the Camondos appear throughout, often as the '*turcaret levantin*' or 'Levantine Turk', exactly the insult that all of their efforts in France appear to have been designed to avoid. If Théodore Reinach and his brothers would later endure the aftermath of the Panama scandal and its devastating impact on public perception of their family, the Camondos were confronted with the Alfassa Affair.

To some extent, Abraham Behor and Nissim de Camondo had distanced themselves from the explicitly Jewish philanthropic activities of the family's patriarch, although they always maintained support for the Alliance and its activities in their native Turkey. Perhaps because of the antisemitism his father and uncle experienced, Moïse de Camondo later scaled back the family's Jewish philanthropy almost to the point of insignificance. But, well into the twentieth century, he maintained the family's approach to public life, this time transposed into the realm of the material.

At first, it might seem unsurprising that Moïse – divorced, humiliated, and charged with raising two children on his own – would choose to return home, to live in the familiar comforts of the family mansion he inherited from his

mother. Although the rue de Monceau address carried with it the undeniable association of affluence – the *salonnière* and painter Madeleine Lemaire lived at no. 31, Maurice de Rothschild at no. 47 – the neighbourhood's appeal was already slightly dated, the preference of an earlier generation.[36] By 1910, the most desirable address for the Third Republic's industrial and financial elite was no longer the quartier Monceau but the more westerly locations of the Champs de Mars and, beyond, the fashionable Bois de Boulogne suburbs.[37] One might assume that Moïse – always private, even a bit reclusive – would have been eager to withdraw into the family compound, but it turned out that he was nostalgic only for the eighteenth century, a world he had never seen. The world he had seen, the storied past of the Camondo, he could do without.

Moïse wasted no time in disposing of the vast majority of the art objects he had inherited from his mother, especially the ones that contradicted his view of the good life. A letter survives from 21 July 1910 – a mere eleven days after Moïse assumed ownership of the house – in which Léonce Tedeschi, his secretary and man of confidence, reports back on a successful disposal of the 'Turqueries' left in the house: 'after two rendezvous yesterday, in the rue de Monceau and other places tomorrow, I've finished with the "Turqueries" having gotten rid of all the pipes . . . and all that was on the table in the dining room,' he assured Moïse.[38] The storied history of the Camondos – especially their Eastern, Turkish roots – was thus the opposite of the legacy that Moïse wished to maintain. That history had to be erased altogether so that he could cultivate a new image in the familiar surroundings of his youth.

Even more poignantly, once his mother had died, Moïse also decided that almost all of the family's extensive Judaica collection had to go, and he did not include plans for a private oratory in the new house. In 1910, the same year he inherited the Monceau house, he and Isaac donated most of their collection to the Buffault synagogue, and, like the Rothschilds, gave a small number of objects to the Musée de Cluny.[39] Moïse even donated the ornate silver Torah plaque that had been presented to him by his parents for his bar mitzvah in 1872. But purging the house of the family's Judaica did not necessarily imply a departure from Jewish identity. Moïse seems merely to have had a different attachment to Judaism than his parents and his grandparents: for him, what mattered was tradition, not so much religious orthodoxy. As he wrote to the

curator at the rue Buffault, describing two particularly beloved candelabra: 'These were always used for the candles that we light the day of Kippur in the memory of our parents, the counts Abraham and Nissim de Camondo. I want them to remain in this destination as long as our descendants will light candles on the occasion of this holiday.'[40]

Even so, that Moïse ultimately chose to enact his dream of a Versailles-inspired home in his family's house underscores, at least in part, the emotional intimacy – and intensity – of the project. Of course, the Camondo renovation of the Monceau mansion bears similarities to other home-restoration projects from the same period that also celebrated the Neoclassicism of the ancien régime: one thinks, for instance, of the construction of the dandy and aesthete Boniface de Castellane's 'Palais Rose' at no. 40, avenue Foch in Paris between 1896 and 1902 and also of Edmond de Fels's transformation of the Château de Voisins at Saint-Hilarion between 1903 and 1906, with the architect René Sergent and the landscape artist Achille Duchêne, both of whom Moïse also employed. But these massive projects were executed on a far grander scale than no. 63, rue de Monceau: Castellane's Palais Rose was a reconstruction of the Grand Trianon complete with a scale model of Versailles's '*l'escalier des ambassadeurs*', and Fels's château was a recreation of the École Militaire. The rue de Monceau was a single townhouse, a lavish but ultimately withdrawn family home.

Although he insisted on a complete transformation of the property, Moïse's vision was perhaps less ambitious than those of his peers drawn to the same style, and his consumption was less conspicuous. He did not seek to establish himself in a more fashionable neighbourhood or boulevard, and, unlike Castellane, he did not – at least on the basis of his extensive correspondence – consider his home and its embrace of ancien régime harmony as public argument against the perceived material excesses and decadence of the fin de siècle. The canvas he chose was ultimately the intimate sphere of a single-family home, the very home in which he had been raised. The harmony of the style he chose seems more directly engaged in a decidedly personal enterprise, not a public one. 'We know perfectly that we feel calmer and more confident when in the old home, in the house we were born in,' observed the philosopher Gaston Bachelard, 'than we do in the houses on streets where we have lived only as transients.'[41] This applies well to Moïse.

Perhaps the greatest expression of Moïse's aesthetic autocracy was his trans-formation of the Monceau house into the perfect reflection of the eighteenth-century objects that he would soon collect with vigour. In terms of styles then in vogue, the nineteenth century had presided over a series of historical revivals – perhaps most notably the Gothic revival – that, by the fin de siècle, had culmi-nated in the decorative excesses and affectations of the so-called Art Nouveau, a global turn in aesthetics that transformed earlier decorative styles – the rococo of the early eighteenth century, the Japonisme of the 1880s – with modern tech-niques and technologies. In a time of exponential growth in the respective finan-cial sectors of European and American economies, the result was often a new built environment in major capitals that employed Art Nouveau as a means of celebrating material wealth through florid ostentation.

Gustav Klimt, a member of the Vienna Secession, painted not just in hues of gold but with the metal itself, and the classier arrondissements of Paris witnessed the erection of gates, façades, and Métro entrances that were wrought-iron fantasies, material translations of the decadence of the age. Architecture was often enacted 'with a loquaciousness that turned it into an almost redun-dant costume', practising 'the flaunting of luxury remorselessly, even to the point of vulgarity'.[42] It was precisely this public excess that Moïse de Camondo wished to avoid in his reconstruction of his family home on the rue de Monceau. Most likely through his continuous association with the Seligmanns, he quickly hired René Sergent, who designed these dealers' mansions in the place Vendôme (1907), as the architect to enact his vision of an eighteenth-century Petit Trianon of his own.

Despite his popularity among a wealthy clientele, in Paris and New York, Buenos Aires and London, René Sergent had not been trained in the grand tradition of French architectural style: he had not, for instance, attended the famed École des Beaux-Arts, attending instead École Spéciale d'Architecture, an institution whose emphasis was practicality, not necessarily aesthetic gran-deur. Consequently, although he was well versed in the masters of French design, he was not necessarily a visionary so much as a translator of historical precedent into a contemporary context. René Bétourné, a former colleague, would describe him thus: 'He [Sergent] studied the works of Mansard [sic], Delafosse, Daviler [D'Aviler], Gabriel, Blondel, Brongniart, Ledoux and Chalgrin with intelligence and passion. He steeped himself in the beauty of the

proportions of their buildings, in the colouring and scale of their profiles, in the elegance and charm of their decoration. Then, once he was sure he understood their grammar and orthography, he began creating.'[43]

This tendency distinguished Sergent from many of his contemporaries, captivated with the prospect of Beaux-Arts pastiches: 'His works are not stage sets but meditations on a world which he sought to bring back to life by remaining faithful to it. He wanted to bring about a veritable "renaissance" of 18th-century art, not merely its evocation.'[44] As his biographer, Michel Steve, has pointed out, Sergent's project naturally overlapped with that of Moïse de Camondo: '*La reconstitution d'un monde parfait*'.[45] This took the form of a painstaking but intimate homage to Ange-Jacques Gabriel's Petit Trianon, a structure that embodied the perfection of a balanced form and, for the proprietor, the sanctuary of a controlled, ordered environment.

In technical terms, Sergent's recreation of his Versailles model was quite loyal to Gabriel's antecedent. Of Nissim de Camondo's original house at no. 63, rue de Monceau he kept only the wine cellar, reconstructing on the plot a house in an elongated 'L' shape that would take advantage of the sunlight and the view of the Parc Monceau. Like the Petit Trianon, the new hôtel Camondo was constructed with an elevation of three main levels: a *rez-de-chaussée*, a cavernous first floor, and a second floor that housed the family's private apartments (an attic existed under the eaves of the roof). The decorative details on the new building's exterior – the frames of the windows, the Corinthian columns, and the balustrades – are all almost precisely identical to those of the Petit Trianon. Because of the spatial constraints of the particular plot of land the house occupies, there are, of course, certain differences: a quarter circle instead of a straight front entrance, for instance, to fit the curve of the inner courtyard; a central rotunda for the Corinthian columns at the perpendicular intersection of the two wings of the house, again due to space constraints.

In any case, Sergent employed precisely the same signature technique as Gabriel in selecting a difference in ground level on opposite sides of the house, one facing the courtyard and the other facing the garden and the park beyond. The effect, for a visitor to the house, is that they enter from the courtyard at a lower level and then discover that the first-floor rooms, up one flight of stairs, are actually the 'ground floor' on the opposite side of the house, opening directly into the garden designed by Achille Duchêne. The effect – in addition

to the fact that the house's two façades are actually different, as they are in Gabriel's rendition – ultimately establishes a theme of dual worlds. The first of these worlds, naturally, is of a kind of public sphere – the house's exquisite rooms for dining and entertaining and, finally, living, all accessed in the normal spiral progression after entrance. But the courtyard-level *rez-de-chaussée* on the opposite side hides an entire sphere of life – namely, servants and the banalities of quotidian maintenance – from visitors and from the occupants of the house alike. This spatial design served Moïse's desire for control well: his house was a stage, complete with characters consigned to certain roles.

That desire for control was evidenced throughout Moïse's extensive exchanges with Sergent, whom he charged with ensuring that certain rooms accommodate his often exceedingly specific ideas regarding his collection. As early as January 1910, for instance – three years before the Camondos would move into the house – Tedeschi wrote to Moïse to assure the latter that his specific vision for the 'Salle des Huets' would be respected in the construction of the new house. The house, in a sense, was an expression of the collection, not vice versa:

> Count, I was able to find a moment today to drop by Mr. Sergent's. He seems to have made his plans for something perfect, and he is waiting for your return to submit them to you. He modified the dimensions you indicated, arranged the half-moons on both sides of the façade facing the courtyard, and found a happier arrangement of the small Huet salon which, instead of having neat hexagonal sections around the oval, gives the whole the appearance of a more architectural and more aesthetic layout.[46]

Objects ultimately governed Moïse's vision for the space he had commissioned. As he wrote to Sergent in July 1911:

> Dear M. Sergent, following our conversation this morning, I would ask you to kindly go to Monsieur Fabre, an antiques dealer in the rue de Rennes, to see two particular lanterns. You would be very kind to take the measurements and make two small models of said lanterns to hang them in our model of the stairs.[47]

What emerges most clearly in his plans for the house is Moïse's attention to detail and his insatiable perfectionism. Both evince not merely a desire but – on some deep, inner level – a need to arbitrate every aspect of the house, a world entirely of his own creation. In January 1913, he wrote the following of a staircase: 'The two galleries were done with wood, so it would be absolutely illogical to do this particular staircase, which connects the two galleries, in different materials.'[48] In October of the same year, his obsession with detail reached an even more extreme level: 'Dear Monsieur Sergent,' Moïse wrote, 'After our meeting earlier today, I chatted at length with Bourdier about the gilding of the stair railing. Bourdier claims that one will never arrive at a suitable result with the gold which was used; therefore we must use LEMON GOLD and have it installed by an absolutely skilled person.'[49] The *majuscules* were Moïse's own.

Moïse's choice of the Louis XVI style – for the house, but also in terms of his collection – was certainly in keeping with a certain strand of conservative cultural politics in the fin de siècle, but it was also a conscious choice that most likely reflected significant dimensions of his inner life. A crucial dimension to Moïse's life as an aesthete is the sense of order that collecting afforded him – order not merely in terms of the particular period he chose to collect, which celebrated the revitalized Greek ideals of balance and harmony, but an order in the sense of strict temporal boundaries to observe in his pursuit of objects. For a man whose experiences by middle age had revealed the utter unpredictability that could upend even the most comfortable of bourgeois lives, collecting provided an obvious antidote to chaos. There were rules to follow. An object was either Louis XVI or it was not. It was either authentic or a copy. It either belonged or it did not.

Throughout his years of selecting and acquiring objects for the Monceau house, these concerns ultimately seemed to characterize the bulk of his exchanges with dealers and *antiquaires*. His collection, after all, had a clear and distinct identity, and, as the collector, Moïse's principal role was thus to respect that identity, a role he assumed with a remarkable discipline. 'As for me, as you know, I don't buy drawings that do not conform at all to the décor of my

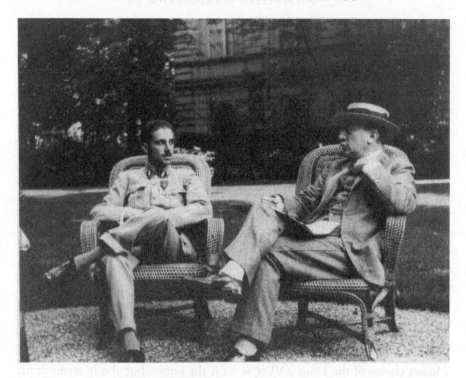

Moïse de Camondo and Nissim de Camondo in the gardens of 63, rue de Monceau, Paris, August 1916.

house,' he wrote to François Boucher of the Musée Carnavalet, who had written to him regarding some pieces from an earlier period. 'It's a pity, because they are charming.'[50] To a Parisian dealer of figurines, his response was brief and simple: 'I hasten to inform you, in response to your letter yesterday, that I am not a buyer of miniatures.'[51]

But it was the parameters of his chosen period that Moïse most religiously respected. 'I thank you for kind proposition,' he wrote to Leopold Davis of London in 1922, 'but I only buy furniture from the Louis XVI period.'[52] Similarly, to an offer from the dealer Henri Pettipas, he responded as follows: 'I had seen [the item] in your sale catalogue from yesterday. . . . It's very beautiful, but I am not a buyer of objects from the Louis XV period.'[53] The family and social world of the fin de siècle did not abide by any such discipline, but the material world that Moïse carefully constructed – an alternative universe in its own right – did indeed abide by a strict sense of harmony. Of course, Moïse was the unquestioned arbiter of this universe, an absolute monarch who expressed his authority in the style of the absolute monarchs themselves.

By 1910, under the tutelage of Charles Éphrussi and the careful guidance of his dealers Jacques and Arnold Seligmann, Moïse had already embraced with a consuming passion the art and style of the French eighteenth century. His clear preference was for its final decades, especially the reign of Louis XVI (1774–93). Unfortunately, there is no surviving document in which Moïse clearly explains the evolution of his taste and his understanding of what exactly the lasting legacy of the eighteenth century had been. Those questions, however, are somewhat illuminated in the extensive correspondence Moïse left behind with his dealers and, later, his architect. During the years when he was furnishing the Monceau house to match his image of perfection, his obsession with the provenance of certain objets d'art situates him somewhat in a larger category of wealthy and often reactionary bourgeois, who had charged themselves with the preservation of the *patrimoine* in a time when, as they saw it, France's national heritage was in grave danger of despoliation or even destruction.

The tumult of France's stinging defeat in the Franco-Prussian War in 1870–71 had galvanized a generation of private collectors in Paris to preserve the city's material heritage. In the years that followed, these collectors eventually came to see objects from the ancien régime as pieces of a shattered world, often assigning 'quasi-magical meanings' to them, 'a mystical strand of royalism, in which the Bourbons appeared as the flesh-and-blood manifestation of God's will for France'.[54] This tendency certainly applied to Moïse's perception of many objects in his collection, with real or, in some cases, imagined connections to the court of Versailles. For him, royal provenance appears to have denoted the highest imaginable watermark.

In January 1913, for instance, Moïse bought, from the dealer S. Lion, a *table chiffonnière* by Martin Carlin (1730–85), the celebrated Parisian cabinet-maker whose trademark was the inclusion of Sèvres porcelain plaques on his chests and cabinets. Lion advertised it to Moïse as follows: 'The table that I have sold you . . . appears to have been given by the Marquise de Pompadour to the ancestor of Mme de Champeaux.'[55] In fact, Madame de Pompadour (1721–64), the mistress of Louis XV from 1745 until her death, could not have owned the table in question, as she died before Carlin was ever admitted to the guild of cabinetmakers, and indeed before the particular piece itself was completed. But the relevant fact is that this imagined association raised the value of the piece in Moïse's eyes: he bought it anyway.

This is not at all to say that Moïse was easily fooled by dealers and decorators; quite the contrary. He often exhibited his extensive – and rather scholarly – understanding of the art of the period he had chosen to collect. As he responded in 1934 to a query from Maurice Darantière, the printer who had released James Joyce's *Ulysses* for Sylvia Beach: 'Sir, you have perfectly identified the Oudry drawing that you possess . . . You probably know that the Château de Versailles has the eight pieces reproduced in Sèvres porcelain plates, made under King Louis XVI, but of which the heads were changed for portraits of King Louis XVI and his hunting companions.'[56]

Likewise, he demanded the same deep level of knowledge about provenance from his dealers. Regarding a series of paintings by the French painter Hubert Robert (1733–1808), known especially for his timeless depictions of ruins, a notary replied to Moïse's exacting questions in March 1927 with a detailed explanation of the paintings' authenticity and a history of their ownership. 'The authentic will of Hubert Robert's widow, maiden name Loos, dated 13 July 1821, is absolutely silent concerning the works of art that interest you,' the notary wrote. 'I found in the affidavit drawn up after her death on 6 September 1821 that an inventory was done after her death by Maitre Delacour, the Paris notary (whose successor is Maitre Salle . . .), on 18 August 1821. You can contact Maitre Salle with some chance of success.'[57] Two days later, Moïse responded, ever the diligent investigator: 'So I will write to your colleague.'[58]

The real prize, however, was any object that had come into contact with Marie-Antoinette, any traces of whom appear to have occupied an especially coveted position in the eyes of collectors such as Moïse. Stammers cites Pichon, for instance, as having called her the 'adorable princess', whose murder was 'one of the most odious crimes to have soiled [the country's] history!'[59] It follows that Moïse's opinion was not very different, and he clearly relished ownership of these most coveted pieces of national patrimony.

In 1935, Jacques Seligmann alerted Moïse to the existence of another rare Carlin table, completed in 1766 with his signature inlaid Sèvres, that came from the collection of a French noble family 'to whom it would have been given by Queen Marie-Antoinette'. Seligmann also located for Moïse two objects – perhaps even rarer – which immediately became among the most cherished in his entire collection: a pair of petrified wood vases that in all likelihood had

come from Marie-Antoinette's private apartments at the Château de Versailles. In the description attached to the invoice, the dealer noted the following: 'these vases attributed to Gouthière . . . are believed to have adorned the boudoir of Marie-Antoinette at the Trianon'.[60] This was only partially true: the bronzes were in fact the work of François Rémond, and they adorned not the boudoir of Marie-Antoinette but her bathroom, where they had ended up in the chaos of the royal family's departure from Versailles in October 1789.[61] In any case, it mattered little. With these acquisitions, Moïse de Camondo had come to possess small but significant pieces of France's royal legacy, the life-blood, in a sense, of its nationhood. For Pierre Assouline, this was Moïse's attempt to brand himself an '*émigré du XVIIIème siècle*', and, indeed, like other prominent members of the contemporary Parisian haute bourgeoisie, such as Théodore-Ernest Coqnacq and Marie-Louise Jay,[62] Edward and Julia Tuck,[63] and even his cousin Isaac de Camondo, Moïse's choice of period reflected a degree of patriotism and class consciousness.[64] But as much as Moïse fits in this context of bourgeois collectors, the self-appointed saviours of France's national heritage, he was also fundamentally distinct. His ambitions were smaller than those of his contemporaries, and his consumption was perhaps less conspicuous.

The others, for instance, including the Cognacq-Jays and the Tucks, donated their collections to public institutions before their deaths, but Moïse did no such thing. For the rest of his life, rocked as it was by repeated ruptures, he wanted to live among the objects he had meticulously chosen and arranged. To borrow from Walter Benjamin, this was his 'magic circle', a sphere of perfect harmony that was also a retreat, and perhaps even a fortress. In old age, he came to see the objects in his collection as the only constants in his life; after the humiliation of his divorce and the death of his son, they were the only sources of joy that could never be taken away from him. And indeed he never let them leave the house.

As a collector, Moïse's initial ambitions were private, not public. Only after the death of Nissim – to whom Moïse had intended to leave the house and his collection – and the departure of his daughter, Béatrice, and her husband, Léon Reinach, in 1923 to a home of their own in Neuilly-sur-Seine, did

he seriously consider the possibility of creating a museum on the rue de Monceau. The question of a carefully curated public identity, so often a motivating force, may be relevant to the case of Moïse de Camondo, but only to the final chapter of his life. Whatever Moïse may have shared with other collectors of his class and time, for him the primary purpose of collecting was its personal, private value – to a point that nearly eschewed any public component at all.

Consider, for instance, the numerous occasions when he rejected out of hand frequent requests to include pieces from his collection in museum exhibitions or even to be photographed in articles for publication. These letters are perhaps the most recurring theme in his voluminous correspondence after Nissim's death, and his opinion on the subject remained almost entirely unchanged throughout the decades: his answer was almost always no.

In February 1925, Moïse responded to a Madame Edgar Stern, then the president of the Conseil d'Administration de la Fédération Française des Artistes, who had requested his permission to include the *Bacchante* by Élisabeth Vigée Lebrun in an exhibition.[65] 'The painting is the only decoration in my office, where I constantly live, and I could not deprive myself of it for such a long period, and also because of all the risks involved with a journey overseas.'[66] His reply betrays not only a veritable separation anxiety, but also a certain intimacy with the painting itself, a personal relationship with a material object that shared with Moïse the privacy of a space he occupied alone. More than the Vigée Lebrun's artistic or cultural value, it was that intimacy that drew Moïse to the portrait: what appears to have mattered was the stability the painting brought to life he lived when no one saw.

In almost the same way, he rejected a request to lend his Houdon bust to an exhibition at the centenary of the sculptor's death. The justification was a bit of a stretch: 'It's the only decoration on my living room's fireplace, and, moreover, I cannot expose it to the risks it would face from transportation and from public exposure.'[67] Sometimes, Moïse even blatantly lied to avoid parting with his objects, as is evident in his response in 1934 to the gallery owner André Weill, who had approached him about a forthcoming exhibition of Claude-Jean-Baptiste Hoin's landscape paintings. 'Dear Sir,' Moïse wrote, 'I'm sorry that I cannot be helpful to you by participating in the exhibition dedicated to Claude Hoin, but I do not have any work by this charming painter.'[68]

In fact, Moïse had acquired two paintings by Hoin in 1932, as Weill almost certainly knew.[69]

Moïse's disdain for the spotlight carried over even into the realm of print magazines, which would not even have required him to separate from his beloved objects. As he wrote to Sir Robert Abdy in 1933: 'My dear friend, I always refuse the publication of all or even individual pieces of the works of art that I possess.'[70] The point of the pieces he owned, in other words, was not at all the publicity they might bring him. On this point, Moïse was even more explicit later in the same year in his response to Armand Dayot, Léon Gambetta's former Minister of Arts and the founder of the journal L'Art et les artistes: 'Your daughter has indeed told me about your intention to publish a series of articles on major collections in your journal. To that end, you ask me for my assistance. I deeply regret not being able to defer to your desire, because I have always refused – to all French and English art publications – any mention of my collection.'[71]

Moïse not only disavowed the public advertisement of certain pieces in his collection, but also his own personal inclusion among the other prominent collectors of his day. Despite the decidedly public – albeit posthumous – life his collection would have after 1935 in the form of a house museum, his response to Dayot ultimately underscores the discretion with which Moïse approached collecting, as well as the sense in which, for him, it was something of a sanctuary, a private retreat predicated on his withdrawal from widespread attention and prominent associations.

Again, a mere six months before his death in November 1935, Moïse, in the only letter in which he acknowledged the worsening political situation in Europe, reiterated his refusal – this time, to none other than Herbert Eustace Winlock,[72] director of the Metropolitan Museum of Art in New York – to be separated from the objects that afforded him such pleasure, and even solace. 'First, given my old age, it seems like punishment to be separated for so long from an object so dear to me.'[73] There is a striking prescience to this letter, one of the final pieces of correspondence in Moïse's extensive archive. Once again, it suggests that for the ageing patriarch, the objects in his collection bore a fixity[74] that had never applied to the intangible aspects of his life.

By 1935, after all, he had lost his wife to another man, his son to the First World War, the prospect of an observant Jewish family existence to the

seductions of a secular modernity, and, finally, the cosmopolitan fluidity of the Camondo's continental Europe to a regime that had already embarked on its devastating project of an unprecedented ethnic nationalism. In a world that had been neither kind nor predictable, the material realm was all that was solid.

5

THÉODORE REINACH
JEWISH PAST, FRENCH FUTURE

In the aftermath of the Second World War, the Reinach family – without which it would have been impossible, a mere generation before, to conceive of French public life – vanished, along with the majority of its written records. Nazi forces destroyed the immense family archive and library that Théodore Reinach had maintained in the Villa Kérylos, his Greek fantasy in Beaulieu-sur-Mer that he had donated to his beloved Institut de France upon his death in 1928. The war claimed the lives of five Reinachs in total: Jean-Pierre Reinach (1915–42), Joseph Reinach's grandson, was killed in combat as a second lieutenant for the French Resistance; Léon Reinach (1893–1944), Théodore's younger son – along with his ex-wife, Béatrice de Camondo, and their two children, Fanny and Bertrand – were murdered in Auschwitz. Julien Reinach (1892–1962), Théodore's elder son, survived Drancy and Bergen-Belsen but was debilitated for the rest of his life.

In any case, physically injured or not, the members of the family who survived into post-war France emerged into an altered social landscape. Either as a result of ethnic cleansing or forced migration, the Second World War had uprooted millions of Europeans, disconnecting them from the homes and institutions that had defined their pre-war lives. The continuity of generations and the fixity of place became less binding on people whose relations had been deported, killed, or murdered.[1] If the individual could survive, the family often could not. This was a trend that grew during the process of European reconstruction, and especially in France, where a stronger, centralized state began providing social services that had often been family matters before the war. The Reinachs were precisely such a family: some of its members continued living well into the 1960s, but, after the Second World War, its family culture became a relic, a thing of the past.

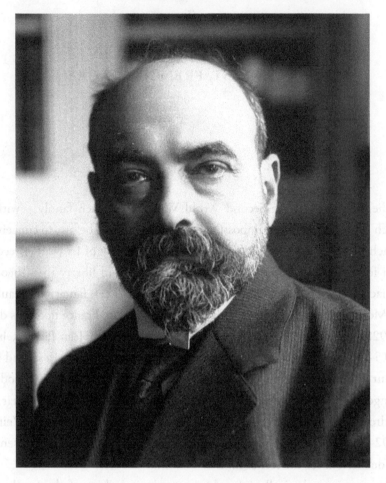

Théodore Reinach (1860–1928).

This was perhaps clearest when six Reinach men (and no Reinach women) were memorialized in May 1949 with a plaque that once adorned the entrance to the family house in leafy Saint-Germain-en-Laye but that has since been removed. It read as follows:

ICI

vécurent au service de la France, de l'art et de la pensée:

Joseph REINACH

Historien et homme politique

1856–1921

Adolphe REINACH

THÉODORE REINACH

Membre de l'Ecole Française d'Athènes

1887–1914

Mort pour la France

Jean-Pierre REINACH

1915–1942

Mort pour la France

Salomon REINACH

Membre de l'Institut

1858–1932

Théodore REINACH

Membre de l'Institut

1860–1928

Léon REINACH

1893–1944

Mort pour la France en deportation

While it still hung, the plaque revealed the attempt to subsume the Reinachs into perhaps the expected post-war narrative of patriotic resistance. There is some truth in it: Jean-Pierre Reinach had indeed served in the French Resistance, and his grandfather and great-uncles had each served the French state in a variety of important capacities. But this comfortable image cracks in the case of Léon Reinach and his children, the Holocaust victims in the family. He did not 'die for France', he died because he was Jewish, as others in the family might have as well had they lived long enough to experience the Occupation (and, indeed, as Julien Reinach, unlisted, nearly did). Either predictably or inevitably, the plaque – the only public memorial to a family that certainly ranks among the most politically and intellectually significant in the history of modern France – effaces their particular lived experiences as Jews in the twentieth century and as individuals with rich and complicated inner lives. In immortalizing their titles and achievements – *'Membre de l'Institut'*, *'Membre de l'École Française d'Athènes'* – it merely commemorates what the Reinachs did. It says nothing of who they were, either as people or as a family.

Both questions today remain elusive. Joseph Reinach, Salomon Reinach, and Théodore Reinach each left behind a staggering bibliography, hundreds of citations that include books, articles, translations, newspaper editorials, and even musical compositions. These, however, evince only a diverse array of scholarly achievements and the contours of three distinct but equally formidable intelligences. But if we know their opinions, we do not know their authors. The Reinachs have come to represent an ideal of French academic excellence and the life of the mind at its most scrutinizing and judicious: they were akin to the William, Henry, and Alice James of the Third Republic. As Charles de Chambrun (1875–1952), the diplomat and future member of the Académie Française,[2] would say at the dedication of the Reinach plaque in May 1949:

> As journalists, as polemicists, as politicians, as scientists, as men, the Reinach brothers knew to transmit to the generations that followed them the fervent message of work and of honour. As the dangerous extremes leave the doors open to excesses, very often macabre ones, these three men wanted, through a harmonious equilibrium, to hold strongly to positions and solutions of wisdom, thereby representing the French tendency, made of both common sense and self-sacrifice.[3]

But the Reinachs were more than mere metaphors. And if the archives that attest to their rich inner lives were virtually all destroyed, what remains is the Villa Kérylos, Théodore's painstaking recreation of an ancient Greek villa on the Pointe des Fourmis in Beaulieu-sur-Mer. Constructed between 1902 and 1908 by the architect Emmanuel Pontremoli (1865–1956), the grandson of a rabbi from Nice, the house can be seen as a reflection of the man who commissioned it, a translation into tile and stone of a powerful mind that eludes facile categorization.[4]

Théodore Reinach was the consummate Hellenist, a life-long student of ancient Greece, whose civilization he believed his own contemporary France to have inherited. In a sense, his entire intellectual project was a means of preserving and advancing the legacy of antiquity in the modern age. Kérylos, in keeping with Théodore's scholarly passion, is an undeniable homage to the harmony and, most of all, the perfection of the Greek ideal of balance. With

modern conveniences such as electricity, plumbing, and central heating, it is also a testament to the (adaptable) durability of those ancient ideals in a decidedly modern context. But there is another, more personal element at work in the design. Of the three Reinach brothers, Théodore was also the most invested in the study of Jewish antiquity and Jewish history. He saw French civilization as the modern reconstruction of an ancient democratic ideal, but he also saw republican universalism as originating in the ethics of the Hebrew prophets.

Kérylos was built in the midst of the dénouement of the Dreyfus Affair, and this was a scandal that had made the Reinach brothers, as Drefyus's leading defenders, the targets of a uniquely hostile stream of antisemitic invective. If the house is not a literal 'Jewish' structure, it cannot be separated from the context in which it was constructed: it was conceived as a refuge, both from personal pain and the inhospitable public tenor of the French fin de siècle, increasingly hostile to Jews, French and foreign alike. It was perhaps Théodore's greatest attempt to derive a sense of meaning in the midst of private and public chaos. The house is essentially an artistry of intellect, one man's tireless quest for beauty in the traditional Greek sense of the term. Kérylos, through its symmetry and its geometry, was an effort to access nothing less than the Platonic Ideal, a higher, purer level of human existence. This Théodore essentially admitted in the inscription he chose to adorn the walls of his library, accompanying the great Greek authors he so cherished: 'It is here in the company of these Greek orators, wise men, and poets that I find a peaceful retreat in immortal beauty.'

The Reinach brothers – Joseph, Salomon, and Théodore – were a fraternity at the very heart of social, political, and intellectual life in the Third Republic. The breadth of their interests and the depth of their collective knowledge was widely known, embodied in the nickname they earned in certain segments of the Parisian press, based on the first letter of each of their first names: '*les frères Je Sais Tout*', the brothers who knew everything.[5] This was a term not without its share of antisemitic implication but that nevertheless evoked the diversity of their endeavours. Joseph (1856–1921), the eldest brother, was chief of staff

and confidante to Léon Gambetta, a future deputy from the Basses-Alpes administrative department and, perhaps most importantly, the lead defender of Alfred Dreyfus throughout the affair. Salomon (1858–1932), the middle brother, was a member of the École Français d'Athènes, an editor of the *Revue archéologique*, and the director of the Musée d'Archéologie Nationale in Saint-Germain-en-Laye, a position he held until his death.[6] Théodore (1860–1928), the youngest, may have been the most diversely academic of the three, not as politically oriented as Joseph – although he, too, would eventually become a deputy, for the Haute Savoie – and less animated by a singular subject as Salomon, whose deep studies mostly focused on religious mysticism and its archaeological traces.

As a young man, Théodore more than outshone his brothers at the Lycée Condorcet, in spite of their already stellar records, garnering no fewer than nineteen separate recognitions in the national merit exam, the Concours Général. The youngest Reinach was a polyglot, a true Renaissance man whose academic pursuits included mathematics, numismatics, musical composition, and translations of Shakespeare, to list but a few. Above all, Théodore was a Hellenist, a passionate student of ancient Greece, whose civilization he believed his own contemporary France to have somehow inherited. In a sense, his entire intellectual project, multifaceted as it may have been, was a means of preserving and advancing that legacy: a cult of Hellenism morphed into an embrace of French universalism, which Théodore and others saw as the natural heir of ancient Greek rationality and order. When Théodore died in 1928, the president of the prestigious Académie des Inscriptions et Belles-Lettres, of which he had been a member, eulogized him as follows: 'What struck one first about him was the universality of his erudition.'[7] Universal was his intellect indeed.

In the end, the Reinachs lived in the Parisian fin de siècle, a time and place in which their numerous successes were not enough to protect them from either ideological or antisemitic attacks. Despite the power that their public personas projected, the brothers felt a profound uncertainty and an all-consuming vulnerability in private. This was especially the case during the unfolding of the Dreyfus Affair, in which both Joseph and Salomon were heavily involved and which consequently brought the entire family an enormous amount of unwanted public attention. Their anxieties were not imaginary: in the eyes of certain anti-

semites, their name became a synonym for a Jewish cabal and political conspiracy. This association metastasized into physical caricature, with the Reinach name standing in for perceived Jewish bodily deformities. 'Look at this small Jew from Hamburg,' Édouard Drumont, France's so-called antisemitic pope, would write of Joseph in the early years of the Dreyfus Affair. 'If his ape-like face and his deformed body carries all the stigmata, all the faults of the breed, his hateful soul swollen with venom better sums up all its evil, all its genius, disastrous and perverse.'[8] Their only sanctuary was their family circle, which 'provided a zone in which they could tease each other and reveal their anger, pain and fear'.[9] If Théodore, like his brothers, was a public man, he never strayed far from the comfortable confines of this decidedly private family world.

Acute intellect was the lifeblood of that world. As the sons of Hermann Reinach, a banker from Frankfurt-am-Main who would eventually leave his sons a fortune of approximately 14 million francs, the Reinach brothers were endowed with the security to pursue the heights of academic success. That success became an animating passion that lasted well beyond their schoolboy days and the metric they always seem to have used in assessing the value of their own careers, different though they were. As it happened, Théodore was not the first Reinach to have been elected to the Institut de France: in 1896, Salomon was named a member of the institute's archaeological and historical branch, the Académie des Inscriptions et Belles-Lettres.

Although the Reinachs left behind innumerable books and publications, few traces of their private lives survive. But in the scattered correspondence that does remain, Salomon's election to this most prestigious of cultural institutions was clearly perceived as a victory for the entire Reinach clan, one in which even its youngest members were made to take pride. 'Congratulations', wrote Ado Reinach, Joseph's eldest son. 'We truly congratulate you on your big success!!!' wrote Lili, his sister.[10] 'Dear Uncle the Wolf,' wrote Hélène, Théodore's daughter, on behalf of herself and her sister, Gabrielle, too young to write, 'I congratulate you so much on being a member of the Academy. I also salute you for Gabie, because, for the moment, she cannot write.'[11] Even the children's English governess expressed her excitement: 'Heartiest congratulations,' she wrote, 'G. Kinkelein'.[12]

If there was a familial pride in the individual intellectual achievements of the brothers *Je Sais Tout*, there was also a clear culture of competition, which often manifested itself as playful one-upmanship. We know, for instance, that Salomon Reinach was in the audience of the Institut the day that Théodore's nomination for membership was discussed, 5 February 1909. One could scarcely imagine higher praise than that lavished on the youngest Reinach. In the words of one member, the historian Jean-Pierre Babelon: 'I can therefore affirm that there are few scholars whose erudition is so encyclopaedic and who can present themselves before the vote preceded by a scientific reputon so solidly established and so universally recognized.'[13]

But in the records of the séances that followed Théodore's official initiation later that month, one can see Salomon was indirectly defending the prestige of his own universally recognized intellect from his brother's encroaching advances. On 12 March, for instance, Théodore gave a presentation to the Académie on a recently discovered inscription on the island of Amorgos, which, as he argued, was an important contribution to the contemporary understanding of Greek medicine. Salomon chose the same day to give a presentation of his own, on the magisterial study that perhaps became his masterpiece: *Orpheus, Histoire générale des religions* (1909).[14] The same would happen the following week, when Théodore reported to the Académie on the International Archaeological Congress in Cairo and Salomon, upon his brother's conclusion, made quite a display of a donation he made to the institution's library – again, in the same week.[15]

This culture of competition was also marked by an undeniable maleness. In a time when antisemites were elaborating an association between Jews and physical weakness – and, during the Dreyfus Affair, the effeteness of the Reinachs themselves – intellectual vigour appears to have been an important means for the brothers to express their masculinity, at least among themselves. In the few pieces of their correspondence that survive, they often bantered among themselves with a crude schoolboy humour. As Joseph wrote to Salomon, who would remain childless and who was considered by certain of his colleagues, and perhaps by his own brothers, as 'a little feminine':[16]

It is quite obvious to me that you have gone mad, and that if you don't lose double quick the ridiculous virginity that is sending you round the bend,

you will end up committing some pretty bad sexual offence, which will lead you straight to the magistrate's court . . . You are more dirty-minded than the Catholic priests who screw chickens and goats . . . Let me tell you, in all friendliness: find yourself a hooker, or you will end up in court. . . . *Vale.* Lose your virginity. It's better than losing your honour.[17]

But within the closed confines of this family, there was a sense in which power and authority were functions of academic achievement. For the Reinachs, masculine prowess was often intellectual prowess. Consider, for instance, a letter sent to Salomon from Léon Abrami, the lawyer and amateur scholar whom Théodore's daughter Hélène had married some years before. 'My dear Uncle,' Abrami wrote:

> You were kind enough to encourage me to write, on my own, these indexes that the editor Conard asked me for, for Herodotus and G. Flaubert. I bravely followed your advice, and as ignorant as I may be, I drew on your reading of Josephus, that of the Jewish Encyclopaedia, the History of Graetz, etc. . . . all the information that allowed me to carry out this little job.[18]

Abrami's letter expresses gratitude but ultimately seeks recognition. Through a vast array of literary and historical allusions across time and place – Herodotus, Flaubert, Graetz – the younger man wanted the older man's approval in order to take his rightful place in the family. An expression of sufficient intellectual vigour, it seems, was more than a feather in the cap: it was a rite of passage, and a decidedly male one at that.

This gendered exclusivity becomes more pronounced in the self-deprecating and self-effacing tendencies of the Reinach women, made to admire their fathers and uncles but never themselves to engage. As Hélène Reinach-Abrami would write in an undated letter to Salomon, around the time his *Cultes, mythes, et religions* was reissued for a subsequent printing: 'Thank you a million times, dear Uncle Salomon: what you sent has given the two of us the greatest pleasure. Since last night Léon has plunged in to "Cultes, mythes . . ." & he found there strokes of light that stupefied us both!'[19] The book was for Léon to read and ponder; Hélène's role was to be stupefied by its insights. She would later distance herself from Judaism because of what she perceived to be the secondary place it afforded women.

Hélène wrote something similar to her uncle in January 1929: 'I hate the intellectual disparity that, even more than age, separates us. Alas! Merit & talents are neither hereditary nor contagious, & the very superficial instruction that I received cannot replace the gifts that nature refused me!'[20] She seems to have felt comfortable engaging with her uncle only in self-effacement, and she concluded that same letter with the following line: 'it's not the family duty that incites me'.[21] Like her uncle, Hélène never reproduced; she and her husband lived essentially the same type of life Salomon lived with his wife, Rose Margouleff. And yet she appears to have felt herself judged for replicating precisely the same life: 'I know that you distrust the bourgeois banality of my ideal,' she would later write as a young bride to her uncle.[22] But for the Reinach men, that bourgeois ideal was never banal; it was unquestioned, the obvious way to structure family life.

The family was always rooted in a particular version of that ideal, the Jewish haute bourgeoisie. If in public life the Reinachs were devoted to the institutions of the secular state and its universal republicanism, their private world was the epitome of communal particularity. As is revealed in the privately published memoirs of Hélène Reinach-Abrami, the family patriarch, Hermann Reinach (1814–99), was the opposite of dogmatically religious, but he nevertheless insisted on the centrality of Jewishness within the family's identity.[23] At Hermann's behest, each of his sons received an elementary religious education, became influential members of the Grande Synagogue de la Victoire after its completion in 1875, and all three, without exception, not only married Jews but also married within the exclusive sphere of Paris's Ashkenazi elite – and sometimes even within the family itself. But these familial and communal bonds clearly mattered to Hermann, who had endowed a 'Reinach dowry', administered through the Consistoire, France's central Jewish organization, and given to a young French-Jewish woman who married an especially promising Jewish man, all in the name of inspiring a Jewish 'regeneration' at all levels of French society.[24]

His sons were subjected to the same social experimentation, and it was perhaps in marriage that they most experienced the notion of sacrifice. In the early 1890s, Joseph, who had fallen in love with an Englishwoman whose exact identity remains unknown, wrote to Salomon of his frustrations with 'the Government', his ironic name for his parents, whose final edict prohibited him

from marrying outside the community. 'My dear friend,' he wrote to his brother with his signature sense of humour, 'the Government must have written to you that Rubicon no. 2 has been crossed and that my marriage with Henriette is decided.'[25] This was Henriette Reinach, Joseph's cousin, the daughter of his uncle Jacques de Reinach, who had been implicated in the infamous Panama scandal and had subsequently committed suicide in 1892. In this way, the Reinachs were similar to the Rothschilds: in the eyes of the older generation, marrying across family branches was a means of bolstering a social position that was still precarious, even with great wealth. The other brothers did not marry Reinach women, but they married other Ashkenazi elites. Salomon married Rose Margouleff, a Russian Jew. Théodore first married Evelyne Hirsch-Kann, and then, after Evelyne's death, he married her cousin Fanny Kann, whose mother had been an Éphrussi.

There are no surviving documents that shed any light on Théodore's experience of losing his first wife. But what is certain is that the family observed little difference between the respective households it contained, and the children of Joseph and Théodore – Adolphe, Julie, Hélene, Gabrielle, and, later, Julien and Léon – were raised together by the same governness in Saint-Germain-en-Laye. They were an extended clan who lived and grew together and who did not necessarily distinguish their members and their respective roles in the same ways that became commonplace in the increasingly nuclear French bourgeois family in the fin de siècle.[26] Pain was felt communally and in equal magnitudes, even in the households not directly implicated in the various tragedies that befell the family over the years. In the First World War, for instance – in which a good number of Reinach men, including Théodore, served – one Reinach man was killed: Adolphe 'Ado' Reinach, Joseph's son. But this was a trauma that shattered the entire family. In the wake of Ado's death, Hélène wrote the following letter to her uncle, which expressed a considerable emotional intimacy and a mutual investment in endurance against circumstance. Perhaps its most relevant insight into the Reinach family culture is the moving declaration that the childless Salomon Reinach in fact had many children, those of his brothers:

These few months of living together allowed me to discover your overly hidden heart, and your enlightened optimism was the source from which I drew the comfort necessary for my constant anguish. I can never thank

you enough for saving me from despair, at the cruellest time of my life. The great service you do me today gives me the opportunity to repeat, drawing inspiration from the book that so charmed my youth. . . 'Salomon Reinach had no children, which was sad for them; Salomon Reinach had nieces, and it was marvellous for them.' I think of this often, and I hope you can be persuaded to as well.[27]

In any case, we can only infer that the same communal solidarity shielded Théodore after the death of his first wife. From Hélène's account in *La Bien-aimée*, the memoirs she wrote for her grandchildren – but never published – in 1934 and 1935, Théodore appears to have outwardly confronted the situation with a stoicism that bordered on emotional absence: 'Say "good morning, mummy",' he told his daughters, when they began to notice him spending more time with their aunt. 'Cousin Fanny is now your mother.'[28] That was the only explanation he ever offered his children, and his exact motives for marrying his wife's relation remained elusive. Was he seeking a natural mother figure for his two young daughters, with whom they were already familiar? Did he feel it imperative to remarry from within the same stratum of the Parisian Jewish elite? Was it both? As Hélène recalled, she and her sister did not take to their new stepmother as quickly as their father would have liked. She recalled wondering the following: 'Does she want to make me eat a poisoned apple?'[29]

In advance of what he would later call his 'peaceful retreat into immortal beauty at Kérylos', Théodore, despite his outward strength, seems to have endured the darkness of personal tragedy through the control of material objects. After Evelyne's death, he completely transformed the family apartment, displacing his children for months as he obsessively and painstakingly rid their private living quarters of any surviving traces of his wife. Hélène would later recall returning after months of living with her uncle Joseph to a home that was entirely unrecognizable:

The old library of blackened pear wood had become white and blue, and there was a four-poster silk bed there. My mother's room, whose purple drapes and rosewood furniture I remember so well, even now, had become the library, and was full of red furniture. In its middle rose a bizarre agglomeration, composed of two canapes [sofas] of the 'Oriental style', two trestle

tables in white wood draped in red velvet, and a high central pedestal table, on which stood, acephalous and distraught, among green plants, the Victory of Samothrace. . . . I hated this assembly . . .[30]

Of all the families in their immediate milieu, the Reinachs were the clan that most actively grappled with the meaning of Judaism and Jewishness. It was a life-long struggle for the brothers *Je Sais Tout*. They were exemplary republicans, even official representatives of the republic and its universal values, but they were also proud defenders – and custodians – of Jewish communal life. They all rationalized that duality in different ways. Salomon, for instance, was convinced that there was no such thing as a Jewish people. Writing to his friend Ernest Renan, the famed French Orientalist, he expressed his agreement with Renan's now-discredited hypothesis that Ashkenazi Jews were descendants of the Khazars, a Turkic people from southern Russia who had converted to Judaism in the eighth and ninth centuries.[31] For Théodore, however, Jewish values were a portal to French universalism and European modernity in general.

Universalism, at least in its French revolutionary variety, had recognized all men as equal citizens. But to accomplish that noble aim, it sought to subordinate all other elements of an individual's identity to the primary identity of 'citizen' – at least in theory if never quite in practice. In seeking to transcend difference, the universalist credo – at its most extreme – ran the risk of confiscating from individuals the liberty to determine their own identities. In that sense, the Reinachs were something of a challenge to this conception of universality as mutually exclusive of particularity: they were unwilling to sacrifice those effaced differences – Jewishness most of all – but they were also unwilling to forfeit the advantages of emancipation that French universalism had afforded them. In their own family circle, the Reinachs showed just how much was possible for a minority community under the auspices of that universalist vision, but also how republican Jewish observance could be.

This attempt to fuse local and global affiliations into a durable whole led them to articulate a Jewish cosmopolitanism in the sense that the Israeli historian Natan Sznaider has imagined it, an aspirationally universalist sensibility that 'neither orders differences hierarchically nor dissolves them, but accepts them as

such – indeed, invests them with positive value'.[32] If universalism sought to rise above differences in the name of equality, this type of cosmopolitanism considered individuals as different *and* equal, albeit simultaneously. For the Reinachs, and Théodore especially, the particular narrative of the Jews in modern history was a parable that served to elucidate the value of that inherently fruitful tension.

As Pierre Birnbaum has pointed out, if Joseph Reinach embodied the promise of Franco-Judaism after 1789, it was his youngest brother, Théodore, who was the leading theorist of that sensibility, the embodiment of dual affinity.[33] As the third and final Reinach brother, who corresponded to the '*Tout*' in the nickname assigned to the family, what is most immediately apparent in a survey of Théodore's writings is that he seemed to believe that association. Indeed, a certain arrogance emerges in the pages of more than a few of the 328 articles and books he wrote over the course of his long intellectual career, including, notably, the preface of his *Mithridate Eupator, roi de Pont* (1890): 'For starters,' Théodore wrote, 'I prefer to leave the final word to the documents; secondly, I found it pointless to boast and loudly proclaim my superiority to my predecessors on account of their errors large and small.'[34] Perhaps it was this self-assurance that enabled him – at the age of 24 – not merely to explore but to answer, with remarkable economy and next to no irony, the ways in which the particular can in fact reconcile with the universal. That, after all, is the thesis of Théodore Reinach's *Histoire des israélites depuis la ruine de leur indépendance nationale jusqu'au nos jours* (1884): allowing the Jewish people to maintain its 'cosmopolitan character' could serve as a lesson for France and, by extension, all humanity.

Histoire des israélites does not quite fit into the broader context of the *Wissenchaft des Judentums*, the movement that first emerged in Germany in the early nineteenth century and that was devoted to the scientific study of Judaism and its history.[35] Théodore's book is an argument, almost a polemic, not quite a work of scholarship despite its depth. But it does follow very much the template of Léon Halévy's 1828 *Résumé de l'histoire des juifs modernes*, the first general study of Jewish history written by a French Jew and a book that interprets the Jewish past through a French republican lens.[36] Halévy's analysis sees clear traces of republican universalism throughout the Hebrew Bible. 'The government of Israel, as it was constituted by Moses,' he writes, 'was a republic with a king, but this king was God.'[37] Mosaic law, he wrote, provided 'the

1 Pierre-Auguste Renoir, *Mlle Irène Cahen d'Anvers* (1880). In 1941, the portrait – then the property of Béatrice de Camondo, the sitter's daughter – was stolen by Nazi authorities, briefly passing into the hands of Hermann Göring. It was eventually restituted to Irène Cahen d'Anvers in 1946, who sold it to the Swiss arms manufacturer Emil Bührle.

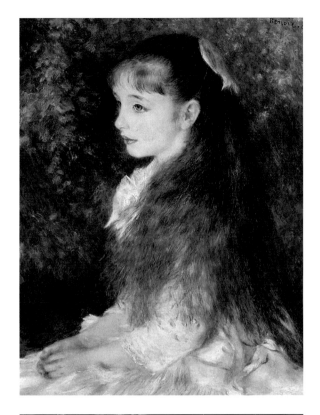

2 Pierre-Auguste Renoir, *Les Demoiselles Cahen d'Anvers* (1881). The portrait depicts Alice Cahen d'Anvers (left) and Élisabeth Cahen d'Anvers (right). At the age of 66, Élisabeth was arrested in hiding in the French countryside and deported to Auschwitz, where she was murdered in 1944.

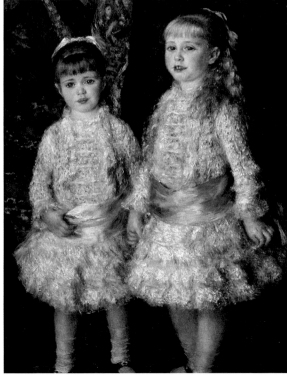

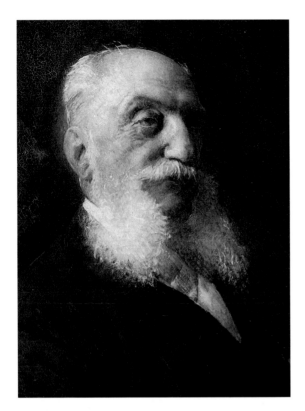

3 Léon Bonnat, *Portrait de Louis Cahen d'Anvers* (1901). Louis Cahen d'Anvers was among the most prominent financiers of his time, belonging to the family that had cofounded the bank later known as Paribas. Like others in his milieu, including his future business partner and son-in-law, Moïse de Camondo, he was a passionate enthusiast of the French eighteenth-century. He was remembered by his grandchildren as 'very authoritarian', although the women in his family – his wife, but especially his daughters – rebelled against the traditional mores he strove to uphold.

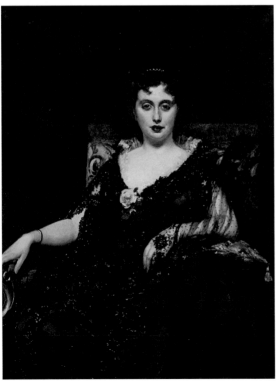

4 Carolus-Duran, *Portrait de Louise Cahen d'Anvers* (1874). Louise Cahen d'Anvers (née Morpurgo) was a leading salonnière of the Parisian fin de siècle, with a particular interest in literature. She corresponded regularly with the novelist Paul Morand, entertained Marcel Proust and was a fixture in French cultural life throughout the Belle Époque. At the same time, she was ridiculed by the antisemites of the day for attempting a life of the mind. The diarists Jules and Edmond Goncourt, for instance, mocked her wealth and referred to her as a 'lazy cat' of a woman.

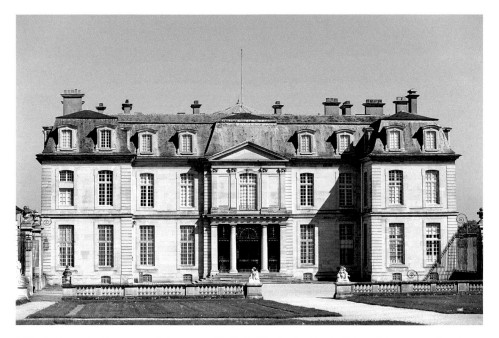

5 The Château de Champs-sur-Marne, outside Paris. The banker Louis Cahen d'Anvers purchased this storied property in 1895 and painstakingly restored its eighteenth-century glory with the help of the architect Walter-André Destailleur. His son, Charles Cahen d'Anvers, donated the château to the French state in 1935.

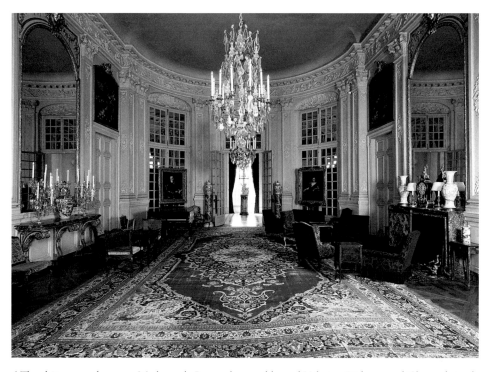

6 The château was home to Madame de Pompadour and hosted Voltaire, Diderot, and Chateaubriand.

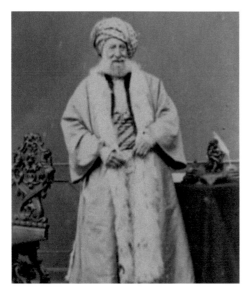

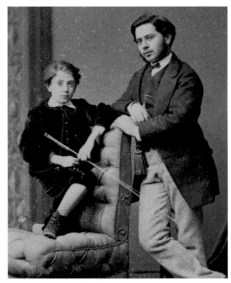

7 Abraham Salomon de Camondo was the patriarch who developed the family bank, I. Camondo & Cie, into a Constantinople powerhouse and established the family's tradition of philanthropy. A cause he particularly championed was the fate of the Jewish community in the Ottoman Empire.

8 Born in Constantinople, cousins Isaac (right) and Moïse (left) de Camondo became legendary collectors in fin-de-siècle France. Both bequeathed their collections to the state: Isaac to the Musée du Louvre and Moïse to the Musée des Arts Décoratifs.

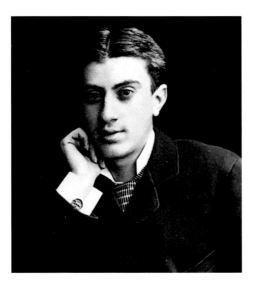

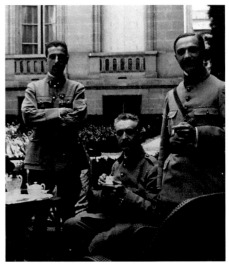

9 Moïse embraced collecting the art of the French eighteenth century after a series of traumas in middle age. His wife, Irène Cahen d'Anvers, abandoned him for another man, triggering a custody battle for his children, Nissim and Béatrice. Nissim later died in the First World War, devastating his father, who seems to have found solace in the control of objects and things.

10 Nissim de Camondo (left) was eager to serve in the French military during the First World War, and yearned for the excitement of aerial combat. In letters home to his father and sister, he downplayed the brutal scenes he witnessed. He was shot down behind enemy lines in September 1917, in the midst of a reconnaissance mission.

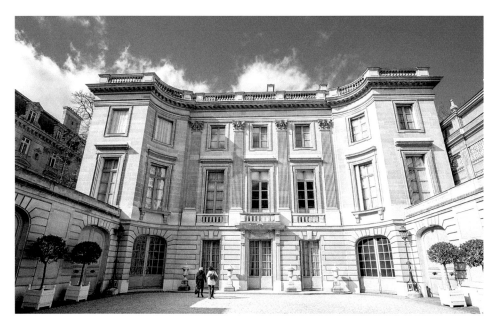

11 The collector Moïse de Camondo transformed his family mansion at no. 63, rue de Monceau into an homage to the Petit Trianon at the Château de Versailles. His aim was to celebrate the style of the ancien régime, which he considered the apogee of French cultural achievement. In honour of his son, Moïse bequeathed the house to the French state on his death in 1935, and it opened as the Musée Nissim de Camondo the following year.

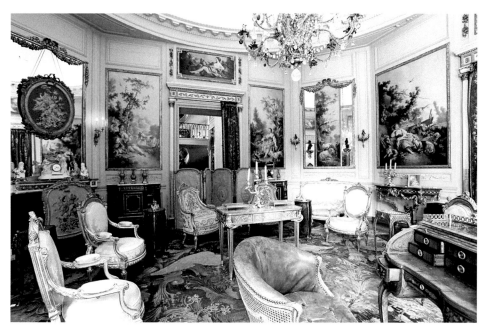

12 Arguably the centrepiece of the Camondo house, this hexagonal-shaped drawing room was designed by Moïse de Camondo's architect specifically to house seven paintings and three panels by Jean-Baptiste Huet, one of the great Rococo painters of animals and pastoral scenes. These particular paintings tell an unfolding love story as the eye travels around the room.

13 Théodore Reinach, self-portrait. Théodore Reinach was a true polymath at the heart of intellectual and political life in the Third Republic. Along with his brothers, he staunchly defended Alfred Dreyfus, the Jewish military captain wrongfully convicted of treason whose trial electrified France and elicited a torrent of antisemitism. Of all in his milieu, Théodore was the most actively engaged with wrestling with the history and meaning of Judaism. His son, the composer Léon Reinach, married Béatrice de Camondo, the daughter of Théodore's neighbor Moïse de Camondo, in 1919.

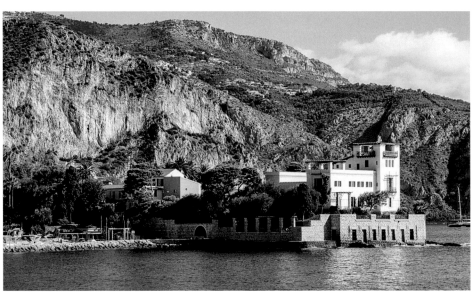

14 Théodore Reinach, a renowned Hellenist, constructed the Villa Kérylos at Beaulieu-sur-Mer, across the bay from where his cousin Béatrice Éphrussi de Rothschild would later build the Villa Île de France, in Saint-Jean-Cap-Ferrat. With the architect and archaeologist Emmanuel Pontremoli, Thédore's aim was to recreate an ancient Greek villa at Delos adapted for modern life. He, too, bequeathed the house to the French state upon his death in 1928 – although it remained in family control until 1967.

15 The Reinach grandchildren at Kérylos.

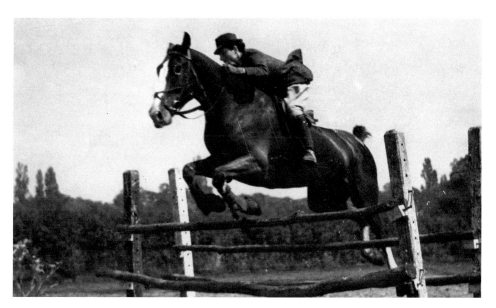

16 Like her mother Béatrice de Camondo, Fanny Reinach was a passionate equestrienne – even in the midst of catastrophe. This photograph dates from August 1942, roughly one month after French authorities had already arrested thousands of Paris Jews in the infamous 'Vel d'Hiv' round-up. But Fanny and her mother appeared convinced that they would somehow be spared the same fate. The two women were arrested on 6 December 1942 and sent to the Drancy internment camp before their deportation to Auschwitz.

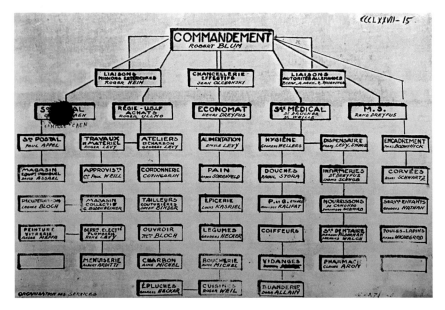

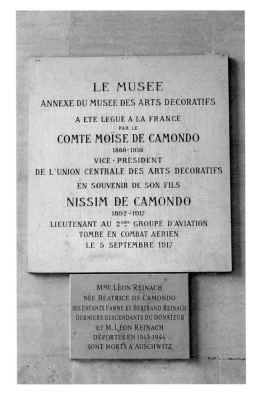

17 Béatrice de Camondo was initially placed in the 'C' category of Drancy internees, which meant that she was part of the camp's Jewish leadership, charged with infant nursery duties (*nourrissons*, second column from right). Béatrice was highly regarded in the camp, known among other prisoners for her work ethic and kindness. A convert to Catholicism, she seemed convinced until the last moment that her newfound faith would save her. She was deported to Auschwitz in March 1944 and murdered there in January 1945, two weeks before the Soviet Army liberated the camp.

18 The small plaque at the Musée Nissim de Camondo reveals the fate of the family. Like Béatrice de Camondo, her ex-husband Léon Reinach and their two children Fanny and Bertrand Reinach were all deported to Auschwitz, where they were all murdered.

means to establish and ensure the absolute equality of citizens'.[38] Decades later, Théodore's book would argue much the same.[39]

Histoire des israélites, of course, appeared in a vastly different moment than Halévy's *Résumé*: 1884 was a time of considerable anxiety among the more elite factions of Paris's Jewish aristocracy who lived what Michael Marrus memorably dubbed the 'politics of assimilation'.[40] For all of its bravado, *Histoire des israélites* is a poetic argument for the value of the Jewish presence in France and in Europe at large, primarily in response to the mass influx of Eastern European Jewish refugees into France in the early 1880s, fleeing Tsarist pogroms. There was also the Tisza-Eszlár Affair of 1882, in which the disappearance of a 14-year-old girl in Hungary elicited, yet again, accusations of Jewish ritual murder across Europe.[41]

The arrival of the observant and Yiddish-speaking Eastern European refugees had coincided with – and exacerbated – a French antisemitism that emphasized the foreignness and racial difference of Jews, and it had also inflamed the dormant insecurities of the assimilated *israélite* establishment, who often viewed Eastern European immigrant Jews as jeopardizing their carefully cultivated social position.

Théodore Reinach, as an indisputable product if not arbiter of that *israélite* establishment, made clear his distaste for Eastern European Jews in order to exalt what he called 'a certain secret affinity between the Jewish spirit and the French spirit – an affinity which has been manifested since the Middle Ages and hastened the moral assimilation of the two races'.[42] In other words, there was a Jewish ethic and there was a French ethic, and, at least in Théodore's conception, both aspired to the same end: the spread of what might be called a moral modernity throughout the Western world.[43]

It was in this way that he was able to interpret the Hebrew prophets as the intellectual antecedents of the French Enlightenment: the latter had inspired a people to lives of contemplation, thought, and reason; the former had created a space in which those principles – at least in theory – were to reign supreme.[44] It was not so much a literal symbiosis he described as it was an essential allegiance or analogy between Jewishness and Frenchness after 1789. For Théodore, Jewishness was the Frenchness of antiquity, a *mission civilisatrice* that had emanated from the ruins of the Second Temple throughout the foreign lands of the Diaspora, carrying with it the precepts and the promise of spiritual and intellectual liberation.

145

In 1928, toward the end of his life, Théodore would frame that continuum in this way:

> In the darkest hours of its history, Israel kept its stubborn eyes on a future of recovery, bliss and universal light. Conceiving an ideal is good, hoping for it is better, but achieving it or seeking to achieve it – that is even better. It is to put into practice this ideal of peace, of justice, proclaimed for the first time by the Prophets of Israel, that we must invite all the religious forces, with the sole and great thought of carrying out fraternity between all men.[45]

In his view, the Hebrew prophets were thus the original source of the values that crystallized in the French Enlightenment and, later, the French Revolution – 'fraternity between all men'. Along those lines, what Theodore calls 'the emancipated Jew' is the heralded figure in *Histoire des israélites*, the living personification of this French–Jewish analogy. This figure, he writes, 'succeeds in reconciling the atttachment to his ancient religious tradition with the duties imposed on him by the progress of civilization and the nature of citizenship in the various countries which have freed him'.[46]

Inherited tradition exerts its pull, but so do the obligations of modern civilization and citizenship, and Théodore's interpretation of Jewish history ultimately locates the widespread acceptance of those mores across Western Europe as a function of the Diasporic necessity to assimilate. For Théodore the history of the Diaspora was the history of modern Europe:

> The history of the dispersed Jews above all deserves to be studied because of its intimate and too little-known relationships with the general history of European civilization. I am not only speaking of the considerable economic role which the Jews played in the society of the Middle Ages ... I also allude to the part which they took in the intellectual and moral development of modern peoples.[47]

The notion that European Jews spurred the intellectual and moral development of the entire continent underscores Théodore's assumption that, in the abstract, the achievements of modernity were somehow 'Jewish' achievements. Although this view clearly serves as a certain defence of Jewish tradition at a

time when French public opinion had begun to view it in an increasingly hostile light, it also relies on the striking assumption that 'European civilization' begins within the confines of a singular national and ethnic enclosure and spreads elsewhere. Somewhat predictably, Théodore was almost defensive on the question of the inherent exclusivity behind this apparent endorsement of a cosmopolitan, European ethic as a kind of historical end: 'the men who work to enlighten, rescue and raise up such a large, ill-fated and gifted population, work not only for the good of Israel but for the good civilization in general'.[48]

'The good of Israel' comes before 'the good of civilization in general' in that conceit, and not merely for rhetorical impact: for Théodore, the former – of no greater value – is the portal through which the latter can hope to be accessed. In other words, the gifts of the Jews to French culture, European civilization, and humanity as a whole were possible only because of the Jewish people's prior maintenance and embrace of their own particularity as a people apart.

At the same time, Théodore – later to serve as a parliamentary deputy for the Savoie from 1906 to 1914, an elected custodian of the French republic – was a staunch advocate of assimilation. This was part of the bargain with the nation that had emancipated the Jews before any other western nation. In 1907, he was among the founders of the *Union Libérale Israélite de France*, a liberal synagogue that still exists today created to inspire a republican Judaism loyal to the spirit of 1789.[49] This, Théodore later said, had been the point of the new congregation:

> Tearing down the barriers and eliminating the misunderstandings that can still separate the enlightened Israelite and the twentieth-century French patriot, definitively reconciling and strengthening our attachment to the great and painful past of Israel, and our no less filial attachment to the redis-covered homeland of the emancipating France of 1789, the mutilated France of 1871 – France the soldier of the law, France the martyr of liberty.[50]

In Théodore's Jewish cosmopolitanism, the particular was prior to the universal, but the universal was still the attainable end, the sphere that he hoped most to improve. In other words, there was a rootedness that defined this cosmopolitanism, an anchoring that afforded individuals the ability to maintain communal ties at the same time as it encouraged them to imagine their community on a universal, and even global, scale.

The Jewish community, Théodore insisted, furnished a 'belief identity' for its members, a 'true or presumed community of origin, the antiquity of traditions, [and] the memory of ills gloriously suffered in common'.[51] It was precisely those communal ties that taught the members of his community what exactly universal human ties could mean. Jewish solidarity, often criticized in France and indeed the crux of post-revolutionary antisemitism, could therefore be seen as a variety of universalism, perhaps, but universalism nonetheless, ultimately geared towards the preservation of humanity as a whole. As Théodore concluded *Histoire des israélites*: 'Israel will never cease to be a family until all of humanity has become a family in its own right.'[52]

Yet despite the remarkable passion with which Théodore devoted much of his working life to the theory of Judaism, he seems to have felt that the beauty and the richness he saw in the Hebrew tradition was lacking in one significant way. For Théodore Reinach, there was no such thing as 'Jewish art'. This he made perfectly clear in his writings on numismatics, one of the more obsessive terrains of nineteenth-century scholarship. It was a field in which he was active in a variety of ways, but perhaps his most enduring contribution to the study of coins was his treatise *Les Monnaies juives* (1888), or *Jewish Coins*. In this brief work, Théodore articulated his concerns about the absence of a Jewish artistic culture that would parallel the richness of the humanitarian universalist tradition he worked so tirelessly to advance:

As for the Roman coins, you see, above all, an incomparable gallery of historical portraits. One should not look in Jewish numismatics for master-pieces or portraits. The engravers of Jewish coins were very ordinary artists, and the main resource of their art, the reproduction of the human or animal figures, was taken away from them by the strict observation of the precept of the Decalogue: 'Thou shall not make any graven image, nor likeness of things that are on the earth, in the heavens, nor under the waters.' By contrast, Jewish coins are, by the very severity of their types, the true image of the deeply religious and poorly aesthetic people who created them.[53]

Perhaps because of the injunctions of Heinrich Graetz[54] and others, who had insisted that pictorial representations diminished the wisdom of the Torah – the same biblical injunction Théodore cited – Jews had become, in his estimation,

a people 'deeply religious and poorly aesthetic'.[55] Kérylos was never designed to emulate the styles of Jewish antiquity, but it can be read as Théodore's response to this perceived deficiency in the realm of Jewish aesthetics, the same trope repeated by the leading antisemites of his time. In using the house to chase an ideal of Greek perfection, Théodore was also demonstrating that Jews could create a coherent, inspiring artistic vision. Kérylos was the encapsulation of Théodore's intellectual project: it reflected the interests of the man as well as the tradition and the sensibility in which he remained forever inscribed.

As René Cagnat, the Secretary of the Institut de France, would note upon Théodore's death, the villa did not so much recreate antiquity as relive it in every material way imaginable: 'all the details have been borrowed from skilfully chosen archaeological documents, mosaics, bas-reliefs, paintings, vases, lamps'.[56] In much the same way as Théodore's intellectual project itself, Kérylos was a monument to Greek style but to a Hebrew ethic: it reflected the interests of the man as well as the tradition and the sensibility in which he remained forever inscribed.

Théodore Reinach was not a great collector. He did not pursue objects with the passionate intensity of Moïse de Camondo, his future in-law, or the compulsive obsession of Béatrice Éphrussi, his distant cousin who built her own villa, the Île de France, directly across the bay from Kérylos.[57] Although he did indeed acquire a few very fine objects from classical antiquity – Tanagra statuettes, shards of painted Greek ceramics, small bronze strigils and fibulas – provenance and *bricabracomania* were not the animating themes of the house Théodore commissioned. Kérylos – much like Moïse de Camondo's Petit Trianon on the rue de Monceau – was never intended as a museum, and Théodore rarely allowed reproductions of his pieces or his house to be published in his lifetime. On the contrary, the house was a metaphor, a means of reconstructing a selective vision of classical antiquity compatible with the nature of modern life. As Théodore's grandson would recall decades later, the house responded to 'a double imperative: that of being a reconstruction of a Greek house on the one hand, and being a place for our time on the other'.[58]

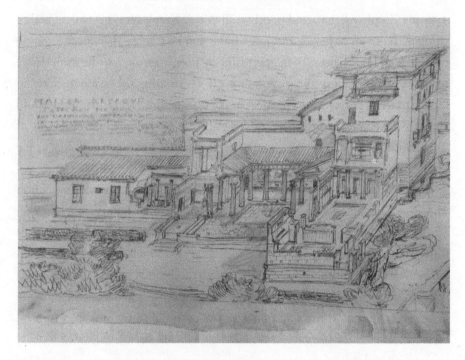

Pontremoli's sketch for Kérylos, the '*maison grecque*'.

Unfortunately, virtually none of Théodore's writings on Kérylos survived the Nazi raid on the house in 1943, but those of his architect, Emmanuel Pontremoli, remain. The two worked closely together, and Pontremoli's observations suggest at least a portion of Théodore's motivations in commissioning Kérylos at the time he did, years that constituted a harsh, discordant moment both personally and politically. Théodore's first wife had died and his second, frequently ill, soon would follow suit. The Drefyus Affair, in all its dramatic intensity, had thrust the Reinachs themselves into the centre of a hostile antisemitic discourse that seemed to respect no boundaries. Kérylos, in that sense, was more than a mere retreat: through its homage to ancient Greece, it was an attempt to transcend temporal troubles and to access a higher, purer plane of human existence. At its core, Kérylos was Théodore's firm belief that the Greek notion of beauty – the elusive Platonic ideal – could be reclaimed in the France of the fin de siècle. Pontremoli articulated this argument most succinctly: 'If life in Ancient Greece – its mores, its customs – coincided so little with ours, the Greek spirit is contradictory neither with life nor with the habits of our time.'[59]

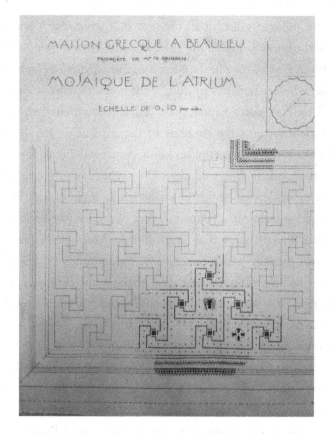

Pontremoli's plans for the villa's mosaics.

Théodore's devotion to 'the Greek spirit' in all its peace and tranquility is well represented in the name he chose for his villa: Kérylos. *Kyrillos* is the Greek name for the halcyon, the mythical bird – typically identified as the kingfisher – that nested on the sea, laying its eggs seven days before and seven days after the winter solstice.[60] This fortnight represented the 'halcyon days' of calm and tranquil seas. In the *Metamorphosis*, Ovid identified the origins of the *kyrillos* as the reincarnation of two lovers, Alcyone, the daughter of Aeolus, and Ceyx, the King of Thessaly, who had drowned after a shipwreck.[61] In death, their enduring love for each other translated into peaceful waters, waters that Théodore Reinach had every reason to desire.

For Pontremoli, Kérylos – 'a name that can be read as easily in French as in Greek' – evinced his patron's devotion to a singular aesthetic ideal, to the idea of the house as a total work of art. 'Kérylos,' he wrote of Reinach's choice, 'showed that he had wanted this house not to be a vague pastiche, but the realization, in

our time, of a thought valid for all times.'[62] In a sense, every material object brought into the house joined in this mission. With the exception of the bronze copies of objects he had seen in the Museo Archaeologico in Naples, Théodore himself designed every item of furniture in the house to reflect the simplicity of the ancient Greek templates: tripod, chair, bed, and chest. His designs, the drawings for which survive in the Archives of the Institut de France, were then produced by the Parisian cabinetmaker Louis-François Bettenfeld, who rendered them in exotic woods such as wild olive, Ceylonese lemon tree, and Australian plum.[63] Kérylos was less an opulent mansion than a stage set for a bygone era.

Emmanuel Ponteremoli, a fellow member of the Institut de France, shared with Théodore Reinach more than institutional affiliations. Perhaps as a function of his own partially Jewish background, Pontremoli was also animated by an interest in the intersection between the Hebrew, ancient Greek, and French republican traditions, an interest that becomes clear in a full consideration of the architectural commissions he accepted. Naturally, he designed a fair number of Parisian townhouses for well-to-do clients, but he remained throughout his career a devoted archaeologist. Pontremoli had observed Théophile Homolle's famous excavation at Delphi and, in 1900, he conducted his own excavation of Pergamon, through which he met Théodore Reinach for the first time. But in addition to a series of somewhat predictable Neoclassical French government buildings – such as the Institut de Paléontologie Humaine in Paris[64] – Pontremoli was also an architect of synagogues, and, even more so, the private synagogues for members of the precisely same social elite to which Reinach belonged.

The most prominent of these was the synagogue near the Rothschild mansion in Boulogne-Billancourt, outside of Paris, commissioned in 1911 by the philanthropist and collector Edmond de Rothschild, another passionate archaeologist and a major supporter of early Jewish colonies in Palestine. Considering Pontremoli's oeuvre in its entirety, then, three distinct strands become clear – the same three strands that, as it happened, united the intellectual endeavours of Théodore Reinach, his first patron. Kérylos was Pontremoli's first major commission, and if the house was a meditation on the exchange between antiquity and modernity, between past present, it was also, for both architect and patron, a meditation on how these traditions related to the question of an 'inner life'.

Inner life, after all, was central to Pontremoli's design for the villa. As he reflected in the 1930s, the experience of entering the house was meant to

furnish an individual with a 'withdrawal into the self', a means for modern man, so insulated by the trappings of industrial, technologically advanced societies, to encounter all that was fundamentally subjective in life. 'This withdrawal into oneself from the moment of crossing the threshold, this interior life, almost primitive, in spite of the harmony of proportions and forms, continued from age to age,' he wrote. 'Then, in a modern conquest, man with security discovered nature, landscape, air, and light.'[65]

These elements were the natural means of elevation through which an individual could escape the trivialities and the tyrannies of modern life. What might be called Pontremoli's thematic thesis was then translated into a literal design for the rest of the villa, and the spatial arrangement of the structure he created at Kérylos enshrined this broader attempt to access a pure Greek 'beauty' amidst the chaos of the twentieth century's first decade. The house, in other words, was not so much a simple reconstruction of an antique form: it was an employment of that form for an abstract – and almost spiritual – purpose. Form fostered function, but function dictated form. At Kérylos, 'the Greek spirit' became an aesthetic whose aim was the discovery of what Walt Whitman, a poet of whom Théodore was fond, had already called the 'multitudes' of the multifaceted, contradictory individual soul.[66]

Early in the construction, Pontremoli realized that the traditional model of the Greek house – symmetrically expanding from the central peristyle – would not be feasible in the tight enclosure of the Pointe des Fourmis, the small jagged peninsula that juts out into the bay, where the house was to be built. The centre of Kérylos is still the peristyle, but only two sides – the east and the south – of this square-shaped central courtyard are flanked with buildings. To conserve space, the rest of the living space was built in a tower between these two sides, which afforded views of the sea as well as sufficient room for a garden outside. Typically, Greek houses did not have more than a single storey, and Pontremoli's improvisation, many said, resembled the Viennese Secession or even the emerging Art Deco in its respect for the cubic form.[67] In any case, it was during the years in which Kérylos was constructed that archaeologists such as Joseph Chamonard – a careful student of Greek domestic architecture and a mentor of Pontremoli's – began to discover houses at Delos with an upper floor.[68] It turned out that these original two-storey houses mirrored the design of Kérylos.

In keeping with Théodore's desire for a reclaimed antiquity, the peristyle is the literal and figurative centre of Kérylos: the rest of the house is built off this enclosure, but it is this space that creates the sense of harmony and the sense of order the house was meant to achieve. As Pontremoli wrote, this sense was achieved in direct contrast to the intensity of the natural environment: 'The warmth of the climate and the intensity of the light oppose, from the entrance, the calm and freshness of the peristyle.'[69] Tiled in white marble, the space is partially reminiscent of Athens, as evidenced in the antefixes of lions' heads that adorn the gutter, direct copies of those found at the Acropolis. The peristyle's walls present large fresco compositions by Gustave Jaulmes (1873–1959) and Adrien Karbowsky (1855–1945). The scenes – all carefully chosen by Théodore himself – copy a series of Greek perfume vases from the fifth century BCE, and they represent stories from Greek mythology that animated some aspect of his imagination.

The fresco that depicts the dispute between Apollo and Hermes over the lyre, for instance, later became the subject of *La Naissance de la lyre*, a 1925 opera by Albert Roussel for which Théodore would write the libretto. There is a sense in which this part of the house – and perhaps the whole thing – was designed to represent frozen music, and the particular rhythm it exudes becomes clearest in the twelve identical Doric columns that surround the peristyle, each made of Carrara marble, juxtaposed with an inner set of Ionic columns. 'Order reigns in the right proportion of the columns,' wrote Pontremoli in 1934, 'their rhythm, their size determine the metric of the house; all parts are ordered by these measures.'[70] And he added: 'This rhythm in general creates a harmony independent from colour and material.'

There was little doubt that Kérylos was a total work of art, even in its construction. Théodore even required that the house be built with the same materials and with the same techniques that would have been original to the Greeks. 'We had to look not only for the design and colour, but for the material of these frescoes, to find the mortar, the marble powder mixture, paint the fresh paste, then smooth it, polish it, make it subtle and immaterial.'[71] Despite the meticulous attention to detail throughout Kérylos – especially in the intricate yet immense mosaics painstakingly copied from models that had recently been discovered at Delos – the point of the house's staggering material reality was to escape the material world altogether. This, it seems, was the hope of both patron and architect for the design's embrace of Greek simplicity:

Grandchildren of Théodore Reinach playing on the peristyle at Kérylos.

through a calculated harmony, it would reach at least a version of classical beauty and the perfection it promised. Each room was subordinated to this larger mission, as Pontremoli would later note: 'The house unfolds room to room, bedroom to bedroom, without break, with the sole instruction of the variously coloured walls, painted and encrusted wooden ceilings, unexpected mosaics and clear or powerful embroidered drapes.'[72]

In terms of the house's attempt to illustrate the compatibility of classical antiquity in the modern age, the *balaneion*, the room of traditional thermal baths essential in any respectable Greek mansion, provides the richest example. The bath itself, a whole metre deep, was cast in the octagonal shape found in many Greek houses, and it was laid in Carrara tiger marble, as was the majority of the peristyle. Decorated with frescoes that depict seaweed and water animals, it appears an exact replica of its ancient counterparts. But the *balaneion* is a feat of contemporary plumbing, equipped with what, at the time, was the most advanced technology available. 'Problems constantly appeared in grappling with the complexity of modern-day life with the simplicity of antique forms,' Pontremoli wrote.[73]

If life in Kérylos was an homage to the glorious Greek past, it was never to be lived without the utmost modern comforts. This was the case in each of the private living spaces throughout the space: Théodore's bedroom, the *Erotès*; Fanny Reinach's bedroom, the *Ornitès*; and the family room, the *Triptolème*. Each was a careful replica of a Greek living space, but each was also in keeping with bourgeois design conventions of the fin de siècle. Nowhere was this clearer than in the case of the decidedly non-Greek piano Fanny insisted on having in Kérylos. A special order from Pleyel in 1912, the lemonwood instrument folded into a chest when closed, its pedals shielded by a small footstool.[74]

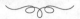

In the end, Kérylos was closer to the allegory of the cave than the Platonic Ideal of 'immortal beauty' that Théodore had sought. His totalizing vision and Pontremoli's painstaking design transcended certain aspects of the immediate surroundings of the house, but they could never escape the context. Théodore died in 1928, and precisely the type of temporal troubles he had sought to escape arrived at his villa in a brutal, visceral way.

As his grandson Fabrice Reinach later recalled, during the Second World War 'the world tragedy descended directly on the house'.[75] After June 1940, when Italian forces occupied the area of south-eastern France that included Beaulieu-sur-Mer, a local commander installed a series of cannons on the villa's terrace.[76] Kérylos had been conscripted into the conflict that destroyed the world of the man who had dreamed it. This was even more clear after September 1943, when the Italians withdrew from southern France in the wake of German pressure. Théodore's villa became a prison for his descendants. Having been made to forfeit his position on France's prestigious Conseil d'État, its highest court, because of the Vichy government's racial laws, Julien Reinach, one of Théodore's sons, had withdrawn to his father's villa to complete a new translation of Gaius's *Institutes*. It was ultimately there that the Gestapo arrested him in the middle of the night, shortly after the German annexation of the Côte d'Azur.[77] Kérylos was imprinted on Julien's experience of the war. It would later appear on his entry card in Drancy, the internment camp outside Paris: 'Villa Grecque, Beaulieu-sur-Mer'. This was an address but also an identity.

Kérylos itself soon became occupied territory: German officials ransacked the house and destroyed the immense archive that Théodore had compiled inside. It was only thanks to the gardener, Joseph Garziglia, that the furnishings and library survived. After Julien's deportation, Garziglia alerted the Institut de France and the entire contents of the house was safely transferred to the Musée de Nice, where it remained undamaged until 1945. 'The essential was saved,' wrote Fabrice Reinach, but 'the house was closed, the garden ruined, and the family dispersed.'[78] Soon the Reinachs would become little more than a memory, names inscribed on the spines of fading volumes and etched on a forgotten, peeling memorial plaque in Saint Germain-en-Laye, which in any case was removed during a recent renovation and never put back. Kérylos is all that remains of the brothers *Je Sais Tout*.

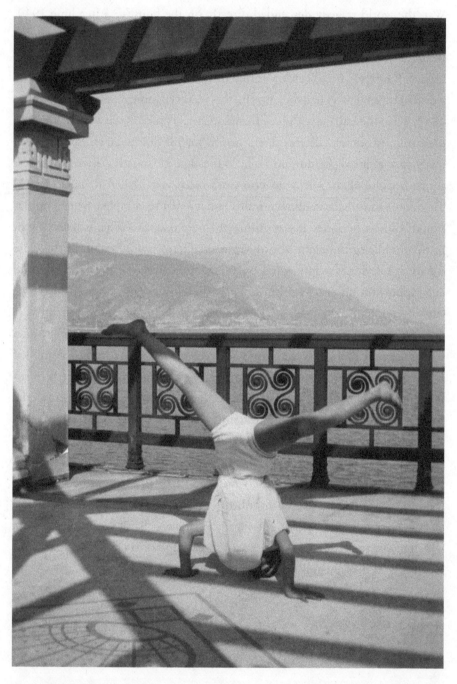

A granddaughter of Théodore Reinach does a cartwheel on the terrace of Kérylos.

6

BÉATRICE ÉPHRUSSI DE ROTHSCHILD
A WOMAN COLLECTS

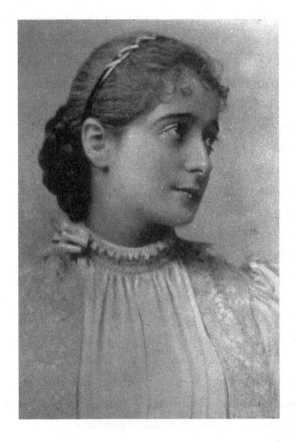

Béatrice Ephrussi de Rothschild (1864–1934).

'Well-behaved women,' wrote the historian Lauren Thatcher Ulrich, 'seldom make history.'[1] Yet the age-old criteria for 'bad' behaviour in a woman – deliberate flouting of social conventions, rejection of traditional gender roles and, perhaps most of all, disrespect for the patriarchal family structure – have never quite guaranteed an automatic entry into history, either. If well-behaved women seldom make history, not all 'badly behaved' women do, either. Béatrice

Éphrussi (née Rothschild) (1864–1934) – divorced, childless, independent, flamboyant, and eccentric – was precisely such a character. Her behaviour – especially scandalous in the eyes of her family – seems to have done little but efface the memory of one of the most unique collectors and *salonnières* from the majority of scholarship on the French fin de siècle. After all, there is an argument to be made that Béatrice personified the themes that have come to define the experiences of cultural elites at the end of the nineteenth century, especially in France: decadence and ennui, commodity fetishism and obsession, malaise and madness.[2]

After her failed marriage to Maurice Éphrussi, a scion of the prominent Russian-Jewish banking family, Béatrice became passionately consumed by material possessions, a zealous art collector and committed home designer who strove to create – and withdraw into – an aesthetic universe of her own design. If she was a female Jean des Ésseintes, the anti-hero of Huysman's iconic novel *À rebours* (1884), a seminal literary artefact of the fin de siècle, few remember her name. Instead, the well-known signposts to the period have become the novels of Huysmans himself, the canvases of the painter Henri de Toulouse-Lautrec, and the memoirs of the aesthete and *bon vivant* Boni de Castellane. While each of these, along with the majority of Béatrice's other (and mostly male) contemporaries, has become the subject of scholarship in the century since, Béatrice appears as a footnote in virtually every history of the period and, in most recent studies of the Rothschild family itself.[3] In recent years, thanks to the art historian Pauline Prevost-Marcilhacy, Béatrice – as both a woman and a collector – has begun to be written back into the record. But despite the refinement of her tastes, she is still far lesser known than the men in her family and her world.[4] Badly behaved by the standards of her milieu, Béatrice Éphrussi may not, in the end, have 'made history'. What did, however, were the houses and extensive collections she left behind, material remnants of the fantastical aesthetic universe she attempted to create with apparently unlimited financial resources.[5]

Although throughout her life she would own, commission, and design several homes throughout France, it is the Villa Île de France in Saint-Jean-Cap-Ferrat that best illustrates the degree to which Béatrice sought solace in materiality. Inspired by her cousin-by-marriage Théodore Reinach's[6] Villa Kérylos in Beaulieu-sur-Mer – and bolstered financially by the large inheritance she received on the death of her father in 1905 – she purchased an expanse of

land on the Cap Ferrat, within sight of Kérylos. At the turn of the century, the south of France was something of a *terra incognita* for members of the social class Béatrice (and, indeed, Théodore Reinach) occupied. Not yet fashionable, it allowed a certain distance from the nineteenth-century resorts of polite society – Deauville, Biarritz, Vichy – and also from the laws of decorum they enforced. In the fin de siècle, the Côte d'Azur 'was a place of escape . . . the place to get away from it all and, eventually, to get away with everything'.[7] This was certainly the appeal for Béatrice, but the Villa Île de France was more than a mere escape from bourgeois convention.

Built after her separation from her husband, who – much to the chagrin of her Rothschild relations – had squandered a significant amount of her inheritance and who had infected her with syphilis, the villa was ultimately a world entirely subject to a woman's control. From the scattered records that survive, Béatrice – in much the same way as Moïse de Camondo, another relation through marriage[8] – was an active, almost tyrannical, dictator of every aspect of the house she built, the gardens she tended, and the collections she amassed. Always loyal to her vision, she hired and fired more than eight architects[9] during the course of the villa's construction and insisted on implementing technical ideas of her own.[10] The Villa Île de France was a sanctuary in which she could reclaim what had been confiscated from her and live, at long last, on her own terms. Of course, for Thorstein Veblen, writing in the late 1890s, the tragedy of the leisure class was its association of material consumption with self-respect.[11] Yet for Béatrice Éphrussi, a woman certainly 'exempted from useful employment' and who thus belonged to precisely this class, objects and things were the essence of her independence. If for social elites material consumption was self-respect, for the women among them it could also serve as a means of self-definition. As the Villa Île de France suggests, materiality could also be agency.

Despite the number of homes she built and the extent of the collections each contained, relatively little is known about the inner life of Béatrice Éphrussi de Rothschild. Her correspondence does not survive, and she died alone in a hotel in Davos in 1934, leaving no descendants. Of the person she was, there are only the

memories of those who recalled '*Madame la Baronne*' as a woman of great beauty but affected luxury. For Marcel Proust, Béatrice was 'a ravishing person, similar to a portrait by Nattier or de Larguillière,' as he put it in a 1901 letter.[12] Her hair had turned white by the age of twenty, 'which gave her the appearance of being constantly powdered,' recalled Élisabeth de Gramont, the Belle Époque socialiate and a distant cousin of Béatrice's by marriage. 'She seemed to always be leaving for a formal ball.'[13] 'I can still see the face of Madame Maurice Éphrussi,' wrote the Belle Époque socialite André de Fouquières, 'a face with fine features framed by silver hair. She was always dressed in Nattier blue, a ribbon of the same colour holding back her curls, a small fox terrier named "Marche" at her feet.'[14] In his memoirs, the prominent art dealer René Gimpel (1881–1945), the brother-in-law of Joseph Duveen, recalled Béatrice along similar lines: 'she was always dressed in pink,' he wrote, 'with a blue hat on her tender white hair, which she had since age 30. She had a face like a rosé wine. Pretty, very much a white rabbit.'[15]

In these observations, Béatrice herself appears as an art object, with a face that serves as a canvas and a body that functions as a mere mannequin for the fashions she displays. Her Riviera soirées – elegant but excessive – also impressed Fouquières, and today Béatrice is mostly known as a hostess who spared no expense: 'I remember one summer night', de Fouquières recalled, 'when we had the privilege to see, in the gardens of her house, bathed in moonlight, Pavlova dance to the nocturnes of Chopin.' Yet those who remembered Béatrice as an art object also invariably commented on her alleged parsimony, perhaps evincing the antisemitism that simultaneously condemned wealthy Jews of the Rothschild class for decadence as well as stinginess. 'It was indeed rumoured that she had a big problem with spending,' recalled Fouquières.[16] 'She didn't like to pay her bills,' wrote Gimpel.[17] In any case, in these images, Béatrice is rooted in a very clear context: she is inseparably linked to the material world she created with no restriction. There is no meaningful distinction between the woman, the clothes she wore, and the money she spent. Without her things, it follows, *Madame la Baronne* did not exist.

These observations, of course, are merely the ways others perceived Béatrice in her own time. But there is nevertheless some truth in them, especially on the question of the primacy of material things in the life of this wealthy woman. The important distinction, however, is that this materiality was not the choice of Béatrice herself: it was the very essence of the milieu into which she was

born and into which she later married. As her name attests, Béatrice Éphrussi de Rothschild existed at the intersection of two distinct family cultures – the Rothschilds and the Éphrussis – whose principal commonality was a reliance on (and, in some cases, an obsession with) material objects, both as a means of private solace and public self-presentation. With branches across continental Europe – the Rothschilds in London, Paris, Vienna, Frankfurt, and Naples and the Éphrussis in Odessa, Vienna, and Paris – these two families were cosmo-politan, multilingual, but always Jewish, both in terms of religious practice and cultural affiliation. In fact, it was the family as a unit of socialization that ensured the survival of Jewish identity among its members.[18]

By the late nineteenth century, especially in a France consumed by the Dreyfus Affair, Jewish families in the rarefied milieu of the Rothschilds, the Éphrussis, the Reinachs, the Foulds, and the Cahen d'Anvers often responded to this anxiety with a 'fierce clannishness'[19] that transcended the injunction to marry within the Jewish community: Rothschilds were to marry Rothschilds and Reinachs were to marry Reinachs. Despite this strict insularity, however, these were families with public – and, in the case of the Reinachs and the Foulds, even political – presences. This necessitated the need for carefully curated public images, often in the form of lavish family homes and extensive art collections, especially those that discernibly glorified the French past, as in the case of Moïse de Camondo's homage to the ancien régime. Objects and their spatial arrangement were thus essential to this project of constructed selves, and the material realm was endowed with an existential politics that afforded these families a means of defining what – if not who – they were.

This was the nature of the world into which Béatrice was born. The Rothschild family culture in which she was raised embraced the material to a far greater extent than perhaps any of the other families in its rarefied milieu. As Pauline Prevost-Marcilhacy has argued in her exhaustive study *Les Rothschild: bâtisseurs et mécènes* (1995): 'The Rothschilds preferred to have vast houses built that would be symbols of their social advancement.'[20] Indeed, in each of its branches, the intimacy of family life by the mid-nineteenth century occurred in spaces – city mansions and country estates – that were designed to reflect the family's nascent status. In Britain, for instance, there were Mentmore and Waddesdon and in France the rue Laffitte and Ferrières (among others). With the intricately designed rooms of these houses and, specifically, with the

Henri James de Rothschild (1792–1868).

arrangement of the material objects they contained, the family identity was communicated and solidified. To be a Rothschild was to inhabit such a space: the mastery and manipulation of material culture was something of a native language, a vocabulary of both self-expression and public presentation.

On this latter front, objects and things were particularly useful tools for the Rothschilds as the most visibly wealthy Jews in a society that often blamed social ills on imagined Jewish financial conspiracy. The long nineteenth century, after all, had seen the emergence of the 'Rothschild Jew'[21] trope, a widespread belief in one family's ability to influence through wealth the politics of countries and the course of history itself. Without question, this association was strongest in France, where, after 1842, when the state authorized railway construction, James de Rothschild's Chemin de fer du Nord received the lion's share of government contracts. In July 1846, when a deadly crash occurred on one of his lines,

a tidal wave of antisemitism targeted the family, as Jewish capitalists but also as murderers. These themes were explored in polemics such as G.M. Dairnvell's *Histoire édifiante et curieuse de Rothschild Ier, rois des juifs* (1846), Pierre Leroux's *Malthus et les economistes ou Y aura-t-il toujours des pauvres?* (1849), and, most prominently, in Édouard Drumont's *La France juive* (1886). The Rothschild family never responded directly to these allegations in any language besides the material. Largely in response, James insisted – against the wishes of his company's board of directors – on erecting an elaborate train station in Paris with soaring glass windows and scores of Greek statues, a cathedral for the mechanized age.[22] The family's reconstruction of the Gare du Nord represented, for James and his family, a chance to show that they could build monuments 'every bit as important as those built by the government'.[23]

Of all the Rothschilds, none was more invested in material self-expression in private and public than Alphonse de Rothschild (1827–1905), the eldest son of James de Rothschild and the father of Béatrice Éphrussi de Rothschild. The head of the family's banking interests, Alphonse's true legacy was his obsession with art and the extensive donations he made later in life to a network of struggling provincial museums throughout France. Elected to the committee of the Exposition universelle in 1867, he was the first Rothschild to be named a member of the Académie des Beaux-Arts in 1885, a major source of pride in the family and seeming evidence of their social arrival. As his youngest brother, Edmond de Rothschild, himself elected to the Académie in 1905, wrote in a letter to the family:

> The big news of the day, which fills us with satisfaction, is the election of our dear brother Alphonse to the Académie des Beaux-Arts. This honour is due both to his capacity for discernment and to his noble personality. We are very proud to have a member of the Académie in our family, which is one of the most eminent titles that can be bestowed in France.[24]

Alphonse, in much the same ways as other haut bourgeois elites in the 1840s, primarily collected eighteenth-century French painting, although he gradually developed an interest in Flemish and Dutch painting, amassing one of the most extensive collections in France of Rubens, Rembrandt, Hals, and de Hooch. But he also represented an important shift in the family's relation to the material things and their use. It was Alphonse who ushered in an era in which art itself

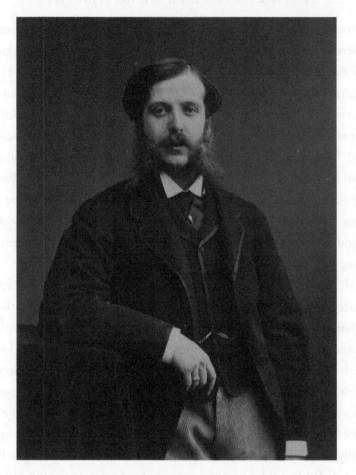

Alphonse de Rothschild (1827–1905).

became a synonym for Rothschild patriotism and philanthropic largesse. As Prevost-Marcilhacy has argued: 'if, for the Rothschilds of the previous generation, collecting belonged to the private domain, Alphonse was animated by an ambition that combined patriotism, educational will, concern for redistribution of wealth and a liberal vision of a society in which private initiative preceded state intervention'.[25]

Largely thanks to the journal *L'Art*, and especially thanks to Léon Gauchez, the Belgian-born merchant-turned-critic who served as his intermediary, Alphonse took a keen interest in contemporary French painting and sculpture, especially that of Auguste Rodin, which he saw as carrying an instructive value for forgotten municipal museums across the nation. In an era when the great French collectors increasingly made their collections public – Louis la Caze

donated 272 works to the Louvre in 1869; Davillier, the banker, donated 582 two years later[26] – Alphonse de Rothschild was perhaps the most invested of them all. Over the course of his career, he donated some 2,000 contemporary works to more than 150 local museums. He donated to the Cannes museum 176 paintings, 40 sculptures, 203 lithographs, 419 photographs, and 92 watercolours.[27] Between 1898 and 1939, it was even renamed the Musée Alphonse de Rothschild, a monument to the man.

The Éphrussis were perhaps similar to the Rothschilds in the realm of art. If this was the culture in which she was raised, the culture into which Béatrice married in 1883 was equally invested in materiality, and possibly more refined in its tastes. The Éphrussis, initially of Sephardic origin, were another prominent Jewish family whose wealth nearly matched that of the Rothschilds. The fortune was forged first in grain factories in Ukraine, then in oil reserves, and then, finally, in banking, where they were among the principal competitors of the Rothschilds in Vienna and Paris from the mid-1850s. A central component in the social milieu of haut bourgeois French Jews in the Third Republic, the Éphrussis – largely through Charles Éphrussi (1849–1905), the collector and critic – were linked to virtually every other Jewish family of social consequence. Charles Éphrussi was a cousin of Maurice Éphrussi, who married Béatrice; the mentor and confidant of the young Moïse de Camondo; the lover of Louise Cahen d'Anvers; and a friend and cousin of Théodore Reinach, to whom he left most of his estate, a gift that essentially financed the construction of the Villa Kérylos. The family's interests in culture were also significantly influenced by Charles's legacy. Indeed, if the other families in their milieu were consumers of art and material objects, the Éphrussis were arbiters of taste.

A portrait of cultural life in fin-de-siècle Paris would be incomplete without mention of Charles Éphrussi – to whom Béatrice and her husband, Maurice, remained close throughout their short marriage.[28] Charles himself left few personal writings aside from the numerous articles he published in the *Gazette des Beaux-Arts: Courrier Européen de l'art et de la curiosité*, a hugely influential art periodical that he bought in 1885 and edited from 1894.[29] The most thorough investigation of the man is probably Edmund de Waal's elegant family memoir, *The Hare with Amber Eyes*, in which the author, himself an Éphrussi, attempts to 'understand how Charles looked at things'.[30] From de Waal's reflections we learn mostly of his ancestor's worldliness: his friendship with Marcel Proust, for

instance, who apparently used him as inspiration for the character of Charles Swann, and his shifting interests in Japonisme, Renaissance art, and, most importantly, Impressionism – a similar trajectory that shaped the tastes of the great collector Isaac de Camondo, a cousin of Moïse de Camondo. Of this last interest, Impressionism, there is ample evidence: Charles was an early patron of Auguste Renoir, and his imprimatur led to the acceptance of Impressionist painters in his circle. He himself owned more than 40 canvases by Renoir, Manet, Degas, Monet, and Pissarro;[31] Renoir immortalized him in *Luncheon of the Boating Party* (1881), in the elusive man with his back turned to the viewer. Charles Éphrussi inspired in his family a culture of aestheticism, a reverence for beauty even more than a desire for material acquisition.

As it was for her cousin Théodore Reinach, this communal, almost familial, notion of beauty – beauty as an ideal, but also as a refuge – became an animating passion for Béatrice. She was firmly situated in the Rothschild family circle, but distant from it at the same time. As her biographer, Michel Steve, has observed, she inherited 'this way of integrating art and luxurious antiques into the decoration of their daily lives, following a new and somewhat theatrical process'.[32] In other words, she inherited this material mother tongue even as she attempted to liberate herself from the family cultures that facilitated it. Because of the conventions of her time, Béatrice was not as well educated as the men in her family, and unlike the men in her milieu who collected, she did not belong to any formal circle of collectors. She mostly taught herself what she knew, and she knew what she liked: an eclectic blend of styles and periods that did not conform to any unifying vision – pieces from the Italian Renaissance, objets d'art from the eighteenth century, and exotic items that struck her fancy. Objects and things were often the mode through which both the Rotshchilds and the Éphrussis expressed their identities in public and in private. Materiality was thus the most available means for these decidedly insular families to respond to the external world. In the end, materiality was also the essence of Béatrice's revolt against the social mores of her time.

To those who knew her – André de Fouquières, René Gimpel, Boniface de Castellane, Élisabeth de Gramont – Béatrice often appeared rash, impulsive,

and even bizarre. Yet, from what little evidence that survives, she appears to have been marked as well by a doleful melancholy that began during her childhood. According to Steve, her father, in keeping with bourgeois parenting practices, was absent; her mother, Leonora, of the English Rothschilds, suffered from hysteria, an affliction commonly ascribed to women in the nineteenth century who expressed any disagreement with the status quo.[33] Consequently, Béatrice rarely saw either of her parents for sustained periods of time and was raised among a host of interchangeable governesses and nannies who never remained in the family's employ for more than a year. Furthermore, during the Franco-Prussian War, she and her siblings were taken to England to live with her grandparents, where she spent her formative years in a foreign context. She never learned to speak English well, and Steve has speculated that the alleged '*froideur*' of the English education she received also took its toll.[34] In any case, as a woman within an elite banking family dominated by male succession and male financial leadership, Béatrice was unable to direct her own life. This was especially true with regard to her marriage to the banker and gambler Maurice Éphrussi (1849–1916), which her father arranged largely for the financial possibilities the union provided.

When they were married at the Grande Synagogue de la Rue Victoire in 1883 – the same synagogue whose construction the Rothschild family had financed – the bride was a 19-year-old woman marrying a groom nineteen years her senior, exactly the same age as Irène Cahen d'Anvers would be when she married her similarly older husband, Moïse de Camondo, at the same synagogue eight years later. They were two women bound by the ties of a tightly knit milieu and the similar fate it proscribed for them. Béatrice's father, Alphonse de Rothschild, would later serve as one of Irène's witnesses at her wedding in 1891; both women soon separated from their husbands. As was the case with many other marriages in the nineteenth century, especially among elites, husband and wife existed at vastly different points in their life trajectories. One imagines that a certain amount of distance characterized their marriage. But if distance separated husband and wife, there was also a certain distance between Béatrice and her own family, which had arranged this marriage. It may have also represented a partial exit from the Rothschild family, in which communal recognition and power at the time was still predicated on leadership within the bank.[35] Likewise, Maurice, albeit an Éphrussi, was not a

director of his family's bank: he was a *bon vivant* and thoroughbred horse racer with a penchant for gambling. The marriage of Béatrice de Rothschild and Maurice Éphrussi was thus a mutual pursuit of pleasure, a testament to listless leisure.

With his brother Michel, Maurice owned Haras du Garzon, a breeding farm in Normandy that produced some of the most successful horses of its day – 'Perth' and 'Roxelane', 'Alicante' and 'Bariolet'. In the nineteenth century, horse racing, as Jonathan Pinfold has argued, represented a means for the wealthy to consolidate their social status.[36] Places like *le Jockey Club* – to which Maurice Éphrussi, along with Charles Éphrussi, Léon Fould, and many of the other men in their milieu belonged – were ultimately stages for Proustian elites to compete in a context that simulated consequence and import. Maurice's desire for distinction among this elite had dangerous consequences with regard to his gambling. By 1904, his debts amounted to more than 12 million gold francs, some 30 million euros in today's currency.[37] By this point, he had also infected his young wife with syphilis, which in her case meant that she could not have children.[38]

No personal account of rupture survives. What does survive, however, is the divorce record, which details the fissure of the financial transaction the marriage had enshrined. On 29 June 1904, the couple were legally separated with the authorization of the Rothschild family, concerned with the status of its accounts.[39] What emerges most in the agreement is the prominence of the bank. Only once does Béatrice's name appear in the document: it appears as if Maurice Éphrussi is divorcing N.M. de Rothschild Frères, which, in a certain sense, he was. His actual wife, however, was subject to a mandated silence. Isolated from her husband, Béatrice was increasingly isolated from her family as well: the divorce affected her inheritance.

When her father died the following year in May 1905, his will contained the following section, which had decreased her share to a quarter rather than a half: 'The amount of hereditary rights of each heir will be established by the attribution of half to Baron Édouard de Rothschild, to Madame Éphrussi a quarter, and to each of the grandchildren of the deceased a twenty-fourth of the total net assets obtained as stated above.'[40] She was still a Rothschild, to be sure, but somehow a lesser Rothschild, having received half of the share her brother took of the 250,942,332 francs to be divided. At the age of 39, Béatrice

was thus an independent woman, marked by pain, but with the means to create an alternate universe of distraction and refuge.

In the years after Béatrice's divorce and her father's death, what society seems to have observed in her character was a woman prone to flippancy, absurdity, and unbridled material excess. Consider, for instance, the recollections of René Gimpel, who regarded Béatrice as an ignorant but authoritarian consumer, going in stubborn search of painted monkeys with her cousin, Léon Fould, all for the purpose of decorating a set of newly acquired *boiseries*. 'Guard! The monkeys?' Gimpel recalls her asking the curator at the Archives Nationales:

> 'You mock,' said the guard, who began to turn red and even began to get angry.
> 'Sir, I am Madame Éphrussi, born Rothschild. Find me a curator.'
> 'They are, Madame, in the Archives,' said the curator.
> 'Let's go then, next door, to Boulanger's, the decorator's,' she said. 'Hello Boulanger, do you have any monkeys?'
> 'Madame, I have only a parrot.'
> 'In paintings?'
> 'Mais non, Madame. In real life.'
> 'You are an idiot, Boulanger. I want monkeys in paintings.'[41]

A second anecdote, relayed to Gimpel by Adolphe Lion, another dealer to the Rothschilds, further underscored the public image of Béatrice as impetuous and entitled. In Lion's memory, she had apparently entered his shop on the rue Laffitte to purchase a porcelain vase she had seen in the window. 'This, Lion,' the dealer recalled Béatrice saying, 'is the business of Edmond de Rothschild – it's his colour, so bring it to him tomorrow morning. Here is my card.' Lion did as he was bidden and arrived at the Rothschild mansion, also on the rue Laffitte, promptly at nine the next morning:

> I waited. At about 11 a.m., I heard in the room next door the voice of the Baroness. There you go – she knew my name. I came in. Her robe was

nearly half open, her hair down her back. She stepped back terrified and yelled 'Who let you in here?'

'Baronness, you called Adolphe, and Adolphe is my name.'

'Get out, fool! Adolphe is the name of my dog.'

'But my vase, madame?'

'Your vase, a piece of junk – take it away!'[42]

Yet these seemingly scattered and impulsive declarations could also have been those of a woman with a troubled and frustrated inner life, struggling with her pain in the only way she knew how. Her grandfather had responded to anti-semitism through his reconstruction of the Gare du Nord, and her father had displayed his Frenchness through extensive donations to provincial museums. On some level, Béatrice also managed her internal anguish through her control of the objects and things she obsessively purchased: the control of the spaces she inhabited was perhaps a means of simulating a control over the life she lived inside them, a control that always eluded her elsewhere. This is perhaps clearest in the very vignette most frequently cited as evidence of Béatrice's flippant frivolity and essential absurdity – the 'dog wedding' she hosted in 1897 for Diane and Major, her favourite poodles. Animals were a fundamental part of the alternate world into which Béatrice withdrew. Albert Laprade, one of the eight architects who worked on the Villa Île de France, recalled – not without annoyance – the veritable Noah's ark always in her retinue: 'A poodle and two monkeys were her favourites and were blessed with a butler chosen from among the former generals of the Tsar's personal guard,' he wrote. 'A small mongoose from India accompanies them. Gazelles lodge in the gardens. And in the villa itself, there is a Peruvian parakeet and oriental fish. . . . Madame Éphrussi attaches great importance to her animals and has strange, annoying and absurd conversations with them.'[43]

Béatrice left behind no writings that contextualize or explain her attachment to animals, but perhaps she found in them interlocutors devoid of the judgement with which so many in her circle – de Fouquières, Gimpel, and even her cousin Élisabeth de Gramont[44] (1875–1954) – considered her. In any case, Laprade does not mention the 'wedding' in his recollections, but undoubtedly it furnished a spectacle far more absurd than her conversations with her pets. It was reported in newspapers around the world, including the *Boston Daily Globe*:

Hundreds of invitations were sent out, addressed to canine guests and their owners. All the men, of both the two- and four-legged variety, showed up during the day in formal evening dress: tails, wing collars and bow ties. . . . At the sound of the wedding march, three little poodles appeared in tails to begin proceedings. Canine 'bridesmaids' and 'best men' escorted the betrothed couple. At the other end of the room, a good and loyal bulldog waited for them wearing a top hat and a red, white and blue sash. . . . The bride had a gold ring set with diamonds slid onto her paw.[45]

At first glance, the 'dog wedding' is the epitome of decadent irreverence, but, despite its frivolity, the event also evinces a deliberate irony, and an undeniable sadness. Although the couple would not legally separate until 1904, by 1897 Béatrice was already estranged from Maurice and living apart from the only man she had ever known intimately, a man who had betrayed her trust, harmed her body, and drained significant portions of her inheritance. By staging a wedding for dogs, she was perhaps indulging in a personal fantasy, but she was also ridiculing and even satirizing marriage, perhaps the most sacred of all bourgeois rites, an institution that had failed her in every respect. In a sense, it was a canine adaptation of the petty bourgeois aspiration that characterized the country nuptials of Flaubert's Charles and Emma Bovary: a fête, a feast, a statement.

That this 'wedding' was a public spectacle to which hundreds were invited only serves to underscore the motivations of its host: this was a work of theatre that required an audience. Béatrice, rather than discarding consumption altogether, ultimately refashioned excessive consumption for her own ends. The Villa Île de France – whose construction she turned to in haste after her separation from Maurice – was the epicentre of her revolt. Her refuge and her passion, the acres she bought on then-undeveloped Cap Ferrat furnished her with a stage for a more elaborate work of theatre: a space – and a life – of her own design.

In the mid-nineteenth century, the 150-mile strip of Mediterranean coastline between Marseilles and Menton was not yet the 'Côte d'Azur'.[46] The winter of 1821–2 had devastated local agriculture and unemployment had skyrocketed;

the closure of Nice as a free port in 1854 had destroyed commercial trade.[47] The Mediterranean coast was a region of rampant poverty, where human excrement was used as fertilizer.[48] Circumstances did not change until 1860, when Victor Emmanuel II of Italy traded Napoléon III the city of Nice for French military and economic assistance. The shift in national affiliation itself made little difference: after its transfer, Nice and its environs still constituted the poorest of all French *départements*. Rather, what transformed an ailing backwater of 7,900 residents into a vibrant city with the highest growth rate in all of Europe was the local embrace of the tourist industry.

Mary Blume has shown how it was the first metropolitan area whose existence was entirely a function of a tourist-based economy.[49] In that regard, it became a favourite of the leisure class, dependent on the culture of the foreign *hivernants* and *rentiers* – predominantly English, but also Russians and Americans – who sought healthy climates and affordable prices during the winter months. Construction began on a lower *corniche* road; the railway was extended from Marseilles in 1864 and by 1874, and a mere fifteen years after French annexation, the city had more than tripled in population to 25,000 inhabitants.[50] Nice, in the words of Paul Valéry, became a 'combination of stimulants . . . such as I have seen nowhere in the world'.[51] It was a city whose

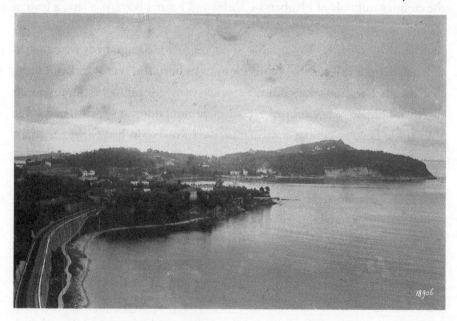

Cap Ferrat, 1912.

entire built environment – façades, boulevards, plazas – constituted an architecture of pleasure, consumerism, and, most of all, fantasy.

Economic circumstances facilitated the ease with which this transformation occurred virtually overnight. Between 1873 and 1896, the French index of wholesale prices fell from 124 to 71 (with 1913 as 100). During the same years, however, securities with variable incomes doubled in value while those with fixed incomes tripled in value.[52] In other words, when disposable incomes were significantly higher, goods were significantly, even drastically, cheaper. The *rentiers* – men and women living on unearned incomes – were thus the designers and the arbiters of a new landscape of desire. The Côte d'Azur, inexpensive and undeveloped, was their canvas, and paint they did. Nice, Cannes, and small fishing towns along the coast – Saint-Tropez, Antibes, Cagnes-sur-Mer – became stage sets for grand hotels, lavish casinos, and shopping arcades to present the latest Paris fashions.

This is the world that appears, for instance, in the pages of F. Scott Fitzgerald's *Tender is the Night* (1934), a novel that depicts the glittering social set of Gerald and Sara Murphy,[53] a cadre of expatriate elites immortalized in the photographs of Jacques-Henri Lartigue (1894–1986) and the guest registers of the Hôtel du Cap. As Nancy O'Neill has written, it was an environment characterized by a nascent social life, a newfound glamour, and a significant amount of artistic collaboration. On the Riviera, after all, Pablo Picasso and Henri Matisse designed stage sets for Serge Diaghilev's Ballets Russes and the writer Jean Cocteau worked with Igor Stravinsky on an adaptation of *Oedipus rex*.[54] As Xavier Girard notes in his recent study, by the interwar period, the Côte d'Azur had become 'an atmospheric ballet'.[55]

The structures erected in the Riviera's newfound cities were often temples of pleasure. Typically painted in shades of pastel, these Beaux-Arts palaces – all public spaces – were designed to lure passers-by off seaside promenades into commoditized spheres in much the same way that the Baroque had attempted to lure fallen Christians back into the Church. In a sense, the development of the Riviera belongs in Walter Benjamin's *Passagenwerk*, the German critic's unfinished analysis of the Parisian arcades: its history, too, evinces consumers discovering themselves as fully formed 'masses' before the public display of goods for purchase. These consumer-citizens then began to define themselves against each other, competing for status and prestige. Consider, for instance, the Palais de Méditérannée, a grand casino, on the Baie des Anges in Nice.

Gambling was the ultimate consumptive competition – for a sense of departure at least as much as for money. But the structure built to facilitate this activity *itself* expressed these values. In 1929, the *Cannes News*, an English-language daily, proclaimed the structure, a cathedral of white in Art Deco angularity, 'the most luxurious building the world has ever known'.[56] The essence of the palais was its superlative imposture, its aspiration. Yet excess alone was never the sole point of this new built environment, as evinced by another class that emerged on the Côte d'Azur distinct from the *rentiers* but equally invested in the project of fantastical local transformation.

These were the artists who eventually made the Côte d'Azur famous and who remain at the heart of its mythology. They were still tourists, but decidedly less elite than the *rentiers*, attracted not by the potential to spend disposable income but rather by the region's intense light and natural colours. Henri Matisse (1869–1954) moved to Nice in 1917, and many others followed during the First World War and the interwar years: Max Beckmann (1884–1950), Pierre Bonnard (1867–1947), Paul Signac (1863–1935), Francis Picabia (1879–1953), Marc Chagall (1887–1985), Serge Diaghilev (1872–1929), Pablo Picasso (1881–1973). According to the art historian Kenneth Silver, what these artists created in tandem was 'a dream space for the twentieth century',[57] a place where consumerist excesses were more than an inevitable by-product of inherited wealth, cheap labour, and a low cost of living.

Thanks to this class of émigré artists, which, as Silver has put it, 'represented the comfortable no-man's land of tourism' by 'looking at the scenic wonders but not belonging to them',[58] regular hedonism became artistic expression. The interchange between these two classes on the fin-de-siècle Riviera allowed the *rentiers* to understand themselves as artists, invested not in a quotidian pursuit of pleasure but an aesthetic enterprise with a broader significance. Perhaps the Riviera was a 'dream space' for them most of all, which becomes clear in the private villas the *rentiers* constructed along the coast – total works of art, painstaking recreations of Russian *isbahs*,[59] Indian temples, or Venetian palazzos.

In many ways, Béatrice Éphrussi de Rothschild, a millionaire through familial inheritance and also a millionaire through marriage – was the iconic *rentier*: a

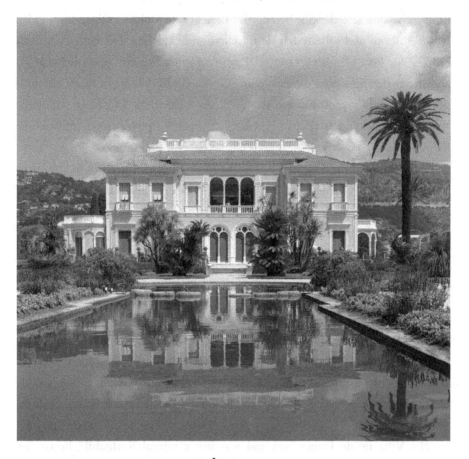

Villa Île de France.

woman with no occupation besides the kaleidoscope of her own imagination, with nothing but the means to translate these fantastical visions into reality. The Villa Île de France was her contribution to the 'dream space' of the Côte d'Azur: it represented the meticulous artistry of her fantasies. Like any fantasy, the project on the Cap Ferrat was fleeting: Béatrice lived in the house only from 1912 to 1920, turning her attention on the other properties she owned in nearby Monaco, the Villa Soleil and the Villa Rose de France. The name of the house betrays something of its occupant's intentions, as well as an homage to the ethos of its location. 'Île de France', as Ulrich Leben has pointed out, was the name of the ocean liner from the Compagnie Générale Transatlantique on which Béatrice travelled frequently, especially after her separation from Maurice.[60] At the turn of the century, Béatrice travelled extensively and alone – to Egypt and Persia, to Greece and Turkey, but most of all to Italy,[61] her principal source of inspiration for the Italianate villa she

ultimately constructed.[62] She belonged, in essence, to a nineteenth-century cadre of adventurous and solitary female travellers and explorers: Elizabeth of Austria (1837–98), Jane Dieulafoy (1851–1916), Alexandra David-Néel (1868–1969), and, from Béatrice's own milieu, Mirra Alfassa (1878–1973). In exotic destinations far from bourgeois Europe, these women – David-Néel in Tibet; Alfassa in Pondicherry – could escape the strictures of gendered performance inflicted on them by social convention. Travel was escape but also transcendence.

Travel's liberating potential was embedded most significantly in the basic design of the Villa Île de France, mansion and gardens alike. Facing three sides of the Cap Ferrat peninsula, the property was reconfigured to resemble a ship charging ahead into the open water. Expansive gardens stretched towards the end point of this triangular expanse: this was the hull of Béatrice's immobile vessel. A Palladian 'Temple of Love' served as a watchtower, the last point on the eye's inevitable journey from house to sea. To be sure, the villa was fixed in place, literally rooted to the Cap Ferrat and figuratively rooted in the commoditized paradise of the fin-de-siècle Riviera. For a thrill-seeking custodian who relied, as did many of her contemporaries, on the casino and the auction house as a means of distraction, the villa's primary visual effect was a simulation of constant voyage. A stationary ship, the house represented the constant promise of departure.

The Villa Île de France was and was not a typical Rothschild house. Its departure from the norms of the family's aesthetic of theatrical ostentation reflected the ways in which Béatrice distanced herself from her family's culture and its stifling norms. The general nature of the so-called 'style Rothschild' is as well known now as it was during the construction of the Villa; the term was relatively common by the early decades of the twentieth century, even among members of the family.[63] But the specific components of the style Rothschild connoted a series of different meanings: the art historian Philippe Jullian famously contended that there was a 'sombre Rothschild style' and a 'light Rothschild style'.[64] Over time, however, style Rothschild came to mean, as Prevost-Marcilhacy has argued, 'a certain opulence linked to a style of life'.[65] To some extent, the house that Béatrice dreamed and made real on the Cap Ferrat was designed in the same style Rothschild that had defined her family's other houses across Europe, regardless of national context. But, in certain ways, the Villa Île de France was also a revolt against this aesthetic, and a woman's revolt at that.

By the mid-nineteenth century – at Mentmore in 1850, at Ferrières between 1853 and 1863, and at Waddesdon in 1874 – the family had begun to embrace the form of the château, which carried with it an unmistakably political set of associations: aristocratic wealth and social ascension, a nobility that was now for sale. For the Rothschilds, however, these châteaux were not used in the ways they had been by previous generations of owners with actual noble pedigrees: family members lived in them year-round and not for mere recreation. These historic spaces thus became homes of quotidian use, stage sets not for special occasions but for daily life. This was certainly the case for the Villa Île de France, in which Béatrice lived for a period of several full years after its construction and then for the winters before she died in 1934.[66]

If Rothschild homes were invariably defined by a certain ostentation, this ostentation was not entirely for the purpose of public display: it also defined the design and the décor of the private spaces in which family members lived as private people. The Villa Île de France, adorned throughout with the finest French paintings and eighteenth-century objets d'art then available for purchase, was nothing if not an extension of the family's idiosyncratic relationship to material display. As the few surviving records of Béatrice's collections suggest, some of the house's most elaborate rooms, after all, were its private spaces. For example, her bedroom contained some of the most impressive and valuable artworks in her collection, such as a Tieopolo depiction of Venetians on a balcony and a set of *trumeau* mirrors painted after Boucher.[67] Visitors rarely, if ever, saw these masterpieces. One has the feeling that these objects, for Béatrice, had a particular personal value, in much the same way that certain pieces in his collection had for Moïse de Camondo, who refused to part with them. These were the adornments of private life, the material aspects of intimacy.

The décor inside the traditional Rothschild home often reflected the family's cosmopolitanism, and their homes were distinguished by their international dimensions: 'before being Germans, Austrians, English, Italians, or French, they were Europeans'.[68] Consequently, typical Rothschild houses – in Vienna, Paris, and Britain – each combined what family leaders considered the finest pieces of cultural and artistic production from all of the respective national contexts they inhabited. They presented an impressive mélange of European artworks that the Rothschilds, as Europeans at home in a multiplicity of national contexts, were well equipped to curate and arbitrate. In that

sense, Béatrice's Villa Île de France is a classic example of the family aesthetic. The villa's external façade, drawing on her affinity for Italy, was done in a style that blends Neoclassical and Italian Renaissance. By contrast, its inner atrium – the first enclosure one enters – showcased a floor of Byzantine-style mosaics, in much the same fashion as those at nearby Kérylos, medieval Gothic arches, and, most notably, a series of twelve columns in pink Veronese marble. There were specific rooms for specific styles: a 'Salon Chinois' for Béatrice's collection of chinoiserie, a 'Salon Louis XV', a 'Salon Louis XVI', and separate rooms for her innumerable porcelain pieces, based on whether they were manufactured at Sèvres or Meissen – although, during her lifetime, her most impressive porcelain pieces were kept at her Paris home at 19, avenue Foche.[69]

Like other members of her family – and, indeed, her milieu – Béatrice was a passionate pursuer of provenance, another crucial hallmark of the *style Rothschild*. This is perhaps clearest in the Salon Louis XVI, the largest and most significant room in the Villa Île de France. Divided in two parts, the larger of the room's two sections displays a selection of eighteenth-century *boiseries* that, in her assessment, once hung in Paris's storied Hôtel de Crillon, completed by Ange-Jacques Gabriel on commission from Louis XV in 1758. Béatrice's collection of antique *boiseries* continued into her private bathroom, adjacent to her boudoir, in which she displayed another set of elaborately decorated wood panels with putative royal provenance: although these do not appear in René Destailleur's encyclopaedic *Documents de décoration au XVIIIe siècle* (1906), Wildenstein, from whom Béatrice acquired them, attributed them to the decorator Leriche, one of several who had collaborated on the Pavillion du Belvédère in Versailles's Petit Trianon.[70]

The Petit Trianon was the domain of Marie-Antoinette, and, as evinced most emphatically in the case of Moïse de Camondo, this specific provenance was the most coveted of all. The association had great appeal for a large variety of individual collectors, but it is easy to imagine the appeal for Rothschild collectors, engaged as they were in demonstrating what Prevost-Marcilhacy has called 'the social ascension and the wealth of the family'.[71] Along those lines, the rest of the Salon Louis XVI is a painstaking homage to the pre-revolutionary way of life. The walls not covered with *boiseries* displayed tapestries from Savonnerie, the royal tapestry manufacturer, and the period furniture was arranged in such a way as to simulate the form and function of a true salon. Small clusters of furni-

ture – one of which was centred around an inlaid wood *table à jeux* by Hache[72] – allowed for tête-à-têtes, chaise longues by the windows for wistful rumination and repose.

And yet the Villa Île de France also represents a significant departure from the *style Rothschild*. Unlike the majority of the Rothschild family's other properties (with the notable exception of Waddesdon), Béatrice's mansion was not a reconstruction of an historic castle or château linked to a narrative of national patrimony. It was the opposite. In the fin de siècle, the Côte d'Azur had essentially been part of the French nation for a mere two generations; in the eyes of local inhabitants, the French who arrived there en masse after 1860 were no different from the Americans, the English, or the Russians. All were foreigners, and the cultural ethos of the Riviera was one of temporal escape, never one of maintained tradition. The essence of what Béatrice built with the Villa Île de France, the stationary ship, was thus at a means of distancing herself – rather than proximity to – history: the house was built from scratch on a site that was cleared for its construction and had never before been inhabited. She was the land's first occupant and, as it happened, its last. But if the Villa Île de France represented a certain aversion to history, it also sought to defy nature, as evinced in the lush gardens Béatrice installed, with great difficulty and even greater expense given the arid Mediterranean climate.

Although she worked with innumerable architects and designers throughout the construction of the Villa Île de France, its gardens – arranged in a series of concentric terraces and tiers from the elevated apex of the property down towards the sea – were largely realized by Achille Duchêne (1866–1947). Duchêne was the landscape artist of choice for the elite social circle to which Béatrice belonged: he designed the gardens for Moïse de Camondo's Paris mansion at 63, rue de Monceau, Louis Cahen d'Anvers's Château de Champs in Champs-sur-Marne, and Léon Fould's Royaumont. Working in the style of André Le Nôtre (1615–1700), the gardener of Louis XIV who transformed the Parc de Versailles into a royal fantasy, Duchêne emulated the strict Neoclassical order and geometric control of *le jardin à la française* for clients who sought to project a certain image of the ancien régime. For Béatrice, however, he designed a sprawling garden that would emulate the fantastical pastiche of the villa itself, mixing plants, flowers, and trees from around the world, regardless of whether they would flourish in the rocky soil of the

Cap Ferrat. Just as the house blended a variety of architectural styles and historical moments – the Italian Renaissance, medieval Gothic, Louis XV, and Louis XVI – the gardens presented a floral diversity that was immediately apparent. Mediterranean Cyprus trees were juxtaposed against rows of cotoneasters from the Himalayas, which were in turn juxtaposed against guayacan trees from Mexico.

Few documents that describe the specifics of Béatrice's affairs survive, but there is a certain amount of correspondence between René Julien, her property manager, and various horticulturalists along the Riviera. The letters exchanged, from 1911, reveal the sheer determination with which the villa's garden – a 'dream space' in its own right – was built against all conceivable odds, both natural and logistical. One florist wrote of the difficulties involved with transporting a vast shipment to the estate: 'this kind of transport is a little more expensive, but more advantageous for the plant', he wrote, 'and even if you count the transport from the Beaulieu station to your home, the price is about the same, and by railway we handle the plants 3 to 4 times . . .'[73] The following day, another landscaper wrote to Julien the following: 'Sir, I have sent you the list of the plants . . . We could, if you want, add in the same wagon 1000 or 2000 francs of green heather whose price is 49 per thousand kg.'[74] Also, on 18 April, the head of a rose company wrote to the estate with confirmation of Béatrice's order: 'I hasten to respond to your request for information,' he noted.[75] Béatrice had ordered more than 2 tons of roses, a flower that cannot survive in Mediterranean climes without constant care. That fact, however, was irrelevant: the garden was to be realized whatever the challenges. Béatrice's vision required it.

Considering the number of plans and sketches that survive from the construction of the Villa Île de France, what is perhaps most striking is the active role Béatrice played in the structural aspects of its design. The house in fact was a laboratory for several of her own original designs, both architecturally and in terms of new furniture styles she imagined. As Leben has written, she was insistent that her architects include a new kind of support system for the Villa's roof, plans for which she drew herself.

It consisted of a metal structure that was attached to a wooden canopy, both of which were covered with layers of plaster and then woven together with iron threads.[76] Suspended between roof and attic floor, this intermediary level provided, at least in theory, extra support for the roof as well as a supple recep-

tacle for the effects of rain and mold. The Rothschild Archive also contains Béatrice's personal drawings for a set of screen doors to adorn her new villa: meticulously drawn, the screens are fully collapsible along their hinges but also double as trays on either side. The practical use of this particular contraption aside, it was an item whose conception, creation, and display were entirely a function of her imagination. All of her designs she patented – either in France or in Britain – as scores of holdings in the Rothschild Archive attest. As one receipt reads: 'Originals sent to PATENT OFFICE, LONDON (per Thomas Cooper), in accordance with the instructions of Madame la Baronne Rothschild-Ephrussi, le 20 Février 1918.'[77] And as Béatrice herself wrote, in English, to this same office later in the same year, in the midst of the First World War:

> I sent you on June 20th 1917 by parcels' post a small box containing a model of a chair showing the application of my Patent in facilitating the work of blind soldiers etc. . . You were to have it on hand to show to the Patent Office. What have you done with the chair and have you it now? On February 20th last I sent you several drawings of screens etc., for delivery at the Patent Office, London. On what date did you deliver them and have you kept a receipt for them. Please reply at once.[78]

As it had been for her father and others in her family and milieu, the material realm was, for Béatrice, a mode of self-expression and her patents a means of owning those expressions. At least in part, the Villa Île de France was thus a space that a woman not only owned and designed but that a woman made.

In a family in which both public and private life were arbitrated by male leadership – even in the realm of family homes, all designed by male Rothschilds – the Cap Ferrat presented uncharted waters indeed. It was presumably a refuge for Béatrice after her divorce, the death of her sister Bettina (1858–92), and the death of her father in 1905; but in the landscape of the Côte d'Azur, then relatively undeveloped, it was also a veritable *tabula rasa* on which she could enact her fantasies, as eccentric and bizarre as they were. As its name suggests, Île de France was a means of departure, a departure from the stric-

tures of family and bourgeois life, but a departure into the realm of dreams. Eventually, and perhaps predictably, she grew tired of this villa and set her sights on other material transformations: these, it seems, were her animating passion. In 1916, she bought a pair of adjacent villas in Monte Carlo, not far from the casino, which she attempted to transform into a Moroccan casbah. This – to be called the Villa Soleil – remained unfinished when she died, alone in a hotel, in 1934. Her revisions and comments on the plans for these new projects were found among her possessions. Consumption and creation occupied Madame la Baronne until the very end.

7

MUSEUMS OF MEMORY
FROM PRIVATE COLLECTIONS
TO NATIONAL BEQUESTS

Among the radical legacies of the French Revolution was the emergence of the public museum, with its particular combination of formal hierarchies and public access. Although art collections had been essential elements of aristocratic life in Europe since at least the mid-seventeenth century, the establishment of the Musée du Louvre in 1793 inaugurated a new era for the role of art, objects, and material culture in public life. Nowhere is this clearer than in the dramatic canvas of Hubert Robert (1733–1808) *Projet d'aménagement de la Grande Galerie du Louvre* (1796), in which the museum furnishes a public space where citizens could see the history of their nation recounted through a display of objects and canvases. Robert's spectators – sketching Old Master canvases, gesticulating at canvases on the walls, educating their children through art – are experiencing nothing less than a nationalistic self-transformation, an attempt to make themselves responsible citizens of the new French republic.[1]

This was not an exclusively French phenomenon: throughout the long nineteenth century, the great capitals of Europe – and, later, their more provincial American counterparts – all established imposing museums, that were encyclopaedic in scope and grandiose in scale. These museums, which Alan Wallach and Carol Duncan have called 'universal survey museums',[2] included the Louvre; the British Museum in London, founded in 1753 but expanded significantly after 1802; the Altes Museum in Berlin, built between 1822 and 1830; and the Metropolitan Museum of Art in New York City, constructed between 1870 and 1872. As universal as these respective museums aspired to be through the breadth of their encyclopaedic collections, they represented and celebrated the image of the particular nations that had established them. Moreover, these public museums, as cultural monoliths, became the type of institution that Michel Foucault identified with the emergence of the modern.

Like the asylum, the clinic, and the prison, the museum presented a discourse that arbitrated what could be understood of the past and interpreted in the present.[3]

But, in time, the encyclopaedic museum was understood as a cold, aloof institution too large to foster an environment sufficiently intimate for the experience of looking at art. This explained, for instance, the vocabulary that emerged to describe the museum as a mausoleum or, in the words of the artist Robert Smithson, a 'tomb'.[4] Thus the form of the museum began to be reimagined – and even redefined – by a generation of avid collectors who had taken advantage of the commercial and transnational art market that had transformed priceless works of art into items for sale. No longer was the museum a public presentation of an abstract national identity: in the form of the collection museum, it had become the embodiment of personal identity. Often staged in the home of an individual collector, a number of smaller museums showcased, as it were, the inner life of the collector him or herself.

Between the revolutions of 1848 and the Second World War, but especially between 1890 and 1940, a number of these museums emerged in both Europe and North America: the Musée Condé near Paris (1898), the Wallace Collection in London (1900), the Isabella Stewart Gardner Museum in Boston (1903), the Huntington Museum in Pasadena (1919), the Frick Collection in New York (1935), and Dumbarton Oaks in Washington, DC (1940). 'When collection museums are grouped together,' the art historian Anne Higonnet has written, 'it becomes apparent that historical forces produced them just as surely as did their individual founders.'[5] But, if these more intimate spaces reflected some of the 'historical forces' that informed their encyclopaedic counterparts, most importantly, they were points of intersection between those discourses and individual subjectivities. In Higonnet's words, 'Collection museums . . . connect the psychological to the social.'[6]

Both personal and political, private collection museums are self-portraits that respond to the vicissitudes of an individual collector's life as well as the nature of his or her times. Individuals belong to their own inner lives, but they are also inscribed in concentric circles of affiliation: family culture, community, religion, and nation, as well as the identities of gender, sexuality, and class. In the end, however, they also belong to specific moments in time, even if they themselves do not recognize the particular characters of those moments or deliberately

avoid reflecting on them. Without question, what individuals choose to collect is a function of particular tastes unique to them as individuals. But each individual exists at the intersection of multiple identities. As Bourdieu famously argued, taste is often a function of those confluences, the clash of structures and categories that push and pull the course of an individual's life.

The items and objects on display in a private collection museum thus serve a dual purpose: they tell us the 'who' component of a collector's identity, but they also tell us something of the 'what'. Collections betray the sensibilities of unique, complicated, and often contradictory people who saw meaning, as did Béatrice Éphrussi, in Meissen monkey figurines, but they also betray, in terms of what was deemed to be desirable in a certain period, the nature of the time in which the collection was amassed. There are, after all, important similarities among the major collections amassed by French elites in the same period of time, many of which emphasized, in some form or other, the decorative arts of the ancien régime. If museums are 'self-portraits', then, they are self-portraits composed of objects with meanings that depend, inevitably, on the history within which they emerged.

This is particularly true of the significant number of donations that Jewish collectors made and of the museums they established in France in the 1920s and 1930s, in the golden age of the private collection museum. Jewish collectors were not necessarily different from their non-Jewish counterparts in terms of what they collected, and nor were they the only philanthropists to establish private museums that bore their names. The Musée Jacquemart-André, established by the will of Édouard André and Nellie Jacquemart in 1913, and the Musée Cognacq-Jay, created by the heirs of Théodore-Ernest Cognacq and Marie-Louise Jay in 1929, both showcase the same type of eighteenth-century collections as the Musée Camondo and the Château de Champs-sur-Marne. The essential difference, however, was the lived experience of these Jewish collectors as the very public targets of antisemitic invective – an unsparing, constant critique that often attacked them in material terms, as laughable custodians of French cultural patrimony.

In general, the years between 1890 and 1940 were a time when the so-called 'Jewish question' was inescapable in French public discourse. This, after all, was a period that began with the Dreyfus Affair and was periodically characterized by surges of antisemitism prompted in part by the arrival of Eastern

European Jewish immigrants but also by other developments in political life. There was the right-wing anti-parliamentary revolt and the Stavisky Affair in 1934, the election of Léon Blum in 1936, and the hostile activities of Action Française throughout, including the attack on Blum in February 1936 that nearly killed him.[7] If the museums that France's leading Jewish collectors established during those years often showcased the same type of art and objects that were visible elsewhere, they all did so under the banners of eminently recognizable Jewish names – some of the same names that had been subjected to years, and in some cases decades, of hostile caricature from the likes of Édouard Drumont and Jules and Edmond Goncourt.

There may not have been anything significantly 'Jewish' about the art in the collections they amassed, but museums, and especially those left to the state, are public enterprises with public motives. The archives are quite clear on what the public motives of these collectors truly were, especially at the end of their lives. As much of their private correspondence and their last wills and testaments suggest, the donations they made and the museums they left behind were subtle attempts to respond to the antisemitism of the fin de siècle, to show that Jews could indeed curate a genuine, authentic image of France and shape its national patrimony. There were important differences in the bequests these collectors made, and each of them ultimately curated a different image of the nation they purported to love. In private, their collections were self-portraits, as all collections are. But translated into the public realm, they also became political statements, arguments in favour of the eternal compatibility of Frenchness and Jewishness.

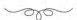

Isaac de Camondo was ill. Living alone at 82, avenue des Champs-Elysées, far from his mistress and the two illegitimate sons he never publicly acknowledged, the renowned aesthete and amateur musician was in the process of putting his affairs in order.[8] Since he had drawn up his will in 1897, he had planned on leaving his extensive collection to the Louvre in a series of rooms that would bear his name. The bequest – a legendary collection of eighteenth-century furniture, Japanese antiques and prints, and more contemporary Impressionist canvases, including twelve by Degas – had been front-page news when it was announced, largely because of the controversy involved in the

Isaac de Camondo (1851–1911).

Louvre accepting contemporary works by artists who were still alive, as Degas, Sisley, and Monet all were in 1897. Isaac had to compromise. As he insisted, the Louvre accepted the entirety of his collection, breaking its rule that a decade had to pass between the death of an artist and the admission of his work to the museum. But the museum agreed to display Isaac's collection only for a period of fifty years. 'We would never discourage millionaires from having these passions,' *Le Figaro* joked, when the agreement was finalized.[9]

Fourteen years later, in the winter of 1911, he saw that the difficult negotiations with the museum were far from over. In February of that year, two representatives of the Louvre – including his fellow collector Raymond Koechlin – paid the ailing Isaac a visit at home. They offered him the title of president of the Société des Amis du Louvre, the prestigious and recently established circle of philanthropists who contributed to the museum's acquisitions. Normally, the president of that society became, by default, an automatic member of France's

Commission des Musées Nationaux, an even more elite group of trustees charged with managing the upkeep and the future development of the hundreds of museums scattered throughout the country. For an aesthete and a collector like Isaac, there would have been no higher honour. But the Louvre's representatives had come to tell him that, despite the value of his bequest to the museum, they could offer him only the first presidency, not the second. Their reasoning: Isaac de Camondo was somehow too 'foreign' to govern a network of French museums.

At least in Isaac's account of the meeting, the Louvre's commission said nothing of his Jewishness. But the accusation of foreignness was hardly something with which Isaac would have been unfamiliar. This, after all, had long been the public perception of the Camondos. The family, both as an ostentatiously wealthy fixture in the Paris of the fin de siècle and as Jewish immigrants from Constantinople, had long drawn the ire of Drumont and his supporters, who saw the family as Jewish interlopers in French cultural life and ultimately as unworthy custodians of the French material heritage they acquired. In Drumont's *La France juive* (1886), the antisemitic screed that sold thousands of copies at the time, he makes a particular point of attacking a portrait of Isaac's uncle, Nissim, by Carolus-Duran, who was a society painter of choice in the late nineteenth century. What Drumont emphasized was the foreignness of the subject: 'That Levantine Turk that that Carolus-Duran has exhibited,' he wrote, 'the pale and timid image.'[10]

In the end, Isaac rejected the Louvre's half-offer. In the lengthy letter he sent the museum detailing his response, he hid neither that he was wounded nor that his motives from the start had been purely patriotic. '"Foreigner,"' he wrote. 'The word seems strange to me, when applied to someone who has only one desire, which is to see the patrimony of our admirable museum strengthened, during his lifetime and after.'[11] He went on to say that he did not expect the committee to make any kind of special exemption on his behalf, and at the end of the letter he reiterated his commitment to leave his collection to the Louvre, the most refined display of French cultural achievement. 'Nothing will be modified – which would be undignified – in my plans to enrich the patrimony of our museum, to which it can certainly not be said that, even if a "foreigner", I was ever a stranger.'[12]

Isaac died in April 1911, two months after this exchange. The Louvre did as his will had instructed and created a somewhat awkward series of

rooms that were known as the 'Salles Camondo' that displayed Isaac's art for a period of fifty years. The Camondo rooms were opened officially in 1914, with an extra million francs that Isaac left for their installation. In his review of the collection, Guillaume Apollinaire heralded the exhibition as a watershed moment in the history of the museum: 'The true modern museum in Paris is now the Louvre,' he wrote.[13] Despite the last exchange Isaac had had with the museum, later generations of curators affiliated with the museum did ultimately read his bequest in the terms in which he had imagined it. 'The gift that the Count Isaac de Camondo made to France is a gift whose value is inestimable,' observed Gaston Brun in 1922, in his introduction to the museum's official catalogue to the Camondo collection, 'because it was made with a constant intelligence and a genuine interest in the museum, and the embarrassment of precious riches it contains gives so much to our country.'[14]

Yet, even in death, Isaac's donation would not permit him to escape the charge that a Camondo could never be French. That was the judgement of the critical establishment. In his review of the Louvre installation for the *Gazette des Beaux-Arts*, the most prestigious art journal of the time, Paul Jamot, a well-known curator, critic, and painter, noted the following: 'Mr de Camondo could not in a more noble fashion have recognized the hospitality he received in our country,' he wrote. 'Perhaps his foreignness excuses him from not having felt as much as we do the value in the rule that imposes on every work destined for the Louvre a delay of at least ten years after the death of its creator.'[15] Jamot also opposed the way the exhibition kept Isaac's collection intact, rather than distributing particular works into the appropriate departments throughout the Louvre. 'Doesn't our museum risk becoming an incoherent assembly of collections that are more or less disparate?'[16] Jamot's point was that the Louvre was 'our museum'. It could never belong to Isaac.

Towards the end of his life – after his divorce, the untimely death of his son Nissim, and the departure of his daughter for married life in Neuilly – Moïse de Camondo appears to have resigned himself to a certain listless languor. As he wrote – not without irony – to a friend after New Year's Day 1934, less than

two years before his death, he had essentially embraced the inevitability of physical demise:

> I wish you also good health and a good year. When you've renounced, as I have, all fun and merriment, you'll go to Merovitch at no. 16, boulevard Haussmann, and you'll buy one of these hearing devices that will do you, like me, the biggest service. . . . It's clear that you have to talk to people in a distinct voice and a slightly elevated tone. The device wasn't made for the easily distracted, and it's taken me a long time to get used to it.[17]

His biographers, Nora Seni and Sophie Le Tarnec, have suggested that with his increasing physical malaise came an inevitable confrontation with the failures in his life – failures from which Moïse ultimately sought solace in the material universe he had created.[18] But even in this solace there was disquiet: his daughter, Béatrice, had shown little interest in maintaining his neo-Versailles on the rue de Monceau, and the son and heir to whom Moïse had planned to leave the collection had died in 1917. Moïse's response was to create a museum out of his home, a museum that would both memorialize his fallen son at the same time as it would celebrate the ancien régime aesthetic he had tirelessly pursued for decades.

This double motive he clearly delineated in the 1924 edition of his last will and testament:

> Desiring to perpetuate the memory of my father Count Nissim de Camondo, and that of my poor son Lieutenant Nissim de CAMONDO, fallen in aerial combat on 5 September 1917, I bequeath to the Musée des Arts Décoratifs, Pavillion de Marsan in Paris, my hôtel located in Paris 63, rue de Monceau, as it will be at the moment of my death – that is to say with all the objets d'art and furnishing it will contain, including paintings, tapestries, statues, bronzes, busts, andirons, chandeliers, sconces, table stools, porcelains, Savonnerie and Oriental carpets, draperies, cabinetry, pendulums, barometers, candelabras and candlesticks, consoles, tables, chairs, window items, boxes of leather goods, engravings, shovels and tweezers, etc., with the exception of a large secretary with a flap signed by Leleu,[19] which is in the large office under Madame Vigée Lebrun's 'Baccante'.[20] This piece of furniture belongs

to my son-in-law Léon REINACH and will have to be returned to him immediately. My hôtel will be given the name of Musée de CAMONDO, the name of my son for whom this house and its collections were intended. . . . By bequeathing to the state my hôtel and the collections it contains, I intend to preserve in its entirety the life's work to which I have attached myself: the reconstitution of an artistic residence of the eighteenth century. To my mind, this reconstruction must serve the education of artists and craftsmen, and it also allows to be kept in France, gathered in a special environment for this purpose, the most beautiful objects that I could collect from this particular decorative art, which was one of the glories of France during the period I loved most among all others.[21]

The will betrays much of the collector's vision for the museum he sought to establish. On a superficial level, what became the Musée Nissim de Camondo, inaugurated on 21 December 1936, was merely an extension of the philanthropic activities that the Camondo family – along with other prominent nineteenth-century Jewish philanthropists – had practised for generations. Moïse's conception of a museum, in fact, bore an unmistakable similarity to the network of Francophone schools that the Alliance israélite universelle had launched in the family's native Constantinople in the mid-nineteenth century – all with the financial support of Moïse's grandfather Abraham Salomon Camondo (1781–1873). Both the schools and the museum, after all, were arguments for the cultural supremacy of what Moïse called the 'glories of France'; both were manifestations of a *mission civilisatrice* that sought to foster public knowledge of precisely that French cultural supremacy.

And yet, as Moïse's will made clear, a central effect of the new museum was to memorialize his son and father. It is significant, in other words, that he did not choose to call his new creation the 'Musée des Arts Décoratifs du XVIIIème siècle' or something similar; rather, he was insistent on naming it the very explicit Musée Nissim de Camondo. Although the transformation of the family home on the rue de Monceau into a museum remained faithful to its founder's desire for a 'total reconstruction' of ancien régime Neoclassicism, there were spaces within it that deliberately juxtaposed the story of the family with the eighteenth-century objets d'art the museum would later display. Within the original design of the museum, there was a 'souvenir room', which

193

Moïse conceived as a material mausoleum for his father and son. As he noted in his will, at no point in time were the family's effects to be altered. The visitor was never to lose sight of the museum as a private, family home:

> As soon as it is vacated, this room will be able to serve as an office for the curators and will keep its current furnishings with the portraits and busts of my parents. I insist that the portrait of my father by Caislus [sic] Duran and the various photographs of my son that are placed or hung in various rooms of the hôtel remain in their current places.[22]

The 'souvenir room' was in fact the only room of the family's private apartments open to the public in the original 1936 design of the Musée Camondo: it contained some of the family photographs he described above, Carolus-Duran's imposing portrait of his father, suspended in darkness, and, as a centrepiece, a professional photograph of his son in military uniform. Here, in what was now a public space, was a preserved private enclave. In one sense, the souvenir room was a nostalgic departure from the narrative that governed the rest of the museum. But, in an equally important sense, it was an attempt to illustrate the points of intersection between the family's experience and the narrative of French national grandeur on display. This was particularly evident in the prominently positioned photograph of Nissim in uniform. The image – personal, intimate, and an emblem of the family's tragic fate – became a plot point in the evolution of the story that the museum's objects tell elsewhere throughout the house. Likewise, Nissim, 'fallen for France in combat', as the plaque near his portrait read, became a martyr for that legacy, and the Camondos the trusted custodians – and even arbiters – of national patrimony.

This was perhaps the most important of Moïse's motives in transforming his private collection into a public museum, especially given that for decades he had often refused to lend particular objects for gallery exhibitions and shows. Reading his will in the context of the family's lived experience as the target of public antisemitic rhetoric, from the likes of Drumont and others, one cannot avoid the sense of pride it contains. The museum he sought to establish was to bear not only the name of his beloved son, but of the entire family. It would unite one of the finest collections of 'the most beautiful objects' in France under the label of 'CAMONDO', a Jewish name that had recently become, in certain

antisemitic circles, a synonym for Levantine and Oriental foreignness, as evidenced in Drumont's attacks on his father's portrait.[23]

But there was another form of antisemitism Moïse seemed to be responding to. For years, Parisian elites – notably, the brothers Jules and Edmond Goncourt – had attacked Jews for a perceived inauthenticity in the lavish material worlds that families such as the Camondos had constructed. A central component of this strain of French antisemitism was that Jews personified bad taste and could never know – much less create – true beauty.[24] In fact, the Goncourts had said exactly this of Moïse's father and Alice Thal de Lancey, his American-born mistress, who owned a property at Louveciennes that had previously belonged to Madame du Barry. 'The ironic interior of Louveciennes, where Madame du Barry once lived,' they sneered in a journal entry from 1882, 'and where Madame de Lancy lives, and where the banker Camondo replaces Louis XV.'[25]

In other words, the presence of a Jewish banker in an aristocratic eighteenth-century setting had apparently subverted the natural hierarchy that the Goncourts, self-proclaimed arbiters of taste, had devoted their lives to maintaining. This was a challenge Moïse answered with his museum, a painstaking 'reconstitution' of the eighteenth-century aesthetic that the Goncourts, who had celebrated and revived that style with their monographic series *L'Art du 18ème siècle*, had declared to be the exclusive property of France's non-Jewish aristocratic elite. The final volume of the Goncourts' *Journal* was published in 1896; there is no evidence that Moïse had read or responded to its criticism directly, although, given the publicity that the publication of the diaries had attracted, it seems unlikely he would have been entirely unaware. In that sense, one interpretation is that in displaying one of the most impressive collections of eighteenth-century objets d'art, the Musée Nissim de Camondo would show that a Jew could not only be French but proudly so, a credible arbiter of what Moïse called the 'glories of France'. Moïse's museum was about more than the prospect of assimilation, which implies a certain anonymity. On a fundamental level, his project was intended as a public statement. Jews, the museum proclaimed, could indeed know and curate a true, authentic beauty.

Of course, the notion of 'authenticity' is central to the conception and execution of any museum. As the art historian Elizabeth Rodini has convincingly argued, it is a concept that particularly elucidates the creation of the Musée Camondo, a private collection that eventually became a public museum.[26] What

mattered most was the ensemble, the unified whole. In the end, it was an ideal for which Moïse was even willing to sacrifice certain objects with the requisite eighteenth-century provenance for those that fitted better into the museum he imagined. He could not locate sufficient bronze fixtures from the period, so he commissioned reproductions that he ultimately interspersed among the real ones. When he could not find an original wrought-iron balustrade, he ordered a copy of the one he had admired in the Hôtel Dassier in Toulouse. The same was occasionally true of his Louis XVI chairs, some of which were upholstered in contemporary fabrics, and with the Neoclassical panelling he bought, which had to be altered to fit the dimensions of particular rooms.[27] These individual pieces may have been 'fakes', but that was irrelevant: if the objects themselves were not authentic, together they composed a genuine truth.[28] Granted, artifice was inescapable at the Musée Camondo, housed in a building that was *itself* a copy of an eighteenth-century château. But for Moïse artifice appears to have been the only means of achieving any worthwhile authenticity.

In pursuit of this aim, Moïse was just as autocratic as he had been throughout the creation of his collection and the construction of his house decades before. It should come as no surprise that, on the same day his last will and testament was notarized, he drafted a set of instructions for the curators and keepers of the future museum that would bear his name. The level of detail with which Moïse concerned himself in this two-page, fine-print document is truly remarkable: nothing was too petty to warrant his attention. Of the windows and the manipulation of light in the house, he stipulated the following: 'All the windows are to be equipped with sun blinds, to ensure that they are used properly.'[29] Of the trees in the museum's inner courtyard: 'The courtyard is adorned with wooden crates containing cut laurels,' he wrote. 'These trees do not support frost and must be taken inside in winter. . . . In good weather it will be necessary to ventilate them by leaving open the doors.'[30]

He even thought through where and how visitors would enter in bad weather: 'Public entry could be done on rainy days by way of the undercover passage that connects the courtyard with the boulevard Malesherbes,' he insisted. 'This passageway is preceded by a vast paved sidewalk that could be covered with mats and racks for umbrellas.'[31] Should the curators of posterity have any questions whatsoever about his collection or his intent, he provided them with a contact: 'my friend Carle Dreyfus', he promised, 'will

at the very least be able to give you precise specifications. He knows all my objects and everything I know myself about the collection.'[32] It was in this document as well that Moïse included the first mention of what would later become the museum's extensive archive, which he intended as a resource for scholars and artists interested in the provenance of particular pieces: 'In addition, I have a small notebook where I mention all my purchases, sadly not since the beginning of my collection but only for the past dozen years or so,' he wrote. 'It contains useful specifications you can use if my heirs ever ask anything of you.'[33]

This obsession with control was a fundamental element of Moïse's personality. But in this decidedly public project more was at stake: Moïse was after all creating a museum that would bear his name, a name that for some was a synonym of foreignness and for others a symbol of Jewish financial plutocracy. 'I want this museum to be, admirably, of a meticulous propriety,' he wrote in the first line of his instructions. In a sense, he had no choice: the museum – and every aspect of its execution – had to be above reproach. If objects, art, and, in general, material things had provided antisemites such as Drumont and the Goncourts an important means of articulating their conception of Jewish foreignness, Moïse could scarcely afford any imperfections. In an important way, the museum was his rejoinder to the unforgiving scrutiny he knew very well to expect.

Judging from critical assessments of the museum at the time of its opening in 1936, Moïse had successfully projected the image he sought to cultivate. Writing in L'Illustration, Jacques Guérin, the museum's first curator, noted that 'the name of Camondo' – which he never referred to as Jewish or as foreign – 'is already inscribed among the great donors of France'.[34] Moïse, in Guérin's view, was the consummate cultural sophisticate: 'The Count Moïse de Camondo,' he wrote, 'an elegant sportsman whose very fine Parisian silhouette was suddenly popularized by Sem in his albums, was also a very cultivated spirit interested in art for many years.'[35] The journal Art & Industrie took a similar stance. It wasted no time in praising the Camondo family's cultural philanthropy, placing Moïse's new museum in the context of his cousin Isaac's major 1911 donation to the Louvre: 'For the second time,' its article began, 'our public Parisian collections will be magnificently bolstered thanks to a member of the Camondo family'.[36]

197

Most importantly, however, the article invalidated the central contention of the previous generation's antisemitic critiques: 'The Count Camondo took care first to create a space as authentic as possible; the antique boiseries, the panels, the door frames, the mirrors and the tapestries, all coming from ancient *hôtels particuliers* . . .'[37] There was thus no question that a foreign-born Jew could indeed create an aesthetic universe that was as publicly valuable as it was authentic. Moïse would likely have been pleased: in a sense, his museum had made his point.

Louis Cahen d'Anvers died in 1922, leaving his son Charles in charge of the beloved family estate at Champs-sur-Marne. In 1935, the same year his brother-in-law Moïse de Camondo bequeathed his rue de Monceau mansion to the state, Charles likewise donated the Château de Champs to France.

A paragon of early eighteenth-century French architecture, the historic Champs-sur-Marne had been the property of the Cahen d'Anvers since 1895, when Louis Cahen d'Anvers began restoring the château to its rococo grandeur. With his donation, Charles Cahen d'Anvers – living by then mostly in Argentina, where the family had extensive financial holdings[38] – had initially hoped that the historic property would serve as a residence for the French government. Instead, the state opened the property as a *monument historique* and, shortly after its donation, it began receiving visitors, who could encounter what was immediately recognized to be one of the nation's finest examples of preserved period architecture.[39] The château did eventually serve as a frequent place for the French government to house visiting foreign heads of state, but it was eventually transferred to the Ministry of Culture in 1971.

The last will and testament of Louis Cahen d'Anvers did not articulate – as did, for instance, those of his contemporaries, Béatrice Éphrussi and Moïse de Camondo – a clear motivation for the public afterlife of his home and his collection. However, Charles Cahen d'Anvers did propose a clear vision for the family home as public space. In 1927, two years after his election as mayor of Champs, he wrote a 'Notice Historique' for guests to consult as they wandered the grounds of Champs-sur-Marne. A lively essay in its own right, the text presented the Château de Champs as a microcosm of modern French history

Charles Cahen d'Anvers (1879–1957) at Château de Champs-sur-Marne.

and, as such, an important piece of French cultural heritage. But the narrative Charles constructed was also political, especially vis-à-vis its conclusion: what he wrote was a kind of *roman national*, a narrative that began in the mythic French past and ended with his own Jewish family, who had as much a right to be in that story as anyone else. There was no difference, Charles suggested, between the Cahen d'Anvers and the previous generations of the château's decidedly noble ownership. Each, it followed, had been equally invested in the project of perfecting and maintaining the highest French aesthetic ideal.

The Château de Champs did indeed have an illustrious history. Designed by Pierre Bullet (1639–1716), a pupil of the famed François Blondel[40] (1617–86), the château, in its symmetry and its measured Neoclassicism, bore considerable similarities to Bullet's celebrated Parisian hôtels on the Place Vendôme, the epicentre of the French Baroque.[41] Bullet died before completing the design, but his son, Jean-Baptiste Bullet, completed it according to his father's plans in 1706. For its first decade, Château de Champs was the home of a financier, Paul Poisson de Bourvallais (d. 1719), later charged with embezzlement and imprisoned in the Bastille. After his imprisonment, Champs-sur-Marne earned its royal pedigree, undoubtedly the basis of its appeal for Louis Cahen d'Anvers in the late nineteenth century.

In 1718, the château was sold to Marie Anne de Bourbon (1666–1739), the so-called 'princesse de Conti', the daughter of Louis XIV and his mistress, Louise de La Vallière. To settle a debt, the princess sold the property to a La Vallière cousin, in whose family it remained and whose future generations transformed it into a centre of Enlightenment social activity. By the mid-eighteenth century, the house's unique *salon chinois* – which the Duc de La Vallière had installed around 1750, with chinoseries painted by Christophe Huet – hosted Voltaire, Diderot, and even the elusive Madame de Pompadour, whose presence would elevate the house's mystique in the eyes of its future owners. In fact, between 1757 and 1759, Madame de Pompadour leased the château, and spent more than 200,000 livres renovating it to her liking. Of all the sites with enviable royal patronage – at least in the eyes of the late nineteenth-century collector – few could surpass Champs-sur-Marne. The Cahen d'Anvers were the owners of an eighteenth-century *bijou*, but they saw themselves as custodians of a dramatic piece of ancien régime history, a veritable theatre in which a certain portion of that history had unfolded.

In the narrative he wrote for visitors, Charles presented Champs-sur-Marne with an age-old provenance that reached to the ancient, mythic heart of *la France profonde*: 'The lordship of Champs owes its name to that which in the neighbouring regions is called "field",' he wrote, tying its origins to a certain conception of the land. The property was so old, he suggested, that its name appeared a frequent footnote in the annals of local history. In fact, it was a constant, impossible to date exactly: 'It goes back to the twelfth century and perhaps further than that,' he wrote, 'as erudite writers cite for us the names of certain lords of Champs.'[42] In a certain sense, Charles even seemed to echo the organicist conception of the French nation as articulated by the likes of Maurice Barrès, a rooted vision tied to the *territoire*.

The nation, in this view, evolved not from a 'general will' but rather from the connection between individuals and the land and the inheritance of a shared past. Charles depicted Champs-sur-Marne as precisely such an inheritance: age-old, rooted, and, to some extent, a source of French national identity. In no small part, he considered his family's château something of a material synecdoche for the experience of the French past. What the nation had experienced in the Middle Ages, for instance, the denizens of Champs-sur-Marne had experienced: 'Events – looting, fire, epidemic – led people to take refuge at Champs,' he wrote, 'and we possess certain information about a Jean de Pisseleu, a parish priest of Champs, who, in 1393, administered an abbey itself already very ancient at the time.'[43] In those very lines, Charles also betrayed the extent of his own – and, indeed, his family's – obsession with the history of the house, suggesting the extent of archival materials he had consulted to construct his narrative. This sense of earnest documentation continues throughout his essay, which locates Champs in sources as diverse as the memoirs of the Duc de Saint-Simon[44] and the canvases of the Flemish painter Adam Frans van der Meulen (1632–90), who had served as court painter for Louis XIV.[45] While this level of detail might be rather unusual for a visitor's guide, readers would certainly emerge with the impression that the author had made his case beyond any reasonable doubt.

Ultimately, Charles's argument was that the story of Château de Champs was the story of France. His emphasis was almost always on the connection of the property to the historical evolution of the French nation, even in the relatively insignificant details of the property's past. 'A very special mention has to

be reserved for the Marquise Vivonne de Pisani,' he wrote, 'who drew to Champs a considerable train of distinguished characters from both France and Italy (1606–1615).' He justified his mention of Vivonne de Pisani as follows: 'This Marquise de Pisani, Roman by birth,' he wrote, 'played a certain role in the embassies of King Henri IV, and his daughter became the celebrated Marquise de Rambouillet.'[46] As was also true of Moïse de Camondo and Béatrice Éphrussi, Charles was clearly proudest of his home's connection with the royal family – or, as it happened, with Madame de Pompadour, the mistress of Louis XV and perhaps the ancien régime's most celebrated patron of the arts.

This chapter of Champs's history took up the greatest portion of Charles's essay: this, in essence, was the point he most wished to communicate to visitors. 'La Vallière was a great friend of the marquise,' he wrote of Madame de Pompadour, 'and it was with him that she carried out many embellishments in the château that we admire today.'[47] This royal chapter, he continued, had made the house into the structure it was in the present day. Charles was careful, however, to make this point with typical archival substantiation: 'we know that this woman of taste was interested in the renovation of the château,' he wrote, 'because we find the traces of significant expenses authorized by Mme de Pompadour for Champs in the records conserved in the Archives de Seine-et-Oise, published in 1863 by M. Leroi, a departmental archivist'.[48] As studied and as measured as Charles's observations remain throughout, he indulged his imagination in his description of the château's royal past. 'Did the Marquise have her rendezvous with Louis XV here?'[49]

The important point, however, was that the aesthetic of the house represented the *longue durée* of French history in all its diversity. Particular rooms in the house, Charles argued, embodied different moments in time:

> We must not conclude that we are indebted to Madame de Pompadour for all the beauties of Champs. Several periods have left their characteristic imprint: the two large living rooms, one on the ground floor, the other on the first, and the dining room, for example, have retained their boiseries and décor from the Louis XIV period. In other rooms, the boiseries are from the time of the Regency; thus, with some research, we can say that what we often suppose to have been the bedroom of the Marquise was actually done in this earlier style. The artist carved in these boiseries the romance

of two doves, with the insignia of peacocks with majestic tails. The design in the gardens is due to Blondel, a pupil of Le Nôtre[50] and whose work is so sober and full of nobility.[51]

The history that Charles considered the house to represent did not end in the early nineteenth century: it continued well into the present day. 'In 1850,' he wrote, 'Champs passed into the hands of M. Santerre, the great-nephew of the officer who beat the drums to stifle the last words of Louis XVI on the scaffold, and was finally acquired in 1895 by M. Cahen d'Anvers.'[52] The Cahen d'Anvers, his presentation suggested, were part of the château's age-old narrative, at least as much as any of its previous occupants had been, royal or otherwise. The family had painstakingly restored the house, hiring the archi- tect Hippolyte Destailleur to oversee the project. They were custodians as much as they were owners.[53] As such, they were inextricably linked to the deeply rooted image of French nationhood that Charles considered the house to embody.

In that sense, what he wrote was nothing less than a subtle 'Jewish return into history',[54] a view of the past that integrated Jews naturally, seamlessly, and almost self-evidently into French history. Reading his essay, visitors to Champs- sur-Marne would draw little if any distinction between the days when ancien régime aristocrats occupied the château and the days when foreign-born Jews resided there.[55] Both were plot points in the same evolving continuum. Yet, in the end, Charles depicted his family as something more than mere plot points. The Cahen d'Anvers were the active curators and the devoted protectors of both the legacy of their home and the legacy of the nation it represented. 'This man,' wrote Charles of his father, 'undertook with Mme Cahen d'Anvers, passionately fond of art, the heavy task of restoring the château to its former glory.'[56] This was the language of sacrifice as much as it was the language of nostalgia. The Cahen d'Anvers, Charles suggested, were exemplars of each – warriors, through art, for the recovery of the glorious French past.

On 30 October 1928, Théodore Reinach's remains were sealed in the family tomb in the Cimitière de Montmartre, where both his wives, Evelyne

Hirsch-Kann (d. 1889) and Fanny-Thérèse Kann (d. 1917), his brother Joseph (d. 1921), and an infant son, Jean (d. 1888), had preceded him.

Gathered there that day were the surviving members of his milieu: his brother, Salomon; his daughters, Hélène Reinach-Abrami and Gabrielle Reinach; and his sons, Julien, Paul, and Léon Reinach, who came with his wife, Béatrice de Camondo, and her father, Moïse. Béatrice Éphrussi, a distant relation, and Edmond de Rothschild, a fellow custodian of the *Gazette des Beaux-Arts*, both came, as did a significant number of Théodore's colleagues from the Institut de France.[57] All had gathered to mourn the loss of one of the great polymaths of the age. Louis-German Lévy, the chief rabbi of the Union libérale, delivered the eulogy of a man who, in his view, was as much a proud Jew as he was a devoted classicist:

What there is in us that loves truth and beauty will forever find itself in his memory. In his memory will sing the most beautiful voices of heaven and earth – grave, sweet, and harmonious. On his name will shine forever these two splendid rays of the divine Hochma: the agile and smiling light of Greece and the pure and holy light of the genius of Israel.[58]

Lévy's concluding remark – about Théodore as a point of intersection between the 'light' of ancient Greece and the 'genius' of Israel – was also a parable for the house that the youngest Reinach brother had bequeathed to his beloved Institut. As a public museum – albeit one that remained partially under family control until 1967[59] – Kérylos became, predictably, a museum to the Greek ideal of perfection. 'It is here in the company of the orators, the wise men, and the poets of the Greeks', Théodore's library inscription read, 'that I find peaceful retreat in immortal beauty.' But the villa, through the personal effects that its rooms displayed to the public, also became a shrine to the man – and the family – that had built it, and that was among the most prominent in the Third Republic's intellectual establishment. Kérylos had one central, if subtle, contention: a Jew could indeed understand and create 'immortal beauty'.

After the death of Théodore Reinach, the Institut assumed ownership of Kérylos, although it was still occupied by the family well into the 1960s. In 1934, the Institut, in collaboration with the Bibliothèque Nationale,

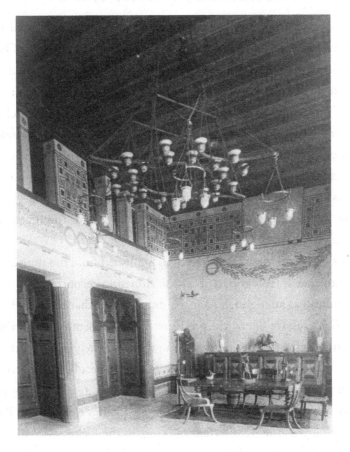

The library at Villa Kérylos.

commissioned a catalogue on the house – complete with an introduction by Emmanuel Pontremoli – that documented the way in which it was transformed into a museum.[60] A series of photographs of the villa's rooms, with furniture arranged to suggest the lived experience of daily, ordinary life, betray the Institut's intention to preserve the memory of the people who had lived at Kérylos, not just the unique design of the structure itself. In other words, at no point in a visit to the house was it possible to forget the presence of Théodore Reinach. The beds in each bedroom were made as if the occupants of the house would return that night; a chaise longue in a reading room was dressed with an afghan and a pillow as if the person it had comforted had left the room merely for a moment. The villa's library, its undoubted centrepiece, showcased not merely the intricate Greek mosaics on the walls and floor but the passion of the man who had installed them. After 1928, the surviving Reinachs donated

Théodore's books from his Paris house and his Savoy château, which meant that Kérylos displayed his library in its diverse, extensive entirety. One could see an entire case devoted to the *Revue des Études Grecques*; another devoted to the *Gazette des Beaux-Arts*; a collection of volumes on numismatics; and shelf after shelf on mathematics, the classics, and histories of music, architecture, and the arts.[61] This reconstructed library was ultimately a bibliographic reconstruction of Théodore himself, visibly uniting for the first time the wide array of intellectual endeavours he had pursued throughout his long and prolific career. His famed standing desk was fitted with paper and pen; the character of Théodore Reinach was inextricably linked to the room, the house, and the ideal it represented.

Almost every interpretation of Kérylos published from the time of its dedication immediately recognized it as an authentic reconstruction of Greek beauty, but also as an argument for the durability of that ideal in the present day. In 1928, Gustave Glotz, the president of the Académie des Inscriptions et Belles-Lettres, referred to Kérylos as a site that accurately reflected the art and architecture of ancient Greece: it was a 'beautiful Beaulieu villa that he had decorated with frescoes and antique vases'.[62] Likewise, in a 1931 essay he wrote on Reinach and Kérylos, René Cagnat, the Institut's Secrétaire Perpétuel, called the house 'a true Mediterranean house in the Delos style, with a single peristyle, and building on this theme, it was not a pastiche, a cold archaeology, but a living and habitable thing'.[63]

This 'true' Mediterranean house was an authentic celebration of ancient history, realized with the aesthetic standards of antiquity itself: 'all the details', Cagnat continued, 'are borrowed from archaeologically selected artefacts, mosaics, bas-reliefs, paintings, vases, lamps'.[64] But what Kérylos presented was ultimately a *living* history, a history that was not at all out of place in the French interwar era. The house, in Cagnat's assessment, was a nexus between past and present, between the dream of Delos and contemporary republican France. 'We are in an antique landscape, adapted to the lines of the landscape,' he wrote, 'and one could believe that the structure had always been there since the era when the Phoceans had just set foot on the Côte d'Azur.'[65] Establishing that connection had always been Théodore's aim.

Kérylos was distinct from its immediate surroundings in several important ways. At the end of the Pointe des Fourmis, it jutted out into the bay from

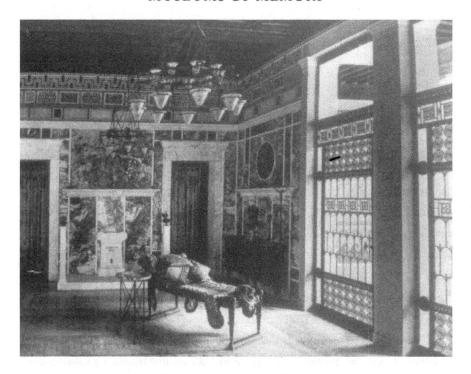

The solarium at Villa Kérylos.

the harbor of Beaulieu-sur-Mer, visible from most points in the village. Architecturally, it also represented a significant departure from the pastel façades of the Beaux-Arts mansions that formed the majority of the local built environment, especially in the first decade of the twentieth century. What further distinguished Kérylos was a plaque, prominently displayed at its entrance, which established the unique and even bizarre villa as the explicit construction of a Jewish patron. In capital letters it displayed the name 'REINACH', a name that had become a synonym for a certain aspect of the Jewish experience in contemporary France, at least in the wake of the Dreyfus Affair. For Drumont and his followers, of course, this name evoked the presence of a fifth column subverting the national interest from within. For France's Jewish community, it had come to mean a crusader for the cause of French Republican Judaism. But, if the Reinach name was also inscribed on the walls of Paris's Grand Synagogue de la Victoire, on a plaque outside the Consistoire Central Israélite de Paris, and, for a time, on the family's memorial in Saint-Germain-en-Laye, it would now be found outside Kérylos, which represented a different project altogether. If they were crusaders, defenders, and even, as in

Théodore's case, philosophers of the Franco-Jewish encounter, they were also aesthetic arbiters, custodians, and creators of 'immortal beauty'.

In 1934, at the age of 69, Béatrice Éphrussi de Rothschild died in Davos, Switzerland, alone in a hotel. There is a sense in which her death belongs in Thomas Mann's *The Magic Mountain*, containing as it does the mythic Berghof sanatorium, a departure from reality and a place of listless decay. After all, for a woman whose principal occupation had been the construction of fantastical mansions – immense, lavish, but ultimately fixed in place – a hotel carried with it a certain degree of metaphor: the transience of life confronted in the most transient of places. As the orienting theme she had chosen for the Villa Île de France suggested, escape had always been one of Béatrice Éphrussi's primary motivations as a collector and a designer. It was fitting, then, that in her Davos hotel room she was designing yet another escape – a new property in Monte Carlo, nearer her beloved casino. 'We do not fear being called meticulous,' Mann wrote in *The Magic Mountain*, 'inclining as we do to the view that only the exhaustive can be truly interesting.'

These words apply rather well to Béatrice, whose dogged pursuit of material dreams was as exhaustive in life as it would be in death. With no living descendants, she bequeathed the Villa Île de France – as well as the entirety of her collections in each of her homes – to the Académie des Beaux-Arts with the explicit stipulation that it be transformed into a museum. She was likely inspired by her father, Alphonse, whose legendary bequests had brought contemporary art to even the most remote corners of France. Perhaps she imagined that her own bequest in Cap Ferrat would link daughter to father in some way: at the time of her death, what was then called the Musée Alphonse de Rothschild was still open in Cannes. In any case, Béatrice's museum was to serve a dual purpose. On the one hand, it was to be a complete environmental installation that presented her objets d'art and art collections in the unchanged setting of a lived-in, real-life home. On the other, it was to be a Rothschild museum, positing an association between an extensive collection of European masterworks, the European Enlightenment, and the decidedly European, cosmopolitan family that had collected them. If her life as a collector had occasionally been in opposition to her

family and its style, the museum she conceived was ultimately an argument for the Rothschild family as curators of an elevated European aesthetic.

In February 1933, Béatrice notarized her Last Will and Testament, the document in which she clearly articulated her plans for a museum and in which she authorized a donation of 6 million francs for its creation:

> I bequeath to the *Institut de France* for the Académie des Beaux-Arts my villa Île de France in St. Jean Cap Ferrat, Alpes Maritimes with all the furniture and objets d'art it currently contains, including the garden which surrounds it, to make it one museum. I would like to put on the front door the following inscription, engraved in gold or dark grey letters on a pink marble plaque: 'Musée Île de France, founded by Madame Éphrussi in memory of her father Alphonse de Rothschild and her mother Eleonora de Rothschild.' I bequeath to this museum all the objets d'art that I possess either in Paris, at 19 avenue Foch, at the Villa Soleil in Monte Carlo, and at the Villa Rose – the furniture, the porcelain, the tapestries, etc., except those that I have arranged otherwise. I wish the museum to keep the actual appearance of a living house as much as is possible, and that the precious objects be kept in vitrines.[66]

The wish that Béatrice expressed in the last line of her will articulated a certain type of museum that was as different from the encyclopaedic museums in major European capitals as it was from the late nineteenth-century house museum. If the private collection museum was a reaction to the daunting breadth of the encyclopaedic museum and the national narrative it often displayed, it was typically – even in the instances when it occupied a collector's home – still a museum space in the traditional sense. Items were displayed in a more intimate setting, to be sure, but that setting was often still a gallery in which viewers encountered art on the walls or objects in glass vitrines. Béatrice, however, envisaged a slightly different type of museum: 'I wish the museum to keep the actual appearance of a living house as much as is possible,' she wrote.

By emphasizing 'actual appearance', she intended the living spaces in the Villa Île de France – the bedrooms, the washrooms, the dining rooms, and the kitchens – to be integrated into the display of the collections exactly as they were. Traditional display techniques – such as glass vitrines – were to be

used only insofar as they protected 'precious objects' that were likely to break otherwise. Compared with other private collection museums established in the early decades of the twentieth century, Béatrice's museum – in much the same way as Moïse de Camondo and Théodore Reinach would conceive their own respective museums – pursued a more mimetic approach that eschewed traditional, taxonomic modes of display. The Villa Île de France – as well as the Musée Nissim de Camondo and the Villa Kérylos – sought to recreate a total environment, but a total environment that never lost sight of the real, contemporary people who had lived among the material things on view.

By the early decades of the twentieth century, museum display practices had gradually embraced installations that favoured the 'period room' as a means of evoking the ethos of a particular moment in history. This was a trend in opposition to the age-old technique of presenting linear genealogies of historical evolution through a sequence of adjacent rooms, each devoted to a specific style or type of art object. Typically, Alexandre du Sommerard (1779–1842), the French collector of medieval and Renaissance objets d'art and the founder of what became Paris's Musée de Cluny, is credited as the source of this approach. At the Cluny, a diversity of objects – furniture, paintings, and porcelains – serve as what the art historian Stephen Bann has called 'synecdoches' for 'an historically authentic milieu'.[67]

Béatrice's museum proved an immediate challenge, especially since it relied on reviving a house that she had not lived in full-time, except in the winters, since around 1920. But it also required the even more complicated task of unifying four separate collections of a famously eccentric collector under one roof: the items she kept on the avenue Foche in Paris, the pieces in her two villas in Monaco, and the artworks already in the Villa Île de France. The architect Albert Tournaire (1862–1958), the museum's first director, was charged with the task, and he managed to create a plausibly coherent narrative in the house. Like the Musée Camondo and the Villa Kérylos, the Villa Île de France was an evocation of a bygone era, but, first and foremost, it was always preserved as a home – the home of people with real names and real lives. Visitors were meant to see and remember.

This, perhaps, was Béatrice's most ambitious goal for her museum: a redefinition of the Rothschild name from its pejorative 'Rothschild Jew' connotation to a synonym for a guardian of French and European cultural heritage. As

she stipulated in her will, not without a reminder of her obsessive interest in even the smallest details: 'I would like to put on the front door the following inscription, engraved in gold or dark grey letters on a pink marble plaque: "Musée Île de France, founded by Madame Éphrussi in memory of her father Alphonse de Rothschild and her mother Eleonora de Rothschild."' In much the same way as the Musée Camondo, the Villa Île de France would neither efface nor conceal the Jewishness of its founder or her family.

On the contrary, it would proudly affirm the family's identity, associating her formidable collection of the finest French objets d'art – Sèvres porcelains, Savonneries carpets, Fragonard canvases – with the name 'Rothschild', the most recognizable Jewish name of all. Aside from a cursory mention of her desire to create a living house, Béatrice's will makes little mention of any conception of 'authenticity' per se. But her decision to name the museum as she did – 'in memory . . . of Alphonse de Rothschild' – suggests a motivation similar to the one that propelled Moïse de Camondo. This was the desire to challenge, even subtly, the strain of French antisemitism that insisted Jews could never know true beauty and could never achieve aesthetic authenticity.

No one, after all, had been a greater target of this aesthetic antisemitism than Béatrice's father, Alphonse de Rothschild. In *La France juive* (1866), Drumont had included an entire section[68] on the Rothschild château at Ferrières, of which Alphonse had been the principal custodian after the death of his father, James, and where Béatrice herself had lived as a child. The neo-Renaissance fantasy, in his assessment, had constituted a grotesque spectacle of inauthenticity, an inadequate Jewish performance of a counterfeit and hollow Frenchness. 'We live in a perpetual lie', he wrote of contemporary France, where sites like Ferrières had been invaded by the Rothschilds and other Jewish elites. 'And it is difficult, for the observer, to reason according to situations and displays, which, most of the time, are absolutely false.'[69]

The Villa Île de France, in a certain sense, was Béatrice's rejoinder to this verdict, as devastating as it was dismissive. Her collection was a mélange of European cultural products, to be sure, but in terms of the quality of the objects it contained, it was an emphatic defence against these accusations of what the Goncourt brothers had called, in reference to her uncle Edmond, Jewish aesthetic '*fausseté*'.

As the reception of Béatrice's donation suggests, her argument was at least somewhat successful. After her death, her younger brother, Édouard de Rothschild (1868–1949), wrote to Charles Widor, the Secretary of the Académie des Beaux-Arts, to inform him of his late sister's bequest. In relaying the news, Édouard's letter repeated the essence of his sister's intentions: 'my sister's will', he wrote, 'contains a stipulation by which she will leave to the Institut de France, for the Académie des Beaux-Arts, her villa in Cap Ferrat, with all its furniture, its objets d'art, and its garden, for a museum in the memory of our parents'.[70] A week later, Édouard had not yet heard back from the Académie and he wrote again to Widor, expressing his displeasure. There was a certain degree of urgency in his appeal, to confirm that his sister's request – and, with it, the Rothschild family name – would be appropriately honoured. 'I hope my letter did not go astray,' he wrote, 'because I am surprised not to have received a response.'[71] The next day, Widor, at the age of 90, assuaged Édouard's anxieties with a dramatic and self-deprecating apology that was also a portrait of the Rothschilds as the guardians of the French cultural past:

> Sir, I am horrified by the appearance of ingratitude. . . . Saturday after our meeting, I left on your door condolence cards in the name of my colleagues profoundly moved by the gift of Madame Éphrussi, your much mourned sister. From that to our admirable and incomparable colleague, Edmond de Rothschild, art, science and France itself are all the richer. . . . I am 90 years old, my legs are swollen, and this afternoon, I am selecting my funeral music at the orchestra conservatory of St. Sulpice. If the swelling does not reach the heart, I ask you to please let me know when it would be possible for you to receive me . . .[72]

In Widor's assessment, the Rothschild name was thus properly understood in terms of French national heritage: the two were inextricably linked, and arguably one and the same. As he wrote of Edmond, a fellow member of the Académie: 'From that to our admirable and incomparable colleague, Edmond de Rothschild, art, science and France itself are all the richer.' This point Widor made even more emphatically the following day in a letter to Édouard, confirming the Académie's official receipt of Béatrice's bequest. 'The Academy has accepted the gifts with the unanimity of the members present, and charged

MUSEUMS OF MEMORY

me with transmitting to you our most sincere thanks for this latest generosity from the Rothschild family,' he wrote, 'the unparalleled protectors of the arts.'[73] In the span of a single generation, then, the Rothschild family had gone from being public exemplars of aesthetic '*fausseté*' to the protectors of what was valuable in French art – and this in the assessment of the most prestigious cultural institution in the land.

Widor was not alone in this opinion. Even *L'Intransigeant*, the right-wing and formerly anti-Dreyfusard newspaper, proclaimed its support for what was already being called the 'Musée Rothschild':[74] 'Here, at a time when the fine arts are so hard-hit, is a beautiful gesture that deserves to be highly praised.'[75] Barely two months after the Stavisky Affair – which had reignited antisemitic riots against a perceived Jewish financial domination – this was no small victory. In the increasingly uncertain political atmosphere of the mid-1930s, the Villa Île de France was therefore evidence that Jewishness and Frenchness could more than coexist. In some instances, Béatrice's palazzo contended, the former could advance and even refine the latter.

213

8

TO THE END OF THE LINE
DRANCY AND AUSCHWITZ

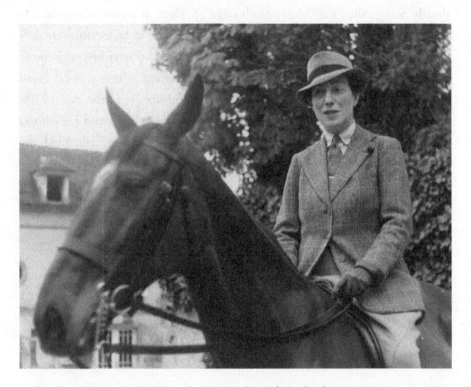

Béatrice de Camondo on horseback.

On 14 June 1940, when the German Army finally arrived in Paris, Béatrice de Camondo and her husband, Léon Reinach, were still at home in their sprawling apartment at 64, boulevard Maurice Barrès in Neuilly-sur-Seine.

By then, the city was largely deserted: shops boarded shut, the streets eerily silent. The French government had abandoned the capital in a state of sheer panic on 10 June – fleeing first to Tours, then to Bordeaux, and then, finally, to Vichy, a Belle Époque resort town chosen merely because of the hotel vacan-

cies it could offer the uprooted Parisian mandarins. A month after it had fled Paris, France's National Assembly ceded full constituent power to Marshal Philippe Pétain, an 84-year-old hero from the First World War who would soon preside over a fiercely reactionary regime that openly collaborated with Nazi Germany. On 23 July 23, Pétain signed an Armistice with Hitler, who left him to govern a so-called 'free zone'. But Vichy was hardly a territorial designation. In the minds of its leaders, it was the great undoing of the French Revolution, a nationalist rejoinder to the excesses of liberal democracy and the impotence of a decadent society. What mattered now was blood and soil, and there were weeds to be rooted out.

The collapse of the French republic happened so quickly that it defied comprehension, even among those who were in the room when it officially expired and who watched France become an authoritarian dictatorship with a show of hands. In the recollections of the journalist Emmanuel Berl, then one of Pétain's speechwriters: 'The event had a sort of mysterious power. At the same time as it unfolded, it hypnotized.'[1] In any case, a staggering percentage of ordinary citizens had probably not even noticed: beyond the collective stupor after the defeat came widespread panic. In the days and weeks after the German invasion, millions had taken to the streets in an event known as *l'exode* – 'the exodus' – a mass upheaval that truly warranted its biblical name. France's population in the summer of 1940 was no more than 40 million, and at least 6 million and as many as 10 million fled south, escaping in cars and caravans and even on foot, in lines that extended for miles on end, even on quiet country roads.[2] The writer and war pilot Antoine de Saint-Exupéry, who would soon disappear in a reconnaissance mission over the Mediterranean, said that the exodus was as if 'somewhere in the north a boot had kicked down an anthill, and the ants were on the march'.[3] But some were convinced they had nothing to lose.

By late July, Béatrice and Léon had installed themselves in the Villa Pataras, a Reinach family house in Pyla-sur-Mer on France's Atlantic coast. If avoiding the Germans was the goal, this particular refuge was a strange choice. The terms of the Armistice had divided France into two zones: the German-occupied zone in the north, which included Paris, and the '*zone libre*' in the south. But for strategic reasons, the Germans drew the map so that the occupied zone included a thin strip of coastline that extended all the way down France's Atlantic coast

to the Spanish border. Béatrice and Léon were thus still in German-controlled territory, a reality that Béatrice soon came to realize, although it remains unclear how much of a threat she considered the Germans to be, at least in those early weeks of the Occupation.

Only one letter survives from her time in Pyla-sur-Mer. Written to her childhood friend Georges Léon on 22 July, the letter suggests first and foremost how busy Béatrice had been with the war effort, and she tells her friend that she had been housing about fifty refugee children in her father's old house at Aumont outside Paris, although the identities of those children remain unknown. And exactly one month to the day after the Armistice was signed, she describes the German presence in the area, even managing a bit of humour. 'There are a lot of troops – they are perfectly correct and try to maintain order, such as forcing the inhabitants of this country to sweep their sidewalks and pick up their rubbish. People grumble, but they clean!' she wrote. 'Other than that, I haven't got used to their sight and every time I go out of my garden I have a shock.'[4]

She was clearly engaged with the refugee children, but Béatrice's letter ultimately makes no mention of the threat that the Nazis posed toward Jews, even if at the time the Vichy regime had not yet promulgated its initial set of anti-Jewish laws, the Statut des Juifs, which it would do in October 1940. She also does not say whether she herself felt personally at risk. Although her conversion to Catholicism would not become official for two more years, it remains entirely unclear whether Béatrice de Camondo still thought of herself as Jewish in any meaningful way at that point, or whether she would have even been aware that the Nazis and their French collaborators would have considered her as such regardless. It was not long before she was made to understand that she had no control over her own identity whatsoever.

Her apparent blindness was hardly unusual. Most French Jews, and especially elites, struggled to understand the enormity of what had transpired in such a short span of time. Many initially saw Vichy's embrace of antisemitism as a threat to foreign Jews, not to well-established French citizens like themselves. At the beginning, there was even some evidence that this was not a delusion. François Darlan, the French admiral who later became Vichy's deputy leader, famously remarked that people like Béatrice should be given preference. 'The stateless Jews, who for the past fifteen years have invaded our

country, do not interest me,' he said. 'But the others, the good old French Jews, are entitled to all the protection we can give them.'[5]

The Statut des Juifs targeted them anyway, and it was a blow that devastated the French-Jewish establishment. But in so many cases, it was still not enough to shake the strength of their convictions. Raymond-Raoul Lambert, who ran the Union Générale des Israélites de France, Vichy's own Jewish task force, wrote in his diary that he wept when the first decree was signed in October 1940 but that he refused to leave France regardless. 'One does not judge one's mother when she is unjust. One suffers and waits,' he wrote. 'So we, the Jews of the France, should bow our heads and suffer.'[6] Lambert was deported to Auschwitz and murdered in December 1943.

In the months and years that followed the Nazi Occupation and the establishment of the Vichy government, the entire social world that a generation of Jewish collectors had built was quickly and deliberately destroyed with the approval – and even the encouragement – of the same nation they had championed. On the whole, their collections survived intact: by the time France capitulated to Nazi Germany, they were already state property and thus spared the brunt of the looting that would disperse so many other private collections. But the establishment of the Vichy government and its eagerness to persecute France's Jewish citizens was the end of the hybrid identity that earlier generation had sought to refine and, ultimately, to display.

Their descendants, some of whom had married each other, represented a varied but still intricately entwined elite – some were artists, some were scholars, some were socialites. They had the diversity of Jewish identities to match. By the outbreak of the war, most were still secular Jews, albeit without the earlier generation's sense of commitment to Jewish communal life. But more than a few had abandoned Judaism and Jewishness altogether. What united an otherwise disparate cast of characters – with each other, but also with their forebears – was an unshakeable faith in Frenchness, in the nation that had allowed their families to prosper and flourish, even in the face of constant antisemitism.

They were complex individuals with complex inner lives, but the war was the moment when they were confined into a single identity category that either effaced the multitudes they contained or, in some cases, directly violated how they understood themselves. They were told in no uncertain terms that they no longer belonged and, worse, that in fact they never had. Such was the strength

of their attachment to France that most of them struggled to accept that reality. Some of them never could.

Élisabeth Cahen d'Anvers – Béatrice's aunt and the subject, along with her sister Alice, of Renoir's *Rose et bleu* – learned that she was still considered Jewish shortly after the Statut des Juifs was passed. The archival traces that survive are almost entirely bureaucratic, but they show an ailing, elderly woman tortured by local authorities into accepting an identity that to her felt foreign.

By the time the Germans arrived in Paris in June 1940, Élisabeth, then 66 and twice divorced, had been living alone in an *hôtel particulier* at no. 90, rue Charles-Laffitte in Neuilly, two blocks from Béatrice de Camondo and Léon Reinach. Unlike her niece, Élisabeth seems to have had some premonition about what the arrival of the Germans might mean, and by June 1940 she had already left Paris to live with her long-time chauffeur, Étienne Foucaud, and his wife, Marguerite Foucaud, her children's former nanny, at their home in Juigné-sur-Sarthe, a small town in the Loire valley, although still within the Nazi-occupied zone.[7] According to the analysis of a local doctor in the Sarthe, Élisabeth was especially vulnerable at the time: she suffered from crippling arthritis in her right knee, which had rendered her incapable of walking.[8]

On 3 October 1940, the Vichy regime passed the Statut des Juifs, which forbade Jews from pursuing certain professions. On 4 October, the regime extended the previous day's restriction by authorizing French prefects to intern foreign Jews. Élisabeth was a French citizen, but, by 21 October, local authorities had forced her to fill out the 'Recensement des Israélites' form, at the orders of the Militärbefelshaber in Frankreich, the head of German military administration in France. These registries were probably baffling for someone like Élisabeth, who had converted to Catholicism to marry her first husband, Jean de Forceville, more than forty years before. The responses she gave to the form's questions suggest that she saw Jewish identity as a simple matter of religious affiliation that did not apply to her. She drew a line through the printed type on the form that notes 'belongs to the Jewish religion' as an identification category. 'Until the age of 20,' she wrote in the margins. 'My father and my mother belonged to the Jewish religion, as did their parents,' Élisabeth wrote at the bottom of the page.[9]

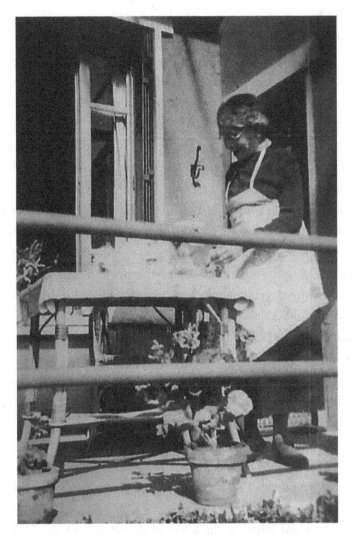

Élisabeth Cahen d'Anvers in Sablé-sur-Sarthe, 1943.

But these details – which she made no effort to hide – seemed irrelevant to her in the autumn of 1940. In red ink, a bureaucrat notes that her identity card was missing the stamp of 'Jew'. This was a label she would never be able to escape.

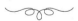

Béatrice and Léon eventually returned from the Atlantic coast to their apartment in Neuilly, where life under German Occupation initially seemed to regain a semblance of normalcy until, suddenly, it did not.

Little is known about the couple's private lives, but among their most prized possessions was Renoir's 1880 portrait of Béatrice's mother, Irène Cahen d'Anvers. By the outbreak of the war, the nature of the relationship between the two women is impossible to know. When Irène left Moïse de Camondo to marry Carlo Sampieri, her ex-husband had made sure to punish her by restricting her access to the children. But it remains unclear what kind of mother she was to Béatrice and her brother Nissim, or even if she was much of a mother at all. She seems to have been absent, but not to have abandoned them altogether.

By the late 1930s, Irène had divorced her second husband and was living alone in the rue Galilée in the 16th arrondissement, less than twenty minutes by car from Béatrice. There is no way to know how frequently mother and daughter saw each other. But Béatrice always kept her mother's portrait. Her Cahen d'Anvers grandparents had apparently hated it ever since Renoir completed it in the 1880s, and her grandmother is believed to have given it to her around 1910. Béatrice clearly saw something in the portrait: possibly a vision of the absent mother she still loved, perhaps the memories of happier times. In any case, she and Léon appear to have been quite proud of the Renoir canvas, lending it in 1933 under their name to a major Renoir exposition held at the Orangerie Museum in the Tuileries gardens.[10] At home in Neuilly, the portrait occupied a place of prominence in their apartment, which is precisely what the couple told French authorities after the Nazis requisitioned 'La Petite Irène', and they tried – in vain – to get it back.

The portrait was seized at the Château de Chambord on 7 July 1941.[11] Looting Jewish art collections had been a central aim of Nazi leadership since the beginning of the war: the material destruction of Jewish property was a fundamental component of the way the Nazis sought to enact the literal destruction of the Jewish people as a whole. Alfred Rosenberg, the Nazi ideologue charged with this mission, reported to Hitler that his task force, the Einsatztsab Reichsleiter Rosenberg (ERR), had begun looting Jewish collections in Paris in earnest by October 1940, with the help of France's own Service de Sûreté. Robert Scholz, a member of the ERR staff, would later testify in the Nuremberg trials after the war how, exactly, the task force had identified particular collections to loot. 'These seizures were carried out

on the basis of preliminary exhaustive investigations into the address lists of the French police authorities, Jewish handbooks, warehouse inventories and order books of French shipping firms, as well as French art and collection catalogs,' he wrote in a memo.[12] Irène's portrait would have been easy to find.

The evidence proves that the portrait was looted not from the boulevard Maurice Barrès but from the Château de Chambord in the Loire Valley. According to a restitution claim his brother made after the war, Léon had in 1939 entrusted a number of the couple's paintings and other valuable artworks to the Direction des Musées Nationaux. The Camondo–Reinach pieces were kept with the thousands of other items from the French National Museums that were sent to Chambord and many other places for safekeeping during the war. But eventually the Germans arrived at Chambord and confiscated whichever pieces they liked from private Jewish collections. By August 1941, the Renoir was gone, and Léon and Béatrice had already been informed of its theft.

From the traces that survive, Léon Reinach was something of a dilettante. He seems to have been something of an effete composer whose career had never amounted to much and who had always been overshadowed by the formidable intellect of his father and the massive fortune of his wife. He was essentially a professional son-in-law with a passion for music. But, in a moment of crisis, Léon was seized by a compulsion to act. In August 1941, he fought back in the only way he could, in a clear attempt to honour the memory of the previous generation – his father, Théodore, his father-in-law, Moïse, and all the others who had constituted their Jewish world so enamoured with the promise of France and so committed to advancing its vaunted ideals. He wrote a long, impassioned letter to Jacques Jaujard, the director of France's National Museums, who later contradicted the orders of the Vichy government and saved thousands of the nation's priceless artworks.

Léon's letter to Jaujard is a testament to his pride, but also to his remarkable conviction, his unshaken faith in a republic that he either did not realize or refused to accept had already ceased to exist. In August 1941, when Léon wrote this letter, the republic his father and uncles had served was no more. The Vichy government aspired to be the great undoing of the French Revolution, and what remained of the republic's vaunted institutions had been

coopted by a band of reactionaries who sought nothing less than a complete social transformation entirely designed to exclude such people as Léon Reinach. On 2 June 1941, Vichy had passed a new Statut des Juifs, far stricter than the first, which defined Jews as a 'race' and banned them from all liberal professions – including composing music. Léon had been told he did not belong, but the message did not seem to compute, at least not quite yet. To him, his family's material legacy was the essence of their belonging. He was mystified that others did not seem to see it that way.

'I believe I should include this protest, asking you to be good enough to forward it to the Occupation authorities so that they may take note that my family and that of my wife, long established in France, have considerably enriched the artistic legacy of their adopted country,' he wrote to Jaujard. Perhaps in reference to the new Statut des Juifs, which did leave open the possibility of exemptions to Jews 'who have rendered exceptional services to the French state', Léon then went on to describe each of the collections his extended family had bequeathed to France and the symbolic value of each. Isaac de Camondo, he wrote, 'left to the Musée du Louvre a collection of such importance that a special building had to be fitted to contain it'. His own father, Théodore Reinach, considered France as his heir more than he did his own children, Léon suggested: 'Although a father of six, he bequeathed a property to the Institut de France, the Villa Kérylos.'

But it was in describing his father-in-law Moïse de Camondo's bequest that Léon was most blunt. 'This sumptuous donation represented such a considerable amount that my wife could very well have contested its validity as exceeding the available portion of the testator's fortune,' he wrote. 'Of course she did no such thing, out of respect for the memory of her brother and the will of her father, considering that this admirable oeuvre, which he painstakingly built himself, was intended to subsist in its entirety and benefit the entire nation.' Léon then referred directly to Moïse's will, the founding document of the Musée Camondo: the mansion on the rue de Monceau, he wrote, 'is a real reconstruction of an eighteenth-century artistic residence filled in particular with the most beautiful specimens of decorative art which was one of the glories of France'.

Léon still believed that collections of that quality and donations of that magnitude would mean to others what they had meant to the families who built

them. They were monuments to France and its history by grateful émigrés who had become nothing less than custodians of the nation's patrimony and champions of its values. Did these bequests not constitute 'exceptional services' to the state?

Two months later, Léon's brother, the eminent jurist and celebrated translator Julien Reinach, made the same argument in defence of his family's intellectual and artistic contributions to the state. On 21 October 1941, he wrote to Vichy's own branch of the Commissariat Général aux Questions Juives, protesting a host of fines that, in his view, only applied to Jews living in occupied France, not those living in the 'free' zone. Writing from the Villa Kérylos, the house their father had built and had left to the state, Julien essentially put into words the same argument that Théodore had made with that house a generation before. His life, his work, and, most importantly, his family were all vehicles that had contributed to the cultural life of the French nation, Julien wrote.

What he provided was essentially a curriculum vitae, an accounting of the Reinach family's contributions to French academic and political life. To make his case, Julien deliberately played with the logic of the Vichy regime, emphasizing in his own underlining the ways in which he personified the regime's principles of '*travail, famille, patrie*' – work, family, fatherland:

> I divided my life between the service of the <u>fatherland</u>, the foundation of a <u>family</u> and a constant <u>work</u> in a number of scientific and literary domains. (I am a member of the administrative council of the Society of Comparative Legislation, the Society of Former Students of the School of Oriental Languages, bursar of the Institute of Slavic Studies, and a member of societies of linguistics, legal history, modern history, of authors, of playwrights, etc. . . .). Poems of mine have been recited in the Sorbonne (translated from the Russian and the Hungarian); a play translated from the German was performed in Rouen under the auspices of the Archbishop. I have actively contributed to any number of legal and literary publications, notably the Vicennial Table of Judgements of the Conseil d'État, which had proposed me for the grade of State Councillor on the eve of the law that you now enforce.[13]

Julien was arrested in September 1943; he was sent first to Drancy outside Paris, then to Bergen-Belsen. Unlike his brother and sister-and-law, he ultimately survived, although the injuries he sustained in the camp stayed with him until his death in 1962. If the Villa Kérylos represented the breadth of Théodore Reinach's academic endeavours – and their adherence to a particular vision of republican France – after the war it came to represent the brutalization of that image. After all, it was at Kérylos that Julien was arrested. Dismissed

Julien Reinach (1892–1962).

from the Conseil d'État after Vichy's 1941 update to the Statut des Juifs, he had retreated to Kérylos to immerse himself in work that could not be taken away from him. When he was arrested, he had been in Théodore's library, labouring over a new translation of *The Institutes of Gaius*.[14]

The only special privilege Léon had sought was the return of 'La Petite Irène'. What he wanted was for Jaujard to reach out to the ERR directly on his behalf: 'If they were informed, perhaps they would consider it fair to leave to the descendants of these generous donors the few works of art they possess, particularly a family portrait whose place in the home has a particular meaning quite independent of its artistic or market value.'

Léon Reinach (1893–1944).

225

The letter came to nothing, and Béatrice and Léon never saw the portrait of Irène again. It is also possible that they never saw the real Irène again, either: no record survives of any direct contact between mother and daughter after the beginning of the Occupation, although the records of Béatrice's sequestered accounts reveal that the Commisariat Général aux Questions Juives did authorize her request to continue paying Irène an annual stipend of 40,000 francs.[15] After the ERR confiscated the Renoir, the Nazis most likely took the painting back to Paris from storage in the Château de Chambord to the Musée Jeu de Paume in the Tuileries Gardens, which had become a kind of concentration camp for the paintings they looted from Jewish collections. There, Renoir's rendition of a young Jewish heiress was hand-selected by none other than Hermann Göring, the second most powerful man in Nazi Germany, to join the ranks of his ever-expanding hoard.

If he was initially charmed by the porcelain profile of the girl in the canvas, Göring ultimately grew tired of 'La Petite Irène', for reasons he never specified. He traded it to the art dealer Gustave Rochlitz for a Florentine tondo in March 1942.[16] Where the portrait spent the rest of the war is unclear. But the Occupation was a period of dizzying coincidences, and the story of the Renoir portrait is no exception. At one point during the war, Göring attended a banquet of sorts at the Paris home of the alcohol heir André Dubonnet, the same man who was helping hide the real Irène at his family château near Fontainebleau.[17] Dubonnet's relationship to Irène: ex-son-in-law, the ex-husband of her daughter, Pussy, and the father of her two granddaughters. His Paris address, where Göring was received: 114, boulevard Maurice Barrès in Neuilly, several doors down from Béatrice de Camondo and Léon Reinach, the portrait's rightful home.[18]

There was a cruel irony in Colette Cahen d'Anvers's experience of the war, particularly with regard to the material splendour of the family life established by her grandfather, the eminent collector Louis Cahen d'Anvers.

If the pre-war world of the *israélite* had been, at least to some extent, a material construction of exhaustive collections and decorative objects, its destruction was ultimately carried out through the liquidation of those same material traces. For Colette – the granddaughter of one of the greatest collec-

tors in the history of modern France – the experience of Nazi captivity was ultimately one of conscription into the Nazi project of destroying Jewish material property.

Although her father, Charles, and her brother Gilbert, along with the rest of her family, had long since moved to Argentina by the outbreak of the Second World War, Colette had remained in France. Like her aunt Élisabeth Cahen d'Anvers, her cousin Béatrice de Camondo, and her cousins-in-law Julien and Léon Reinach, she was arrested in 1943 and sent to the French detention camp at Drancy. Unlike them, however, she was not deported to a concentration camp outside of France. Instead, in July of the same year, Colette was drafted into a unit that would assist in sorting confiscated Jewish property to be sent to Germany and beyond. Even more ironic was that one of the three makeshift Parisian labour camps used by this mission was none other than the old Cahen d'Anvers townhouse at no. 2, rue Bassano, where the family had lived for decades at the epicentre of Parisian society.

By 1940, the house was vacant. After the death of the patriarch, Louis Cahen d'Anvers, the family's fortune had been depleted, and his youngest son, Charles – Colette's father – had tried to sell it. In 1938, the family had one potential buyer, who offered them 5.5 million francs for the house, but they judged this amount too low.[19] When the war broke out, the Bassano house technically belonged jointly to Yvonne Cahen d'Anvers, then married to Anthony Gustav de Rothschild and living with him in London, and Marie Cahen d'Anvers de Monbrison, living elsewhere in Paris.

As Jean-Marc Dreyfus and Sarah Gensburger have written, it was ultimately identified as 'Jewish house' in May 1941, when a neighbour wrote to the Aryanization committee of the Commissariat Général aux Questions Juives asking the name of the administrator who would be carrying out the sale transaction.[20] It was appraised in January 1942, and the Germans saw it as an ideal place for their looting mission: the house had an entire floor that was not visible from the street, with no windows, not to mention a sprawling, 300 square metre space that was ideal for storing objects and interning the prisoners assigned to sort them. By March 1944, no. 2, rue Bassano had become a makeshift camp. The mansion that had once hosted glittering banquets in the fin de siècle, with guests from Marcel Proust to the King of Serbia, now imprisoned sixty Jews.[21]

Colette was never imprisoned in her own house, but she was a prisoner in the same looting unit. She was instead sent to Lévitan, a major department store on the rue Saint Martin, most likely on 9 July 1943.[22] There were more than 800 Jewish prisoners at Lévitan, forced to sort furniture and objects seized by Nazi forces from over 38,000 Jewish-owned apartments across the city. Colette was one of them, but perhaps because of her particular family background, the experience carried a particular pain. It was precisely to attack families like the Cahen d'Anvers, after all, that places like Lévitan had been transformed into makeshift camps. The lavish reality of the family's Château at Champs-sur-Marne or their mansion in the rue Bassano had inspired veritable factories for the destruction of Jewish material culture. If the collectors had turned to objects and things to project a certain image, that image was now being actively erased.

Colette would later recall Lévitan in her memoir, *Eight Years of a Life*, written in English after the war. When she saw the store's name appear out of the window of her bus from Drancy, she recognized it immediately: it was 'where all the cheaper type of furniture has been made ever since Paris was a small fortified village hundreds of years ago'. Even if nothing from Lévitan had ever found its way into a Cahen d'Anvers home, Colette was nevertheless horrified by the spectacle of thousands of objects piled in heaps, each a metaphor for a life uprooted, as hers had been. These lives, as she pointed out, came from across the social spectrum, blended together in a violent pastiche: 'The lots we received were sometimes pathetically miserable and poor – rags, or dishes containing remnants of a meal cut short by the dreaded ring at the door. Sometimes they would be well known paintings of international repute, and silver worth a king's ransom.'[23]

The true labour, she wrote, was in sorting these objects and the human traces that were often still on them: 'Some of the cases we received were in a hopeless muddle and we had to spend hours sorting them out, especially the ones in which we found a horrible tangle of threads, lace, ribbon, elastic, needles, and goodness knows what else.'[24] Colette observed the profound role of material destruction in the human destruction of the Nazi genocide. First came the elimination of people, but second came the removal and destruction of every object those people had owned or used or loved. Only when the material remnants of a person's life had been destroyed, it followed, would a person truly vanish. 'The Gestapo arrested these unfortunate people, whose

only crime was being born a Jew,' she wrote, 'and throw [*sic*] them into concentration camps to die.'[25] As she noted, that task required minimal effort. But a person's material effacement required a much more exhaustive effort to achieve: 'a moving gang would take over', she wrote of this continuous project, 'and pile into packing cases everything they could lay their hands on, and bring it to our camp to be sorted and packed'.[26] No one was safe: 'Sometimes it would be a private house, rich or poor, an office, factory, shop, shack, doctor's or dentist's office, from which they grabbed anything and everything.'

What Colette witnessed was the literal destruction, object by object, of the world of her family and its peers. But she is relatively reticent, in her memoir, about the destruction and dispersal that the Cahen d'Anvers experienced in the Second World War. She mentions only the following: 'I learned that a sister of Father's, who was an old lady crippled with rheumatism, and who could not harm a fly even if she tried, had been sent off in the last convoy. As was to be expected, she never came back.'[27]

This, of course, was an allusion to Élisabeth. But there was a cryptic reference to another relation she encountered in the Drancy internment camp, although nothing more than a line. 'I found a first cousin, B.R., her husband and two children, a boy of eighteen and a girl, nineteen. Later they were herded into a cattle train, and died miserably in a camp in Poland.'[28] B.R. was Béatrice.

Despite the chaos and the rupture of the Occupation, Béatrice and Léon decided to divorce. There is a record of the divorce agreement in the Archives de Paris, a short document that clearly states that the reason was Léon's infidelity: it was Béatrice who had requested the divorce, and it was in her favour the judge had ruled. She was also given custody of Bertrand, who was still a minor at the time.[29]

Even so, the context is difficult to ignore: the divorce was finalized in October 1942, when the roundups of Jews had become regular occurrences and Vichy's antisemitic persecutions had reached a fever pitch. In the mid-1980s, shortly before his death, the writer Philippe Erlanger, a distant cousin of Béatrice's who had founded the Cannes Film Festival, gave an interview about the Camondos in which he speculated that the divorce was meant to protect Béatrice. If her legal name went back to 'Camondo' from 'Reinach', Erlanger argued, she would

somehow be safe, given the immense contributions her family had made to its beloved France.[30] This explanation would match the sentiment in Léon's 1941 letter about the enduring value of the collections his milieu had left behind: 'my family and that of my wife, long established in France, have considerably enriched the artistic inheritance of their adopted country', he wrote.

But there are other aspects of their situation – and their separation – that suggest that the divorce was about more than bureaucratic scheming. If they viewed the Camondo name as an important lifeline, the divorce would have saved only Béatrice. Léon and their children, Fanny and Bertrand, would still have been at risk. In any case, Léon left home in December 1941, nearly a year before the divorce was finalized, which suggests the couple saw no means of salvaging their marriage – even in the midst of the Occupation. Béatrice could stand it no more. As Béatrice wrote to a childhood friend in September 1942, a month before the divorce was finalized, she occasionally had second thoughts: 'There are moments where it seems to me that it would have been better not to fight and to take all the blows.' But the point is that there were still emotional 'blows', and the betrayal was too much to bear.

If the divorce agreement is accurate, the identity of Léon's lover remains unclear, as does the way in which Béatrice discovered the affair. But, beyond the affair, it also appears as though the couple had reached a point of irreconcilable differences beforehand. A few short months after he had appealed to the values of the French republic that the Reinach men had long embraced with an almost religious fervour, Léon arrived at a point where he no longer saw any future in France. Exactly what the deciding factor was remains unclear; perhaps it was the realization that, in the eyes of the authorities, the legacy of his forebears turned out to be worthless. For Léon – the son of one of the great architects of liberal Judaism in France – his wife's conversion was also likely a step too far that he could not forgive.

There are so many questions that remain. Perhaps Léon saw his wife and her newfound faith as delusional; perhaps he pitied her. After all, by the time he left, the authorities had already confiscated all of Béatrice's bank accounts, and she had to haggle with the Commissariat Général aux Questions Juives to allow the bank to keep transferring funds to pay the family's various employees. Béatrice was even forced to use the antisemitic framework imposed by the Nazi regime and its Vichy acolytes to make her case, which was ultimately successful.

In a 1942 letter to the Commissariat Général, she counted out which of her employees were 'Aryan' and which were not: 'To my knowledge, all these people are Aryans, except Madame Tedeschi, who has a blocked account, and Mme Danon,' she wrote.[31] But even after writing those words, it still did not occur to Béatrice to attempt any kind of escape. France was her home, and 'God and the Virgin' would protect her – of this she appears to have been absolutely certain.

Her conversion to Catholicism in the summer of 1942 was genuine; this, too, may have mystified Léon, who never converted even as a security measure. As Béatrice wrote to a childhood friend in September 1942, a message she began by describing the riding conditions at Versailles, 'I am certain that I am miraculously protected,' she wrote. 'I've sensed it for years but only in this last year have I understood from where all this good fortune has come to me. Will I have the years necessary to thank God and the Virgin enough for their protection? I am so little and so low, so unworthy.' In the same letter, she also reveals that she has apparently made progress in convincing her son, Bertrand, to consider conversion as well. What Léon would have made of his wife's apparent attempt at proselytizing remains unknown, but it seemed to be working. Fanny had apparently convinced Bertrand, Béatrice wrote to her friend, although the nature of Fanny's faith also remains unclear. 'He seems such a rebel, so forcibly an atheist, that I cannot believe he wrote to me that he thinks all this would do him a lot of good,' Béatrice wrote. 'Even if his light is pale, it would be better than darkness.'[32]

As it turned out, she would not have the years she wanted to thank God and the Virgin for their 'protection', a period that would last only for three more months to the day after she wrote this letter. She and Fanny were arrested in Neuilly on the night of 5 December 1942, taken to a police depot in the 16th arrondissement, and then to the Drancy internment camp outside Paris at three o'clock the following afternoon, police records show.[33] By coincidence, Léon and Bertrand were arrested the following week in an unrelated raid, on 12 December 1942, near Ariège, trying to escape into Spain. Father and son were taken to a separate internment camp, in Merignac, before their eventual transfer to Drancy two months later, on 3 February 1943. Broken in the midst of the Occupation, the Camondo–Reinach family was reunited once more.

One wonders if Béatrice ever questioned her faith inside the camp, whether she felt that God and the Virgin had abandoned her. Only one surviving letter

details her actions after she entered the camp. On 3 December 1943 – after nearly a year of imprisonment and forced labour – her lawyer wrote to the Commissariat in Paris on her behalf. 'Our client, Madame Léon REINACH, currently interned in the Drancy camp, has just charged us with asking you to renew the provision . . . permitting the payments of the pensions guaranteed by Madame Léon REINACH.'[34] She had debts to pay, and she did not forget them.

At the time of Béatrice's arrest, her aunt Élisabeth Cahen d'Anvers was still in the Sarthe, still in hiding, and still infirm. But by late December 1942, local authorities had set their eyes on her, coming back to her more and more frequently to ask her to repeatedly reregister as a Jew. It was a slow and steady torture.

In March of that year, Jean Roussillon, the regional prefect in Anger, had written to his deputy in the Sarthe, Marcel Picot, concerning Élisabeth's file. 'The Chief of Police of Jewish Questions in the occupied zone has just brought to my attention the Jew Élisabeth Cahen d'Anvers, normally living at 90, rue Charles-Laffitte in Neuilly-sur-Seine and currently residing in Sablé-sur-Sarthe,' he wrote, noting that she 'would have broken the law of 2 June 1941 in not having completed her declaration of belonging to the Jewish race'.[35] The law to which he was referring was the second iteration of the Statut des Juifs, which had defined Jews by race instead of by religion. In 1940, Élisabeth had escaped the first time around by successfully convincing authorities that she no longer belonged to the Jewish religion, but it proved far more difficult to convince them that she did not belong to their idea of the 'Jewish race'.

In late December, the mayor of Sablé-sur-Sarthe finally spoke to Étienne Foucaud, who was still hosting Élisabeth, regarding his guest. The mayor clearly told Étienne that Élisabeth had overstayed her welcome, because the next day Élisabeth wrote to the mayor directly to plead her case. She disputed the claim that she had violated the new Statut des Juifs and said that she had even managed to convince a pair of German soldiers that she was not Jewish the year before, when the Vichy government had passed the law, by showing them a copy of her decades-old baptism certificate.

But Élisabeth's letter expressed an utter powerlessness, which it seems that she hoped would appease the mayor. She wrote that she no longer had any assets to speak of, and thus could not be considered a threat. 'I therefore have no proper home in Paris, or elsewhere in France, and I live in Clotau-Maupertis, in your community, with Monsieur and Madame Étienne Foucaud, who have offered me their hospitality since the beginning of the war,' she wrote, referring to the specific commune where she was staying. 'I offer my apologies for this long letter, but as it's impossible for me to go to the *Mairie* without a means of transport and because of my infirmities, I hope that these documents will suffice.'[36] They did not: in May 1943, the mayor forced her to attest once more to the fact that she was now a stateless Jew.[37]

The Gestapo came for Élisabeth on 26 January 1944 and she was rounded up along with the celebrated writer and historian Marguerite Aron, who was also living in the area. Élisabeth was then 69; Marguerite Aron was 70. 'These two persons are of French nationality, but were born to Israelite parents,' read a French police report. 'The nature of these arrests is unknown.'[38] Élisabeth was transferred to Drancy on 30 January. Béatrice would still have been there when she arrived.

A few days later, Irène Cahen d'Anvers, living under the name Irène Sampieri in the rue de Galilée, went to the headquarters of the Préfecture de Police in Paris to argue Élisabeth's case. How she had been notified of her sister's arrest so quickly remains unclear. Another lingering question is why Irène would have felt comfortable walking in the front door of precisely the same organization she had taken such pains to avoid since the outbreak of the war, although the prefect's report indicates that Xavier Vallat, the Commissaire Général aux Questions Juives, had somehow ruled that Irène was not Jewish in 1942.

In any case, she lied to the officer she spoke to, claiming that in fact she and Élisabeth had two non-Jewish grandparents on their mother's side: Joseph de Morpurgo and Elise Parente, both of whom were actually from Ashkenazi banking families but had Italian-sounding names that perhaps she hoped would not sound Jewish to French authorities. The Préfecture seemed unconvinced, but transferred Irène's message to its deputy office in the Sarthe regardless, 'signalling in any case that Mme Irène de Cahen did not produce any proof of her parentage or that of the lady Élisabeth de Cahen'.[39] The Préfecture's

report only reached the Sarthe on 9 February, more than a week after Élisabeth had been sent to Drancy. Irène's intervention was too late.

The prefect's report is a difficult document to read, simply for what it does not include. In February 1944, Irène still had a daughter in Drancy, while her son-in-law and two teenage grandchildren had already been deported to Auschwitz – although whether she would have known their fate is unclear. What the available archives reveal is this: she was willing to risk exposure to save her sister, but she made no mention whatsoever of Béatrice when she had the opportunity, even though she was still receiving an annual stipend from her daughter's requisitioned estate. If she had ever attempted to save Béatrice, even in the past, there are no known records of any such attempt.

What is certain, however, is that her appointment at the Préfecture that day was her last chance to try and save Béatrice, if she had thought to try: her daughter would be deported to Auschwitz in exactly one month, on convoy 69.

Drancy is technically the name of a town, a working-class suburb north-east of Paris, but it has become a synonym for betrayal. It was here – in a drab social housing project from the 1930s, known as *la cité de la Muette*, or the city of the mute – that French authorities handed over Jewish citizens to Nazi authorities for deportation and death.

In the words of one survivor, Drancy was an 'antechamber to Auschwitz',[40] and this was undeniably the case: approximately 67,000 of the 75,000 Jews deported from France passed through the makeshift camp.[41] Historians have long debated the fact that most of the victims deported were foreign Jews and not French citizens, examining whether the Vichy government may have tried to protect its own nationals where possible. But a human life is a human life and, in the aftermath of the Holocaust, that debate often seems beside the point. In any case, French citizens were still deported from 'the city of the mute', a cruel reality that would have been especially devastating to those who were. Some of those citizens struggled to accept what was happening even in that inferno; some still sang 'La Marseillaise' as their convoys departed for Auschwitz.[42]

Béatrice de Camondo arrived in the camp with her daughter, Fanny, some-time in the afternoon of 6 December 1942. Soon thereafter, the world of the collectors partially reconstituted, crammed into the squalor of overcrowded stairwells. Shattered in the midst of the Occupation, the Camondo–Reinach family was reunited once more in the hell that was Drancy. Léon and Bertrand arrived in the camp on 3 February 1943, after their failed attempt to cross the Spanish border. Beatrice's cousin Colette Cahen d'Anvers and her brother-in-law, Julien Reinach, arrived with his wife, Rita Lopez Silva di Bajona, later in 1943. Her aunt Élisabeth Cahen d'Anvers arrived from the Sarthe in February 1944 before her deportation in March of that year.

They were an elite immediately recognized by the other Jews in the camp, many of whom knew their names and the collections their families had amassed. One inmate remembered Fanny Reinach, then 23, as particularly beguiling. 'She was seductive, cheerful, attractive,' the woman remembered. But Fanny apparently never let anyone forget who she was. 'Fanny had so much energy, and she would say, "I was born in a museum."'[43] A young Simone Veil, who would later become France's health minister and oversee the legalization of abortion in the mid-1970s, was also interned in Drancy before her own depor-tation to Auschwitz. Then Simone Jacob, she had grown up in Nice and vaguely knew the Reinachs, whom she called 'our friends from the Villa Kérylos'. In her memoir, Veil recalls the moment she saw Julien and Rita Reinach in the camp for the first time. 'Mrs Reinach, always dynamic, was supervising one of the camp's kitchen services. I went up to her and had the joy to tell her: "I got a letter last week from your daughter Violaine.[44] All your family is fine and is not at risk."'[45]

What Béatrice would have seen immediately upon her arrival was a camp whose existence may have been ordered by the Nazis but whose manage-ment was then entirely staffed by French authorities. Personnel from Vichy's Commissariat Général aux Question Juives prepared prisoners for deporta-tion; three French police officials served as head commandant before Alois Brunner took over in July 1943.[46] Even the Nazis were reportedly taken aback by the quality of the conditions at Drancy, where dysentery was rampant, many prisoners suffered from starvation, and approximately 950 deaths were recorded in the first ten months of the camp's existence. Those who have not with their own eyes seen some of these released from Drancy can only have a

faint idea of the wretched state of internees in this camp which is unique in history,' read a French intelligence report from December 1941. 'It is said that the notorious camp of Dachau is nothing in comparison with Drancy.'[47]

Drancy was a world unto itself, complete with its own laws and social hierarchy. When Brunner did assume full control of the camp, he essentially copied the Nazi system already tested in Berlin and Vienna: implicating the Jews in their own destruction. He created a Jewish administration within the camp charged with managing every aspect of Drancy's internal life – food, medicine, the post, showers, and even the small *épicerie* in the housing project quadrangle. France's own Union Générale des Israélites de France supplied the prisoners with all their material needs, and it was Brunner's Jewish administration that would transmit orders to the other prisoners. Any resistance would immediately result in shootings or deportation, and the camp's Jewish administration was thus incentivized to report fellow prisoners to Nazi authorities if they broke any rule.[48] This was the cruelty of that system: more than a year after the Nazis had decided on the 'Final Solution', or the total extermination of European Jewry, Brunner still convinced Drancy's Jewish leaders that enforcing Nazi directives would protect the entire community of prisoners. Béatrice de Camondo was among them.

In the archives of the Mémorial de la Shoah in Paris, a flowchart survives that depicts the chain of command of Drancy's Jewish administration. Dated 23 July 1942, it shows that Béatrice served in the medical division, in charge of the camp's nursing facilities along with Dominique Schwab. This was an elite, coveted position to occupy, and being in the camp's Jewish administration entailed significant privileges: living in bloc III, the most comfortable quarters available to prisoners, the ability to receive packages more frequently than others, and the right, in certain cases, to go into Paris for the day on supervised visits.

Nazi officials classified prisoners into one of six categories denoted with letters: A for 'Aryans', their spouses, or half Jews; C1 for camp leaders; C2 for those of protected foreign nationalities; C3 for the wives of prisoners of war; C4 for those awaiting the arrival of their families who were still free. But the vast majority of prisoners were classified as 'B', those with no protection who could be deported at any time. Violating the rules or attempting to escape would immediately result in a demotion to category 'B', which

Drancy identification card of Béatrice de Camondo.

typically implied deportation. From the moment of her arrival in the camp, Béatrice was C1, a distinction scrawled in thick red ink over her camp identity card. So were the rest of her family and the other members of their circle.

How she secured this status is unclear. Georges Wellers, who survived Drancy and who likewise served with Béatrice in the medical division of the camp's Jewish administration, albeit in the hygiene department, later recalled that C1 selection was entirely arbitrary, based on an examination by Nazi authorities that could change at any time: 'The definitive classification remained Brunner's prerogative,' he wrote.[49] In any case, Béatrice appears to have charmed her fellow inmates and to have taken her work seriously.

'Béatrice had a lot of class,' recalled a Mme Appel, who was apparently friendly with Béatrice and Fanny in the camp, in a testimony recorded after the war.[50] Doda Conrad, the Polish-born opera singer, was interned in Drancy along with his mother, the soprano Marya Freund. Doda was housed in the same stairwell as Béatrice and recalled much the same. Knowing the Camondo collection quite well, he was struck by the way in which a woman whose entire existence had been embellished with ornate objects could instantly adapt to a prison. 'The uselessness of hanging onto objects!' he wrote in his memoirs. 'Mme de Camondo, not long ago, had the support of fourteen maids. She was 48 years old, but here she did chores. She would go to the peeling station where, for three or four hours, she would peel vegetables for the soup of thousands of poor people. She would sweep and wash the floor, make her bed, clean the casseroles and the dishes after the meals, anything and everything.'[51]

Béatrice lasted a remarkably long time in the squalor of Drancy – from December 1942 to March 1944, almost exactly fifteen months to the day. How she survived that long remains unclear, but the strength of her faith seems to have been sustaining. In the course of my research, I came across another rare letter of Béatrice's – written to her niece Nadine Anspach, just before her imprisonment in Drancy, sometime in August 1942. Shared with me by her cousin's granddaughter, Béatrice's letter reveals that Nadine Anspach had likewise recently decided to convert, albeit to Protestantism, not Catholicism. Her aunt had the following to say:

> Your mother may have committed a slight indiscretion, but here I am in the know and happy for you. I hope you will find the calm, the inner happiness and the strength that will allow you to go through these current trials with serenity. My experience is recent but I hope you will find as much good in it as I do. This little book will help you, and I will bring it on Sunday.[52]

Although the details of the two women meeting remain unclear, the book Béatrice mentioned was *L'Imitation de Jésus-Christ* by the Abbé F. de Lamennais, a small, pocket-sized leather-bound volume. Nadine kept Béatrice's letter folded in a square in the book for decades. Until the very end, it seems that Béatrice believed that 'God and the Virgin' would save her still.

Letter from Béatrice de Camondo to Nadine Anspach, August 1942.

Béatrice's ex-husband and children did not share her certainty. So many details remain unknown about the family in Drancy, namely the relations between Béatrice and Léon. But the same issue that apparently divided them before their divorce seems to have divided them in the camp even more so. Béatrice had her newfound faith; Léon had a sense of foreboding. Just as he had before his arrest, he fought back again in Drancy. Once again, he tried to escape.

In autumn 1943, Léon and Bertrand were part of an attempt to build a tunnel out of the camp and into safety. The idea for the tunnel began in September 1943, after the Nazis had fully assumed control of Drancy. It was meant to be 2 kilometres long: from the storage units on the southern edge of the camp, underneath a roundabout, and parallel to the avenue Jean Jaurès on the other side, to an exit that an ally in the defence forces had agreed to open when the time was right.[53] The tunnel was about 1.2 metres tall and 1.5 metres

below ground.[54] Digging it was a massive undertaking: Georges Wellers, the survivor, remembered that three separate teams of twenty men each were involved in ploughing through the hard dirt and limestone underground. They worked day and night, and there was always a separate squadron on duty to keep watch in the event of a surprise German inspection.[55]

The camp's Jewish administration was more than aware: at least a quarter of them were volunteers or involved in some way.[56] As a member of that administration, Béatrice was almost certainly aware of the project, although there is no evidence of her involvement. In any case, the men who spearheaded the project were hardly Léon's type. One of the leaders, Roger Schandalow, was a 28-year-old black marketeer who had been sentenced to six months in prison before his internment in Drancy; two of the others, the brothers Georges and Roger Gerschel, were accomplished rugby players in their thirties, brought onto the project because of their muscle power.[57] This kind of masculine showmanship most likely appealed to Bertrand, 20 years old at the time, who was a woodworker and liked to work with his hands in a way that few of the other men in his family, including his father, ever had. But Léon was on the project nevertheless.

By 9 November 1943, the tunnel had reached about 36 metres in length. Three German guards came into the camp and began an impromptu inspection of the storage areas. The watchmen immediately alerted those in the tunnel and the group quickly and quietly dispersed, hiding the entry to the tunnel as well. But one of the men, an internee named Henri Schwartz, had left a piece of clothing at the site that had his identification number on it. The Germans quickly detained Schwartz and furiously tortured him; three days later, he gave them the names of thirteen other men in the plot. Eventually, they learned all the names.

On 20 November, the Germans enacted their revenge. They instantly reclassified sixty-five elite status 'C' class inmates who had been involved in the tunnel project to status 'B', which paved the way for their deportation. Léon, Bertrand, and Fanny were among those reclassified, as was the head of the camp's administration: their Drancy identity cards show the letter 'C' replaced with 'B' on that date. But Béatrice was not reclassified, an unusual decision given that the family members of the other tunnel participants were also deported as a reprisal. Somehow she was allowed to stay behind; perhaps that

was her punishment. Béatrice would have seen her family leave the camp by bus for the Gare de Bobigny that day. After nearly a year in the camp, she would have known she was unlikely to see them again, and they would have known they were unlikely to return.

Convoy 62 left the Gare de Bobigny at 12:10 p.m. on 20 November, a Saturday, and arrived in Auschwitz three days later, between 4 and 5 a.m. It carried 1,200 passengers, including other descendants of the world that the collectors had built. Madeleine Lévy, the granddaughter of Alfred Dreyfus and a relation of the Reinachs by marriage, was on board the train. So was the doctor Léon Zadoc-Kahn, the grandson of the rabbi who had been the spiritual counsellor to the older generation in the milieu, conducting their weddings, overseeing their sons' bar mitzvahs, and extolling their virtues as custodians of the community. Jacques Helbronner, who had been the wartime president of the Consistoire central israélite de France and a close friend of Philippe Pétain's who had hoped that the Maréchal would spare French Jews, was also among the passengers. All of them were murdered.

Béatrice remained in Drancy for another four months, until 7 March 1944. Exactly why she was deported when she was remains unclear, but she was among the passengers on convoy 69, who had been isolated in the camp three days before their departure. It was an unusually large transport. Guy Kohen, a passenger on that same convoy who survived Auschwitz, later recalled that passengers on the train were given food for three days and then packed into cattle cars at the Gare de Bobigny, about sixty people in each.[58] The journey east was the usual route, slow and winding: Bobigny to Noisy-le-Sec to Épernay to Châlons-sur-Marne to Revigny to Bar-le-Duc to Novéant-sur-Moselle to Metz to Saarbrücken to Homburg to Kaiserslautern to Mannheim to Frankfurt to Fulda to Burghaun to Erfurt to Apolda to Weißenfels to Engelsdorf Leipzig to Wurzen to Dresden to Görlitz to Kohlfurt to Miłkowice to Legnica to Jaworzyna Śląska to Kamenz to Kamieniec Ząbkowicki to Nysa to Cosel to Heydebreck to Katowice to Mysłowice to Auschwitz.

None of the Reinachs were selected for extermination upon arrival. Léon and Bertrand were sent to work in 'Buna', or the Monowitz labour camp division of the complex. Fanny was the first to die, on New Year's Eve, 1943, three months before her mother arrived. Women and men from the same countries tended to be housed together in the same barracks, so Béatrice probably would

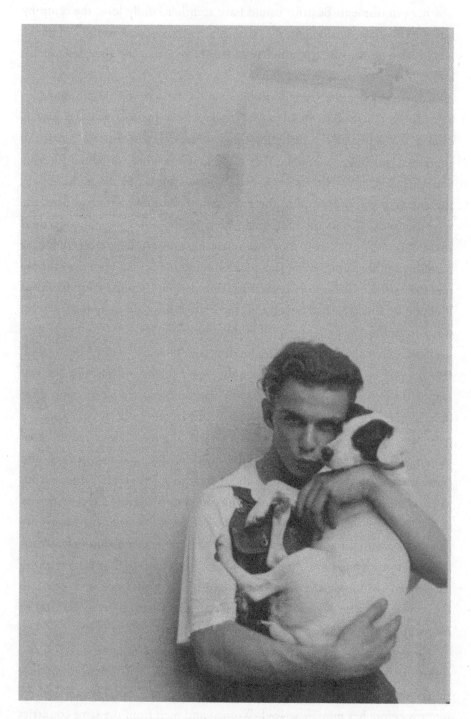

Bertrand Reinach (1923–44).

have eventually learned of her daughter's death after she encountered other French women. Four days after her arrival, the camp's archives show that Bertrand was admitted to the Auschwitz hospital, on 14 March 1944. The hospital was a notorious cesspool, filled with fleas and lice and rats, and Bertrand died there on 22 March.[59] Léon died on 12 May. It is unlikely Béatrice would have known about either her ex-husband or her son. As she had in Drancy, she lasted a remarkably long time in Auschwitz – nearly ten months. She was killed on 4 January 1945, a little more than two weeks before the Soviets liberated the camp.

The Nazis were no longer operating the gas chambers by then, and they had not yet ordered the Death March that followed the evacuation of the camp. How, exactly, Béatrice de Camondo died remains unknown, but with her an entire world was extinguished.

'LA PETITE IRÈNE'
THE AFTERLIFE OF A PORTRAIT

After the war, Renoir's *Mlle Irène Cahen d'Anvers* – among Béatrice's most prized possessions – made its way back to France. Its journey mirrored that of many other works of art looted by the Nazis, including Ingres's iconic 1848 portrait of Betty de Rothschild, another face from the same milieu. During his interrogation by Allied investigators in August 1945, the German art dealer Gustav Rochlitz, who had played a key role in identifying pieces to steal for the ERR in France, mentioned 'La Petite Irène' in his testimony. He probably told investigators the portrait's whereabouts, although those details are not recorded in the transcript of his interrogation. In any case, it arrived at the Munich Central Collecting Point by 4 September 1945. By March 1946, it was sent back to France, and, by June 1946, it was in an exposition at the Musée de l'Orangerie for French-owned paintings recovered in Germany. This was a tragic return: the portrait had already been exhibited at the Orangerie once before, in 1933, lent by Béatrice and Léon for a Renoir show. At the time, their names had been on the accompanying plaque, there for all to see. In the 1946 show, those names were nowhere to be seen, already erased from the record.

In 1946, the real Irène Cahen d'Anvers was still alive. The Countess Sampieri, as she was known, had spent the war in hiding in Paris, living in an apartment in the rue de la Tour, using her Italian name, her Italian passport, and, every so often, the nearby château of her ex-son-in-law, André Dubonnet.[1] Although she was the sitter, she had never owned the Renoir portrait that depicted her young self and that bore her name: it had belonged to her parents, Louis and Louise Cahen d'Anvers, who then gave it to Béatrice as a gift in 1910. Béatrice had kept the portrait of her absent mother until it was stolen in 1941, after which point she never saw it again. But as early as 1945, almost a

year before it appeared in the Orangerie, Irène had been attempting to claim it as her property. She would ultimately succeed.

Not much remains of Irène, who is something of a mystery in the story of this milieu. Her adult life was essentially a rejection of the elite Jewish world of her youth, and by 1946 she had achieved her goal. She was a free woman: she had divorced her second husband, she had raised a new non-Jewish daughter who had married the debonair heir to a fabulous fortune. Most of all, she had survived the war. Others close to her had not been so fortunate. Her daughter Béatrice and her sister Élisabeth had both died in Auschwitz, but it remains unclear how Irène had come to terms with the fact that she had lived and they had died. From the scant records of her that do survive, only one thing is clear: after the war, Irène wasted no time in seizing what remained of the fortune of her estranged and murdered daughter. That quest began with the Renoir portrait.

There is one file on Irène in the archives of France's Ministère des Affaires Étrangères, the Foreign Affairs Ministry. In painstaking detail, it documents her attempt to claim the canvas as her own. On 21 November 1945 – ten months after Béatrice was murdered – Irène wrote a brief note to one of her lawyers asking him to look into finding the painting. 'I hope you will be successful in locating this charming memory of my youth,' she wrote.[2] Nothing happened until the portrait, unbeknownst to Irène and her lawyers, ended up in the Orangerie show, 'Les Chefs-d'oeuvre des Collections Privées Françaises', which ran between June and November 1946. In a catalogue of 283 items, *Mlle Irène Cahen d'Anvers* was number 41. 'Before a backdrop of greenery, the little girl, turned to the left, her face almost in profile, is seated,' the description read. 'She wears a blue dress and a white belt; her long brown hair, decorated with a blue ribbon, falls down her shoulders and covers a part of her arm.'[3] What was most important was that the catalogue listed a rudimentary provenance history beneath that description, and there was no mention of Irène anywhere except in the title of the painting. The catalogue did mention, however, the portrait's appearance in the 1933 show, when it had hung on those same museum walls under the Reinach name. But there was no one to challenge Irène's claim.

After they learned of the painting's appearance in the show, Irène's lawyers must have immediately contacted the French restitution authorities, although a copy of that letter does not survive in the file. What does survive is the

response her lawyers received from Albert Henraux, the president of the Commission de Récupération artistique, the French Commission for Art Recovery, which had organized the Orangerie exposition in the hopes of finding the rightful owners of the works on display. It was clear that Henraux was sceptical about Irène's claim to the portrait but that he also wanted to close the case as soon as possible. 'The Orangerie show will close its doors this coming 3 November. You know that we exhibited there the portrait by Renoir depicting "Mademoiselle Irene Cahen d'Anvers", which belonged to baroness Reinach,' he wrote. 'I would be particularly grateful to you if you could let me know me to whom I should return the painting claimed by the Countess Sampieri.'[4]

Another of Irène's lawyers quickly fired off an aggressive response to Henraux, insisting – without providing or describing any evidence – that his client had always been the portrait's true owner. To do so he sought to write Béatrice out of the narrative: 'I believe I should signal to you that this painting does not belong and has never belonged to Mme Léon REINACH, in whose home it was displayed, but to her mother, Madame Irène SAMPIERI, of whom the portrait is a depiction,' the lawyer wrote. 'If procedures, in view of restitution from German authorities, were engaged in the name of Madame REINACH, this is no way implies that the latter was the rightful owner. In light of these circumstances, nothing prevents the painting from being returned to Mme SAMPIERI or to her representatives.'[5] No surviving piece of correspondence mentions what had happened to Béatrice, and there is no indication that Irène had wanted the portrait to preserve the memory of the daughter who had so cherished the canvas. In fact, the opposite was true: almost immediately after it was restituted to her, Irène sold the portrait once and for all – to a man who had sold arms to the Nazis.

Henraux ultimately agreed to award the painting to Irène, living at the time at the Villa Araucaria in Cannes, one of the multiple properties she owned in the city. By early October 1946, before the Orangerie show had even finished, she was growing increasingly impatient with the necessary bureaucratic procedures. As she scribbled to her lawyers on 10 October, 'And my painting – where is it?'[6] It finally arrived on 4 November, the day after the show concluded. Irène was still in Cannes, and she instructed the lawyers to have the portrait sent to the Paris apartment of her daughter, Pussy, at no. 1, Place d'Iéna. The portrait arrived as instructed, but it would not stay long.

Irène sought far more from Béatrice's estate than the Renoir canvas. She and her daughter, Pussy, went after what was left of the Camondo fortune, which Béatrice had inherited after Moïse's death. The cards were in their favour from the beginning: Béatrice's divorce from Léon, officially settled before her arrest, meant that the Reinachs had no claim to a share of the money. Then there was the reality that Fanny and Bertrand Reinach, Béatrice's own heirs and Irène's grandchildren, had also died in Auschwitz. There was therefore no one left but Irène to inherit the fortune of the family she had abandoned in 1903. In an interview he gave decades later, Moïse's cousin Philippe Erlanger speculated that, to get the money, Irène and Pussy first had to prove somehow that Fanny and Bertrand Reinach perished before their mother, thus ensuring that no surviving Reinach relations could claim any share of the children's inheritance. The basis of that claim remains unclear, but Irène and Pussy did inherit the Camondo fortune in 1946, by whatever means. Also unknown is the exact amount of that fortune, although it appears that the value at least of Béatrice's stocks and shares had significantly diminished by 1945.[7] But whatever remained of the wealth that Moïse de Camondo had left for his descendants had officially fallen into the hands of the person he hated most.

Irène and Pussy soon decided they had no use for the Renoir portrait, which Irène had earlier called a 'charming souvenir of my youth'. Shortly after it was returned to her, Irène began to receive queries asking for permission to reproduce the painting in various publications. Perhaps it was then that she realized how lucrative selling it might be; perhaps she had no desire to preserve the memories it represented any longer. In 1949, three years after she had retrieved it, Irène sold the portrait through an intermediary in Paris to none other than Emil Bührle, the German-born naturalized Swiss arms dealer who had sold war *matériel* to Nazi Germany and Fascist Italy throughout the Second World War.

Bührle, who owned the Oerlikon arms factory in Zurich, was known to have taken advantage of the looted art market in Paris throughout the German Occupation. In a 1945 report, US intelligence authorities identified him as an 'important recipient of looted works of art by purchase,'[8] and after the war he was in possession of several paintings originally stolen from the Parisian gallery of the legendary art dealer Paul Rosenberg.[9] In future decades, the Swiss government forced Bührle's heirs to return thirteen works in his collection, housed in his Zurich museum, to the descendants of their original

French-Jewish owners, from whose homes the works in question had originally been looted. But Renoir's portrait of Irène is a different story altogether. It, too, was once the property of a Holocaust victim, and it, too, had been looted from a Jewish collection. But the mother of the victim in question sold it to a collector whose fortune had grown significantly from his wartime dealings with Nazi Germany, the same regime that had murdered her daughter. Irène received 240,000 Swiss francs in the sale, in which one of the only remaining traces of Béatrice became the legal property of a Nazi collaborator.[10] The portrait hangs in the Collection Emil Bührle in Zurich to this day.

More than a decade after the sale, there was another attempt to reclaim the painting. In 1958, an ailing Julien Reinach, then 66 and still suffering from the injuries he had sustained in Bergen-Belsen, charged his lawyer with tracking down the items stolen from his brother Léon's estate. These included *Mlle Irène Cahen d'Anvers*, his lawyer insisted, the most important item in the group of valuable paintings that Léon had apparently given to the Direction des Musées Nationaux for safekeeping as early as 1939. Those had been transported to the Château de Chambord along with other works from the National Museums' inventories, including the Louvre's *Mona Lisa*, later that year. It was there at Chambord that the Nazis had stolen the portrait of Irène and taken it to Germany, Julien's lawyer believed. By 1958, the West German government had begun passing restitution laws, and most importantly the Bundesrückerstattungsgesetz, a piece of legislation enacted in July 1957 that covered restitutions of expropriated Jewish property. Julien's lawyer mentioned this law and hoped it would mean that the Reinach family had a chance. So he wrote to Georges Salles, the director of the Musée de France, the body that oversaw all French museums, for advice. 'The contents are very important because they would be worth the equivalent of a strong compensation for the heirs,' the lawyer wrote.[11]

Once again, Béatrice was entirely effaced from yet another claim on her property. Julien had spent months in Drancy with her, but at no point does his letter even mention her name. The lawyer mentions that Julien is Léon's heir, and that Léon 'died in deportation'. But it makes no mention that Béatrice, the mother of Léon's children and the only reason he would have had any claim to the portrait in question, suffered the same fate. Perhaps most predictable of all, the letter fails to mention the inconvenient truth that Léon Reinach and Béatrice de Camondo had divorced in October 1942, and that the divorce agreement

included no provision that declared him the owner of *Mlle Irène Cahen d'Anvers*. Léon had tried, valiantly, to get the Renoir back in 1941 before their divorce, but this by all accounts had been as a final labour of love for his wife and her late father, calling the canvas 'a family portrait whose place in the home has a particular meaning, quite independent of its artistic or market value'. But the Renoir had never been Léon's property, in life or in death. It had always been Beatrice for whom it had 'particular meaning'. Whatever that meaning was remains a secret she took with her to her death.

In any case, Julien's entreaty to Georges Salles was based on faulty information: 'To aid your eventual research, I inform you that this case most likely contained the well-known painting of Renoir, "Portrait de Irène Cahen d'Anvers", which appeared in the Musée de l'Orangerie in Paris as lot no. 57 and is located today in the Sao-Paulo Museum,' his lawyer wrote. But it was the other Renoir portrait of Irène's sisters, Alice and Élisabeth Cahen d'Anvers, which was already in São Paulo, and the portrait of Irène had been lot no. 41 at the Orangerie, not 57. 'We believe that this painting was in the shipment in question and was sold by the Germans either during or after the war to the museum in that city.' One wonders if Julien ever learned the truth, which was that in fact the portrait had been sold back to a Nazi collaborator by its own namesake. He died shortly thereafter, in early 1962. A short obituary appeared in the *Revue internationale de droit comparé*, heralding Julien as a brilliant and indefatigable jurist:

> Deported to a German camp, he returned very gravely ill. Despite an unfortunately deplorable state of health, he resumed his duties at the Conseil d'État with a tenacity, a courage, and a devotion that earned the admiration of his colleagues who were all, at the same time, his friends. For him, the accomplishment of his work was a far more serious preoccupation than his health, which was more and more deficient but about which he never complained.[12]

The ravages of the twentieth century destroyed the world the collectors thought they knew: the First World War and the Holocaust claimed the lives of many

of their descendants, and the aftermath of the Second World War eradicated the interwoven family cultures they had known for generations, the legacies they believed themselves to be preserving. Nissim de Camondo and Adolphe Reinach were killed in the First World War; Béatrice de Camondo, Léon Reinach, Fanny Reinach, Bertrand Reinach, and Élisabeth Cahen d'Anvers were murdered in Auschwitz. Julien Reinach, Colette Cahen d'Anvers, and Renée Cahen d'Anvers de Monbrison all survived the Second World War, but only narrowly so. Those who did survive ultimately found that they entered a changed world after 1945, a world that did not sustain the family cultures they had defined their lives before the war. What had vanished was a shared sense of communal solidarity, tradition, and even history. A number of those who did survive renounced any kind of Jewish identity altogether, while others left France forever, reinventing themselves in the United States, in Britain, or in South America. This was an exile from a certain past, but it was also an exile from the people they used to be.

The feeling of being foreign even to oneself could be deeply traumatic. In some of her post-war writings, Hélène Fould-Springer describes her own experience in strikingly intimate prose. Hers was a remarkable journey: she had left the Fould family's Royaumont estate outside Paris for a life that bore little resemblance to what had come before. Married to a Spanish diplomat, Eduardo Propper de Callejón, she moved with her husband to various postings including Washington, Oslo, and, finally, London. During these years, she suffered a psychotic breakdown and, in 1961, she wrote (but never published) a book under the pseudonym of 'Hélène Praday' which attempts to come to terms with the ruptures that had taken control of her life since the war.

Hélène's self-exile was fully realized by the end of 1942, when in November the German Army had occupied the entirety of France after Operation Torch, the Allied landing in North Africa. Her husband, Eduardo, punished by the Francoist regime for having rescued Jewish refugees in Bordeaux in the summer of 1940, had been transferred to Larache, Morocco, and she was living there with him at the time. It was there that she converted to Catholicism. Before she and Eduardo had left Cannes in 1941, her brother and sister, Max Fould-Springer and Liliane Fould-Springer – soon to be Liliane de Rothschild – had resisted leaving France and to join them in North Africa.[13] By 1942, despite the fact that Eduardo had arranged for exit visas for them much earlier, the

two managed to escape on 13 November, in the midst of Operation Torch and, as Hélène would later put it, 'by the skin of their teeth'.[14] She added: 'I swore to myself that if they did manage to escape unharmed, my way of giving thanks would be to convert from Judaism to Roman Catholicism, then and there.'[15]

When the news came that they were safe, Hélène wrote that she was overwhelmed, as she 'had not told anyone of my intention to convert . . . not even Eduardo'.[16] Her rationale, however, was not that she experienced any notable religious epiphany or even a spiritual transformation. She merely wished to leave a religion that 'would surely', in her words, have caused her family to have been arrested 'and sent to their deaths in a concentration camp'.[17] Cancelling her Jewishness was her own decision, but it was a decision made under the duress imposed by the same aggressors who sought to eradicate Jews and Jewishness altogether. When she was received at the Église Sainte Jeanne d'Arc in Tangier in the autumn of 1942, Hélène had escaped those aggressors, but also the only self she had ever known.

The collections these families left behind remain largely intact, as they were left to the French state well in advance of the Second World War. But some of the objects that belonged to this milieu experienced the same displacement as the families that had owned them. Particularly illuminating is the fate of *Rose et bleu*, the Renoir portrait of Alice and Élisabeth Cahen d'Anvers. Louis Cahen d'Anvers, their father, had hated that portrait as much as he had Renoir's portrait of Irène and he had left it hidden in obscurity in the family house. In 1900, Louis eventually sold it to the well-known Parisian art dealer Alexandre Bernheim (1839–1915) for his gallery in the rue Lafitte. For a time, *Rose et bleu* hung in the private Monte Carlo collection of Bernheim's son, Gaston (1870–1953), who ultimately sold it to the New York dealer Sam Salz (1894–1981). Eventually, Salz sold the portrait to the Wildensteins, who then sold *Rose et bleu* to the São Paulo Museum of Art in 1952.[18] In the end, the picture travelled from France to South America – in much the same way as many of the descendants of the Cahen d'Anvers, who established themselves in Argentina in the late 1930s. Like the surviving members of the family, *Rose et*

bleu has existed in South America longer than it ever did in France: it, too, remains in a perpetual exile from a cosmopolitan past.

Mlle Cahen d'Anvers soon had an afterlife of its own: the angelic face of the girl in the canvas proved irresistible to generations of viewers. In 1960, it reappeared in Jean-Luc Godard's *À bout de souffle*, one of the iconic films of the day. The character of Patricia, played by the actress Jean Seberg, hangs a poster of the portrait on the wall of her studio apartment and asks Michel, the rogue existentialist, who is more attractive, herself or the girl in the painting. In the film, that girl seems pretty, timeless, but, most of all, nameless: she has neither context nor identity. At the time Godard's film debuted, Irène was still alive, but the world that had produced her likeness had evaporated long before. In the end, her portrait was a fragment of a vanished culture, in transition from family heirloom to meaningless kitsch. Before 1967, it appeared on postage stamps in the Kathiri State of Seiyun, a sultanate located in present-day Yemen and Oman that no longer exists, and in more recent years Irène's profile has become a popular image in Japan, reprinted on t-shirts and tote bags.

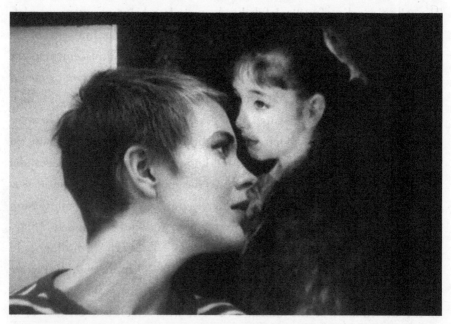

Jean Seberg with 'La Petite Irène' in Jean-Luc Godard's *À bout de souffle* (1960).

Irène Cahen d'Anvers lived out the rest of her life at the Villa Araucaria in Cannes, one of the three villas she owned in the glittering Riviera city. Her daughter, Pussy, became a well-known socialite, as did the two daughters Pussy later had with André Dubonnet. They were fixtures on the Côte d'Azur in the 1950s and 1960s. The memoirs of Lorraine Dubonnet, Irène's granddaughter, read like the pages of *Vanity Fair*: yachting with Aristotle and Tina Onassis, hobnobbing with celebrities at the funeral of Grace Kelly, entertaining a young US senator by the name of John F. Kennedy at Dubonnet's villa. By then, Irène was an old woman approaching her nineties, even a matriarch, remembered fondly but vaguely by her great-granddaughters. But as the decades wore on, the Camondo fortune diminished almost to nothing, spent on parties and clothes and houses, none of which the family maintained. Pussy eventually moved into what the French call a '*viager*' apartment, an arrangement where sellers, typically later in life, drastically reduce the price of their homes in exchange for monthly payments from a buyer along with permission to stay put for the rest of their lives.

For the world of the Cahen d'Anvers, the Camondos and the Reinachs, the end came without any profound meaning. It was a melancholy obscurity. Their family names today are mostly relics, etched on the façades of a cluster of adjacent but crumbling stone tombs off the Chemin Halévy, the narrow passage that surrounds the Jewish section of Paris's Cimetière de Montmartre. These families lie in death exactly as they lived their lives: interwoven in quiet intimacy, neighbours for eternity. But even this repose requires maintenance, and their tombs – once elaborate stone structures, inlaid with stained glass, Hebrew inscriptions and stars of David – have begun to crumble. The Camondo tomb in particular has fallen into disrepair, the inside clouded with cobwebs, the names of the patriarchs obscured by grime. When her father died in 1935, Béatrice had inherited the title to the tomb from Moïse, but after her own death, its upkeep fell to her sole identifiable heirs – her mother, Irène, and her half-sister, Pussy. But the two women declined to pay the cemetery's annual maintenance fees and, just as they had disposed of the Renoir portrait Béatrice had so cherished, they disposed of the Camondo tomb, handing it over in November 1961 to Nadine Anspach, the same cousin to whom Béatrice had sent the prayer book just before her arrest.[19] Béatrice's name, and the names of her children, have never been added to the walls of the sepulchre. It was as if they never existed.

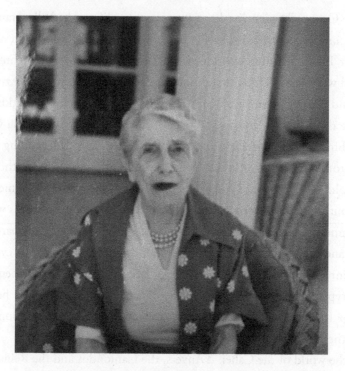

Irène Sampieri, Paris, *c.* 1958.

Irène died in 1963, nearly two years after she got rid of the Camondo plot. But her effacement of her firstborn daughter continued. Maguy Tran, the daughter of a wealthy Vietnamese family who lived part of the year in a neighbouring villa, frequently had tea with Irène at her home in Cannes before her death in 1963.[20] In an interview, Tran recalled that the old woman seemed to be increasingly interested in discussing her past, at least in part. 'She spoke to me often about her son, the Great War hero. She would speak about him so often, even about the cake he liked,' she said. But there was one subject Irène never broached: 'Béatrice she never mentioned.'

CONCLUSION
A DEATH CERTIFICATE

Death certificate of Béatrice de Camondo.

Béatrice de Camondo's death certificate was hard to find. France files these records of its Holocaust victims in the Office National des Anciens Combattants et Victimes de Guerre. There is no clear finding aid; all one can do is make an official request and hope for a response. When I finally got my hands on a copy of the certificate, thanks entirely to a friend and fellow researcher, it was a strange feeling. I had hoped that seeing this document – meant to be the last in what had at times felt like an endless, fruitless quest – would provide some kind of final revelation, or at least some kind of closure. I suppose it did, but the only closure the certificate brought was a feeling of further exasperation.

'De Camondo, Louise Béatrice,' it read. 'The year nineteen hundred forty five, 4 January. *"MORT POUR LA FRANCE" à Auschwitz (Pologne)*.' '"DIED FOR FRANCE" in Auschwitz (Poland).' But Béatrice de Camondo did not die 'for' France; if anything, she died *because* of France, and specifically because she had been Jewish in France. Even if she had renounced Judaism, in the end

the nature of her identity had not been hers to arbitrate. She had been classi-fied as undesirable and ultimately eliminated by the same nation that she and so many others in her world had seen as their natural and even self-evident home. But here on her death certificate that nation still claimed her as a fallen comrade, as if nothing had happened, as if she was a partisan killed in combat defending the flag. What is so striking is how out of place this elision now seems. Given how forthcoming the French state has since become in acknowl-edging its wartime past, I had not expected to find those words, an unwelcome relic of post-war denial.

In the decades since the Second World War, there has been a major and commendable shift in France's collective memory of the Holocaust. Starting in the late 1960s, a steady stream of scholarship has chipped away at the post-war myth, bolstered by Charles de Gaulle, that France was a nation of resisters and only resisters. The war broadly conceived is now among the most thoroughly examined areas in French history and memory – a phenomenon Henry Rousso famously called the 'Vichy syndrome'. That syndrome is also evident in popular culture: the documentaries of Marcel Ophüls, the feature films of Louis Malle, and the novels of Irène Némirovsky, recently rediscovered, have all contributed to a fuller understanding of the Jewish experience in twentieth-century France.[1] After decades of pressure, the French government itself now openly acknowl-edges its darkest days: President Jacques Chirac formally apologized for Vichy collaboration in 1995, and black plaques now adorn the Paris façades of virtually every school from which a Jewish child was known to have been deported. Those plaques now remind passers-by that the victims in question died '*parce que juifs*' – because they were Jewish, not because they died for France.

At least in France itself, the world of Béatrice de Camondo is still a distant memory, albeit a faded one. The writer Pierre Assouline published *Le dernier des Camondo*, a lyrical portrait of the family in the mid-1990s, and the Musée Nissim de Camondo goes to painstaking lengths to show visitors all remaining traces of the family who once lived in its rooms. There is no way to wander through the museum without feeling a sense of crushing emptiness, even in rooms otherwise crowded with ancien régime furniture. One might think the museum would represent a final word on the Camondos, a monument to their memory and the tragedy they endured. But unfortunately it does not. Another turn in the historiography of this eternally fraught period has begun, one that

emphasizes – not without a certain defensiveness – that, during the Holocaust, French Jews, and especially French-Jewish elites, did not suffer as much as other Jews in other occupied countries. Statistically, this is indeed the case: 75 per cent of France's Jews survived the war, as the provocative recent book by the historian Jacques Semelin has amply demonstrated.[2] But I am not convinced that this should be a question of numbers.

In his conclusion, Semelin explains the factors that most likely contributed to the relatively high Jewish survival rate in France. One of his explanations deals with elites such as Béatrice de Camondo, who he sees as beneficiaries of revolutionary emancipation and the promise of assimilation, even in a moment of crisis. In Semelin's words, these elites 'had numerous social resources at their disposal which enabled them to circumvent the new discriminatory laws, with many in a position to go for help to relatives in the Free Zone, or at least to send their children to safety there'. He adds that 'they were able to draw on a variety of resourceful strategies, facilitated by their century-long integration into French society'.[3]

The fates that befell the characters in this book – admittedly a very small sample size – show that those 'resources' and that 'century-long integration' were not always as valuable as they might have seemed. In any case, none of this invalidates Semelin's argument, and he is still correct that, statistically, this milieu was touched far less than others. But victimhood is not a simple matter of life and death. If many French Jews did survive the war, their relationship to France was forever altered. The betrayals of the Vichy years put an end to the sensibility of the *israélite* and undermined the faith that many Jews had in the nominally universal values of the French republic. Some in this milieu who did survive the war simply left; their descendants live in London, New York, Montréal, Geneva, and Buenos Aires. Survival was also rupture.

As for the museums and the houses the collectors left behind, they are not necessarily memorials, although the stories of the families are somewhat unknown. There is a small plaque in the entryway of the Musée Camondo, and the family is now a fundamental part of the permanent exposition. There are likewise small plaques at the Villa Kérylos, the Villa Île de France, and the Château de Champs-sur-Marne, but not much else that reveals anything substantial about the network of Jewish families that built these houses, all of whom were intimately connected and engaged in the same project of

advancing, and even defining, the cultural legacy of their adopted homeland. Seen alone, the houses appear as obscure bijoux, fine places to while away an afternoon. But considered together, they are a powerful statement, the remnants of a vanished milieu and how it derived meaning in a world that changed beyond the point of recognition.

As I have tried to argue, these places are crucial sources for achieving a fuller understanding of the Jewish experience in France in the late nineteenth and early twentieth centuries. They were the private sanctuaries of the leaders of the French-Jewish establishment, refuges and fortresses whose design reveals quite a lot about the individual psychologies of the men and women who led the community in a time of unprecedented tumult. Their names may be familiar, but their inner lives are not.

Unfortunately, the 'Jewishness' of the houses has largely been forgotten. After the war, when they had long been state property, many of these homes became stage settings for government showmanship. Charles de Gaulle, for instance, took a particular liking to the Château de Champs, where he hosted the likes of Senegalese president Léopold Sédar Senghor in April 1961 and British Prime Minister Harold Macmillan in June 1962. For a time, the historic home of the Cahen d'Anvers essentially became a hotel for visiting dignitaries. A similar fate has befallen the Villa Kérylos, the pride and joy of Théodore Reinach and the fulfilment of his quest for 'immortal beauty'. It was there that President Emmanuel Macron hosted Chinese President Xi Jinping in March 2019. The two were photographed sitting in an annex of Théodore's beloved library, not far from where his son Julien was arrested in 1943.

The memory of the Reinachs in particular has not fared well. Among the most important families in the history of the Third Republic, and in French intellectual life in general, they are today almost entirely forgotten except to scholars, footnotes in stories about other people. There was once a plaque in their honour in Saint-Germain-en-Laye, where they lived and where Salomon Reinach ran the Musée des Antiquités nationales (today the Musée d'Archéologie nationale et domaine national de Saint-Germain-en-Laye). Dedicated in 1949, the plaque was removed in the midst of a recent renovation. I can only hope that one day it will be restored.

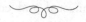

I have spent years of my life researching the people in this book, which began as a doctoral dissertation and evolved into an all-consuming obsession – an obsession with people who were themselves motivated by obsessions: obsessions with objects, obsessions with beauty, and obsessions with an image of a nation that turned out to be an illusion. Aside from the intoxicating suspense and unrivalled pleasures of archival research, there were times when I asked myself why this milieu matters. In the end, this was a rarefied elite that collected beautiful things while the world collapsed around them. Even more so, they neither anticipated nor understood that collapse; in fact, they were stunned by its arrival and in many cases were victims of their own blindness.

Among the cardinal sins in the writing of history is the embrace of nostalgia. This is what I feared most in my research. Nostalgia, even of the unwitting variety, is a particular risk in studies of elites, who command more attention in life, leave more behind in death, and whose memory so easily comes to seem like an artefact to cherish and admire rather than to interrogate. In *Le Premier Homme*, Albert Camus's great unfinished novel, his autobiographical sojourn into his childhood in working-class Algiers, there is an arresting line about precisely this phenomenon: 'Lost time is found only among the rich.'[4] This was Camus's rejoinder to Proust, whose *À la recherche du temps perdu,* or *In Search of Lost Time* was an elegy, at least in part, for the world of the collectors, the glittering universe of the Parisian fin de siècle that began to disappear after the First World War and vanished completely after the Second World War.

Camus's critique is a fair challenge to historians of the period, one that warrants a response. My response is that the collections these families left behind are unique testaments to a worldview that defined the French-Jewish establishment at a moment of crisis, a worldview that was ultimately shared by many others beyond their rarefied world. They themselves were not necessarily representative of anything other than who and what they were, but the values that motivated them were products of a moment that demands a deeper understanding. That their collections still exist is indeed a consequence of their wealth, but those collections are invaluable source materials that remain intact and show us something important about the moment in which they were created.

I also feel that these collections have a special significance in the Jewish history of the twentieth century, and not only in France. In revisiting the museums that house them – the Musée Camondo in Paris, the Villa Kérylos in

Beaulieu-sur-Mer, the Château de Champs-sur-Marne – I came to realize that much of my second-guessing was a function of my own biases, shaped as they are by the false security of hindsight. All historians are shaped by their own subjective experiences, and I am no exception. I have an American Jewish perspective and grew up with both a romantic ideal of Europe as well as what I felt – wrongly – was a sense of certainty about how that story had ended and had to end. I was born in 1989 at the end of the Cold War, and I cannot remember a time in my life when I did not know about the Holocaust, the memory of which had become, by the time I was born, a fixture of American public life. Some of my earliest childhood memories are of spending after-noons with our next-door neighbours at the time, two German Jewish refugees who had arrived in Dallas in the late 1930s and who my mother had asked to talk to me about what had happened. Hearing those stories at such a young age changes you, and for years the Holocaust was all I read about. I remember the consuming feeling that it was something I had to know, even though of course the Holocaust is the definition of an event that cannot be 'known'.

But that obsession had one unfortunate and unintended consequence: I began to see the Holocaust as inevitable, as the inescapable and inexorable end to the long and horrible history of antisemitism in Europe. This is an assump-tion all too common among Americans, and especially those of my generation, precisely because of the twentieth-century experiences of so many families and the stories we grew up hearing. But that assumption is also dangerous, not to mention anathema to the historian's task, especially in trying to make sense of such victims as Béatrice de Camondo. Because in fact the Holocaust was the opposite of inevitable: it was not predestined or divinely preordained, and it was not somehow beyond the realm of human control. What makes it so uniquely haunting is that it did not have to happen, that it never should have happened, but that it happened nevertheless. At every point it was the result of human actions and choices that might have been otherwise.

This is why I do not regret my foray into this rarefied world. Each in its own way, the collections – and now museums – that this Jewish elite left behind were attempts to create something beautiful in an increasingly hostile environment. That beauty endures, but it is not in the salon des Huets at the Musée Camondo or the peristyle at Kérylos. The true beauty these collectors achieved is in their respective visions of the Franco-Jewish encounter, a

passionate embrace by a cast of outsiders of a place where they came to see themselves as insiders. Before the Second World War, they saw in France a nation and a patrimony they could help shape, and they were loyal custodians of each: fighting in its wars, serving in its parliament, governing its museums. They did everything in their power to contribute and to belong, but they were not fools – to judge them as such would be to misunderstand them, and perhaps even to insult them. If the museums that today bear their names are overshadowed by the trauma of the 1940s, they are still entirely valid readings of a moment whose ending was never quite obvious and that could very well have turned out differently. We owe it to them, to the people they were, to consider the world as they knew it, the world that might have been, and, for a time, the world that was.

The catastrophe of the Holocaust should not be allowed to destroy the dreams and the visions of those whose lives it claimed, however vulnerable they may have been. For a while, I was frustrated by the considerable gaps in the archival traces of Béatrice de Camondo, the details I will never be able to know about how she understood the collapse of her own illusions. But now I find comfort in those gaps, as did the writer Patrick Modiano, at the end of his quest for traces of Dora Bruder, a teenage girl who disappeared during the German Occupation of Paris. The absence of any details about his subject's final days is a kind of revenge, Modiano concludes. 'That is her secret. A poor and precious secret that the butchers, the rulings, the so-called Occupation authorities . . . the barracks, the camps, history, and time – everything that defies and destroys you – could not steal from her.'[5] So it is for Béatrice; what remains unknown is the only property she still controls.

But the absences in the records are more than posthumous power. The end of the story is clear, and always has been. The Moïse de Camondo line was extinguished entirely in Auschwitz, and the murders also devastated the Cahen d'Anvers and the Reinach families, clans whose surviving members dispersed after the war and decidedly left the world of the collectors behind. But everything we do not know about Béatrice and the others is an infinite variety of permutations that merely converge on the terrible ending we know, an ending that is simply an ending – not a beginning, and not a middle. Their deaths are not how we should remember their lives and, with all the evidence I could find, I have tried to reconstruct some of those permuta-

tions to the best of my ability. It is my hope that this book will preserve at least some sense of the people in this world as they were. In the end, that is all that matters.

I often think back to that afternoon I spent in Neuilly, now some years ago, where the old man whose mother had known Béatrice in childhood was kind enough to receive me – although not without his suspicions. Once I convinced him my motives were purely academic, he gave me those two letters that Béatrice had written to his mother and that he has kept in his apartment all

Letter from Béatrice de Camondo to a childhood friend,
9 September 1917.

these years. The first, sent in September 1942, details Béatrice's conversion. But the second letter she wrote decades earlier, in September 1917, after the death of her brother, Nissim, in the First World War. There is a haunting line in it, at least from the perspective of hindsight. 'I do not know what the future holds for us,' Béatrice wrote, 'but it seems to me that whatever comes our way, these memories will reunite us always.' The future would be crueller than she or anyone else in her world could have imagined, but it has not erased their memory. Their house of fragile things still stands.

NOTES

the second. The first sent by Béatrice embraced Vichy's odious 'conversion' but the second letter she wrote suggested earlier, in September 1917, after the death of ... Charles Michel, at the height of the First World War. There is a haunting line in a letter from the perspective of hindsight: 'I do not have what the rains bring for us,' Béatrice wrote, 'but it seems to me that I have between now.' ... their income will continue as usual.' The rains would be crueller than she or anyone else in her world could have imagined, but it but craved their income. Their houses of frozen things will remain.

INTRODUCTION: A LETTER

1. Irène Cahen d'Anvers to Béatrice de Camondo and Nissim de Camondo, 4 March 1903, P.IC., Archives of the Musée Nissim de Camondo (hereafter AMNC), Paris.
2. Interview with Philippe Erlanger by Jean-Franklin Yavchitz, 5 October 1982, Private Archives, Paris.
3. These compositions were discovered in the Harvard University Library by the Italian writer Filippo Tuena in the course of researching his beautiful 2005 book on Léon Reinach. They were then subsequently re-recorded. See Tuena, *Le variazioni Reinach* (Milan: Rizzoli, 2005).
4. On the Commissariat général aux questions juives, the most authoritative study is Laurent Joly's brilliant *Vichy dans la 'solution finale': histoire du Commissariat général aux questions juives 1941–1944* (Paris: Grasset, 2006). See also Joly, *L'antisémitisme du bureau: enquête au cœur de la Préfecture de police de Paris et du Commissariat général aux questions juives (1940–1944)* (Paris: Grasset, 2011).
5. 'Pensions servies par Madame Léon REINACH, née de Camondo', 1942, Archives of Centre Documentation Juive Contemporaine, Paris. All translations from primary sources are the author's.
6. In terms of 'expendability' I draw here on Claire Zalc's stimulating recent study on Vichy denaturalizations of French Jews, *Dénaturaliser: Les retraits de nationalité sous Vichy* (Paris: Seuil, 2016). In thinking through the problems of the Holocaust and microhistory, I particularly appreciated *Pour une microhistoire de la Shoah*, ed. Claire Zalc, Tal Bruttmann, Ivan Ermakoff, Nicolas Mariot (Paris: Seuil, 2012).
7. Béatrice de Camondo-Reinach to childhood friend, 5 September 1942, Private Archives, Paris, p. 2.
8. Béatrice's letter describing her conversion was mentioned in the 2009 exposition on the Camondo at the Musée d'Art et d'Histoire du Judaïsme in Paris, but I never believed that her conversion was genuine until I was finally allowed to read the letter myself, ten years later. There is also a memorable evocation of Béatrice de Camondo's wartime experience, including her conversion, in Anne Sebba's engrossing book on women under the Nazi Occupation. See Sebba, *Les Parisiennes: How the Women Lived, Loved and Died Under Nazi Occupation* (New York: St. Martin's Press, 2016).
9. The case of Irène de Leusse is well known. Her ancestry was the subject of a long investigation by the Commissariat Général aux Question Juives, whose verdict hung on whether her paternal grandmother, Jeanne Halphen, had really been baptized in October 1858. The Commissariat ultimately declared the records of that baptism to be fraudulent. See Richard H. Weisberg, *Vichy Law and the Holocaust in France* (New York: Routledge, 2013), p. 208.
10. Béatrice de Camondo-Reinach to childhood friend, p. 1.
11. In trying to understand Béatrice's state of mind, I found myself thinking often of another moving memoir from the same period, written between 1942 and 1944 by Hélène Berr, a young French Jewish woman from a similarly wealthy family whose members seemed to believe they would be protected by their connections. Along with her mother and father, she

was arrested, sent to Drancy, and ultimately deported to Auschwitz on Convoy 70 on 27 March 1944 – three weeks after Béatrice had been deported on Convoy 69. See Hélène Berr, *Journal* (Paris: Tallandier, 2008).

12. 'Jugement de divorce REINACH / De CAMONDO', 26 October 1942, Archives de Paris, 38W 103.

13. Ibid., p. 2.

14. Ibid.

15. Ibid.

16. I follow here a line of analysis from Anne Higonnet's *A Museum of One's Own* (Reading: Periscope, 2009), a study of private collection museums.

17. Robert Darnton, *The Great Cat Massacre and Other Episodes in French Cultural History* (New York: Basic Books, 1984), p. 3.

18. On the nature of the *israélite*, I draw on the helpful definition provided by Maurice Samuels in *Inventing the Israelite: Jewish Fiction in Nineteenth-century France* (Stanford, CA: Stanford University Press, 2010).

19. In terms of real-life Proustian figures, there have been several recent studies of the author's Parisian inspirations. See Caroline Weber's beautifully written *Proust's Duchesses: How Three Celebrated Women Captured the Imagination of Fin-de-Siècle Paris* (New York: Knopf, 2018). See also Edmund de Waal's lyrical study of Charles Éphrussi, a distant relation, *The Hare With Amber Eyes: A Hidden Inheritance* (New York: Farrar, Straus and Giroux, 2011).

20. Walter Benjamin, 'Unpacking my library', in *Illuminations*, trans. Harry Zohn, ed. Hannah Arendt (New York: Schocken, 1968), p. 60.

21. Ibid., p. 61.

22. See especially Jannell Watson, *Literature and Material Culture from Balzac to Proust: The Collection and Consumption of Curiosities* (Cambridge: Cambridge University Press, 2009).

23. Henry James, *The American* (New York: Penguin, 2005), p. 13. For more on American attitudes toward collecting in the late nineteenth century, see Neil Harris's excellent study, *Cultural Excursions: Marketing Appetites and Cultural Tastes in Modern America* (Chicago: University of Chicago Press, 1990). Particularly of note is his contention that in the period a 'true collector' was not at all a distinction reserved for the exclusive social province of elites: workers, he writes, could also be recognized as such, even with *tchotchkes* and *bric-à-brac*.

24. Pierre Cabanne, *Les grands collectionneurs: Du Moyen-Age au XIXe siècle*, tome I (Paris: Éditions de l'Armateur, 2003).

25. Susan Stewart, *On Longing: Narratives of the Miniature, the Gigantic, the Souvenir, the Collection* (Durham, NC: Duke University Press, 1993), p. 151.

26. Russell Belk, *Collecting in a Consumer Society* (London: Routledge, 1995), p. 1.

27. See Susan Crane, *Collecting and Historical Consciousness in Early Nineteenth-century Germany* (Ithaca, NY: Cornell University Press, 2000), esp. 'Collective collecting in "the Age of Associations"', pp. 60–105.

28. See *Tangible Things: Making History through Objects*, ed. Laurel Thatcher Ulrich, Ivan Gaskell et al. (Oxford: Oxford University Press, 2015), p. 3.

29. Leora Auslander, 'Beyond words', *American Historical Review*, vol. 110, no. 4 (October 2005), p. 1015.

30. Ibid., p. 1017.

31. By 'cousinhood', I refer, here, to Chaim Bermant's classic study of English Jewish elites. See Bermant, *The Cousinhood: The Anglo-Jewish Gentry* (London: Eyre and Spottiswoode, 1971). But in recent years, the French-Jewish elite in the Third Republic has been documented meticulously by Cyril Grange, whose painstaking research on an entire social world has greatly informed this book. See Cyril Grange, *Une élite parisienne: Les familles de la grande bourgeoisie juive 1870–1939* (Paris: CNRS Editions, 2016).

32. For the best recent study of Alphonse de Rothschild, see the portion on him in Pauline Prevost-Marcilhacy's multi-volume landmark study of the Rothschilds as a family of prolific collectors. Prevost-Marcilhacy, 'Le mécénat envers les artistes en faveur des musées de région 1885-1905', P. Prevost-Marcilhacy (dir.), *Les Rothschild, une dynastie de mécènes en France*, 3 vol., (Paris: Éditions du Louvre/BNF/Somogy), vol. I, pp. 135–77.

33. Aron Rodrigue, 'Rearticulations of French Jewish identities after the Dreyfus Affair', *Jewish Social Studies*, vol. 2, no. 3 (spring–summer 1996), pp. 1–24. Rodrigue's analysis focuses on Bernard Lazare, André Spire, Edmond Fleg, Henri Franck and Jean-Richard Bloch.

34. See Patrice Higonnet, 'Three literary visions', in *Paris: Capital of the World* (Cambridge, MA: Harvard University Press, 2002), pp. 261–88. Higonnet considers the works of Balzac, Baudelaire, and Zola, all of whom, especially the latter, emphasize the effects of materiality and commoditization on daily life in the city.

35. See Alexia Yates, *Selling Paris: Property and Commerical Culture in the Fin-de-siècle Capital* (Cambridge, MA: Harvard University Press, 2015).

36. Walter Benjamin, 'Paris, capital of the twentieth century', in *Reflections* (New York: Schocken, 1978), p. 155.

37. The excellent study by the historian Tom Stammers is the most authoritative on this subject date. See Tom Stammers, *The Purchase of the Past: Collecting Culture in Post-revolutionary Paris c.1790–1890* (Cambridge: Cambridge University Press, 2020).

38. Grégoire Kauffmann makes this point in the latest biography of Drumont. See Kauffmann, *Édouard Drumont* (Paris: Perrin, 2008), pp. 51–2.

39. Édouard Drumont, *La France juive: Essai d'histoire contemporaine*, vol. II (Paris: Flammarion, 1886), p. 108.

40. I draw, here, on Tom Stammers's rich discussion of Drumont's observations at Ferrières in a memorable passage. See Stammers, 'Collectors, Catholics, and the Commune: Heritage and counter-revolution, 1860–1890', French Historical Studies, vol 37. no. 1 (winter 2014), pp. 53–87. The original passage in Drumont's *La France juive* can be found in vol. II, pp. 109–10. .

41. See Leora Auslander's stimulating study, *Taste and Power: Furnishing Modern France* (Berkeley, CA: University of California Press, 1998). Miriam Levin has discussed at great length the ideology of art in the Third Republic. See Levin, *Republican Art and Ideology in Late Nineteenth Century France* (Ann Arbor, MI: UMI Research Press, 1986).

42. See Stammers, *The Purchase of the Past*, p. 4.

43. See Tom Stammers, 'Old French and new money: Jews and the aesthetics of the Old Regime in transnational perspective, c.1860–1910', *Journal of Modern Jewish Studies*, vol. 18, no. 4, pp. 489–512.

44. Moïse de Camondo, Last Will and Testament, 20 January 1924, pp. 1–3, AMNC, Paris.

45. On this 1960s 'rediscovery', especially in a French context, see, among others, Samuel Moyn's *A Holocaust Controversy: The Treblinka Affair in Postwar France* (Boston: Brandeis University Press, 2005).

46. See Hannah Arendt, 'Antisemitism', in *The Origins of Totalitarianism* (New York: Harcourt, Brace, Jovanovich, 1973).

47. See Michael Marrus, *The Politics of Assimilation: The French Jewish Community at the Time of the Dreyfus Affair* (Oxford: Clarendon Press, 1971).

48. Birnbaum has written extensively on Jews in France during the Third Republic, but see especially his classic 1992 study, which remains a major intervention in the field. Birnbaum, *Les fous de la République: Histoire politique des juifs d'État de Gambetta à Vichy* (Paris: Fayard, 1992).

49. See Paula Hyman, *The Jews of Modern France* (Berkeley, CA: University of California Press, 1998).

50. See Nadia Malinovich, *French and Jewish: Culture and the Politics of Identity in Early Twentieth-century France* (Liverpool: Littmann Library of Jewish Civilization, 2012).

51. See Michael Graetz, *The Jews in Nineteenth-century France: From the French Revolution to the Alliance Israélite Universelle* (Stanford, CA: Stanford University Press, 1996).

52. See Lisa Moses Leff, *Sacred Bonds of Solidarity: The Rise of Jewish Internationalism in Nineteenth-century France* (Stanford, CA: Stanford University Press, 2006).

53. See Samuels, *Inventing the Israelite: Jewish Fiction in Nineteenth-century France* (Stanford, CA: Stanford University Press, 2010). See also *French Universalism and the Jews* (Chicago: University of Chicago Press, 2016).

54. There have also been a number of important recent family studies of French-Jewish elites, each of which has been immensely useful in my research. See Helen M. Davies, *Emile and*

Isaac Pereire: Bankers, Socialists and Sephardic Jews in Nineteenth-century France (Manchester: Manchester University Press, 2015); Lorraine de Meaux, *Une grande famille russe: les Gunzburg Paris/Saint-Pétersbourg XIXe–XXe siècle* (Paris: Perrin, 2018); and Sarah Abrevaya Stein, *Family Papers: A Sephardic Journey Through the Twentieth Century* (New York: Farrar, Straus and Giroux, 2019).

1 PORTRAITS OF A MILIEU: A JEWISH ELITE IN CRISIS

1. Philippe Jullian, '"Rose" de Renoir retrouvée', *Le Figaro Littéraire*, 22 December 1962, p. 6.
2. Ibid.
3. The role of art dealers in general – and Jewish art dealers in particular – in the formation of taste before the Second World War on both sides of the Atlantic is its own field of study. Recent years have seen a number of superb works on this subject, mostly studies of individual families but also some in comparison. See, for instance, Philip Hook, *Rogue's Gallery: The Rise (and Occasional Fall) of Art Dealers, the Hidden Players in the History of Art* (New York: The Experiment, 2017). On the Duveens, see Charlotte Vignon's terrific recent study, *Duveen Brothers and the Market for Decorative Arts, 1880-1940* (London: Giles, 2019). See also Meryle Secrest, *Duveen: A Life in Art* (Chicago: University of Chicago Press, 2005). The 1951 *New Yorker* profile of Duveen by the playwright and journalist S.N. Behrman was also recently reissued by Daunt Books. See S.N. Behrman, *Duveen: The Story of the Most Spectacular Art Dealer of All Time* (London: Daunt Books, 2014). On Daniel-Henry Kahnweiler, the best book remains Pierre Assouline's splendid 1989 biography. See Assouline, *L'homme de l'art: D.-H. Kahnweiler 1884-1979 (Paris: Gallimard, 1989)*. On Paul and Léonce Rosenberg, see the memoir written by Anne Sinclair, Paul Rosenberg's granddaughter: *Anne Sinclair, 21 rue la Boétie* (Paris: Grasset, 2012). Diana Kostyrko has also published an excellent monograph on the dealer René Gimpel: Kostyrko, *The Journal of a Transatlantic Art Dealer: René Gimpel 1918-1939* (Turnhout, Belgium: Harvey Miller, 2017). This interest in art dealers has also manifested itself in a number of important museum expositions in recent years. These have ranged from dealers in this pre-war set but also more contemporary dealers. See *Picasso, Léger, Masson: Daniel-Henry Kahnweiler et ses peintres.* 27 September 2013–12 January 2014, Lille Métropole Musée d'art moderne, d'art contemporain et d'art brut, Lille, France; *Ileana Sonnabend, Ambassador for the New*, 12 December 2013–21 April 2014, Museum of Modern Art, New York; *Paul Durand-Ruel. Le Pari de l'impressionnisme*, 9 October 2014–8 February 2015, Musée du Luxembourg, Paris; Seth *Siegelaub: Beyond Conceptual Art*, Stedelijk Museum, 12 December 2015–17 April 2016, Stedelijk Museum, Amsterdam; 21 *rue la Boétie*, 2 March 2017–23 July 2017, Musée Maillol, Paris; *The Conditions of Being Art: Pat Hearn Gallery & American Fine Arts, Co.* (1983-2004), 23 June–14 December 2018, Bard College, Annandale-On-Hudson, New York.
4. Paula Hyman, *From Dreyfus to Vichy: The Remaking of French Jewry, 1906–1939* (New York: Columbia University Press, 1979), p. 28.
5. See especially Nancy L. Green, *The Pletzl of Paris: Jewish Immigrant Workers in the Belle Époque* (New York: Holmes and Meier, 1986).
6. Hyman, *The Jews of Modern France*, p. 64.
7. Ruth Harris, *The Man on Devil's Island: Alfred Dreyfus and the Affair that Divided France* (London: Allen Lane, 2010), p. 66.
8. See, for instance, Maurice Samuels, *The Right to Difference: French Universalism and the Jews* (Chicago: University of Chicago Press, 2016). Samuels argues that French Jews 'emphatically did not confine their Jewish identity solely to the private sphere after the Revolution' and nor did they 'abandon their solidarity with other Jews' (p. 8).
9. See Arendt, *The Jewish Writings*, ed. Jerome Kohn and Ron Felman (New York: Schocken, 2007), p. 466.
10. Todd M. Endelman, *Leaving the Jewish Fold: Conversion and Radical Assimilation in Modern Jewish History* (Princeton, NJ: Princeton University Press, 2015).
11. See Philippe-E. Landau, 'Se convertir à Paris au XIXème siècle', *Archives Juives*, vol. 35, no. 1 (2002), pp. 27–43.

12. Only recently has attention begun to be paid to these factors in the French-Jewish experience of the twentieth century. Yaël Hirsch, for instance, has recently published an illuminating study on the question of conversion in the twentieth century, focusing on prominent cases such as Simone Weil, Jean-Marie Lustiger, Édith Stein, and Henri Bergson. These individuals, of course, come from a diverse array of personal and socio-economic backgrounds, and they did not necessarily exist in a common social group, as was the case for the individuals considered in this book. Their decisions were thus largely personal and often devoid of the communal ramifications that conversion had within the intermarried, interwar French-Jewish élite. See Hirsch, *Rester juif? Les convertis face à l'universel* (Paris: Perrin, 2014).

13. See Mary Louise Roberts, *Disruptive Acts: The New Woman in Fin-de-siècle France* (Chicago: University of Chicago Press, 2002). See esp. Roberts's chapter on the alliance between the 'New Woman' and Jews during the Dreyfus Affair.

14. The details of the couple's separation are detailed in Box 54, OE393 of the 'Laffite Papers' in the Rothschild Archive, London (RAL); the details of Maurice Éphrussi's debts are detailed in Box 55, OE395, RAL.

15. In autumn 2014, the AMNC received a great many letters between Nissim de Camondo and Renée Dorville which detail the romance and engagement plans of the young lieutenant and his nurse. I am very grateful to Mme Sophie d'Aigneaux-Le Tarnec, the museum's principal archivist, for calling my attention to them. I have relied on these letters a great deal in chapter 3. The museum subsequently published some of the letters on the centennial anniversary of Nissim's death in 2017, in the volume *Correspondance et journal de campagne de Nissim de Camondo, 1914–1917* (Paris: 2017), which remains an invaluable resource.

16. I have also seen the original of this document in the Bibliothèque Méjanes in Aix-en-Provence, but Joseph's penmanship remains illegible. As a result, I have relied on the published translation from Ruth Harris, *The Man on Devil's Island*, p. 188.

17. Thérèse sat for Renoir in 1880. Her portrait, *Madame Léon Fould*, hangs in a private collection in New York City.

18. Hélène Fould-Springer, *I Loved My Stay: The Autobiography of Hélène Propper de Callejón* (London: privately published, 1997), pp. 43–5. The Foulds were a wealthy French-Jewish banking family intermarried with both the Éphrussis, as in the case of Léon Fould and Thérèse Éphrussi, and with the Rothschilds, as in the case of Hélène's sister, Liliane Fould-Springer, who married Élie de Rothschild by proxy in 1941. Hélène's memoirs were published privately before her death in 1997, under the supervision of her daughter, Elena Bonham Carter, and her sister Liliane de Rothschild. A copy of her memoirs – written in English – was given to me by her son, Felipe Propper de Callejón, in New York City in September 2013.

19. This 'sexual' relationship collectors could have with the items they pursued was a theme first advanced in the novels of Balzac. See a very insightful essay by John Patrick Greene, 'Balzac's most helpless heroine: The art collection in *Le Cousin Pons*', *The French Review*, vol. 69, no. 1 (October 1995), pp. 13–23. Léon Fould fits well into Greene's analytical framework.

20. On Zadoc Kahn, see generally Julien Weill's *Zadoc Kahn* (Paris: Félix Alcan, 1912). Julien Weill was Kahn's successor and son-in-law.

21. *Discours prononcés aux obsèques de M. Le Comte Cahen (d'Anvers)* (Paris: 1881), p. 11. Bibliothèque Nationale de France.

22. Ibid., p. 6.

23. Ibid., p. 12.

24. The art historian Alice S. Legé has written an excellent study of the Cahen d'Anvers family with particular attention to its reliance on portraiture. See Legé, 'La sociabilité par le portrait: Bonnat, Renoir et les autres', in 'Les Cahen d'Anvers en France et en Italie: Demeures et choix culturels d'une dynastie d'entrepreneurs', Doctoral thesis, supervised by Philippe Sénéchal and Giovanni Agosti, Université de Picardie Jules Verne, Università degli Studi di Milano, defended June 2020, pp. 141–50.

25. In much of my analysis of portraiture and femininity that follows, I have relied heavily on the insightful work of the art historian Tamar Garb. See, for instance, Garb's *Bodies of*

Modernity: Figure and Flesh in Fin-de-siècle France (London: Thames and Hudson, 1998). See also *The Body in Time: Figures of Femininity in Late-nineteenth-century France* (Seattle, WA: University of Washington Press, 2008). Finally, see *The Painted Face: Portraits of Women in France, 1814–1914* (New Haven, CT: Yale University Press, 2007).

26. See Debora Silverman, *Art Nouveau in Fin-de-siècle France: Politics, Psychology, and Style* (Berkeley, CA: University of California Press, 1992), p. 145.

27. At the age of 19, Betty de Rothschild, the daughter of Salomon Mayer von Rothschild, the founder of the family's Vienna branch, married her uncle, James de Rothschild, who founded the family's Paris branch. Her portrait was looted by the Nazis from the Rothschild family's collection during the Second World War and returned to the family in 1946. It has rarely been exhibited since. For the best analysis of the painting and its popular reception in the mid-nineteenth century, see Gary Tinterow, 'Baronne James de Rothschild, née Betty von Rothschild', in *Portraits by Ingres: Images of an Epoch*, ed. Garty Tinterow and Philip Conisbee (New York: Harry Abrams, 1999), pp. 414–25. Carol Ockman has also considered the portrait as an 'eroticized body' in her 1995 study of Ingres's portraits. See Ockman, *Ingres's Eroticized Bodies: Retracing the Serpentine Line* (New Haven, CT: Yale University Press, 1995). For the best biography of Betty de Rothschild, see Laura S. Schor, *The Life and Legacy of Baroness Betty de Rothschild* (New York: Peter Lang, 2006). But the portrait has captivated many other writers and artists in recent years. See Pierre Assouline, *Le portrait* (Paris: Gallimard, 2007). See also the writer Anita Brookner's moving review of the 1968 Ingres exposition at the Petit Palais in Paris, one of the few shows in which the portrait of Betty de Rothschild has appeared: 'Ingres at the Petit Palais', *The Burlington Magazine* 110, no. 779 (1968): pp. 94–6. See also the exhibition catalogue written by the French-Israeli painter Avigdor Arikha, J.A.D. *Ingres: Fifty Life Drawings from the Musée Ingres at Montauban* (Houston: Museum of Fine Arts, 1986).

28. Edmond et Jules Goncourt, *Journal: Mémoires de la vie littéraire 1866–1886*, vol. II (Paris: 1956), p. 858.

29. Gilbert Cahen d'Anvers, *Mémoires d'un optimiste* (Paris: privately published, 1994), private collection.

30. 'The Memoirs of Lorraine Dubonnet', from the private collection of Catherine Bonnet, Saint-Cloud, France. This document was generously shared with me by Catherine Bonnet, Saint-Cloud, France, 2020.

31. Émile Zola, 'Le Salon de 1875', *Écrits sur l'art*, ed. Jean-Pierre Leduc Adine (Paris: Gallimard, 1991), pp. 302–3. The passage is quoted – in translation – in Colin B. Bailey's excellent piece, 'Portrait of the artist as a portrait painter', in *Renoir's Portraits: Impressions of an Age* (New Haven, CT: Yale University Press, 1997), p. 2.

32. Bailey, pp. 1–2.

33. See Guy Saigne, *Léon Bonnat: Le portraitiste de la IIIe République – Catalogue raisonné des portraits* (Paris: Mare & Martin, 2017).

34. By all accounts, she was an eminently dutiful wife, at least in public. She wrote, for instance, a wonderfully detailed account of an 1893 trip she took with her husband and daughter Élisabeth to Brazil, Argentina, and Paraguay – a journal she had illustrated and bound to present to her husband as a token of her affection. 'To my dear Louis,' Louise wrote in the dedication. 'In memory of the beautiful trip we took together. See Louise Cahen d'Anvers, *Notes de voyage pour mes enfants: Le Brésil, la République argentine, le Paraguay, les Andes, le Chili, le Canal de Smith* (Paris: privately published, 1893). These memoirs, which remain in family archives, were generously shared with me by both Christian de Monbrison and Jean de Monbrison in Paris, 2019.

35. Sonia Warshawsky, *Baboushka Remembers* (London: privately published, 1972), p. 48. Sonia's memoir was published privately at the insistence of her grandson Evelyn de Rothschild. She wrote it in English, and the only publicly available copy today is held in the RAL.

36. See Emily D. Bilski and Emily Braun, 'The power of conversation: Jewish women and their salons', in *Jewish Women and Their Salons* (New Haven, CT: Yale University Press, 2005), p. 16.

37. See, for instance, Edmund de Waal, *The Hare with Amber Eyes* (New York: Farrar, Straus and Giroux, 2011), esp. 'Paris 1871–1899', pp. 21–110.
38. Goncourts, *Journal*, vol. II , p. 1265.
39. Quoted in Philip Nord, *Impressionists and Politics: Art and Democracy in the Nineteenth Century* (Oxford: Routledge, 2000), p. 104.
40. Renoir to Deudon, 19 February 1882. Quoted in Marcel Schneider, 'Lettres de Renoir sur l'Italie', *L'Âge d'Or I* (Paris: Calmann-Lévy, 1945), p. 99.
41. Anne Dumas, 'Renoir and the Feminine Ideal', in Anne Dumas and John Collins, *Renoir's Women* (London: Merrell, 2005), p. 50.
42. See J. Buisson, "Le Salon de 1881," *Gazette des Beaux-Arts*, Vol. 24, no. 2 (Paris: September 1881), p. 41.
43. *La Mode de style*, 'Chronique mondain: Marriage Camondo-Cahen', 28 October 1891 : https://gallica.bnf.fr/ark:/12148/bpt6k6560684t/f2.image.r=irene%20cahen%20d'anvers?rk=21459;2
44. *Le Matin*, 16 October 1891.
45. *Le Mode de style*, 'Chronique mondain'.
46. *Le Figaro*, 'À travers Paris', 16 October 1891.
47. Ibid.
48. *Le Mode de style*, 'Chronique mondain'.
49. Interview with Philippe Erlanger by Jean-Franklin Yavchitz, 5 October 1982, p. 7. Private Archives, Paris.
50. See Article Trois, Contrat de Mariage de Monsieur le Comte Moïse de Camondo et de Mademoiselle I. de Cahen (d'Anvers), 8 Octobre 1891, par M. Labitte, Notaire à Paris, boulevard Malesherbes, 85, AMNC, P.IC.
51. Article Deux, Contrat de Mariage.
52. Boni de Castellane, in his memoirs, described Sampieri thus: 'J'avais confié la direction de mon écurie au comte Sampieri, amiable sportman, qui s'acquitta de sa tâche avec dévouement.' See Castellane, *Mémoires de Boni de Castellane* (Paris: Perrin, 1987), p. 156.
53. Jugement du divorcé De CAMONDO / CAHEN d'ANVERS, rendu le 8/01/1902 & 22/07/1903 – 1ère Chambre – cote DU5 1238, Archives de Paris.
54. See 'Mariages du mois', *Le Carnet mondain*, 20 March 1903; 'Mariages', *Gil Blas*, 7 March 1903.
55. Jugement du divorce De CAMONDO / CAHEN d'ANVERS.
56. Ibid.
57. 'La garde des enfants', *Le Temps*, 31 July 1903.
58. Letter from Irène Cahen d'Anvers to her children, 4 March 1903, AMNC, P.IC.
59. Irène refers here to her niece Audrey Townshend (1900–87), the daughter of Alice Cahen d'Anvers and Charles Townshend.
60. This refers to Irène's brother, Charles Cahen d'Anvers (1879–1957).
61. 'Memoirs of Lorraine Dubonnet', p. 10.
62. Ibid.
63. I am deeply grateful to Mme Catherine Bonnet, a great-granddaughter of Irène Cahen d'Anvers, who shared these photographs with me.
64. I discuss Théodore Reinach's *Histoire des Israélites* extensively in chapter 5. For the intellectual and communal context that surrounded his idea, see generally Philip Nord, *The Republican Moment: Struggles for Democracy in Nineteenth-century France* (Cambridge, MA: Harvard University Press, 1995), esp. 'Jewish republicanism', pp. 64–90.
65. Hélène Reinach-Abrami, *Le Bien-aimée* (Paris: privately published, 1935), p. 103. Musée d'Art et d'Histoire du Judaïsme, Paris.
66. Ibid., p. 105.
67. Ibid., p. 100.
68. Ibid., p. 113.
69. Ibid., p. 112.
70. Ibid., p. 114.
71. Ibid., pp. 114–15.
72. Ibid., p. 130.

2 DREYFUS AND DRUMONT: TOWARDS A
MATERIAL ANTISEMITISM

1. Edmond bought the house from the heirs of Baroness de Pontalba in 1876 and charged the architect Félix Langlais with renovating it. The mansion was requisitioned by the German army during the Second World War for a Luftwaffe officers' club, and in 1948 the property was purchased by the U.S. government. Today the Hôtel de Pontalba is the official residence of the U.S. Ambassador to France.

 There is a vast literature on Edmond de Rothschild in particular. On his life as a collector, in addition to the portion on Edmond in Prévost-Marcilhacy's *Les Rothschild, une dynastie de mécènes en France* (2016), there is also a very thorough single-volume study of his bequest to the Louvre. See Pascal Torres, *La collection Edmond de Rothschild au Musée du Louvre* (Paris: Musée du Louvre, 2010). On Edmond's role as an early supporter of Jewish life in Palestine, the classic study remains Simon Schama's *Two Rothschilds and the Land of Israel* (London: Collins, 1978), but see also Israël Margalith's earlier study, *Le Baron Edmond de Rothschild et la colonisation juive en Palestine 1882–1899* (Paris: Marcel Rivière et Cie, 1957). For a more complete biography of *Edmond, see Élizabeth Antébi, Edmond de Rothschild: L'homme qui racheta la Terre sainte* (Paris: Éditions du Rocher, 2003). And for the best summary of the way Edmond's settlements in Palestine were administered, see Derek Penslar, *Zionism and Technocracy: The Engineering of Jewish Settlement in Palestine, 1870–1918* (Indiana, 1991).
2. The best study of the Goncourts and antisemitism is Michel Winock, 'L'Antisémitisme des Goncourt', in Jean-Louis Cabanès et al. (eds) *Les Goncourt dans leur siècle: Un siècle de 'Goncourt'* (Paris: Presses Universitaires du Septentrion, 2005).
3. Goncourts, *Journal*, vol. III, 4 June 1889, p. 277.
4. Dreyfus acquired this painting, informally called 'The Dreyfus Madonna', in Britain in 1872. His heirs sold the Madonna canvas to the dealer Joseph Duveen in 1930 along with the rest of his collection, and in 1951 the painting was sold again to the American collector Samuel Kress. It was then sold to the National Gallery of Art in Washington, D.C., the following year. For the most complete study of Dreyfus, see Alice S. Legé, *Gustave Dreyfus: Collectionneur et mécène dans le Paris de la Belle Époque* (Officina, 2019).
5. Léon Daudet, *L'Entre-deux-guerres*, in *Léon Daudet: Souvenirs et polémiques* (Paris: Bouquins, 1992), p. 286.
6. Ibid.
7. Maurice Samuels, *The Right to Difference: French Universalism and the Jews* (Chicago: University of Chicago Press, 2016), p. 5.
8. Arthur Hertzberg, *The French Enlightenment and the Jews* (New York: Columbia University Press,1968), p. 5.
9. Janell Watson, *Literature and Material Culture from Balzac to Proust: The Collection and Consumption of Curiosities* (Cambridge: Cambridge University Press, 1999). Watson shows the remarkable extent to which material objects appear in nineteenth-century French literature, citing Balzac, Huysmans, Flaubert, Zola, Proust, Mallarmé, and the Goncourts, among others.
10. See also Rémy Saisselin, *Bricobracomania: The Bourgeois and the Bibelot* (London: Thames and Hudson, 1985). Saisselin discusses in depth the meaning of the Goncourts' observations.
11. See Véronique Long, 'Les collectionneurs juifs parisiens sous la Troisième République (1870–1940)', *Archives Juives*, vol. 42, no. 1 (2009), pp. 84–104.
12. Stammers, *The Purchase of the Past*, p. 22.
13. See also Stammers, 'Collectors, Catholics, and the Commune', p. 61.
14. See Pierre Birnbaum, 'Annexes', *Les fous de la République: Histoire politique des juifs d'État de Gambetta à Vichy* (Paris: Fayard, 1992), pp. 495–502.
15. See Maurice Samuels, 'Proust, Jews, and the arts', in *Proust and the Arts*, ed. Christie McDonald and François Proulx (Cambridge, UK: Cambridge University Press, 2015), pp. 223–31.
16. Daudet, *L'Entre-deux-guerres*, p. 285.

NOTES to pp. 53–60

17. See especially Pierre-André Taguieff, 'Determinisme racial, antisémitisme et nationalisme: de Drumont à Soury', in *La couleur et le sang: Doctrines racistes à la française* (1998) (Paris: Fayard, 2002), pp. 135–97.

18. I follow, here, the line of interpretation advanced by Sandrine Sanos, who has argued that 'the twentieth century far-right, antisemitic and fascist ideologies actually mined and used a language of perversion, gender, and sexuality for their foundations'. It is my contention that in the fin de siècle, earlier proponents of these ideologies often relied on the language of objects and things, couched as sites of Jewish material invasion. See Sanos, *The Aesthetics of Hate: Far-right Intellectuals, Antisemitism, and Gender in 1930s France* (Stanford, CA: Stanford University Press, 2012), p. 3.

19. Eugene N. White, 'The crash of 1882 and the bailout of the Paris Bourse', *Cliometrica*, vol. 1, no. 2 (May 2007), pp. 115–44. For a discussion of Zola's *L'argent*, and especially of Zola's evolving views of Jews between writing the novel and his famous public defense of Dreyfus during the Affair, see Maurice Samuels, 'Jews and Money', *French Universalism and the Jews*, pp. 96–103.

20. See especially Bontoux's memoir of the entire affair. Eugène Bontoux, *L'Union Générale: sa vie, sa mort, son programme* (Paris: Albert Savine, 1888). See also Jeannine Verdès-Leroux, 'La presse devant la krach d'une banque catholique: L'Union Générale (1882)', *Archives de Sciences Sociales des Religions*, vol. 19 (1965), pp. 125–56. See also Verdès-Leroux, *Scandale financier et antisémitisme catholique: Le krach de l'Union Générale* (Paris: Éditions du Centurion, 1969).

21. See Alfred Colling, *La Prodigeuse Histoire de la Bourse* (Paris: Société d'Éditions Économiques et Financières, 1949), p. 304.

22. Mermeix, *Les Antisémites en France: Notice sur un fait contemporain* (Paris: Dentu, 1892), p. 22. Also quoted in Verdes-Leroux, 'La presse devant la krach', p. 126.

23. Mermeix, *Les Antisémites en France*, p. 39. Also quoted in Verdes-Leroux, 'La presse devant la krach', p. 126.

24. 'Un sinistre financier', *Le Figaro*, 16 April 1885.

25. Léon Alfassa to Abraham Behor de Camondo, 14 April 1885, AMNC, P.F.4.

26. Ibid.

27. 'Affaire Alfassa-Camondo', *Le Figaro*, 17 April 1885.

28. 'Douze millions', *Le Matin*, 16 April 1885.

29. Drumont, *La France juive*, vol. I, footnote 69.

30. On the Panama scandal, see Jean-Yves Mollier, *Le scandale de Panama* (Paris: Fayard, 1991) and also Louis Bergeron, *Les Capitalistes en France, 1780–1914* (Paris: Gallimard, 1978). See also Frederick Brown's recent interpretation, 'The Panama scandal', in *For the Soul of France: Culture Wars in the Age of Dreyfus* (New York: Knopf, 2010), pp. 155–75.

31. Grégoire Kauffmann recounts this episode in his painstakingly researched biography of Drumont. See Kauffmann, *Édouard Drumont*, pp. 272–4.

32. See Hannah Arendt, *Sur l'antisémitisme: Les origines du totalitarisme*, trans. Micheline Pouteau (Paris: Seuil, 1984), p. 212.

33. See Drumont, *La France juive*, vol. II, pp. 1–67.

34. See, for instance, Robert F. Byrnes, 'Édouard Drumont and *La France juive*', *Jewish Social Studies*, vol. 10, no. 2 (April 1948), pp. 165–84.

35. Thomas P. Anderson, 'Édouard Drumont and the origins of modern antisemitism', *Catholic Historical Review*, vol. 53, no. 1, p. 28.

36. See, for instance, Frederick Busi's *The Pope of Antisemitism: The Career and Legacy of Édouard-Adolphe Drumont* (London: Rowman and Littlefield, 1986).

37. The most authoritative biography of Drumont to date is Grégoire Kauffmann's excellent study. Kauffmann discusses Drumont's antiquarian origins in detail. See Kauffmann, 'Premiers pas dans le journalism (1864–1878)', in *Édouard Drumont*, pp. 31–55.

38. Édouard Drumont, *Mon vieux Paris*, vol. I (Paris: G. Charpentier, 1878), p. ii.

39. Ibid., vol. II, p. vi. Philip Nord has also discussed Drumont's *Mon vieux Paris* in cultural terms. See Nord, *The Politics of Resentment: Shopkeeper Protest in Nineteenth-century Paris* (Princeton, NJ: Princeton University Press, 1986), pp. 376–8. For more on how Drumont's

writings on the Jews were connected to his interest in the art market, see Tom Stammers, 'Facets of French heritage: Selling the crown jewels in the early Third Republic', *Journal of Modern History*, vol. 90, no. 1 (2018), pp. 76–115.

40. See Kauffmann, pp. 60–1.
41. Drumont, *La France juive*, vol. II, p. 116.
42. Ibid., p. 115.
43. Ibid., p. 109.
44. See Pauline Prevost-Marcilhacy, *Les Rothschild: Batisseurs et mécènes* (Paris: Flammarion, 1995). See also Prevost-Marcilhacy, *Les Rothschild: Une dynastie de mécènes en France* (Paris: Somogy, 2016).
45. Drumont, *La France juive*, vol. II, p. 109.
46. Ibid.
47. Ibid., pp. 109–10.
48. See Niall Ferguson, *The House of Rothschild: The World's Banker 1849–1999*, vol. II (New York: Penguin, 1998), pp. 198–204.
49. Drumont, *La France juive*, vol. II, p. 111.
50. Ibid., p. 112.
51. On the way French Jews were perceived as exotic, see Julie Kalman's terrific study, *Orientalizing the Jew: Religion, Culture and Imperialism in Nineteenth-century France* (Bloomington, IN: Indiana University Press, 2017).
52. During the Franco-German War, for instance, the Rothschilds initially feared a Jacobin take-over in Paris, but they ultimately acquiesced to supporting a moderate republican regime, about which they had initially had their doubts. But Alphonse de Rothschild, in particular, wished for the end of the Bonapartist regime, which he had openly opposed in its final phase. As he wrote to his London cousins after the republic was declared: 'As the republic has been proclaimed, it is probable that popular anger will be disarmed and that there will be no serious disorder in the street.' See Ferguson, *The House of Rothschild*, vol. II, pp. 198–201.
53. Proust, *Sodome et Gommorhe*, vol. III of *À la recherche du temps perdu* (Paris: Pléiade, 1988), p. 89.
54. I discuss the Reinach family in depth, especially Théodore Reinach, in chapter 5.
55. Proust, *Le Côté de Guermantes*, vol. II of *À la recherche du temps perdu* (Paris: Pléiade, 1988), p. 593.
56. Drumont, 'Espionnage juif', *La Libre Parole*, 3 November 1894.
57. Theodore Reinach, *Histoire sommaire de l'Affaire Dreyfus* (Paris: Ligue des droits de l'homme, 1924), p. 230.
58. Helen Fould-Springer, *I Loved My Stay*, p. 51.
59. See Miriam Levin, *Republican Art and Ideology in Late Nineteenth-century France* (Ann Arbor, MI: UMI Research Press, 1986).
60. See Francis Haskell, 'The two temptations', ch. 2 in *Rediscoveries in Art: Some Aspects of Taste, Fashion, and Collecting in England and France* (Ithaca, NY: Cornell University Press, 1976).
61. See Monica Preti, 'The "rediscovery" of eighteenth-century French painting before La Caze: Introductory notes', in Guillaume Faroult, Monica Preti and Cristoph Vogtherr (eds), *Delicious Decadence: The Rediscovery of French Eighteenth-century Painting in the Nineteenth Century* (London: Ashgate, 2014), p. 8.
62. See Charles Paul Landon, *Annales du musée et de l'école moderne des Beaux-Arts* (16 vols, Paris: 1801–24). Quoted in Preti, 'The "rediscovery"', p. 7.
63. Pierre Charles Lévesque, 'Goût', in Claude Henri Watelet and Pierre Charles Lévesque, *Encyclopédie méthodique* (3 vols, Paris, 1788), vol. I, pp. 341–4. Quoted in Preti, 'The "rediscovery"', p. 8. The *Encyclopédie méthodique par ordre des matières* was published between 1782 and 1832: in roughly 210 volumes, it was an updated and much-expanded version of Diderot and d'Alembert's original *Encyclopédie*, published between 1751 and 1772.
64. See Antoine Renou, *Dialogues sur la peinture*, seconde édition, enrichie de notes, Paris imprimé chez Tartouillis, aux dépens de l'Académie, & se distribué à la porte du Salon (Paris, 1773), pp. 104–6. Quoted in Preti, 'The "rediscovery"', p. 8.

65. Seymour O. Simches, *Le Romantisme et le goût esthétique du XVIIIe siècle* (Paris: Presses Universitaires de France, 1964).
66. Denon's commentary on Watteau – the 'Note de M. Denon' – is reprinted in Pierre Rosenberg's *Vies anciennes de Watteau* (Paris: Hermann, 1984), pp. 125–7. Pierre Rosenberg's work on the French eighteenth century is formidable and has very much contributed to my understanding of the period.
67. See Carole Blumenfeld, 'Les pionniers de la redécouverte du XVIIIe siècle', in Guillaume Faroult and Sophie Eloy et al., *La Collection La Caze: Chefs d'oeuvre des peintures de XVIIe et XVIIIe siècles* (Paris: Hazan, 2007), pp. 84–95.
68. Jean Charles Chrysostome Pacharman, the Baron de Vèze, was an avid collector and amateur artist who was also chosen to join a historical effort to catalogue all the important pieces of French national heritage. This cataloguing effort was published as *Monuments de la France classés chronologiquement et considérés sous le rapport des faits historiques et de l'étude des arts* (Paris: Jules Didot l'Aîné, 1816–36).
69. See Preti, 'The "rediscovery"', p. 6.
70. Edmond and Jules de Goncourt, 'Boucher: Étude contenant quatre dessins gravés à l'eau forte', *L'Art du XVIIIe siècle*, vol. I: *Watteau, Chardin, La Tour, Boucher* (Paris: Charpentier, 1881), p. 90.
71. In my estimation, Goncourt here most likely refers to *Le Coucher de la Mariée*, a painting by Pierre Baudoin (1723–69) that was engraved by a young Gustave Moreau (1826–98) in the nineteenth century.
72. Goncourts, *Journal*, vol. II, 6 June 1874, p. 580.
73. Ibid., vol. III, 28 December 1887, p. 83.
74. See Aviva Briefel, 'Real sons of Abraham: Jewish art dealers in the traffic in fakes', in *The Deceivers: Art Forgery and Identity in the Nineteenth Century* (Ithaca, NY: Cornell University Press, 2006), pp. 116–46.
75. Drumont, *La France juive*, vol. II, p. 574.
76. See Hervé Duchêne, '"Nous n'étions pourtant pas si bêtes de croire à la tiare!" – Edmond Pottier, Salomon Reinach: Deux amis dans l'épreuve', *Journal des Savants*, no. 1 (2005), pp. 165–211.
77. See Vicomte G. Rorthays, 'The tiara of Saitapharnes', *Burlington Gazette*, vol. 1, no. 1 (April 1903), pp. 1–5.
78. Théodore Reinach, 'Pour la tiare d'Olbia', *Gazette des Beaux-Arts*, vol. 3, no. 16 (July 1896), p. 248–9.
79. Quoted in Rorthays, 'The tiara', p. 5.
80. 'La tiare de Saïtapharnès', *Le Temps*, 14 April 1903.
81. Quoted in Duchêne, '"Nous n'étions pourtant pas si bêtes de croire à la tiare!"', p. 198.
82. 'La tiare de Saitapharnès', *La Libre Parole*, 29 March 1903.
83. Ibid.

3 'THE APOGEE OF THE *ISRAÉLITE*': JEWISH COLLECTORS AND THE FIRST WORLD WAR

1. Bruno Cabanes, *August 1914: France, the Great War, and a Month that Changed the World Forever*, trans. Stephanie O'Hara (New Haven, CT: Yale University Press, 2016), p. 2.
2. Jean-Jacques Becker, *Les Français dans la Grande Guerre* (Paris: Robert Laffont, 1980).
3. Marc Bloch, 'Souvenirs de guerre 1914–1915', in *Écrits de guerre*, ed. Étienne Bloch (Paris: Armand Colin, 1997), pp. 119–20.
4. Bloch, 'Le carnet de guerre 1914', in *Écrits de guerre*, p. 41.
5. In Britain, Benjamin Disraeli, twice a conservative prime minister in the nineteenth century, converted to Anglicanism at the age of 12. He was baptized on 31 July 1817.
6. Léon Daudet, *L'Avant-guerre: Études documents sur l'espionage juif-allemand en France depuis l'affaire Dreyfus* (Paris: Nouvelle Librairie Nationale, 1913), p. vi. Quoted in Cabanes, *August 1914*, p. 149.

7. See Derek Penslar, *Jews and the Military: A History* (Princeton, NJ: Princeton University Press, 2013), p. 119.
8. Georges Wormser, 2 September 1914, private archives of Marcel Wormser. Quoted in Philippe-E. Landau, 'Un hussard dans le ciel', in *Nissim de Camondo: Correspondance et journal de campagne* (Paris: Les Arts Décoratifs, 2017), p. 16.
9. Ibid. The memoir is dated 1922.
10. See Philippe-E. Landau, *Les Juifs de France et la Grande Guerre: Un patriotism républicain* (Paris: CNRS Éditions, 2008), p. 10.
11. See Cyril Grange, 'Lycées, grandes écoles et universités: À propos de la formation des garçons', in *Une élite parisienne: Les familles de la grande bourgeoisie juive (1870–1939)*, p. 311. Quoted in Philippe Landau, 'Un hussard dans le ciel', in Correspondance et journal de campagne de Nissim de Camondo, 1914–17 (Paris: Les Arts Décoratifs, 2017), pp. 11–12.
12. See Claude Colomer, *Janson de Sailly: Histoire d'un lycée de prestige* (Paris: Éditions de la Tour, 2003), p. 180. Quoted in Philippe Landau, 'Un hussard dans le ciel', in Correspondance et journal de campagne de Nissim de Camondo, 1914–17 (Paris: Les Arts Décoratifs, 2017), pp. 11–12.
13. Nissim de Camondo to Moïse de Camondo, 3 August 1914, AMNC, P.LN.1.
14. Nissim de Camondo to Renée Dorville, 5 November 1915, AMNC, P.RD.1.
15. Moïse de Camondo to Piperno, 4 April 1919, AMNC, LC.37.
16. Nissim refers here to a Jewish friend, Sous-Lieutenant Robert Aboucaya (1892–1914), who was a member of the 136th infantry regiment and killed on 14 September 1914 near Reims.
17. Julien Reinach (d. 1962) was a friend of Nissim's and soon to become Béatrice's brother-in-law.
18. Nissim refers here to Hélène Reinach-Abrami, whose privately published memoirs are quoted in previous chapters.
19. Nissim de Camondo to Béatrice de Camondo, 16 November 1914, AMNC, P.LN.1.
20. Nissim de Camondo to Moïse de Camondo, 29 September 1915, AMNC, P.LN.2.
21. See, for instance, the remarks that the Egyptologist Raymond Weill, who co-discovered the Coptic Decrees with Ado, delivered to the Académie des Inscriptions et Belles-Lettres, of which both Théodore and Salomon Reinach were members, in January 1911. 'Les décrets de l'empire ancien égyptien trouvés a Koptos en 1910', *Comptes rendues des séances de l'Académie des Inscriptions et Belles-Lettres*, vol. 55, no. 3 (1911), pp. 268–75.
22. Referenced in Salomon Reinach, 'Avant propos', in Adolphe Reinach, *Textes grecs et latins relatifs à l'histoire de la peinture ancienne: Recueil Milliet*, vol. I (Paris: Librairie C. Klincksieck, 1921), p. vi.
23. Hélène Reinach-Abrami to Salomon Reinach, 25 October 1915, Bibliothèque Méjanes, Aix-en-Provence, Fonds Salomon Reinach, Boite 1, no. 2.
24. Salomon Reinach, 'Avant-propos'.
25. Ibid., p. viii.
26. Ibid., p. vi.
27. Ibid., p. vii.
28. Nissim de Camondo to Moïse de Camondo, 20 October 1915, AMNC, P.LN.2.
29. The role of horses in the First World War has inspired an extensive bibliography. See especially Gene Tempest, *The Long Face of War: Horses and the Nature of Warfare in the French and British Armies on the Western Front* (New Haven, CT: Yale University Press, 2013).
30. Nissim de Camondo to Béatrice de Camondo, 29 October 1914, AMNC, P.LN.1.
31. Nissim de Camondo to Moïse de Camondo, 17 July 1917, AMNC, P.LN.4.
32. Nissim de Camondo to Tedeschi, 3 January 1915, AMNC, LC.36.
33. Nissim de Camondo to Renée Dorville, 4 April 1915, AMNC, P.RD.1.
34. Nissim de Camondo to Renée Dorville, 8 April 1915, AMNC, P.RD.1.
35. Nissim de Camondo to Renée Dorville, 5 November 1915, AMNC, P.RD.1.
36. Nissim de Camondo to Renée Dorville, 3 July 1917, AMNC, P.RD.1.
37. Landau, *Les Juifs de France et la Grande Guerre*, p. 10.
38. RAL, XI/130A/8/148

39. Gilbert Cahen d'Anvers, *Mémoires d'un optimiste*, p. 24.
40. Hélène Propper de Callejón, *I Loved My Stay*, p. 18.
41. Hélène Praday, 'Absents de nous-mêmes' (unpublished, Paris, 1961), p. 19. Propper Family Archive, New York City.
42. Gilbert Cahen d'Anvers, *Mémoires d'un optimiste*, p. 25.
43. Nissim de Camondo to Moïse de Camondo, 23 January 1916, AMNC, P.LN.3.
44. Nissim de Camondo to Moïse de Camondo, 8 May 1916, AMNC, P.LN.3.
45. Nissim de Camondo to Moïse de Camondo, 15 March 1916, AMNC, P.LN.3.
46. Nissim de Camondo to Moïse de Camondo, 7 July 1916, AMNC, P.LN.3.
47. 'Note du lundi 10 septembre 1917 résumant le rapport verbal fait par un officier de l'escadrille de passage à Paris', AMNC, P.LN.5.
48. Lieutenant Rotival to Moïse de Camondo, 5 September 1917, AMNC, P.LN. 5.
49. Jacques Truelle, a close friend and confidante of Marcel Proust's, was born into a Parisian bourgeois family and later became a French diplomat who served as the Vichy government's ambassador to Romania during the Second World War. See Carol Iancu, 'Un diplomate français en guerre: Jacques Truelle et sa mission en Roumanie (1941–1943)', in Jean-François Muracciole and Frédéric Rousseau (eds), *Combats: Hommage à Jules Maurin, historien* (Paris: Michel Houdiard, 2010), pp. 304–14.
50. Marcel Proust to Moïse de Camondo, undated, AMNC, P.LN. 5.
51. Béatrice de Camondo to childhood friend, 9 September 1917, Private Archives, Paris.
52. Moïse de Camondo to Capitaine Augustin Pérouse, 7 December 1917, AMNC, P.LN.5.
53. This became legal with a law passed on 30 July 1920.
54. Victor Mizrahi to Léonce Tedeschi, 19 November 1918, AMNC, P.LN.5.
55. August Bastien to Moïse de Camondo, 26 January 1919, AMNC, P.LN.5.
56. 'Deuil', *Le Figaro*, 13 October 1917, p. 3.
57. Ibid.
58. Moïse de Camondo to Piperno, 19 April 1919, AMNC, LC.37.
59. Ibid.
60. I discuss this collection in the following chapter.
61. *Le Gaulois*, 12 March 1919.
62. Moïse de Camondo to Piperno, 4 April 1919, AMNC, LC.37.

4 MOÏSE DE CAMONDO: CHAOS AND CONTROL

1. Letter from Moïse de Camondo to Rouyrre, 6 June 1898: 'Mon ami Charles Éphrussi m'engage beaucoup à visiter l'hôtel que Madame Bernstein fait construire rue Hamelin.' AMNC, LC.29.
2. On Moïse de Camondo on the rue Hamelin, see Bertrand Rondot, 'Building a collection', in Marie Noël de Gary (ed.), *The Camondo Legacy: The Passions of a Paris Collector* (London: Thames and Hudson, 2008), p. 89.
3. Ibid., p. 88.
4. Moïse de Camondo to Rouyrre, 6 February 1899, AMNC, LC.29.
5. François Loyer, 'A mansion in the 18th-century style', in *The Camondo Legacy*, p. 64.
6. See Michel Steve, 'Un monument pastiche, le Musée Nissim de Camondo à Paris', *Histoire de l'Art*, no. 28 (October 1994), p. 63. 'Pour ériger ce monument en hommage à l'art et au goût français,' he writes, 'Moïse de Camondo entend faire table rase, au propre comme au figuré.' See also Pierre Assouline, *Le Dernier des Camondo* (Paris: Gallimard, 1999), p. 28. 'Il choisit d'en faire table rase.'
7. Moïse de Camondo, Final Will and Testament, AMNC.
8. See Philip Conisbee, *Painting in Eighteenth-century France* (London: Phaidon, 1981), p. 9.
9. I am indebted, here, to Gaston Bachelard's *The Poetics of Space: The Classic Look at How We Experience Intimate Places* (1958) (Boston: Beacon Press, 1992), a brilliant exploration of the concepts of house and home in which he conducts a phenomenological study of architecture and lived experience it engenders. His principal argument is that the house – imagined, inhabited, and constructed – is an individual's first and primary 'cosmos', a space

whose shape and form impact the human lives sheltered inside it as much as those lives conceive and create the house itself. In the case of Moïse de Camondo, of course, the house he constructed on the rue de Monceau was something he not only inhabited but dreamed, executing his vision with his vast resources. Particularly relevant in Bachelard's analysis to that end are his pages on the warmth and security a home provides its occupant in the proverbial and universal winter of the exterior. 'The dreamer of houses knows and senses this,' he writes, 'and because of the diminished entity of the outside world, experiences the qualities of intimacy with increased intensity' (see Bachelard, 'House and universe', in *Poetics of Space*, p. 41). Moïse de Camondo was precisely such a 'dreamer', and enacting his dreams seems to have afforded a degree of control absent from a private life of humiliation and familial strife, and a public life of dwindling financial stature and antisemitic caricature.

10. Francesca Trivellato, *The Familiarity of Strangers: The Sephardic Diaspora, Livorno, and Cross-cultural Trade in the Early Modern Period* (New Haven, CT: Yale University Press, 2009), p. 2. See also Victor Eskenazi, *Beyond Constantinople: Memoirs of an Ottoman Jew* (London: I.B. Tauris, 2016).

11. For the best and most comprehensive history of the Venetian Ghetto, see Riccardo Calimani, *The Ghetto of Venice* (New York: M. Evans and Co., 1987). See also Benjamin Ravid and Robert C. Davis (eds), *The Jews of Early Modern Venice* (Baltimore, MD: Johns Hopkins University Press, 2001).

12. See Edouard Roditi, 'Camondo's Way', *Grand Street*, vol. 6, no. 2 (winter 1987), p. 152.

13. See Nora Seni, 'The Camondos and their imprint on 19th-century Istanbul', *International Journal of Middle East Studies*, vol. 26, no. 4 (November 1994), p. 664. See also Seni and Sophie le Tarnec, *Les Camondo ou l'éclipse d'une fortune* (Paris: Actes Sud, 1997, new edn 2018).

14. Aron Rodrigue, 'Abraham de Camondo of Istanbul: The transformation of Jewish philanthropy', in Frances Malino and David Sorkin (eds), *From East and West: Jews in a Changing Europe, 1750–1870*, (Oxford: Blackwell, 1990), p. 46.

15. The year 1839 saw the emergence of a reformist climate at the Sublime Porte, spurred by the passage of a slew of new measures, heavily influenced by the European Enlightenment, that reflected the desire to inculcate a European-style 'modernity' in Constantinople, especially along financial lines. See Nora Seni and Sophie Le Tarnec, 'From Istanbul to Paris', in *The Camondo Legacy*, pp. 23–4.

16. The Camondo bank, for instance, negotiated loans for the Ottoman state with many prominent Western banks, and, quite significantly, it played the lead role in financing the Ottoman war effort in the Crimean War in 1854–6. As Rodrigue notes, Abraham de Camondo was an associate and close friend of Turkish political elites such as Resit, Ali, and Fuat Pashas. See Rodrigue, 'Abraham de Camondo of Istanbul', p. 89.

17. Seni, p. 665. See also Seni and Le Tarnec, 'From Istanbul to Paris', note 1, p. 294.

18. As Trivellato has written in the case of Livorno, the grand dukes of Tuscany issued a series of ad hoc policies designed to attract refugees from Spain, such as the charters of 1591 and 1593 (known as *livornine*), which essentially granted Jews rights and privileges unparalleled in neighbouring Catholic societies. As a result, Livorno, if never quite an Amsterdam, became the second largest Sephardic settlement outside the Dutch capital and also the European city with the highest proportion of Jewish residents (approximately 10 per cent). See Trivellato, *The Familiarity of Strangers*, p. 5.

19. Roditi, 'Camondo's Way', p. 151.

20. Ibid., p. 158.

21. Seni and Le Tarnec, 'From Istanbul to Paris', pp. 27–8.

22. Rodrigue, 'Abraham de Camondo of Istanbul', p. 50.

23. Ibid., p. 55.

24. Lee Shai Weissbach, 'The nature of Jewish philanthropy in nineteenth-century France and the *mentalité* of the Jewish elite', *Jewish History*, vol. 8, no. 2 (1994), pp. 191–204. See also Weissbach, 'The Jewish elite and the children of the poor: Jewish apprenticeship programs in nineteenth-century France,' *AJS Review*, vol. 12, no. 1 (spring 1987), pp. 123–42.

25. As Rodrigue notes, in 1858, a rabbi excommunicated the school and those who had enrolled their children in it, on the grounds that they were contributing to a 'growing laxity among the Jews of Istanbul'. Camondo, however, was able to mobilize his many connections to have the school reopened, but only after agreeing to bring more religion into the curriculum. See Rodrigue, 'Abraham de Camondo of Istanbul', p. 52.

26. Lisa Moses Leff, 'The making of Jewish solidarity', in *Sacred Bonds of Solidarity: The Rise of Jewish Internationalism in Nineteenth-Century France* (Stanford, CA: Stanford University Press, 2006), p. 157.

27. Ibid., p. 179.

28. Rodrigue, 'Abraham de Camondo of Istanbul', p. 55.

29. Archives of the Alliance israélite universelle, III A 17, 3 March 1864, quoted in ibid.

30. Quoted in Seni and Le Tarnec, 'From Istanbul to Paris', p. 28.

31. See Ludwig August Frankl, *The Jews in the East*, vol. I (London: Hurst and Blackett, 1859), pp. 122–3.

32. Émile Zola, *La Curée* (Paris: Livre de Poche, 1981), p. 52.

33. Arthur Meyer, *Ce que mes yeux ont vu* (Paris: Plon, 1911), p. 305. Meyer was the grandson of a rabbi from a middle-class Jewish family, who, over the course of his life, converted to Catholicism, edited *Le Gaulois* while embracing the right-wing political agenda, and espoused the anti-Dreyfusard agenda during the affair. Despite his elected affiliations, however, Meyer never ceased to be publicly associated with Jewishness, as his famed duel with Édouard Drumont attested.

34. From *L'Art et La Mode*, 1881, t. II, p. 26, referenced in Seni and Le Tarnec, *Les Camondo ou l'éclipse d'une fortune*, p. 112.

35. *L'Art et la Mode*, 1884, p. 344, quoted in Seni and Le Tarnec, *Les Camondo ou l'éclipse d'une fortune*, p. 116.

36. Madeleine Lemaire (1845–1928), for instance, was known as one of the inspirations for Proust's Madame Verdurin. Camondo's mentor, Charles Éphrussi (1849–1905), is widely cited as the principal inspiration for the character of Charles Swann. See de Waal, *The Hare with Amber Eyes*.

37. For the history of this shift in desirability, see Yvan Christ, Jean-François Barrielle, Thérèse Castieau and Antoinette Le Normand-Romain, *Champs-Élysées, Faubourg Saint-Honoré, Plaine Monceau* (Paris: Henri Veyrier, 1982). They argue that, throughout the nineteenth century, desirability moved first from the Left Bank to the Faubourg Saint-Honoré, then to Étoile or Monceau, and then, finally, to Trocadéro and the western suburbs of Boulogne.

38. Tedeschi to Moïse de Camondo, 21 July 1910, AMNC, LC.47.

39. See Roditi, 'Camondo's Way', p. 157. See also Anne Hélène Hoog, 'Les objets de culte juif, de l'oratoire familiale au musée', in *La Splendeur des Camondo: De Constantinople à Paris 1806–1945* (Paris: Musée de l'Art et de l'Histoire du Judaïsme, 2009), p. 124.

40. Moïse de Camondo to the president of the rue Buffault synagogue's administrative commission, 6 July 1910, AMNC, LC.33.

41. Bachelard, 'House and universe', in *Poetics of Space*, p. 43.

42. Loyer, 'A mansion in the 18th-century style', p. 69.

43. René Bétourné, *René Sergent architecte. 1865–1927* (Paris: Horizons de France, 1931), p. 6, quoted in Loyer, 'A mansion in the 18th-century style', pp. 67–8.

44. Loyer, 'A mansion in the 18th-century style', p. 69.

45. See Michel Steve, 'Un monument pastiche, le Musée Nissim de Camondo à Paris', p. 64.

46. Tedeschi to Moïse de Camondo, 16 September 1910, AMNC, LC.47. This letter is also quoted in Nora Seni and Sophie Le Tarnec, *Les Camondo*, p. 221.

47. Letter from Moïse de Camondo to René Sergent, 19 July 1911, AMNC, LC.34.

48. Letter from Moïse de Camondo to René Sergent, 25 January 1913, AMNC, LC.35.

49. Letter from Moïse de Camondo to René Sergent, 28 October 1913, AMNC, LC.35.

50. Moïse de Camondo to François Boucher, 9 February 1931, AMNC, LC.42.

51. Moïse de Camondo to Mlle Jumel, 30 March 1927, AMNC, LC.40.

52. Moïse de Camondo to Leopold Davis, 17 May 1922, AMNC, LC.38.

53. Moïse de Camondo to Henri Pettipas, 3 May 1929, AMNC, LC.40.

54. Stammers, 'Collectors, Catholics, and the Commune', p. 68.

55. S. Lion to Moïse de Camondo, 14 January 1913, AMNC, CM.1.1.
56. Moïse de Camondo to Maurice Daranitère, 19 July 1934, AMNC, LC.43.
57. Louis Bossy to Moïse de Camondo, 8 March 1927, AMNC, P.M.5.
58. Moïse de Camondo to Louis Bossy, 10 March 1927, AMNC, LC.40.
59. Stammers, 'Collectors, Catholics, and the Commune', p. 69.
60. Jean Seligmann to Moïse de Camondo, 30 March 1935, AMNC, CM.3.2.
61. See Christian Baulez, 'Le grand cabinet intérieur de Marie-Antoinette: Décor, mobilier et collections', in *Les Laques du Japon: Collections de Marie-Antoinette*, exhibition catalogue (Paris: Réunion des Musées Nationaux, 2002), p. 39. See also Rondot, 'Building a collection', in *The Camondo Legacy*, footnote 110.
62. The Cognacq-Jays, the founders of La Samaritaine department store, amassed a massive collection of eighteenth-century French painting and decorative arts, some 1,200 items in total, including paintings by François Boucher, Jean-Honoré Fragonard, and Jean-Antoine Watteau. It is housed today in the Musée Cognacq-Jay at 8, rue Elzévir in Paris.
63. The Tucks, a wealthy Franco-American couple, collected almost exclusively Louis XV objets d'art and furniture, a collection they donated to the Musée du Petit Palais in 1921.
64. Seymour Simches has written on the bourgeois taste for the ancien régime: 'Après 1840, le genre Watteau et Boucher eut encore plus de succès auprès des artistes et du public. La classe bourgeoise qui se développpaient, avec son goût grandissant du luxe, son intense désir de raffinement aristocratique, raffolait des Fêtes Galantes qu'on trouvait partout.' Moïse de Camondo fits in this demographic to some extent, although he preferred Neoclassicism to the Rocaille, the exuberant ancien régime style that was its immediate predecessor. See Simches, *Le Romantisme et le goût esthétique du XVIIIe siècle*, pp. 2–3.
65. By the time the collection became a museum, Vigée Lebrun's painting hung in the Large Study, where it remains today (CAM 113). See de Gary (ed.), *The Camondo Legacy*, p. 137.
66. Moïse de Camondo to Mme Edgar Stern, 25 February 1925, AMNC, LC.39.
67. Moïse de Camondo to M. Justin Godart, 28 March 1928, AMNC, LC.40.
68. Moïse de Camondo to André Weill, 12 October 1934, AMNC, LC.43.
69. The Camondo archives include a receipt from Cailleux on 26 June 1932, when Moïse bought the two paintings.
70. Moïse de Camondo to Sir Robert Abdy, 21 April 1933, AMNC, LC.43.
71. Moïse de Camondo to M. Armand Dayot, 18 November 1933, AMNC, LC.43.
72. Herbert Winlock (1884–1950), an Egyptologist by training, was director of the Metropolitan Museum between 1932 and 1939.
73. Moïse's comments on Europe were as follows: 'De plus, la situation politique, si troublée en Europe, ne me permet pas de prendre des engagements pour une date aussi lointaine.' See Moïse de Camondo to Herbert Winlock, 4 May 1935, AMNC, LC.45.
74. This quality Moïse seems to have appreciated and, to some extent, celebrated through his painstaking care of the objects themselves. This becomes clear in the pieces of his correspondence concerned with repairs, which he frequently demanded. See, for instance, his letter to M.P. Hamot dated 28 December 1929: 'J'ai bien reçu la chaise en tapisserie que vous m'avez renvoyée. Elle est parfaitement nettoyée et réparée et me donne toute satisfaction. Voulez-vous procéder au même travail pour les cinq autres chaises que je vous ai confiées.' AMNC, LC.41. See also his letter of 2 April 1930 to the director of the famed Gobelins tapestry manufacturer: 'Je vous remets . . . la somme de 38,000 Fr montant de la réparation des chaises en tapisserie que je vous ai confiées. Cette réparation a été faite et c'est là une preuve de plus du travail impeccable de la manufacture.' AMNC, LC.41.

5 THÉODORE REINACH: JEWISH PAST, FRENCH FUTURE

1. This is a phenomenon Tony Judt has described in some detail in the opening pages of *Postwar*. See Judt, *Postwar: A History of Europe Since 1945* (New York: Penguin, 2005), esp. 'The legacy of war', pp. 13–41.
2. De Chambrun, from an old French aristocratic and political family, was the French ambassador to Rome between 1933 and 1935.

3. Charles de Chambrun, quoted in *À la mémoire des Reinach* (Paris: Société d'Éditions Françaises et Internationales, 1950), p. 11.
4. Recently, the Villa Kérylos has begun to captivate writers. See, for instance, the beautiful novel about Théodore Reinach and his architectural fantasies by Adrien Goetz. Goetz, *Villa of Delirium*, trans. Natasha Lehrer (New York: New Vessel Press, 2020).
5. Initially, it was Julien Benda (1867–1956), the well-known author of *La Trahison des clercs* (1927), who coined this term, which was then employed by others in a variety of less playful contexts. Benda, also born into an assimilated Parisian Jewish family, had known the Reinach brothers at school. This he recounts in his memoir, Benda, *La Jeunesse d'un clerc* (Paris: Gallimard, 1936, reissued 1968).
6. Among other things, Salomon Reinach, a contemporary of Émile Durkheim's, was interested, as many were in the fin de siècle, in the sociology of religion. Between 1905 and 1923, for instance, he published his multi-volume study *Cultes, mythes et religions*; in 1909, he published *Orpheus: Histoire générale des religions*. In each, he had much to say about Judaism and Jewishness. In response to his friend Ernest Renan (1823–92), for instance, he decried what he called 'la prétendue race juive', which he considered an imagined community full of heterogeneous elements that derived from different ethnicities that had converted to Judaism throughout the centuries. Essentially, Salomon espoused a version of the so-called 'Khazar theory' of modern Jewish history, the divisive hypothesis that considers Ashkenazi Jews the descendants of the Khazars, a Turkic people from southern Russia, who allegedly converted to Rabbinic Judaism in the eighth and ninth centuries. 'Vous voyez', he wrote, 'combien est légitime la conclusion ainsi formulée par M. Topinard: "Les Juifs ne sont qu'une fédération religieuse. Ils ne sont ni une nation ni une race."' See Salomon Reinach, *Cultes, mythes et religions*, vol. III (Paris: Ernest Leroux, 1908), pp. 457–71. For the best general survey of Salomon's intellectual career in the fin de siècle, especially vis-à-vis the topic of religious sociology, see Aron Rodrigue, 'Totems, taboos, and Jews: Salomon Reinach and the politics of scholarship in fin-de-siècle France', *Jewish Social Studies: History, Culture, and Society* (new series), 10 (winter 2004), pp. 1–19.
7. *Discours de M. Gustave Glotz Président de l'Académie à l'occasion de la mort de M. Théodore Reinach, Membre de l'Académie*, 2 November 1928, Archives of the Institut de France, Paris.
8. Drumont published this article in *La Croix* in December 1899. Quoted in Pierre Birnbaum, *Les Fous de la république*, p. 22.
9. Ruth Harris, *The Man on Devil's Island*, p. 193.
10. Adolphe Reinach to Salomon Reinach and Juliane 'Lili' Reinach to Salomon Reinach, dated December 1896, Fonds Salomon Reinach, Boîte 136, no. 197, Bibliothèque Méjanes, Aix-en-Provence.
11. Hélène Reinach-Abrami to Salomon Reinach, dated December 1896, Fonds Salomon Reinach, Boîte 136, no. 198, Bibliothèque Méjanes, Aix-en-Provence.
12. Gertrude Kinkelein to Salomon Reinach, Boîte 136, no. 197, Fonds Salomon Reinach, Bibliothèque Méjanes, Aix-en-Provence.
13. Séance du Vendredi 5 février 1909, Procès Verbaux. Archives of the Institut de France, Paris.
14. Séance du Vendredi 12 mars 1909, ibid.
15. Séance du Vendredi 19 mars 1909, ibid. According to the meeting's minutes, the books Salomon donated were rare editions of Raymond Weill's *Des monuments et l'histoire des IIe et IIIe dynasties egyptiennes* and *La presqu'île du Sinaï* and M.J. Loth's *Les Vases à quatre anses* and *Fouilles de Massés vengeuen en Baden*.
16. It was the fellow art historian and archaeologist Edmond Pottier who had made this comment originally, but it was repeated elsewhere. See Charles Picard, 'Salomon Reinach, Théodore Reinach, Adolphe J. Reinach', in *À la mémoire des Reinach*, p. 39.
17. Joseph Reinach to Salomon Reinach, undated, Boîte 134, no. 75, Fonds Salomon Reinach, Bibliothèque Méjanes, Aix-en-Provence. I have seen the original document, but Joseph's penmanship in this letter is entirely illegible. I have therefore relied on Ruth Harris's full translation in *The Man on Devil's Island*, p. 190.
18. Léon Abrami to Salomon Reinach, 26 March 1910, Fonds Salomon Reinach, Boîte 1, no. 1, Bibliothèque Méjanes, Aix-en-Provence.

19. Hélène Reinach-Abramai to Salomon Reinach, undated, Fonds Salomon Reinach, Boîte 1, no. 15, Bibliothèque Méjanes, Aix-en-Provence.
20. Hélène Reinach-Abrami to Salomon Reinach, 13 January 1929, Fonds Salomon Reinach, Boîte 1, no. 5. Bibliothèque Méjanes, Aix-en-Provence.
21. Ibid.
22. Hélène Reinach-Abrami to Salomon Reinach, 2 May 1932, Fonds Salomon Reinach, Boîte 1, no. 12, Bibliothèque Méjanes, Aix-en-Provence.
23. See Hélène Reinach-Abrami, *La Bien-aimée*, 'Au Bois', pp. 4–5. Held in the Archives of the Musée d'Art et d'Histoire du Judaïsme, Paris.
24. See Corinne Casset, *Joseph Reinach avant l'affaire Dreyfus: Un exemple de l'assimilation politique des juifs de France au début de la IIIe République*, thesis, École des Chartes, 1992, quoted in Birnbaum, *Les Fous de la république*, p. 17.
25. Joseph Reinach to Salomon Reinach, undated, Fonds Salomon Reinach, Boîte 134, no. 102, Bibliothèque Méjanes, Aix-en-Provence.
26. See Christopher E. Forth and Elinor Accampo (eds), *Confronting Modernity in Fin-de-siècle France: Bodies, Minds, and Gender* (London: Palgrave Macmillan, 2010), esp. Steven C. Hause, 'Social control in late nineteenth-century France: Protestant campaigns for strict public morality', pp. 135–50.
27. Hélène Reinach-Abrami to Salomon Reinach, 25 October 1915, Fonds Salomon Reinach, Boîte 1, no. 2, Bibliothèque Méjanes, Aix-en-Provence.
28. Hélène Reinach-Abrami, *La Bien-aimée*, p. 21.
29. Ibid., p. 20.
30. Ibid., p. 23.
31. In direct response to his friend Renan (1823–92), Salomon decried what he called 'la prétendue race juive', which he considered an imagined community full of heterogeneous elements that had derived from different ethnicities that had converted to Judaism throughout the centuries. 'Vous voyez', he wrote, 'combien est légitime la conclusion ainsi formulée par M. Topinard: "Les Juifs ne sont qu'une fédération religieuse. Ils ne sont ni une nation ni une race."' See Salomon Reinach, *Cultes, mythes et religions*, vol. III (Paris: Ernest Leroux, 1908), pp. 457–71. For the best general survey of Salomon's intellectual career in the fin de siècle, especially vis-à-vis the topic of religious sociology, see Aron Rodrigue, 'Totems, taboos, and Jews: Salomon Reinach and the politics of scholarship in fin-de-siècle France', *Jewish Social Studies: History, Culture, and Society* (new series), 10 (winter 2004), pp. 1–19.
32. Natan Sznaider, *Jewish Memory and the Cosmopolitan Order* (Cambridge: Polity, 2011), p. 6. Snzaider's analysis centres on the case of Hannah Arendt, herself an uprooted 'cosmopolitan' by his definition at the same time as she was a thinker eternally engaged with reconciling Jewish particularity and universality, a theme he sees in the roots of all her major works.
33. See Pierre Birnbaum, 'Introduction', in Pierre Birnbaum (ed.), *Histoire politique des juifs de France: Entre universalisme et particularisme* (Paris: Fondation nationale des sciences politiques, 1990), p. 15. Birnbaum has also written what remains the best and most succinct survey of the Reinach family, which serves as the opening chapter of his landmark 1992 book on Jewish republicanism. See Birnbaum, 'Au coeur de la politique républicaine, les Reinach', in *Les fous de la République: Histoire politique des juifs d'État de Gambetta à Vichy* (Paris: Fayard, 1992), pp. 13–28.
34. Quoted in Sznaider, *Jewish Memory and the Cosmopolitan Order*, p. 66.
35. See, in general, Yosef Hayim Yerushalmi, *Zakhor: Jewish History and Jewish Memory* (Seattle: University of Washington Press, 1982).
36. See Aron Rodrigue, 'Léon Halévy and modern French Jewish historiography', in E. Carlebach, J. Efron, and D. Meyers (eds), *Jewish History and Jewish Memory: Essays in Honor of Yosef Hayim Yerushalmi* (Hanover, NH: Brandeis University Press, 1998), pp. 413–27.
37. Quoted in ibid., p. 415.
38. Ibid.
39. On Jewish studies in fin-de-siècle France, including a discussion of Théodore and Salomon Reinach, see especially Perrine Simon-Nahum, *La Cité investie: La 'Science du judaïsme' français et la République* (Paris: Éditions du Cerf, 1991).

40. See Michael Marrus, *The Politics of Assimilation: A Study of the French Jewish Community at the Time of the Dreyfus Affair* (Oxford: Oxford University Press, 1971).

41. See János Dési, 'An Old-New Story: The continued existence of the Tiszaeszlar blood libel', in *Antisemitism in an Era of Transition: Continuities and Impact in Post-Communist Poland and Hungary*, eds. François Guesnet and Gwen Jones (Frankfurt: Peter Lang, 2014), pp. 51–68.

42. Théodore Reinach, *Histoire des israélites depuis la ruine de leur indépendance nationale jusqu'à nos jours* (1884) (Paris: Hachette, 1901), p. 342.

43. Perrine Simon-Nahum has discussed Théodore's embrace of morality in the context of other contemporary Jewish scholars. See 'La foi et la science', in *La Cité investie* (Paris: Éditions du Cerf, 1991), pp. 219–39.

44. In a sense, Théodore was building on a trend in European political thought that had existed since at least the early modern period, in which Christian scholars across the continent began to view the Hebrew Bible and newly translated rabbinic materials as God-given guides for the practical functioning of a pure republic. On this, see Eric Nelson's stimulating study, *The Hebrew Republic: Jewish Sources and the Transformation of European Political Thought* (Cambridge, MA: Harvard University Press, 2010).

45. See de François de Callatay, 'Théodore Reinach, entre histoire ancienne et engagements contemporains', in Sophie Basch, Michel Espagne and Jean Leclant (eds), *Les Frères Reinach* (Paris: Colloque réuni les 22 et 23 juin 2007 a l'Académie des Inscriptions et Belles-Lettres, published by AIBL, 2008), p. 69.

46. Théodore Reinach, *Histoire des israélites*, p. vii.

47. Ibid.

48. Ibid., p. 377.

49. What Théodore called 'scientific truth' had to come above all else, and the *Union Libérale* would maintain from Jewish tradition only the practices that were 'piously essential' while repudiating those that were 'incompatible with the sense of beauty, with the large current of national life in which we wish to remain fully blended'. This was a vision essentially in line with the Reform movements advocated by *Abraham Geiger and others in the nineteenth-century. On Abraham Geiger, see Max Weiner, ed. Abraham Geiger & Liberal Judaism: The Challenge of the Nineteenth Century* (Philadelphia: Jewish Publication Society of America, 1962). See also Susannah Heschel, *Abraham Geiger and the Jewish Jesus* (Chicago: University of Chicago Press, 1998). For a general survey of Jewish reform movements and the long nineteenth century in Germany, see Amos Elon, The *Pity of It All: A Portrait of the German Jewish Epoch 1743-1933* (New York: Picador, 2003). For a concise and thorough survey of this transformation in the United States, see Jonathan D. Sarna, *American Judaism: A History* (New Haven, CT: Yale University Press, 2004), pp. 135–271.

50. Théodore Reinach, *Ce que nous sommes* (Paris: Union liberal israélite, 1917), p. 11.

51. Théodore Reinach, *Histoire des israélites*, p. 376.

52. Ibid., p. 378.

53. Théodore Reinach, *Les Monnaies juives* (Paris: Ernest Leroux, 1888), p. 8.

54. Heinrich Graetz (1817–91) wrote one of the first modern analyses of the history of the Jewish people. In his study, he was rather insistent that art was little more than a sophisti-cated form of paganism, an irrational and superstitious form of expression that did not at all befit the people of the book.

55. Only relatively recently have historians begun to consider the role of the visual arts in modern European Jewish life. The invaluable works of Richard I. Cohen, Ezra Mendelsohn, Elliot Horowitz, and Michael Berkowitz, among others, are all important foundations of the field. See especially Richard I. Cohen's excellent study, *Jewish Icons: Art and Society* in *Modern Europe* (Berkeley, CA: University of California Press, 1998); *Ezra Mendelsohn, Painting a People: Maurycy Gottlieb and Jewish Art* (Hanover, NH: University Press of New England, 2008); 'Jews, Communism and Art in Interwar America', *Studies in Contemporary Jewry* No. 20, 2004, pp. 99–133; and Elliot Horowitz, 'Giotto in Avignon, Adler in London, Panofsky in Princeton: Some Reflections on the Story of an Illuminated Fifteenth Century Italian Manuscript and Its Meaning', *Journal of Jewish Art*, No. 19–20 (1993–4), pp. 98–111. Much more scholarly attention has been paid to music's role in Jewish cultural

life and Jewish contributions to the history of music in modern Europe. Essentially from Gustav Mahler (1860–1911) onwards, this has taken the form of an interest in the respective contributions of Jewish composers, but especially in Jewish performers and conductors such as Mahler, Felix Mendelssohn (1809–47), and Arnold Schoenberg (1874–1951), among others. See, for instance, George Eliot's novel *Daniel Deronda* (1876), in which Jewishness is fundamentally linked to music and music-making. In the novel, Herr 'Klesmer' is a German-Jewish musician whose expertise Gwendolen Harleth can never surpass; Daniel Deronda's mother – the key to his own Jewish identity – is an opera singer. For more synthetic studies of this relationship, see Ruth Ellen Gruber, *Virtually Jewish: Reinventing European Jewish Culture* (Berkeley, CA: University of California Press, 2002) and Philip V. Bohlman, *Jewish Music and Modernity* (Oxford: Oxford University Press, 2008). On Mahler specifically, see Talia Pecker Berio, 'Mahler's Jewish Parable', *in Mahler and His World*, ed. Karen Painter (Princeton, NJ: Princeton University Press, 2002), pp. 87–111.

56. René Cagnat, 'Notice sur la vie et les travaux de M. Théodore Reinach', in *Comptes rendus des séances de l'Académie des Inscriptions et Belles-Lettres*, vol. 75, no. 4 (1931), pp. 374–93. Archives of the Institut de France, Paris.
57. Béatrice Éphrussi, née Rothschild, was a cousin by marriage of the collector and critic Charles Éphrussi (1849–1905), who was also a cousin by marriage of Théodore Reinach.
58. Fabrice Reinach, 'Le rêve de Théodore Reinach: La vie à Kérylos de sa construction au Musée', in *Architecture du rêve: Actes du 3ème colloque de la Villa Kérylos à Beaulieu-sur-Mer les 29&30 octobre 1992* (Paris: Académie des Inscriptions et Belles Lettres, 1994), p. 29.
59. Quoted in ibid., p. 30.
60. See 'The legend of Kérylos', in *The Villa Kérylos* (Paris: Culture Spaces, 2003), p. 15.
61. See Ovid, *Metamorphosis*, Book XI: ll. 710–48. These are the lines in which we find recounted the story of the halcyon, the inspiration for Théodore's villa. In brief, Ceyx and Alcyone were married and had angered Mount Olympus by referring to themselves as Zeus and Hera, respectively. The wrath of the gods caused them to die at sea, but, later, their compassion transformed them into halcyon birds. Ovid tells the story as follows:

> People doubted whether Ceyx felt this, or merely seemed to raise his face by a movement of the waves, but he did feel it: and at last through the gods' pity, both were changed to birds, the halcyons. Though they suffered the same fate, their love remained as well: and their bonds were not weakened, by their feathered form. They mate and rear their young, and Alcyone broods on her nest, for seven calm days in the wintertime, floating on the water's surface. Then the waves are stilled: Aeolus imprisons the winds and forbids their roaming, and controls his grandsons' waves.

See *Metamorphosis*, trans. David Raeburn (London: Penguin, 2004), pp. 420–62.
62. Emmanuel Pontremoli, 'Avant propos', *Kérylos* (Paris: Éditions des Bibliothèques Nationales de France, 1934), p. 12.
63. *The Villa Kérylos*, p. 16. See also Françoise Reynier, 'Archéologie, architecture et ébénisterie: Les meubles de la Villa Kérylos à Beaulieu-sur-Mer', *In Situ: Revue des Patrimoines*, no. 6 (2005): http://insitu.revues.org/9376#quotation
64. Built between 1911 and 1914, Pontremoli's Institut de Paléontologie is located at 21, boulevard Saint-Marcel, in Paris's 13th arrondissement. See Jean-Marie Pérouse de Montclos, *Le Guide du patrimoine: Paris* (Paris: Hachette, 2004), p. 466.
65. Pontremoli, 'Avant propos', *Kérylos*, p. 6.
66. These famous lines come from Whitman's *Song of Myself*: 'Do I contradict myself? / Very well then I contradict myself, / (I am large, I contain multitudes.)' In the interwar period, Whitman was popular among certain circles of European academic elites, largely thanks to his humanism, his pacifism, and his cosmopolitanism. He was especially popular among Jewish intellectual elites, a phenomenon the writer George Prochnik discusses in some detail in his recent study of Stefan Zweig. See Prochnik, *The Impossible Exile: Stefan Zweig at the End of the World* (New York: Other Press, 2014).
67. *The Villa Kérylos*, p. 26.
68. Ibid.

69. Pontremoli, in *Kérylos* (Paris: Éditions Bibliothèque Nationale de France, 1934), p. 8.
70. Ibid.
71. Ibid., p. 9.
72. Ibid.
73. Ibid.
74. *The Villa Kérylos*, p. 48.
75. Fabrice Reinach, 'Le rêve de Théodore Reinach', p. 34.
76. Ibid.
77. Ibid.
78. Ibid.

6 BÉATRICE ÉPHRUSSI DE ROTHSCHILD: A WOMAN COLLECTS

1. See Laurel Thatcher Ulrich, 'Vertuous women found: New England ministerial literature, 1668–1735', *American Quarterly* vol. 28 (1976), pp. 20–40.
2. I refer, here, mostly to Eugen Weber's now-standard interpretation of the French fin de siècle. See Weber, *France, fin de siècle* (Cambridge, MA: Harvard University Press, 1988), 'Decadence', pp. 9–27; 'The old arts and the new', pp. 142–59. See also Carl Schorske, *Vienna Fin-de-siècle: Politics and Culture* (New York: Vintage, 1979), 'Introduction', pp. xvii–xxv. See also Michel Winock, *Décadence fin de siècle* (Paris: Gallimard, 2017).
3. This is the case, for instance, in Bertrand Gille's two-volume study of the Rothschild family (1965–7), which mentions Béatrice only in its genealogy. Guy de Rothschild's memoir *Contre bonne fortune* (1983) mentions her only in a few parenthetical lines, and Niall Ferguson's monumental study of the Rothschild family, *The World's Banker* (1998), mentions only her marriage to Maurice Éphrussi and its potential financial appeal to her father, Alphonse. Even more interesting is that studies more closely related to Béatrice herself also avoid significant mention of her, such as Stanley Weintraub's *Charlotte and Lionel: A Rothschild Love Story* (2003) and Edmund de Waal's *The Hare with Amber Eyes* (2010), a portrait of the Éphrussi family, into which Beatrice married.
4. Most importantly, Pauline Prevost-Marcilhacy's monumental 2016 three-volume study of Rothschild collections and donations includes a very substantial section on Béatrice Éphrussi de Rothschild and the Villa Ile de France. See 'Beatrice Éphrussi de Rothschild, 1864-1934', in P. Prevost-Marcilhacy (dir.), *Les Rothschild, une dynastie de mécènes en France*, 3 vol., (Paris: Éditions du Louvre/BNF/Somogy), vol. II, pp. 250–381. Among the various essays in this section, see especially Prévost-Marcilhacy's own biographical sketch of Béatrice, 'Béatrice Éphrussi de Rothschild', pp. 250–9. This is the definitive work on Béatrice as a collector, and that volume includes multiple essays by specialists on various aspects of the Villa's collections. Philippe Malgouyres has written on its sculptures, pp. 260–71; Esther Moench on the villa's Italian and Spanish paintings, pp. 272–85; Ulrich Leben on Beatrice's eighteenth-century pieces and style, pp. 286–315; Guillaume Seret on her porcelains, pp. 316–59, among other contributions. In addition to this study, there is Michel Steve's *Béatrice Éphrussi de Rothschild* (Nice: Andacia Éditions, 2008) and Jacqueline Manciet's *La Sphinge* (Paris: Persée, 2011).
5. I draw, here, on recent scholarship on women collectors, specifically Julie Verlaine's excellent transnational study of women collectors from 1880 to the present. See Julie Verlaine, *Femmes collectionneuses d'art et mécènes, de 1880 à nos jours* (Paris: Hazan, 2014). See also *Women and the Art and Science of Collecting in Eighteenth-Century Europe*, ed Arlene Leis and Kacie L. Wills (New York: Routledge, 2021).
6. Béatrice Éphrussi's husband, Maurice Éphrussi, was a cousin of both of Théodore Reinach's wives; Charlotte-Marie Evelyne Hirsch-Kann (1863–89) and Fanny Thérèse Kann (1870–1917), who was a niece of Charles Éphrussi. Maurice Éphrussi, as it happened, was also the brother of Thérèse Fould, the wife of Léon Fould who later posed for Renoir.
7. See Mary Blume, *Côte d'Azur: Inventing the French Riviera* (London: Thames and Hudson, 1992), p. 10.

8. Moïse de Camondo's daughter, Béatrice de Camondo, married Théodore Reinach's son, Léon Reinach, in 1919. Théodore Reinach was a cousin of Béatrice Éphrussi's through marriage, via Charles Éphrussi.
9. These were Paul-Henri Nénot (1853–1934), who designed the Hôtel Meurice; Charles Girault (1851–1933), who designed the Petit Palais and had been contracted by Édouard de Rothschild for the manor at Gouvieux; Walter-André Destailleur (1867–1940), the son of Hippolyte Destailleur; Aaron Messiah (1858–1940), the court architect of Leopold II of Belgium; Ernest Sanson (1836–1918), a master of the Beaux Arts; René Sergent (1865–1927), Moïse de Camondo's architect; and Marcel Auburtin (1872–1926).
10. Most prominently among these ideas was the metal structure that supported the villa's roof, attached to a wooden canopy covered in plaster and stitched together with iron threads, which Béatrice was determined to see realized. I am grateful to The Rothschild Archive for providing me with this information. See esp. Ulrich Leben, 'Béatrice Éphrussi de Rothschild: Collector and curator', The Rothschild Archive, 2008–9, pp. 26: https:// www.rothschildarchive.org/materials/review_2008_2009_beatrice_ephrussi_1.pdf
11. See Thorstein Veblen, *The Theory of the Leisure Class: An Economic Study of Institutions* (1899; Oxford: Oxford University Press, 2009). Veblen discusses the notion of self-respect in great depth in his second chapter, 'Pecuniary emulation'.
12. See Philip Kolb, ed. *Correspondance de Marcel Proust* (Paris: Plon, 1988), tome XVI, no. 17, p. 67.
13. See Élisabeth de Gramont, 'La famille de Rothschild', *Au temps des équipages* (1928) (Paris: Grasset, 2017), p. 200. Élisabeth de Gramont, known as 'Lily', is among the most fascinating characters of the French fin de siècle. A close friend of Marcel Proust's, she was another writer whose memoirs are an indispensible document that describe the mindset of the age, chronicling as they do the world of the French aristocracy into which she had been born. De Gramont's father had married Marguerite de Rothschild (1855–1905), a relation of Béatrice's. But Élisabeth de Gramont was decidedly unusual for her milieu, becoming an outspoken supporter of the Popular Front and other socialist causes, and she was best known for her longtime romance with the American writer Natalie Clifford Barney. See Diana Souhami, *Wild Girls: Paris, Sappho, and Art: The Lives and Loves of Natalie Barney and Romaine Brooks* (New York: St. Martin's Press, 2004), esp. 'Lily de Gramont', pp. 72–8.
14. André de Fouquières, *Traces écrites* (Paris: 1951), p. 43.
15. René Gimpel, *Journal d'un collectionneur: Marchand de tableaux* (Paris: Calmann-Lévy, 1963), p. 16. Along with the Wildensteins and the Duveen brothers, René Gimpel – a brother-in-law of Joseph Duveen's – was among the most important art dealers in France in the interwar period, and indeed his memoir is a comprehensive eyewitness account of a seminal chapter in the history of modern art. He was an important champion of Pablo Picasso and Georges Braque when few of his contemporaries were.
16. Fouquières, *Traces écrites*, p. 43.
17. Gimpel, *Journal d'un collectionneur*, p. 16.
18. See Paula Hyman, 'Introduction', in Steven Martin Cohen and Paula Hyman (eds), *The Jewish Family: Myths and Reality* (New York: Holmes and Meier, 1986), p. 6.
19. This is Ruth Harris's term for the communal sensibilities of Jewish families during the Dreyfus Affair, which appears in her discussion of the Reinach family in particular. See Harris, *The Man on Devil's Island*, p. 188.
20. Pauline Prevost-Marcilhacy, 'La quête de la reconnaissance', in *Les Rothschild: Batisseurs et mécènes*, p. 53.
21. The definitive interpretation of this trope is Michael Graetz's *The Jews in Nineteenth-century France: From the Revolution to the Alliance Israélite Universelle*, trans. Jane Marie Todd (Stanford, CA: Stanford University Press, 1996), in his chapter entitled 'Rothschild, King of the Jews'.
22. The best single-volume biography of James de Rothschild remains Anka Muhlstein's *Baron James: The Rise of the French Rothschilds* (New York: Vendome Press, 1982).
23. Karen Bowie, *Les Grandes Gares parisiennes au XIXe siècle* (Paris: Action Artistique, 1997), p. 89.

24. Edmond de Rothschild to cousins, 5 December 1885, RAL, 13/202.
25. Prevost-Marcilhacy, 'Commanditaires et architectes', in *Les Rothschild: Batisseurs et mécènes*, p. 150. But the most important piece to date written on Alphonse's donations – and his collaboration with Léon Gauchez – is Prevost-Marcilhacy's more recent treatment of this subject in her 2016 multi-volume study of Rothschild collectors in France. See Pauline Prevost-Marcilhacy, 'Le mécénat envers les artistes en faveur des musées de région 1885–1905', P. Prevost-Marcilhacy (dir.), *Les Rothschild, une dynastie de mécènes en France*, 3 vol., (Paris: Éditions du Louvre/BNF/Somogy), vol. I, pp. 135–77.
26. Ibid.
27. Ibid.
28. Michel Steve, *Béatrice Éphrussi*, p. 43
29. The *Gazette des Beaux-Arts*, founded in 1859, was an indispensable resource for art historians, critics, and collectors alike until its closure in 2002. It was the primary locus of conversation and debate on all topics related to art and material culture in the fin de siècle, and it published many of the period's greatest names: Marcel Proust and John Ruskin, Bernard Berenson and the Goncourts. In keeping with the theme of this chapter, however, the *Gazette* provided ample evidence of the primacy of material culture among French-Jewish elites in the early decades of the twentieth century. In fact, many of the collectors featured here played a significant role in the journal, as contributors, funders, or editors. Edmond de Rothschild, for instance, partially financed it; Moïse de Camondo served on its advisory committee; and, after the death of Charles Éphrussi, Théodore Reinach served as its editor-in-chief. It then fell under the control of the prominent dealer Georges Wildenstein, whose family continued to operate it until its closure. In any case, the *Gazette* was yet another tie that linked this network of Jewish elites together in their common pursuit of art, objects, and the public identities that, in their eyes, material culture alone could furnish.
30. Edmund de Waal, *The Hare with Amber Eyes*, p. 36.
31. 'Charles Éphrussi', *Grove Art Dictionary* : http://www.oxfordartonline.com/subscriber/article/grove/art/T026431
32. Steve, *Béatrice Éphrussi*, p. 20.
33. Ibid., p. 16. For more on hysteria and its place in French society, specifically, see Janet Beizer, *Ventriloquized Bodies: Narratives of Hysteria in Nineteenth-Century France* (Ithaca, NY: Cornell University Press, 1994).
34. Ibid., pp. 26–8.
35. Ibid., p. 185.
36. Jonathan Pinfold, 'Horse racing and the upper classes in the nineteenth century', *Sport in History*, vol. 28, no. 3 (2008).
37. Steve, *Béatrice Éphrussi*, p. 44.
38. Ibid.
39. OE 465, RAL.
40. Memorandum des Règles Adoptés pour le Partage de la Succession de Feu le Baron Alphonse de Rothschild, OE 465, RAL.
41. René Gimpel, *Journal d'un collectionneur*, pp. 16–17.
42. Ibid., p. 17–18.
43. Albert Laprade's remarks have been published online by the Villa Île de France itself.
44. A fixture of Belle-Époque society, the writer Élisabeth de Gramont, best known for her memoirs of the period and her long-term romance with the American playwright Natalie Clifford Barney, was a cousin of Béatrice's by marriage. Her father had married Marguerite de Rothschild (1855–1905).
45. See *Boston Daily Globe*, 17 January 1897.
46. The origins of the 'Côte d'Azur' as a concept and a myth are unclear. Between 1862 and 1869, five editions of Émile Negrin's *Les Promenades de Nice* were published: these certainly depicted the impoverished, forgotten territory as a romantic tableau. In 1887, there was Guy de Maupassant's *Sur l'eau*, an account of a boat trip taken in Antibes – some of which, it turned out, he had written before he arrived – and the arrival of Queen Victoria in Cannes. Most of all, however, there was Stephen Liégard's *La Côte d'Azur*, published in

December 1887, which articulated the vision of the region we know today. Liégard, a wealthy Burgundy landowner, was an amateur poet and a minor literary figure in the Second Empire. He essentially gave the Côte d'Azur its name, a term he is believed to have coined by adapting the name associated with Biarritz at the time, 'La Côte d'Argent'. A handsome volume meant to be displayed in the home, Liégard's *La Côte d'Azur* was a tour of each major town and village along the coast, with an emphasis on the celebrities and luminaries who lived in each. This, Mary Blume has written, had a profound effect: 'Liégard did more than describe the Côte d'Azur: he defined it. What he called a fringe of coastline, a ribbon, now had a memorable name: it was packaged.' See Blume, *Côte d'Azur*, p. 44.

47. See Blume, *Côte d'Azur*, p. 36.
48. Ibid., p. 35.
49. Ibid., p. 37.
50. Ibid.
51. Quoted in ibid., p. 12.
52. Ibid., p. 38.
53. Gerald and Sara Murphy, acquaintances of Béatrice Éphrussi's, were wealthy American heirs who owned a villa on the Cap d'Antibes that they called the Villa America. There, they entertained the majority of the (mostly American) artists and writers known as the 'Lost Generation', the same milieu depicted in Ernest Hemingway's *A Moveable Feast*. They were amateur painters themselves, but they were mostly known as important Riviera *salonniers*. See Calvin Tomkins's 1962 *New Yorker* profile of the couple, which later became a book. Tomkins, 'Living well is the best revenge', *New Yorker*, 28 July 1962: http://www.newyorker.com/magazine/1962/07/28/living-well-is-the-best-revenge. See also Tomkins, *Living Well is the Best Revenge* (New York: Modern Library, 1998); Amanda Vaill, *Everybody Was So Young: Gerald and Sara Murphy, a Lost Generation Love Story* (New York: Houghton Mifflin, 1998).
54. See Nancy O'Neill, *Art and Visual Culture on the French Riviera, 1956–1971: The École de Nice* (London: Ashgate, 2012), esp. 'Postwar Nice: The Eden of the hexagon', pp. 17–49.
55. Xavier Girard, *The French Riviera in the 1920s* (Paris: Assouline, 2015), p. 8.
56. Quoted in Blume, *Côte d'Azur*, p. 56.
57. See Kenneth Silver, *Making Paradise: Art, Modernity and the Myth of the French Riviera* (Cambridge, MA: MIT Press, 2001), p. 25.
58. Ibid., p. 49.
59. There was, for instance, a significant Russian expatriate community in Menton, near the Italian border, where members built a Russian Orthodox church, a Russian cemetery, and several houses in this style which survive today.
60. Ulrich Leben, 'Béatrice Éphrussi de Rothschild: Creator and collector', p. 24.
61. Steve, *Béatrice Éphrussi*, p. 45.
62. Louis Mézin, 'Béatrice Ephrussi de Rothschild et l'Italie. Architecture et mobilier', *De la sphère privée a la sphère publique: les collections Rothschild dans les institutions publiques françaises*, dir. Pauline Prevost-Marcilhacy, Laura de Fuccia, and Juliette Trey (Paris: INHA, 2019). https://books.openedition.org/inha/11535?lang=en
63. Prevost-Marcilhacy, *Les Rothschild*, p. 16.
64. This observation – 'il existe un style Rothschild sombre et un style Rothschild clair' – is cited in Mario Pratz's study, *Histoire de la décoration d'intérieure* (Paris: Tisné, 1964; reissued by Thames and Hudson, 2008), p. 334.
65. Prevost-Marcilhacy, *Les Rothschild*, p. 16.
66. Leben, 'Béatrice Éphrussi de Rothschild: Creator and collector', p. 24.
67. I am grateful to the RAL for providing me with a copy of the inventory taken at Béatrice's death in January 1934 of every item and object in her possession – in the Villa Île de France, the Villa Rose in Monaco, and her Paris townhouse at 19, avenue Foch. The inventory for the Villa Île de France, a staggering list of 36 pages in small print type, lists the following under the heading 'Chambre de Madame': 'Tiépolo – Toile marouflés au plafond réprésentant renomée et un groupe de personnages vénitiens près d'un balcon'; '2 glaces trumeau en bois laqué blanc avec peinture en gris dans le goût de sauvage, réprésentant des amours aux bulles de savon et des amours dénicheurs d'oiseaux'. The value of the Tiepolo, appraised

in 1934, is listed as 10,000 francs; the value of the *trumeau* mirrors at 5,000 (2,500 each). In my analysis of the entire inventory, these specific pieces rank among the most valuable for specific objects. See: Succession de Madame Éphrussi: Etat Descriptif des Objets d'Art et d'Ameublement garnissant la Villa 'ILE DE FRANCE' située à Saint-Jean-Cap-Ferrat (Alpes Mmes), RAL, OE 405, p. 14.

68. Prevost-Marcilhacy, *Les Rothschild*, p. 15.
69. These aspects are covered in detail in Prevost-Marcilhacy's recent study. See especially Ulrich Leben, 'Le XVIIIe siècle à la Villa Ephrussi de Rothschild', in P. Prevost-Marcilhacy (dir.), *Les Rothschild, une dynastie de mécènes en France*, (Paris: Éditions du Louvre/BNF/Somogy, 2016), vol. II, pp. 286–315.
70. On this specific question of provenance, I have relied on the thorough analysis of Régis Vian des Rives, the former curator of the Villa Île de France and the former director of the Fondation Théodore Reinach. Unlike in the case of Moïse de Camondo, hardly any archival materials contextualize the personal attraction of Béatrice Éphrussi to specific objects and items in her collection: what survives is mostly the technical records of the house and its construction. See Régis Vian des Rives, 'Les Boiseries', in Vian des Rives (ed.), *La Villa Éphrussi de Rothschild* (Paris: Les Éditions de l'Amateur, 2002), p. 91.
71. Prevost-Marcilhacy, *Les Rothschild*, p. 15.
72. Hache was a family of *ébénistes* from Grenoble who produced some of the finest tables and cabinets of the ancien régime, pieces of local walnut wood decorated with marquetry that were extremely coveted in the nineteenth century. See Marianne Clerc's catalogue from an exhibition at Grenoble's Musée dauphinois. Clerc, *Hache, ébénistes à Grenoble* (Grenoble: Glénat, 1997).
73. André Gordelon to René Julien, 17 April 1911, Moscow Papers, box 1390, RAL.
74. Denis Troncy to René Julien, 18 April 1911, RAL.
75. P.C. Nabonnand & Cie, Les Roses du Golfe-Juan to René Julien, 18 April 1911, RAL.
76. Leben, 'Béatrice Éphrussi de Rothschild: Creator and collector', p. 26.
77. OE 466, RAL.
78. Ibid.

7 MUSEUMS OF MEMORY: FROM PRIVATE COLLECTIONS TO NATIONAL BEQUESTS

1. See Andrew McLellan, *Inventing the Louvre: Art, Politics, and the Origins of the Modern Museum in Eighteenth-century Paris* (Cambridge: Cambridge University Press, 1994).
2. Carol Duncan and Allan Wallach, 'The universal survey museum', *Art History*, vol. 3, no. 4 (1980), pp. 468–9.
3. I am grateful, here, to the argument advanced by Tony Bennett, who advocates the inclusion of the museum on Foucault's list of 'discourse'-generating institutions. See Bennett, 'The exhibitionary complex', in *The Birth of the Museum: History, Theory, Politics* (London: Routledge, 1995). See also Donald Preziosi, *The Brain of the Earth's Body: Art, Museums, and Phantasms of Modernity* (Minneapolis, MN: University of Minnesota Press, 2003).
4. See Robert Smithson, 'Some void thoughts on museums', in *Robert Smithson: The Collected Writings*, ed. Jack Flam (Berkeley, CA: University of California Press, 1996), pp. 41–2.
5. Quoted in ibid.
6. Ibid., p. xvi.
7. On the Stavisky Affair, see Paul Jankowski, *Cette vilaine affaire Stavisky: Histoire d'un scandale politique* (Paris: Fayard, 2000). On the Action Française, the best recent book is Laurent Joly, *Naissance de l'Action française* (Paris: Grasset, 2015).
8. Isaac de Camondo had a longstanding relationship with Lucie Bertrand (1866–1941), an acclaimed Opera singer who performed under the name Lucie Berthet. They had two sons together: Jean Bertrand (1902–80) and Paul Bertrand (1903–78).
9. 'Le Comte I. de Camondo', *Le Figaro*, 5 February 1897. The archives pertaining to Élisabeth Cahen d'Anvers during the war were assembled in one place for a 2015 local exhibition in Juigné-sur-Sarthe in Élisabeth's honor organized by Marie-Thérèse Ledier, Henri Massé and Luce Court. The documents they found have since been digitized here: https://lesdeportes-desarthe.wordpress.com/de-cahen-danvers-elisabeth-mme-la-comtesse/

10. Édouard Drumont, *La France juive*, vol. II, p. 150.
11. Isaac de Camondo to Musée du Louvre, 15 February 1911, AMNC, LC. 33.
12. Ibid.
13. Guillaume Apollinaire, *Chroniques d'art 1902–1918* (Paris: Gallimard, 2002), p. 488.
14. Musée National du Louvre, Gaston Braun (ed.), *Catalogue de la Collection ISAAC DE CAMONDO* (Paris: Louis-le-Grand, 1922), p. 4.
15. Paul Jamot, 'La Collection Camondo au Musée du Louvre', *Gazette des Beaux-Arts*, vol. 1 (1914), p. 388.
16. Ibid.
17. Moïse de Camondo to unnamed (female) friend, 10 January 1934, AMNC, Paris.
18. Nora Seni and Sophie Le Tarnec, *Les Camondo ou l'éclipse d'une fortune* (Paris: Actes Sud, 1997), p. 255.
19. Here Moïse refers to the drop-front oak sécretaire, *c.* 1770–80 – decorated in 'à la reine' marquetry – by the leading cabinetmaker Jean-François Leleu (1729–1807), who was named master of his workshop in 1764. Moïse eventually bought this piece for his son-in-law, Léon Reinach, in 1924 and displayed it in the library.
20. Moïse refers here to the painting *Bacchante* by Élisabeth Vigée Lebrun (CAM 113).
21. Moïse de Camondo, Last Will and Testament, 20 January 1924, pp. 1–3, AMNC.
22. Ibid., pp. 6–7.
23. See Drumont's comments on the Camondos''Oriental' origins in *La France juive*: 'Le projet de Banque orientale, qui souleva particulièrement contre lui Camondo et les Juifs levantins, aurait donné à la France une grande influence en Orient.' Drumont, *La France juive*, vol. I, p. 99.
24. See Winock's article on the Goncourts' particular brand of antisemitism: his argument is ultimately that it tied Jewish alterity to the realm of aesthetics and considered Jews as fundamentally averse to the principle of 'art for art's sake'. See also Michel Winock, 'L'Antisémitisme des Goncourt', in Jean-Louis Cabanès et al. (eds), *Les Goncourt dans leur siècle*.
25. Goncourts, *Journal*, vol. II, p. 943.
26. See Elizabeth Rodini, 'Preserving memory at the Musée Nissim de Camondo', *Museum History Journal*, vol. 7, no. 1 (January 2014), p. 43. Her excellent analysis focuses primarily on overlapping modes of memorialization at the Musée Camondo, particularly the impact of Holocaust memory on the existing collections and display.
27. Ibid., p. 44.
28. See David Lowenthal, 'Changing the past', in *The Past is a Foreign Country* (Cambridge: Cambridge University Press, 1985), pp. 263–362.
29. See Moïse de Camondo, 'Instructions et conseils pour Messieurs les conservateurs du Musée Nissim de Camondo', 20 January 1924, AMNC, p. 2. See also, de Gary (ed.), *The Camondo Legacy*, p. 273.
30. Ibid.
31. Ibid.
32. Ibid.
33. Ibid.
34. Jacques Guérin, 'Le Musée Nissim de Camondo', *L'Illustration*, 26 December 1936, p. 530.
35. Ibid., p. 531.
36. 'La Collection Camondo', *Art & Industrie*, (July 1936), p. 3.
37. Ibid., p. 5.
38. The Cahen d'Anvers, a traditional '*haute banque*' family, had interests in several industries in Argentina – silver, mining, and local infrastructure. Gilbert Cahen d'Anvers (1909–1995), Charles's eldest son, describes the family's partial relocation there in the late 1930s in the memoirs he published privately one year before his death, *Mémoires d'un optimiste* (1994). Today, most of the family's descendants remain in Buenos Aires, where they are active in the city's public life. Gilbert's daughter, Mónica Cahen d'Anvers (b. 1934, Buenos Aires), for instance, is a well-known Argentinian television journalist.
39. On the gardens specifically, see especially the celebrated horticultural historian Ernest de Ganay's 1934 article on the value of the house's gardens, restored by the landscape architect

Henri Duchêne (1841–1902) with the help of his son Achille Duchêne (1866–1947), who had also designed the gardens of Béatrice Éphrussi's Villa Île de France and Moïse de Camondo's Paris mansion. See also Runar Stranberg's 1963 analysis in the *Gazette des Beaux-Arts* on the architecture of the château, which praised its preservation of history. De Ganay, 'Le Château de Champs', *La Gazette illustrée des amateurs et jardins* (1933–4), pp. 1-29. Stranberg, 'Le Château de Champs', *Gazette des Beaux-Arts*, no. 1129 (1963), pp. 81–100. More recently, the most authoritative volume on the château in general is Renaud Serrette, *Le Château de Champs* (Paris: Éditions du Patrimoine, 2017).

40. Blondel was a formidable force in the French late Baroque, known most of all for his *Cours d'architecture*, which remained a seminal text for generations of students, such as Bullet. See Anthony Gerbino, *François Blondel: Architecture, Erudition, and the Scientific Revolution* (London: Routledge, 2010).

41. These included the Hôtel d'Evreux and the Hôtel Crozat, now the Hôtel Ritz.

42. Charles Cahen d'Anvers, 'Le Château de Champs: Notice historique', April 1927, p. 1. The document is held in the archives of the Bibliothèque Nationale de France, Paris.

43. Ibid.

44. Describing the bankruptcy of Charles Renouard de la Touanne, Treasurer during the reign of Louis XIV, Charles wrote the following, complete with precise citation: 'Mais la Touane [sic] fit faillite en 1701, et, décrété d'arrestation, mourut de saisissement sur le perron du château devant les exempts qui se présentait pour l'appréhender (Mémoires de Saint-Simon, Edition Régnier, T. 8, p. 302, Journal de Dangeau, T. 8, p. 117).' Ibid., p. 2.

45. Charles refers to a van Meulen painting that hung in the château's dining room. 'Cette peinture,' he wrote, 'où l'on reconnaît la tenue de l'équipage de Conti, nous montre l'aspect du château et de ses jardins à cette époque.' Ibid., p. 5.

46. Ibid., p. 2.

47. Ibid., p. 8.

48. Ibid., p. 9.

49. Ibid.

50. Here Charles refers to André Le Nôtre (1613–1700), perhaps the most famous landscape artist in French history and, notably, the principal designer of the gardens at Versailles. Le Nôtre's work is essentially synonymous with the '*jardin à la française*' – formal, ordered and geometric.

51. Ibid., pp. 9–10.

52. Ibid., p. 11.

53. See Alice Silvia Legé, 'Les Cahen d'Anvers en France et en Italie: Demeures et choix culturels d'une lignée d'entrepreneurs', PhD thesis (2020), pp. 233–64.

54. As popularized by Emil Fackenheim in his 1978 book, the term 'Jewish return into history' typically refers to the establishment of the state of Israel. It can also, as evidenced by uses in the 1920s and 1930s, refer to the origins of the Zionist movement in the 1880s and the project of reclaiming Jewish political autonomy. Charles Cahen d'Anvers was no Zionist – and, indeed, hardly a practising Jew – but his narrative seeks nevertheless to claim a rightful place for Jews in the narrative of French history he relays. See Fackenheim, *The Jewish Return into History: Reflections in the Age of Auschwitz and a New Jerusalem* (New York: Schocken, 1978).

55. His father, Louis Cahen d'Anvers, was born in Antwerp in 1837; his mother, Louise Morpurgo, was born in Trieste in 1845.

56. Ibid., p. 11.

57. See Michel Steve, *Théodore Reinach* (Nice: Serre, 2014), p. 180.

58. Quoted in ibid., p. 180.

59. See Fabrice Reinach, 'Le rêve de Théodore Reinach'.

60. See *Kérylos* (Paris: Éditions Bibliothèque Nationale de France, 1934).

61. Despite the Nazi destruction of the extensive papers and family archive Théodore maintained in this library at Kérylos, his books remained largely untouched and remain on display today.

62. Gustave Glotz, *À l'occasion de la mort de Théodore Reinach* (1928), p. 6. Archives of the Académie des Inscriptions et Belles-Lettres, Institut de France, Paris.

63. René Cagnat, *Notice sur la vie et les travaux de Théodore Reinach* (1931), p. 4. Archives of the Académie des Inscriptions et Belles-Lettres, Institut de France, Paris.
64. Ibid.
65. Ibid.
66. Béatrice Éphrussi de Rothschild, Last Will and Testament, 25 February 1933, OE 405, RAL.
67. See Bann's comparison of Alexandre du Sommenard's more innovative, environmental display practices with the traditional, taxonomic approach of Alexandre Lenoir (1761–1839), conservator of the Revolutionary Musée des monuments français, which housed art and objects looted from châteaux and aristocratic homes across France. Bann, 'Historical texts and historical objects: The poetics of the Musée de Cluny', *History and Theory*, vol. 17 (1978), pp. 251–66.
68. This section is the entire fifth chapter of *La France juive*'s second volume.
69. Drumont, *La France juive*, vol. II, p. 71.
70. Baron Édouard de Rothschild to Charles Widor, 11 April 1934, OE 405, RAL.
71. Rothschild to Widor, 18 April 1934, ibid.
72. Widor to Rothschild, 19 April 1934, ibid.
73. Widor to Rothschild, 20 April 1934, ibid.
74. Widor himself, by the summer of 1934, began referring to Béatrice's bequest of the Villa Île de France as the 'Musée Rothschild', an association which suggests the ways in which the family was fundamentally linked to the public afterlife of Béatrice's collections and home.
75. 'En faveur des beaux-arts', *L'Intransigeant*, 16 April 1934, OE 405, RAL.

8 TO THE END OF THE LINE: DRANCY AND AUSCHWITZ

1. Emmanuel Berl, *La Fin de la IIIe République* (1968) (Paris: Gallimard, 2007), p. 60.
2. Julian Jackson, *France: The Dark Years 1940–1944* (Oxford: Oxford University Press, 2003), p. 120.
3. Antoine de Saint-Exupéry, *Pilote de guerre* (1942), in *Oeuvres*, ed. R. Caillois (Paris: Gallimard, 1961), p. 317.
4. Béatrice de Camondo to Georges Léon, 22 July 1940, Archives of Musée de l'Art et d'Histoire du Judaïsme, Paris.
5. See Jacques Adler, *The Jews of Paris and the Final Solution: Communal Response and Internal Conflicts, 1940–1944* (Oxford: Oxford University Press, 1987), p. 85.
6. Raymond-Raoul Lambert, *Carnet d'un témoin 1940–1943*, ed. Richard Cohen (Paris: Fayard, 1985), p. 85.
7. Élisabeth Cahen d'Anvers, 21 October 1940, 'Attestation de residence', Archives départementales de la Sarthe (hereafter, ADS).
8. Élisabeth Cahen d'Anvers, 18 October 1940, 'Certificat médical', ADS.
9. Élisabeth Cahen d'Anvers, 'Recensement des israélites', 21 October 1940, ADS.
10. *L'Exposition Renoir 1841–1919*, exhibition catalogue (Paris: Musée de l'Orangerie des Tuileries, 1933), no. 57.
11. See 'Collections particulières saisies par les Allemands dans les dépôts de Chambord, de Brissac et du Louvre', Archives Nationales, 20144792/270 [5]. In addition to the Renoir portrait, the inventory list reveals ten other pieces stolen from the Camondo-Reinach apartment, including a watercolour by Gustave Moreau and two gouaches by Christophe Huet.
12. Reproduced in Joseph Wulf, *Die bildenden Künste im Dritten Reich: Eine Dokumentation* (Berlin: Gebrüder Mann, 1983), pp. 415–19. This translation comes from the US Office of Strategic Services, National Archives, Washington, DC. The document is also available online via the Documentation Project of Loyola University: http://docproj.loyola.edu/jdp/index.html
13. Julien Reinach to Commissariat Général aux Questions Juives, Vichy, Beaulieu-sur-Mer, 27 October 1941, AMNC, Paris.
14. See Fabrice Reinach, 'Le rêve de Théodore Reinach: La vie à Kérylos de sa construction au musée', *Publications de l'Académie des Inscriptions et Belles-Lettres*, no. 3 (1994), pp. 25–34.

15. 'Paiment de pensions', 17 February 1942, Commissariat Général aux Questions Juives, Paris.
16. Nancy H. Yeide, *Beyond the Dreams of Avarice: The Hermann Goering Collection* (Dallas, TX: Laurel Publishing, 2009), no. D100.
17. This anecdote was told to me by Catherine Bonnet, the granddaughter of André Dubonnet and Claude ('Pussy') Sampieri.
18. Dubonnet's *hôtel particulier* in Neuilly is referenced in the privately published memoirs of Lorraine Dubonnet, shared with me by Catherine Bonnet. The Dubonnet home also appears in the archives of the Carlhian design firm, preserved at the Getty Research Center in Los Angeles.
19. See Jean-Marc Dreyfus and Sarah Gensburger, *Des camps dans Paris: Austerlitz, Levitan, Bassano, juillet 1943–août 1944* (Paris: Fayard, 2003), p. 102.
20. Ibid., p. 101.
21. Ibid., p. 102.
22. Ibid., p. 93.
23. Colette Cahen d'Anvers-Moore, *Eight Years of a Life*, undated. Archives of the United States Holocaust Memorial Museum, Washington, DC, p. 35.
24. Ibid.
25. Ibid.
26. Ibid.
27. Ibid., pp. 31–2.
28. Ibid.
29. 'Divorce Reinach', 12 October 1942, Archives de Paris, 38W103, pp. 18–19.
30. Interview with Philippe Erlanger by Jean-Franklin Yavchitz, 5 October 1982, p. 4. Private Archives, Paris.
31. 'Pensions servies par Madame Léon REINACH, née de Camondo', 1942, Archives of Centre Documentation Juive Contemporaine.
32. Béatrice de Camondo-Reinach to childhood friend, p. 2.
33. Archives of the Préfecture de Police de Paris, 'Registre Consignations Provisoires', 29 November 1942–15 March 1943.
34. Vernes et Cie to Commisariat Genéral aux Questions Juives, 3 December 1943, Commissariat Général aux Questions Juives, Paris.
35. Préfecture Regional d'Angers to Préfet Régional de la Sarthe, 18 March 1942, ADS.
36. Élisabeth Cahen d'Anvers to the mayor of Juigné-sur-Sarthe, 30 December 1942.
37. Recensement: Élisabeth Cahen d'Anvers, Mairie de Juigné-sur-Sarthe, 6 May 1943.
38. 'Rapport', Préfecture de la Sarthe, 31 January 1944, ADS.
39. Préfecture de Police de Paris to Préfet de la Sarthe, Affaires Juives, 7 February 1944, received 9 February 1944, ADS.
40. Georges Wellers, *L'Étoile jaune à l'heure de Vichy: De Drancy à Auschwitz* (Paris: Fayard, 1973), p. 184.
41. Annette Wieviorka and Michel Laffitte, *À l'intérieur du camp de Drancy* (Paris: Perrin, 2012), p. 8.
42. Wellers, *L'Étoile jaune*, p. 165.
43. Testimony of Mme Appel, quoted by Filippo Tuena, *Le variazioni Reinach* (Rizzoli: Milan, 2005), p. 270.
44. Violaine Reinach and her sister Laurence were saved by Jeanne Talon, a Parisian knitting worker who hid them and their two cousins Donatella and 'Titon' Allatini in a small village in Normandy. All four girls survived the war, and Talon was subsequently honoured by Yad Vashem in 1999.
45. Simone Veil, *Une vie* (Paris: Stock, 2007), p. 52.
46. Robert Paxton and Michael Marrus, *Vichy France and the Jews* (New York: Basic Books, 1981), p. 253.
47. Quoted in ibid.
48. Brunner devised this system after a meeting with Adolf Eichmann in Berlin in June 1943, before officially assuming control of Drancy. See Wieviorka and Laffitte, *À l'intérieur du camp de Drancy*, p. 230.

49. Wellers, *L'Étoile jaune*, p. 194.
50. Tuena, *Le variazioni Reinach*, p. 270.
51. Doda Conrad, *Dodascalies: Ma chronique du XXe siècle* (Paris: Actes Sud, 1997), p. 482.
52. Béatrice de Camondo to Nadine Anspach, undated, Private Archives, Paris.
53. See Wieviorka and Laffitte, *À l'intérieur du camp de Drancy*, p. 294.
54. See Wellers, *L'Étoile jaune*, p. 216.
55. Ibid., p. 217.
56. Wieviorka and Laffitte, *À l'intérieur du camp de Drancy*, p. 297.
57. Ibid., p. 295.
58. See Guy Kohen, *Retour d'Auschwitz: Souvenirs du déporté 174949* (1945) (Paris: Éditions Le Manuscrit, 2006).
59. 'Liste officielle No. 3 des décédés de camps de concentration', Archives Nationales de France, Dossier F/9/3213, p. 68

9 'LA PETITE IRÈNE': THE AFTERLIFE OF A PORTRAIT

1. For the story of Irène Sampieri in general, I am extremely grateful to Catherine Bonnet, her great-granddaughter, who graciously shared her recollections with me.
2. Irene Sampieri to unnamed recipient, 21 November 1945, 'Comtesse Irène Sampieri', 15-917, Archives Ministère des Affaires Étrangères, La Courneuve, France.
3. See *Les Chefs d'oeuvre des Collections Privées Françaises retrouvés en allemagne par la Commission de Récuperation Artistique et les Services Alliés* (Paris: Musée de l'Orangerie, 1946), p. 17.
4. Henraux to E. Servant, 16 October 1946, 'Comtesse Irène Sampieri', 15-917. Archives Ministère des Affaires Étrangères, La Courneuve, France.
5. René Joly to Henraux, 18 October 1946, ibid.
6. Irène Sampieri to lawyer, 10 October 1946, ibid.
7. See Filippo Tuena, *Le variazioni Reinach*, pp. 179–81.
8. Art Looting Intelligence Unit (ALIU) Reports 1945–1946. The reports are available digitally at: https://www.lootedart.com/MVI3RM469661
9. On Buhrle and Paul Rosenberg, see Emmanuelle Polack, *Le marché de l'art sous l'occupation 1940–1944* (Paris: Tallandier, 2019), pp. 164–6, 215.
10. I refer, here, to Stanley Hoffmann's famous definition of 'collaborators' in wartime France. Some were 'voluntary' while others were 'involuntary', Hoffmann argued. Bührle's motivations are difficult to deduce, although he had previously sold arms to the Allies before Switzerland was surrounded by Axis powers. See Hoffmann, 'Collaborationism in France during World War II', *The Journal of Modern History*, Vol. 40, No. 3 (September 1968), pp. 375–95.
11. Yves Mainguy to Georges Salles, 31 October 1958, 'Comtesse Irène Sampieri', 15-917. Archives des Affaires Étrangères, La Corneuve, France.
12. 'Nécrologie: Julien Reinach', *Revue internationale de droit comparé*, vol. 14, no. 2 (avril–juin 1962), p. 433.
13. The dramatic story of the Fould-Springer family at Royaumont before and after the war has been beautifully told by David Pryce-Jones in his memoir, *Fault Lines* (New York: Criterion, 2015).
14. Hélène Propper de Callejón, *I Loved My Stay* (London, 1998), p. 121. Propper Family Archive, New York City.
15. Ibid.
16. Ibid.
17. Ibid.
18. See *Catálogo do Museu de Arte de São Paulo Assis Chateaubriand: Arte Francesa e Escola de Paris*, ed. Luis Marquez (São Paulo, 1998), pp. 124–41.
19. 'Donation de sépulture par Mesdames Sampieri à Mme Anspach', 7 November 1961. Notaire M. Pierre Ader, Private Archives, Paris.
20. Telephone interview with Maguy Tran, 4 August 2020.

CONCLUSION: A DEATH CERTIFICATE

1. See especially Susan Suleiman, *The Némirovsky Question: The Life, Death, and Legacy of a Jewish Writer in 20th-century France* (New Haven, CT: Yale University Press, 2016).
2. Jacques Semelin, *The Survival of the Jews in France 1940–1944* (Oxford: Oxford University Press, 2019), trans. Natasha Lehrer and Cynthia Schoch.
3. Ibid., p. 247.
4. Albert Camus, *Le Premier Homme* (Paris: Folio, 1994), p. 93.
5. Patrick Modiano, *Dora Bruder* (Paris: Gallimard, 1997), pp. 144–5.

INDEX

Page references to illustrations are shown in *italics*.

Abrami, Léon, 139
Alfassa, Léon, 55–6
Anspach, Nadine, 238, *239*, 253
antisemitism
 financial scandals and, 54
 following the Dreyfus Affair, 12, 13–14,
 15–16, 21, 135, 136–7, 138
 history of French antisemitism, 7,
 49–50
 impact of the tiara of Saitaphernes affair,
 76–7
 against Jewish financiers, 55, 56, 57
 Jewish threat to French cultural patrimony,
 14, 50, 60–4, 72–3, 187–8, 194–5
 material antisemitism, 14, 47–8, 53,
 59–62
 in the military, 79–80
 of Pierre-Auguste Renoir, 32
 the 'Rothschild Jew' trope, 164–5, 210
 during the Third Republic, 52–3, 117
 see also Drumont, Édouard
Apollinaire, Guillaume, 191
Arendt, Hannah, 15, 22–3, 49
Aron, Marguerite, 232
art
 ancien régime objects and national iden-
 tity, 47–8, 51, 53, 68–71, 107
 French schools of, 69–70
 relationship between aesthetics and poli-
 tics, 69–70
art collections
 as bequeathed to the state, 1–2, 6, 8, 11,
 15
 of the French-Jewish establishment, 7–8,
 10–11, 12–14, 20, 47–8, 217
 French-Jewish identities and, 12–13,
 259–61
 Jewish threat to French cultural patrimony,
 14, 50, 60–4, 72–3, 187–8, 194–5

Léon Reinach's letter to Jacques Jaujard,
 221–3, 225, 230
 Nazi looting of, 220–1, 227–9, 247–8
 see also collectors
Auslander, Leora, 10

banking
 Alfassa Affair, 55–6
 antisemitism against Jewish financiers, 55,
 56, 57
 I. Camondo & Cie bank, 55, 81, 104,
 109–10
 Jewish-owned banks, 52
 Panama scandal, 56–7, 67, 74
 Union Générale collapse, 54–5
Benjamin, Walter, 8–9, 13, 50, 127, 175
Bloch, Marc, 78–9
Bonnat, Léon, 27, 30
Boucher, François, 70, 71–2
Brunner, Alois, 235, 236, 237
Bührle, Emil, 247

Cagnat, René, 206
Cahen d'Anvers, Albert, 31, 35
Cahen d'Anvers, Alice *see* Townshend, Lady
 Alice (née Cahen d'Anvers)
Cahen d'Anvers, Charles
 at Château de Champs-sur-Marne, *199*
 donation of Château de Champs-sur-
 Marne to the state, 198–203
 move to Argentina, 227
 role of Château de Champs-sur-Marne in
 French history, 200–3
 during WWI, 92
Cahen d'Anvers, Colette, 92, 226–9, 235,
 250
Cahen d'Anvers, Élisabeth
 arrest and deportation of, 229, 235
 Jewish identity of, 218–19, 232–4

marriages, 24
photograph of, *219*
Rose et bleu (Renoir) portrait, 18, 19, 30,
 32–4, 251–2
Cahen d'Anvers family
 Bassano townhouse, 26, 28, 34, 39, 105,
 227
 as exemplars of Jewish family life, 26–7
 during WWI, 81, 92, 229
 see also Château de Champs-sur-Marne
Cahen d'Anvers, Gilbert, 30, 92, 94–5, 227
Cahen d'Anvers, Irène
 in Cannes, post-WWII, 253
 claim on the Camondo estate, 247
 death of, 254
 death of Nissim, 102
 defence of Élisabeth Cahen d'Anvers non-
 Jewish status, 233–4
 dispute over the children, 37–9, 220
 divorce from Moïse de Camondo, 23, 37,
 41, 106–7
 marriage to Carlo Sampieri, 24, 37–40
 marriage to Moïse de Camondo, 11, 23,
 35–7
 photographs of, *33, 95, 254*
 Renoir's portrait of, 5, 18, 19, 30, 32, 34,
 220–1, 225–6, 244
 social milieu of, 20, 23–4
 during WWII, 244–5
Cahen d'Anvers, Louis
 bailout of the Union Générale, 55
 character of, 30
 as a collector, 26
 marriage of Irène to Moïse, 37
 portrait of Louise Cahen d'Anvers, 31
 Renoir commissions for, 18
 renovation of Château de Champs-sur-
 Marne, 11, 94–5, *95*, 181, 198
Cahen d'Anvers, Louise de (née Morpurgo)
 at Château de Champs-sur-Marne, *95*
 as a collector, 26
 as the feminine ideal, 28–31
 marriage of Irène to Moïse, 37
 portrait of, *29*, 30–1
 social status of, 31–2
Cahen d'Anvers, Meyer Joseph, 26–7
Camondo, Abraham Behor de, 55, 56, 81,
 110, 114, 115–16
Camondo, Abraham Salomon, 110–13, 114,
 119, 193
Camondo, Béatrice de
 after her parents' divorce, 37–9, 41, 220
 after the German invasion, 214–16, 219–20
 arrest and deportation of, 2, 5–6, 234,
 235, 241–3

at Château de Champs-sur-Marne, *95*
conversion to Catholicism, 4–5, 216,
 230–2, 238
death certificate, 255–6
death of, 131
death of Nissim de Camondo, 99–100,
 103–4
divorce from Léon Reinach, 5, 24,
 229–30, 247, 248–9
in the Drancy camp, 5, 236–41, *237*
funeral of Théodore Reinach, 204
marriage to Léon Reinach, 11, 103, 127
ownership of 'La Petite Irène' portrait, 5,
 19, 34, 220–1, 225–6, 244, 248–9
passion for horses, 87, 117, *214*
photographs of, *1, 39, 40*
relationship with Nissim de Camondo, 87,
 99–100
requests for payments to non-Jewish em-
 ployees, 3, 230–1, 232
source material on, 2–4
see also *Mlle Irène Cahen d'Anvers* ('La
 Petite Irène')
Camondo, Bertrand de
 after his parents' divorce, 229, 230
 arrest and deportation of, 2, 5–6, 231,
 235, 240–1
 conversion to Catholicism, 5, 231
 death of, 131, 243
 escape attempt from Drancy, 239–40
 photograph of, *242*
Camondo, Clarisse de, 55, 56
Camondo, Fanny de, 2, 5–6, 131, 230, 235,
 240–1
Camondo, Irène de *see* Cahen d'Anvers,
 Irène
Camondo, Isaac de
 bequest to the Louvre, 11, 188–91, 197,
 222
 as a collector, 81, 116
 'foreignness' of, 190, 191
 photograph of, *189*
Camondo, Moïse de
 ancien régime aesthetic in the collection
 of, 2–3, 107–8, 120, 123–7
 bailout of the Union Générale, 55
 caricature of, *106*
 as a collector, 36, 105, 116, 123–30
 creation of the Musée Nissim de Camon-
 do, 1–2, 17, 191–8
 death of Nissim, 83–4, 98–100
 dispute over the children, 37–9, 220
 divorce from Irène Cahen d'Anvers, 23,
 37, 41, 106–7
 family background, 35, 36

marriage to Irène Cahen d'Anvers, 11, 23, 35–7
with Nissim de Camondo, *124*
repatriation of Nissim's body, 100–2
rue de Monceau house, 107–8, 115, 117–23, 181, 191
rue Hamelin house, 105

Camondo, Nissim de
after his parents' divorce, 37–9, 41, 220
in the airforce, 96–8, *97*
appendicitis, 88–9
in the banking industry, 81–3
at Château de Champs-sur-Marne, 95–6, *95*
death of, 97–9
in the military, 83, 86–7
with Moïse de Camondo, *124*
Moïse's repatriation of the body of, 100–2
photographs of, *39, 82, 89, 95*
relationship with Béatrice de Camondo, 87, 99–100
relationship with Renée Dorville, 89–90, *89*
snobbery of, 87–8

Camondo, Nissim de (1830–89), 56, 110, 113, 114, 115–16, 117, 119, 190, 195

Camondo family
Alfassa Affair, 55–6
Camondo tomb, 253
contribution to French cultural life, 116, 194–5, 222, 229–30
as exotic Orientals, 113–14, 115, 190
I. Camondo & Cie bank, 55, 81, 104, 109–10
Jewish identity of, 111–13
Marcel Proust's friendship with, 89–90, 99
Monceau house, 114–15, 116
origins of, 108–10, 118
as part of the Parisian elite, 116–17
personal collection of Judaica, 115–16, 118–19
philanthropy of reform, 110–13, 115
during WWI, 81

Camus, Albert, 259
Carolus-Duran (Charles Durand), 27, 30, 31, 36, 190, 194, 195
Chasseloup-Laubat, Marie-Louise de, 4
Château de Champs-sur-Marne
aerial view of, *19*
the Cahen d'Anvers family and, 11, 26, 94–5, *95*, 181, 198
Charles Cahen d'Anvers at, *199*
donation of to the state, 198–200
government use of, 258
Louise Cahen d'Anvers portrait in, 31

Nissim de Camondo at, 95–6, *95*
significance of in French history, 200–3
Château de Ferrières, 14, 60–4, *63*, 211
collection museums, 186–7, 209, 257–8
collectors
ancien régime objects and national identity, 47–8, 51, 53, 68–71, 107, 125, 127
of the fin de siècle, 13–14, 20, 50–1
gendered differences among, 24–6
in literature, 9
within material culture, 10, 14–15
psychological motivations, 7–8, 9–10, 20
transformation of collected objects, 8–9
Conrad, Doda, 238
Côte d'Azur
as an artistic centre, 176
Cap Ferrat, *174*
development of, 173–5, 180–1
see also Villa Île de France, Saint-Jean-Cap-Ferrat; Villa Kérylos

Darnton, Robert, 6
Daudet, Léon, 48, 53
Denon, Dominique Vivant, 70
Dorville, Renée, 89–91, *89*
Drancy camp, 234–41
Dreyfus, Alfred
accusation of treason against, 79–80
granddaughter of, 241
photograph of, *12*
Reinach brothers' defence of, 24, 42, 65–7, 74, 135–6
Dreyfus, Gustave, 48
Dreyfus Affair
antisemitism following, 12, 13–14, 15–16, 21, 135, 136–7, 138
events of, 79–80
French-Jewish identities and, 7, 64–5, 67–8
Drumont, Édouard
antisemitism against the Reinachs, 74, 137
antisemitism of, 49, 58–62
attack on Nissim de Camondo's portrait, 190, 195
as a collector, 14, 59
critique of the Château de Ferrières, 14, 60–4, *63*, 211
deal with Jacques de Reinach, 57
on the Dreyfus Affair, 67
Jewish threat to French cultural patrimony, 14, 50, 60–4
La France juive, 14, 52–3, 59–60, 61, 165, 190
La Libre Parole, 57, 60, 77

Mon vieux Paris, 59–60
 photograph of, *58*
 on the tiara of Saitaphernes scandal, 77
Dubonnet, André, 226, 244, 253
Dubonnet, Lorraine, 30, 40–1, 253
Duchêne, Achille, 95, 119, 121–2, 181

Éphrussi, Béatrice (née Rothschild)
 character of, 159–60, 161–2, 168–9,
 170–3
 as a collector, 160, 180, 208
 death of, 208
 the 'dog wedding', 172–3, 183
 funeral of Théodore Reinach, 204
 marriage to Maurice Éphrussi, 36, 169–70
 material culture of, 161, 162–3, 168
 roof design for Villa Île de France, 182–3
 see also Villa Île de France, Saint-Jean-Cap-
 Ferrat
Éphrussi, Charles, 25, 32, 105, 125, 167–8
Éphrussi, Maurice, 36, 160, 161, 167,
 169–70
Éphrussi family, 167
Erlanger, Philippe, 108, 229, 247

Fould, Eugène, 68, 92–3
Fould, Léon
 as a collector, 25–6, 68
 at Nissim de Camondo's funeral, 102
 Royaumont, 25, 181
Fould-Springer, Hélène, 25, 68, 93, 250–1
Fould-Springer, Liliane, 250–1
Fould-Springer, Marie-Cécile, 92–3
Fould-Springer, Max, 250–1
Fragonard, Jean-Honoré, 70, 71
Frankl, Ludwig August, 114
French-Jewish establishment
 after the German invasion, 216–17
 Alliance israélite universelle, 112–13
 art collections of, 6, 7–8, 10–11, 12–14,
 20, 217
 clannishness of, 163
 between the Dreyfus Affair and WWII,
 7–8, 11, 12–13, 15–16
 financial scandals and, 54
 French histories of Judaism, 144–8
 within French material culture, 14–15
 gendered roles in, 23–7
 horse racing culture, 169–70
 houses of, 11, 15
 Jewish cosmopolitan identity, 143–4
 Jewish faith, 41–2
 Jewish identities of, 6–7, 15–16, 21–3,
 42–5, 217–18
 Parisian society of, 11, 13

post-WWII, 249–50
during the Third Republic, 52–3, 79, 117
tradition of philanthropy of reform,
 112–13, 115
during WWI, 80–1, 84–5, 91–4
during WWII, 257

Godard, Jean-Luc, 252, *252*
Goncourt, Edmond de
 antisemitism of, 28–30, 47–8, 53, 72
 critique of collecting culture, 13, 50–1
 descriptions of Louise Cahen d'Anvers,
 28–30, 32
 Jewish threat to French cultural patrimony,
 62, 63, 72–3, 195
 nostalgia for art of the ancien régime,
 71–2, 107, 195
 remarks on Edmond de Rothschild, 60–1,
 72–3
Goncourt, Jules de
 on Alphonse de Rothschild, 211–12
 antisemitism of, 28–30, 53, 72
 critique of collecting culture, 13, 50–1
 descriptions of Louise Cahen d'Anvers,
 28–30, 32
 Jewish threat to French cultural patrimony,
 62, 63, 72
 nostalgia for art of the ancien régime,
 71–2, 195
Göring, Hermann, 5, 226
Grande Synagogue, Paris, 35
Guérin, Jacques, 197–8
Guggenheim, Peggy, 9

Halévy, Léon, 144–5
Haskell, Francis, 69
Henraux, Albert, 245–6
Higonnet, Anne, 186, 204
Holocaust
 Édouard Drumont as a Holocaust harbin-
 ger, 58–9
 France's collective memory of, 255–6
 history of French antisemitism and, 49–50
 knowledge of, 260
Hôtel de Pontalba, Paris, 47–8
houses
 Bassano townhouse, 26, 28, 34, 39,
 105, 227
 Château de Ferrières, 14, 60–4, *63*, 211
 of the French-Jewish establishment, 11, 15
 as military hospitals during WWI, 94–5
 of the Rothschild family, 163–4, 178–9,
 180
 rue de Monceau house, 107–8, 114–15,
 116, 117–23, 181, 191

rue Hamelin house, 105
see also Château de Champs-sur-
Marne; Villa Île de France, Saint-Jean-
Cap-Ferrat; Villa Kérylos

James, Henry, 9
Jaujard, Jacques, 221–3, 225, 248
Jews, French see French-Jewish establishment
Jullian, Philippe, 18, 19

Kahn, Zadoc, 26–7, 30, 45, 46
Klimt, Gustav, 120

Lambert, Raymond-Raoul, 217
Landon, Charles Paul, 69–70
Lévy, Madeleine, 241

Marrus, Michael, 16
Mlle Irène Cahen d'Anvers ('La Petite Irène')
in À bout de souffle (Godard), 252, 252
commission of, 32
exhibition of at the Orangiers, 18
idealization of feminine beauty, 30, 34
Irène Cahen d'Anvers claim on, 244–6
Julien Reinach's claim on, 248, 249
Léon Reinach's petition for the return of,
225–6, 248
Nazi confiscation of, 5, 19, 220–1, 248
recovery from Germany, 244
sale of to Emile Bührle, 246, 247–8
Musée du Louvre
Annales du musée et de l'école moderne des
Beaux-Arts, 69–70
establishment of, 185
Isaac de Camondo's bequest to, 11,
188–91, 197, 222
Société des Amis du Louvre, 189–90
tiara of Saitaphernes scandal, 74–7
Musée Nissim de Camondo
commemorative plaques, 1–2
custodianship of national patrimony,
194–8
as a memorial to the Camondo family, 16,
193–4, 256–7
Moïse's creation of, 1–2, 17, 192–8, 222
museums
collection museums of Jewish collectors,
187–8
custodianship of national patrimony,
187–8, 194–5
display practices, 209–10
encyclopaedic museums, 185–6
period rooms, 210
private collection museums, 186–7, 209,
257–8

see also Château de Champs-sur-Marne;
Musée du Louvre; Villa Île de France,
Saint-Jean-Cap-Ferrat; Villa Kérylos

Paxton, Joseph, 61–2
Pétain, Philippe, 4, 215, 241
Pontremoli, Emmanuel, 134, 149–50, 151,
152–3
Propper de Callejón, Eduardo, 250–1
Proust, Marcel
À la recherche du temps perdu, 7, 50, 65,
66, 168, 259
friendship with the Cahen d'Anvers family,
32, 36
friendship with the Camondo family,
89–90, 99

Reinach, Adolphe, 85–6, 141–2
Reinach, Henriette, 57, 141
Reinach, Hermann, 141
Reinach, Jacques de, 57, 77, 141
Reinach, Jean-Pierre, 131, 133
Reinach, Joseph
academic achievements of, 135–6, 137–40
bibliography, 134
defence of Alfred Dreyfus, 24, 42, 65–7,
74, 135–6
Jewish identity of, 144
marriage to Henriette Reinach, 57, 140–1
in Nissim de Camondo's correspondence, 87
at Nissim de Camondo's funeral, 102
photograph of, 66
Reinach, Julien
arrest and deportation of from Villa Kéry-
los, 131, 157, 223–5
claim on 'La Petite Irène' portrait, 248,
249
funeral of Théodore Reinach, 204
letter to Jacques Jaujard, 230
photograph of, 224
during WWI, 81, 84, 86–7
Reinach, Léon
after the German invasion, 216, 219–20
arrest and deportation of, 2, 5–6, 231,
235, 240–1
death of, 131, 243
divorce from Béatrice, 5, 24, 229–30, 247,
248–9
escape attempt from Drancy, 239–40
funeral of Théodore Reinach, 204
letter to Jacques Jaujard, 221–3, 225, 248
marriage to Béatrice de Camondo, 11,
103, 127
photograph of, 225
war effort of WWI, 81

INDEX

Reinach, Paul, 204

Reinach, Salomon
academic achievements of, 85–6, 136, 137–40
bibliography, 134
defence of Alfred Dreyfus, 65–6, 74, 135
Jewish identity of, 143
as a scholar and antiquarian, 42, 258

Reinach, Théodore
academic achievements of, 136, 137–40, 144
archives of, 131
bibliography, 134, 205–6
death of, 203–4
defence of Alfred Dreyfus, 65–6, 67, 74, 135
as a Hellenist, 134–5, 136, 150–1
Histoire des israélites, 42–3, 144, 145–8
on Jewish aesthetics, 148–9
Jewish identity of, 42–3, 44, 135, 143, 144, 204
at Nissim de Camondo's funeral, 102
numismatic works, 148
photograph of, *132*
remarriage of, 141–3
rue Hamelin home, 105–6
tiara of Saitaphernes scandal, 75
l'Union Libérale Israélite, 147
see also Villa Kérylos

Reinach family
aftermath of WWII, 131–3
art forgeries and the credibility of, 74
commemorative plaque, Saint-Germain-en-Laye house, 132–4
contribution to French cultural life, 221–3
family culture, 139–42
French-Jewish identities and, 42–3, 143–4
legacy of, 132–4
memory of, 258
Panama scandal, 56–7, 67, 74
tiara of Saitaphernes scandal, 74–7
during WWI, 84–5
see also Villa Kérylos

Reinach-Abrami, Hélène, 42–6, *43*, 85, 137, 139–40, 141–2, 204

Renoir, Pierre-Auguste
antisemitism of, 32
Rose et bleu, 18, 19, 30, 32–4, 251–2
see also *Mlle Irène Cahen d'Anvers* ('La Petite Irène')

Robert, Hubert, 185

Rothschild, Alphonse de
as a collector and philanthropist, 165–7
Édouard Drumont's attacks on, 58, 211
the Goncourt's attacks on, 211–12

at the marriage of Irène Cahen d'Anvers, 35
photograph of, *166*
and the Villa Île de France museum, 209, 210, 211, 212

Rothschild, Béatrice *see* Éphrussi, Béatrice (née Rothschild)

Rothschild, Edmond de
on Alphonse de Rothschild, 165
as a collector and philanthropist, 11, 152, 165–7, 213
Edmond de Goncourt's description of, 60–1, 72–3
funeral of Théodore Reinach, 204
at Nissim de Camondo's funeral, 102

Rothschild, Éduard de, 212–13

Rothschild, Henri James de, 164–5, *164*

Rothschild Bank, 55

Rothschild family
Château de Ferrières, 14, 60–4, *63*, 211
family culture, 163
houses of, 163–4, 178–9, 180
material culture of, 165
as protectors of French art, 212–13
the 'Rothschild Jew' trope, 164–5, 210
and the Villa Île de France museum, 209, 210–11, 212–13
during WWI, 81, 91–2

Sampieri, Carlo, 37–40
Sampieri, Claude (Pussy), *39*, 40, *40*, 246–7, 253
Sampieri, Irène *see* Cahen d'Anvers, Irène
Séligmann, Jacques, 87–8, 102, 119, 125, 126–7
Semelin, Jacques, 257
Seni, Nora, 108–9
Sergent, René, 107, 119, 120–3
Seymour-Conway, Richard, 9
Stammers, Tom, 13, 14–15, 51
Statut des Juifs, 216, 218, 222, 232

Third Republic, 51–3, 79, 117
Townshend, Lady Alice (née Cahen d'Anvers)
life of, 18, 19–20, 28
marriage, 24, 92
photograph of, *93*
Rose et bleu portrait, 18, 19, 30, 32–4, 251–2

Veil, Simone, 235
Vichy government, 4, 15–16, 49–50, 214–15, 216–17, 222, 229, 235, 256
Villa Île de France, Saint-Jean-Cap-Ferrat

INDEX

Béatrice Éphrussi's construction of, 160–1,
172, 173, 176–8, 181
bequest as a museum, 208–13
gardens, 181–2
interior design, 179–81
as a preserved home of the Rothschild
family, 209, 210–11, 212–13
roof design, 182–3
view of, *177*
Villa Kérylos
as an authentic reconstruction of Greek
beauty, 134–5, 148–9, 151–2, 206–8
within the Côte d'Azur, 206–7
Emmanuel Pontremoli's design for, *150,
151*, 152–6
government use of, 258
Julien Reinach's arrest at, 157, 223–5
the library, 205–6, *205*
name of, 150–1
the peristyle, 153–4, *155*, 156, 206
as a public museum, 204–6, 222
the solarium, *207*

Théodore Reinach's construction of, 16,
134–5, 142, 149–50, 151–2, 154,
155, *158*, 167
during WWII, 131, 156–7
Voltaire, 49, 50

Waal, Edmund de, 167–8
Warshawsky, Louise, 30, 31
Warshawsky, Sonia, 31
Watteau, Antoine, 70, 71
Widor, Charles, 212–13
women
abandonment of Judaism, 41–2
as art objects, 24–6
constraints of Judaism, 23, 41–2, 44–6
of the elite Jewish families, 23–4
idealization of feminine beauty in portrai-
ture, 27–31
portraits of, 27

Zadoc Kahn, Léon, 241
Zola, Émile, 30, 42, 50, 116

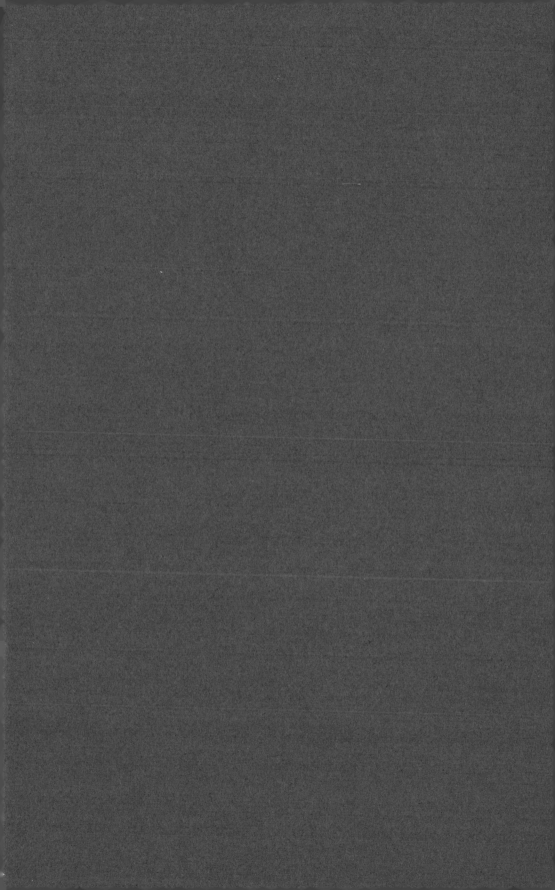